# DRUNKEN BOAT

# DRUNKEN BOAT

AUTONOMEDIA / LEFT BANK BOOKS

**EDITOR:**
Max Blechman

**DESIGN:**
Max Blechman
Jim Fleming

**PRODUCTION:**
Jim Fleming
Leah Lococo
Keith Nelson
Alex Trotter

**COVER:**
"Sunflower Sutra"
Watercolor by Eric Drooker

**COVER DESIGN:**
Eric Drooker
Eric Goldhagen

Please send all correspondence, manuscripts and art to:
**DRUNKEN BOAT, P.O. Box 718, NYC, NY, 10009 USA**

This is *Drunken Boat* #2. Subscriptions are no longer accepted.
*Drunken Boat* #1 is available for $6.

**CO-PUBLISHED BY:**

**AUTONOMEDIA**
55 South Eleventh Street
Brooklyn, NY 11211-0568 USA
(718) 387-6471

**LEFT BANK BOOKS**
4142 Brooklyn N.E.
Seattle, WA, 98105 USA
(206) 632-5870

**COPYRIGHT ACKNOWLEDGEMENTS:**
The editor wishes to thank Arthur Mitzman, Francis Naumann, Rose Carol Long,
Gary Snyder, Paul Avrich, and Jackson Mac Low for permission to reprint and freely
illustrate their essays. Their work appeared in the following books and journals
respectively: *Passion and Rebellion: The Expressionist Heritage* (Columbia
University Press), *New York Dada* (Willis Locker and Owens), *Art Journal*
(Spring 1987), *Labor History* (Summer 1977), *Journal For the Protection of All
Beings* (City Lights) and *The Poetry Project* (October/November 1992).

Special thanks to Amy Valor Meselson, Virginia Admiral,
Knickerbocker, Peter Lamborn Wilson, and R. O. Blechman.

Printed in the United States of America.

# CONTENTS

# INTRODUCTION

**F**rom the sagging dock of modernity, *Drunken Boat* sets out to sea. Leaving the shores of liberalism and Marxism, it aims to reveal and revitalize unexplored regions of anarchist culture. This issue provides little-known information on the life and work of Wassily Kandinsky, Man Ray, Otto Gross, and Jean Vigo. In an interview conducted during the last weeks of his life, John Cage discusses his ongoing commitment to anarchism. Jackson Mac Low, a longtime friend and colleague of Cage, offers a celebration of his life and work. Judith Malina recounts her work with The Living Theater, and in particular her activities during the Paris, May '68 insurrection. In his *Skoal To Drunken Boat*, George Woodcock recalls his early years in London as a poet in the context of a general overview of anarchism, literature and art.

In a similarly historical vein, Richard Sonn describes the symbiotic relationship between anarchism and culture, focusing on *fin de siècle* Europe. Pat Frank provides a close-up view of anarchism in San Francisco in 1952 and demonstrates how certain strains of abstract expressionism evolved from this consciousness. André Breton, in a remarkably revealing essay written toward the end of his life, articulates the relevance of anarchism to the surrealist project and repudiates surrealism's former Bolshevism as a deviation from its true ideals.

*Drunken Boat* operates as a forum for contemporary thought on the anarchist aesthetic. The editor opens with an essay outlining the basis for the synthesis of anarchy and aesthetics. Alex Trotter takes on the elusive world of Romantic and Decadent aesthetics and discusses the political bohemianism of these movements. Gary Snyder argues for a synthesis of Buddhism and anarchist rebelliousness against authoritarian society. Hakim Bey, in his meditations on Immediatism, formulates an anarchist sensibility and analysis for what he hopes to become a "secret" art movement. Lastly, Richard Kostelanetz reinterprets the controversial idea of an avant-garde from an anarchist perspective.

In addition to history and theory, *Drunken Boat* features fiction and poetry. Holley Cantine's story, *Second Chance*, is introduced by Dachine Rainer, who co-edited *Retort*, their anti-war anarchist journal of the arts. While the country continues to pay homage to the quincentennial of Columbus's conquest of America, this story about a Native American reconquest is especially pertinent.

A highlight of this issue is Jon Hillson's devastating *Room 19*, which portrays with bitter irony the scientific socialism of the recently fallen Communist regime. His poem articulates an intransigent critique of totalizing politics, a critique that has been familiar to anarchists since Emma Goldman's *My Disillusionment with Russia*. In his poem on Kronstadt, Tuli Kupferberg reminds us of the many libertarian spirits who supported the Bolshevik regime until those bloody days of betrayal, in the hopes that the vanguard was in fact realizing

country's celebrated high-brow culture. Readers will also no doubt be eager to read the recent work of Diane di Prima, an important member of the anarchist literati.

The book reviews section takes a look at the works of Joseph Conrad, Voltairine de Cleyre, Freddie Baer, James Koehnline, Herbert Read and B. Traven, to name a few. These reviews cover the realms of aesthetic and political theory, collage, poetry and fiction.

The editor apologizes for the enormous delay in the appearance of this issue, and for the omission of essays that were promised to appear in these

pages and will have to wait for the next *Drunken Boat*. Hopefully the boat will sail on a more reliable schedule, and successfully steer its way through the stormy seas of capitalist commercialism. Although a sobering change in format was deemed necessary by the editor and publishers, readers may rest assured that the integrity of the vessel remains intact.

their vision of social harmony.

*Drunken Boat* is honored to receive a contribution from a poet who has done much to synthesize the values of individual autonomy with artistic creation for the last forty years, Lawrence Ferlinghetti. His *Triumph of the Post-Modern* pokes fun at the emptiness of much of this

"THE DREAMER WHOSE DREAMS ARE
NON-UTILITARIAN HAS NO PLACE IN THIS WORLD.
WHATEVER DOES NOT LEND ITSELF TO BEING BOUGHT
AND SOLD, WHETHER IN THE REALM OF THINGS,
IDEAS, PRINCIPLES, DREAMS OR HOPES, IS DEBARRED.
IN THIS WORLD THE POET IS ANATHEMA, THE
THINKER A FOOL, THE ARTIST AN ESCAPIST, THE
MAN OF VISION A CRIMINAL."

HENRY MILLER, 1945
THE AIR-CONDITIONED NIGHTMARE

# TOWARD AN
# ANARCHIST AESTHETIC

## BY MAX BLECHMAN

## "RUN COMRADE, THE OLD WORLD IS BEHIND YOU"
### -Paris Graffiti, May '68

ociety stands uncertainly at the pinnacle of Progress. It is not the *bang* which haunts us as much as the continual *whimpering* of the human soul, not the sudden eclipsing of light but its gradual fading, not the fiery apocalypse of the Bible but the progressive decaying of all that is beautiful.

In *Beyond Good and Evil* Nietzsche describes the long period of "obedience in a certain direction," the "unfreedom of the spirit," the constraint imposed by the church and state, the harsh self-disciplining necessary for "cultivation," and how ultimately "an irreplaceable amount of strength and spirit had to be crushed, stifled, and ruined" for the development of civilization. The bombing of Hiroshima and Nagasaki announced the conclusion of modernity—and the forms of social control that Nietzsche invoked continue to reign on a throne embedded in the minds of a homogeneous society.

Power has become radically decentralized, by which is not meant community self-empowerment, but the dissemination of coercive relations in all spheres of life. The historical punitive structure has been internalized, the state reproduces and sustains itself within the collective unconscious. People build their own jails, forge their own chains, act as their own worst enemies. Capitalist exchange relations—far from creating the revolutionary proletarian solidarity envisioned by Marx (and the various authoritarian "isms" that have pontificated in his name)—have ultimately served as an efficient means for pacification and conservatism. The Hegelian self-becoming of the masses, that grand historical mission of the working class, turns out to have been a failed prophesy, a flawed crusade, a dialectical hoax.

Confronted by the ever-encroaching Iron Cage of Bureaucracy and the deception and hypocrisy of past revolutionary movements, a cynicism abounds, and for many, a certain emptiness and hopelessness as well. And yet the diffuse quality of contemporary oppression and the historical failure of authoritarian models of revolution may serve as the basis for a more radical critique of the process of social change and, therefore, a more fundamental rejection of the past. Because it is the individual's self-determination that has consistently been assaulted in the development of both

Illustrated by Frans Masereel (1889-1972)

capitalist society and authoritarian revolutions, self-determination must become the starting point and the end for any attempt to truly leave the twentieth century behind. Any teleology that differentiates the means from the end, be it communism through capitalism, egalitarianism through authoritarianism, or individual liberty through the oppression of individuals, fails to address the problem of domination per se. And if domination is not confronted as a problem in itself, then it is not addressed at all. Human emancipation must begin with itself as the only means and the realization of each person's individuality as a continuous end, not as an abstract aim but concretely in the here and now. Real liberation means immediate liberation. "Run comrade, the old world is behind you!"

## THE ANARCHIST AESTHETIC

In combining anarchism (from *anarchos*:without ruler) and aesthetics (from *aesthetikos:* sensitive, which evolved from *aisthanesthai:* to perceive) a conception of art radically different from bourgeois and Marxist aesthetics may be gleaned. At the heart of the formulation is the belief that the creative process, as necessarily evolving from individual (but not isolated) experience exists to the extent that the individual is insubordinate to authority. The idea that insubordination to authority is integrally connected to the broadening and intensification of sense perception associated with art is by no means novel. The radical individualism of a James Joyce or an Oscar Wilde was consciously based on this

belief, and as *Drunken Boat* goes some way in demonstrating, anarchism has played a significant role among art and literary movements generally.

Anarchist insubordination to authority, like the perpetual struggle to realize the self, is at best a never ending process. There is no final solution, no ultimate reconciliation between subject and object, no day after the revolution, no Eden that will ever grace all of human society. Yet, as Albert Camus has pointed out, to rebel against omnipresent forces of domination which suppress one's desires is not to attempt their absolute destruction. Social structures can and will be negated at some point, but above all rebellion is an affirmation of one's own existence in the present. At the moment of rebellion one begins to experience what one is, for it is then that desire and love are acknowledged as realities that must be lived. Not only must they be lived, but they must be realized in the immediate moment, not postponed to a number on a calendar whose day will never come.

This is the impetus of art, for what is creativity other than the affirmation of one's unique individuality in the primacy of the moment? By living for the moment one is by proxy engaging in an act of rebellion against all those social forces which demand the sacrifice of the present time for the sake of some future reward. Rebellion constitutes the essence of life, each act of insubordination gives rise to an existential individualism and with it, the dynamic creativity with which everyone is gifted. As such rebellion is at

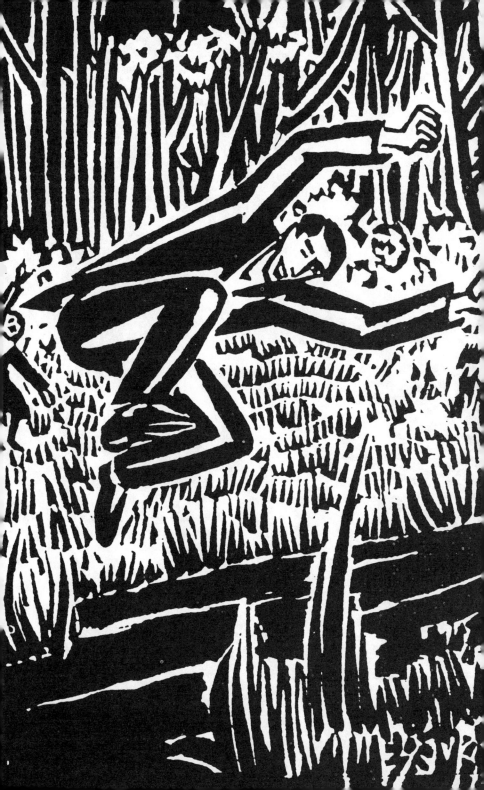

the same time a rejection of all that which inhibits and destroys one's creative capacity, and the process of discovering what a creative existence might mean.

## CRITIQUE OF MARXIST AND BOURGEOIS IDEOLOGY

Artistic activity is necessarily an affirmation of the present, for it is only in the liberty of the moment that we may wholly exist, and in truly being, allow for the creativity in ourselves to develop. The faith in dialectical materialism intrinsic to Bolshevik ideology is the antithesis of fully inserting one's life into the present. For the Bolsheviks it was never the present that mattered, and they could therefore destroy direct democracy in the factories and suppress libertarian communes in the Ukraine all in the name of an alleged good that was to come. The end may have been the withering away of the state but the Bolsheviks' means ensured its increased power and predominance. The soviet work-camps, the systematic breaking of the workers' councils, the aesthetic dogma of socialist realism, all functioned hand-in-hand and have in common the destruction of the creative spirit.

Capitalist and orthodox Marxist ideology share the same principles to the extent that they both fail to question the Progressist fetish of production and deny workers the ability to organize themselves. Creation in such a society is undermined because the worker exists entirely for the production of commodities to which s/he has no meaningful relationship and because everyone is subordinated to the dictates of a political hierarchy. Creativity, being inextricably linked with self-determination, is stunted as soon as the autonomy of the individual is trampled upon. By destroying the autonomy of people, capitalism, as much as authoritarian socialism, liquidates their innate individualism. In both cases the dominant social institutions find their basis in a mechanized negation of everything that contains an inkling of sensitivity, free perception, imagination. Neither capitalist nor orthodox Marxist ideology can foster a society conducive to artistic creation for they both refuse to differentiate between human beings and things. In the end they both perpetuate a social structure which replaces the spontaneous subjectivity of people with a disciplined hierarchy of objects.

Like their economic ideologies, both bourgeois and Marxist aesthetics are ultimately a form of social control, the former through distraction and the latter by deceit. For Marx, art could never last meaningfully through the ages but is limited in its communication to the people of its period. It is therefore not surprising that the Bolshevik regime, since its historical period was defined as revolutionary, declared that the only genuine art is art that communicates the ideals of the revolution. Individual consciousness had to conform, in Procrustean manner, to class consciousness. Art became subordinate to an ideal that was disguised as a reality, and by being subordinate, ceased to express the artist's unique perception and experience. It is what

Adorno called "praxis art," a uniform art filled with didactic content, a homogenized art that fails as art because it fails to be autonomous.

Bourgeois aesthetics perpetuates its own form of meaninglessness, with the same instincts to preserve the status quo as those of socialist realism. In bourgeois society art has the degraded role of acting as a commodity in a market economy and hiding the ugliness of that economic system. Art that is otherwise fresh and vital is appropriated by capitalism and functions as a palliative to spruce up the drabness of everyday life. In the supermarket, for example, a synthesized version of the Beatles' "Can't Buy Me Love" is played to distract one from the frustrating monotony of a long line and the boredom of everyday life. In bourgeois society art becomes inseparable from the dominant exchange relations, and as with all other aspects of life, it loses its autonomy by becoming a tool for capitalist expansion.

## THE FORMS OF THINGS UNKNOWN

It is said that an anarchist society is impossible. Artistic activity is the process of realizing the impossible. It extends the realm of the possible to that which has been considered impossible. To use the words of the English art critic, Herbert Read, art has the potential to "communicate those objective realities... which rule and convention have hitherto concealed." The realms of art can be considered forms of knowledge as yet alien to most human experience but always latent components of human consciousness that are ready to transform themselves into actuality. Artistic activity can be, when freely undertaken, the act of creating a form for that which does not yet exist. The cognitive and individualistic process of nurturing and exercising one's imaginative capabilities is a prerequisite to anarchic collective action. In order for the radical democracy of anarchy to facilitate free association and the flourishing of everyone's personality it must not become mob rule, and the only way mob rule and all other forms of authoritarianism can be avoided is if people develop confidence in their own creative capacity. Artistic activity allows for the growth of this confidence, and nurtures a form of questioning and exploration necessary to avoiding blind allegiance and fostering creative action.

The work of art has generally been considered worthy only so far as it presents a historically viable content on the one hand (Marxist aesthetics) or decoration and market value on the other (bourgeois aesthetics). In both cases the cognitive function of art is ignored, which is that process of imaginatively exploring subjective emotional content. By becoming aware of one's own repression, and speaking the poetry that is found in the recesses of the imagination the individual posits a different experience. This is the task of art. The autonomy of art embodies the anarchic, self-determining consciousness without which emancipatory movements are doomed to repeat all the atrocities of previous revolutions.

A society based on domination creates a submissive, mechanized consciousness. In contrast, art arrests the wheels of mindless routine and submission in the act of creation. When painting a picture or writing a poem, the artist breaks away from established perceptions of reality and scrutinizes his/her own experience. Embedded in the creative process is the potential to construct forms for that which has been robbed from human experience and retrieve these forms back into the consciousness of the human mind. Modern art was largely the striving for this liberation of form, for the magic and wonder so absent in social reality. At stake was ripping consensus reality, going into the darkness beyond it, and creating a form that was both a memory of things past and a vision for what remains possible. Creativity is that activity of the senses without which people's spirits die and float away. Art expresses the need for happiness, against which domination is always pitted. As Herbert Marcuse put it, if people lived in a free society, "then art would be the form and expression of their freedom."

Art acts as a reminder of the potential joy of life, and as an anarchic force against all that which usurps it. It functions as a perpetual reminder that all meaningful life involves a stretching of the limits of the possible, not toward an absolute, but away from absolutes and into the depths of imagination and the unknown. This creative adventure, at the bottom of all great art, is the power which, if universalized, would embody the driving force of social anarchy.

# CULTURE & ANARCHY

## BY RICHARD D. SONN

In the late 1860s, the progressive and optimistic mood of upper-class Englishmen was disturbed by some ominous portents of discontent. In 1866 Parliament defeated a Reform Bill designed to expand the franchise to include lower and middle-class males. The Reform League organized protests, one of which marched into Hyde Park, where protestors tore down some of the iron railings and trampled on the flowers of a park that had been regarded by middle-class Londoners as their own preserve. Seeing the inevitable, the Conservative Party under Disraeli spearheaded passage of the Reform Bill the following year, but many Englishmen feared giving such power to the populace. Meanwhile Fenian outrages culminated in the plot to blow up Clerkenwell prison in order to free Irish prisoners. The attempt failed, but twelve local people were killed, another 120 injured. To that eminent Victorian Matthew Arnold, such violent and democratic movements reinforced a general social and cultural malaise that he termed anarchy.

In his famous book *Culture and Anarchy*, written during and immediately after passage of the Second Reform Bill of 1867, Arnold found fault with all strata of English society, levels which he uncharitably distinguished as "barbarians, philistines, and populace." England was anarchic not only among its unwashed masses but even among the middle classes, especially those Nonconformist successors of the Puritans who championed the *laissez-faire* principles of free trade and minimal government. Arnold, in his public capacity as an inspector of schools, wanted a larger role for goverment, but more importantly he championed the claims of higher culture against the dissolving forces of rampant individualism and mob democracy. He spoke for a higher reason, for culture as the perfection of the highest aspirations of humanity, for "sweetness and light." It was indubitably clear to Matthew Arnold that culture as he knew it was threatened by all the forces of modern society.

While high Victorian England weathered the storms of social and political change, the cultural elite did increasingly feel alienated from society, and withdrew into a mannered aestheticism that peaked in the "yellow nineties" with the langorous decadence of Aubrey Beardsley and Oscar Wilde. At the same time as Arnold was railing against the anarchy of contemporary English culture, a genuine anarchist movement was developing on the continent of Europe. In France the followers of Pierre-Joseph Proudhon, who died in 1865, were becoming more numerous; in Italy, Spain, and Switzerland the words and deeds of Mikhail Bakunin were attracting support. Between 1868 and 1872 Bakunin and his fellow anarchists dissociated themselves from the followers of Marx in the Working Man's International, and anarchism emerged as a distinct movement, which would grow in numbers and notoriety for the next half century. There is a double irony in Matthew Arnold's fears for culture at the hands of anarchy. Anarchy was indeed

Facing page: Walter Crane. To the memory of the Paris Commune.

emerging at precisely this moment, though not as he envisioned it. And anarchists would in the following decades embrace culture as fundamental to their criticism of the status quo, though they also envisioned culture very differently from Arnold.

For the newly emerging anarchist movement, culture and anarchy became not opposing but symbiotic tendencies. Because anarchists rejected not simply the political power structure—the parliaments, judicial systems, police forces, and armies—but all forms of domination and hierarchy however manifested, their critique of contemporary society took on a broadly cultural dimension. They attacked the authority of bosses, of teachers and administrators, of the arbiters of taste in the Salons and Ecole des Beaux-Arts, of fathers in the patriarchal family (though this last was one area in which Proudhon admittedly fell short). Since they attacked authority at all levels from the most personal to the most public, their radical alternatives to the status quo necessarily involved a total cultural rethinking, and envisioned a utopian set of aspirations for personal and interpersonal liberation. Anarchists did not draw up plans for a future revolution while living contentedly by the bourgeois norms of the present; they embodied the revolution in their daily lives. In this sense, anarchists created a counterculture of free schools, free press, and free love that challenged existing social mores as surely as their bombs contested public centers of power.

Anarchists of the late nineteenth century not only created a vibrant cultural scene; they relied upon it to give their movement the cohesion and solidarity that it otherwise might have lacked. Anarchism had serious liabilities as a social and political movement. Anarchists were hard to organize, hard even to recognize since they carried no cards, paid no dues, never voted for candidates, acknowledged no leaders. Cultural institutions functioned as alternate centers of the organization they otherwise would have lacked. Turn to the major figures of the movement around the turn of the century, aside from the terrorists who achieved short-lived notoriety. Most well-known activists were connected with the anarchist press. Emma Goldman in the United States, Sebastien Faure, Emile Pouget, Jean Grave in France, Peter Kropotkin at least initially in Switzerland, the Montsenys in Spain, all wrote for and edited newspapers or journals. Their offices became centers of activity as their papers served as networks of information and coordination. Others who excelled at oratory, such as Louise Michel or, again, Emma Goldman, might be more loosely attached, but they too relied upon the anarchist press for publicity. Francisco Ferrer became famous as an educator, and anarchist free schools (often called Ferrer schools after his martyrdom in 1909) were important community and cultural centers as well as being sites for the inculcation of antistatist and anticlerical values among the young.

Less formal than schools and newspapers but probably more a part

of quotidian reality were the cafés, cabarets, and wine shops where anarchists felt comfortable in meeting and sharing information. A merchant who was known to be sympathetic to the cause might extend credit to indigent *compagnons*, provide reading material, and allow local groups to meet in his back room. Many group activities were explicitly cultural, such as the *soirées familiales* (family evenings) held in a variety of Parisian restaurants and bars in the 1890s. Some would feature a notable singer with anarchist sympathies, or perhaps only group singing. Given the ubiquity of police informers, it was wiser to use such meetings to establish bonds of solidarity than actually to plan political activities.

Some performances might be more lavish, as at the various cabarets run by Maxime Lisbonne between 1889 and 1894. Lisbonne had been a member of the Paris Commune of 1871, had been exiled for the next decade, and returned determined to capitalize on his radical notoriety. His cabarets were all located in Montmartre, the artists' colony at the northern edge of Paris, which became the locus of French anarchist culture in the *fin de siècle*. His most famous enterprise was probably the Taverne du Bagne, named after the infamous prison hulks. The cabaret experience was used to travesty authority, as the waiters served the patrons in chains and prisoner garb. Lisbonne's cabarets made explicit what most Montmartre cabarets implied, contesting the dominant culture and social status quo. As long as popular culture was localized it could afford

to thumb its nose at the authorities, and could even profit off its irreverence. Irreverent insouciance was the essence of cabaret style in the era of Toulouse-Lautrec and Aristide Bruant; the anarchists had only to give it a firmer ideological frame.

Could the popular culture described above be described in class terms as lower-class? Not in the Marxist sense, certainly. Many anarchists worked, but generally in restaurants and small workshops rather than in factories. Tailors, printers, waiters, workers in the building trades were typical urban anarchist trades. Anarchists remained artisanal rather than proletarian, when they weren't actually peasants as in parts of Italy and southern Spain. In Paris, anarchist culture was less proletarian than *déclassé*, including bohemian artists, prostitutes, store clerks, students, and a variety of other types that refused easy categorization in class terms. People who adhered to anarchist ideals presumably felt exploited and alienated, but could not easily fall back on ready-made economic categories to explain their opposition to the authorities. Socialists might argue that unskilled workers must necessarily espouse socialist values because of what they did; anarchists often drew support from skilled workers and *déclassé* intellectuals, united by their dreams of an alternative society. Their solidarity was not a social given but a cultural creation.

All popular culture during the anarchist heyday was not inherently anti-governmental, although it is difficult to imagine the sort of jingo-chau-

*Paul Signac,* In the Time of Harmony *(1894), an oil study of Signac's most overtly anar-chist painting. A lithograph of the same title and design was issued by Grave's journal* Les Temps Nouveaux *in 1896. (Courtesy of Françoise Cachin.)*

vinistic music hall culture of England holding sway in France, Italy, or Spain. One reason that French cabaret culture sometimes merged with anar-chist culture was its bohemian color-ing. Bohemia was not always politi-cally radical, but it was always social-ly marginal and hence suspect. In Paris it was geographically marginal-ized on the slopes of Montmartre, in a floating world that the cabarets shared with artists, prostitutes, and much of the anarchist press. Socialists per-ceived themselves as inhabiting the center of the working-class world; anarchists thrived on the peripheries, refusing easy class identification, making common cause with the mar-

ginal social elements left out of the modern, industrial state.

This liminal milieu in which anar-chist culture thrived conjoined the popular cultural forms of circuses and cabarets with the emerging high cul-ture of the artistic avant-garde. Impressionism, Post- and Neo-Impressionism, Fauvism, and Cubism were all born in Montmartre, or at least provided cheap studios for many of the major artists early in their careers. Many of these artists either flirted with anarchism or were full-blown adherents of the movement. That the same milieu sheltered artists and anarchists, that many of the former espoused the ideals of the latter, was

not a mere coincidence. Much more than has previously been suspected, avant-garde art and anarchism evolved together and reinforced each other. Anarchism turned artistic rebelliousness into a principled position of autonomy, originality, and hostility to bourgeois morality. Avant-garde artists may have been natural anarchists, leading lives of bohemian unconventionality and creative license, but the same values motivated the parallel avant-gardes of painting and politics. By the early 1890s important critics were virtually defining the poetic movement called Symbolism in anarchist terms. Impressionists, Symbolists, and Cubists all thrived by opposing the artistic authorities of the Academy and the Salons. They valued independence, individuality, autonomy, integrity to their subjective vision and disregard of all the rules of perspective, composition, and rhyme. In their hands art came to signify freedom from rules. True poetry had to be free verse.

In some respects both bohemian culture and the avant-garde may seem like neo-Romantic effusions, with Classical order rejected and subjective individualism cherished. There is some truth in seeing mid-century Realism and Naturalism as emanations of the Enlightenment in drab nineteenth-century industrial garb, and the late-century movements as a reaction against this materialist and positivist fetish of fact and scientific method. There is a strong generational dialectic at work in the art world. The problem with this perspective is that many of the Realists saw themselves as rebels, and one of them, Gustave Courbet, was an avowed anarchist and friend of Pierre-Joseph Proudhon. Impressionism was itself a sort of realism that aspired to retinal accuracy; Neo-Impressionism went even further in this direction, with Georges Seurat and Paul Signac, both anarchists,

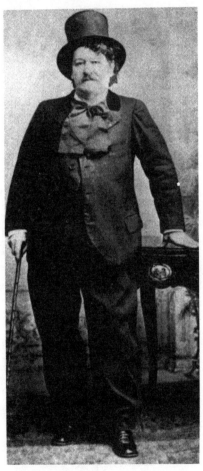

*The anarchist as bohemian—Maxime Lisbonne, ca. 1885. (From Mariel Oberthur, Cafés and Cabarets of Montmartre, trans. Sheila Azoulai [Salt Lake City: Gibbs M. Smith, 1984]. Courtesy of Peregrine Smith Books.)*

seeking to conjoin art and science. At the same time Van Gogh, Charles Maurin, Toulouse-Lautrec and other Post-Impressionists had little use for science but were equally adamant about challenging aesthetic orthodoxy while they positioned themselves as *hors la loi*, outlaws from the status quo. While the Fauves of 1905, men like André Derain and Henri Matisse, might exult in their sobriquet "wild beasts" as they continued the Post-Impressionist exploration of subjective emotional states, the Italian Futurists who assaulted the international art scene around 1909 with their celebrations of movement and industrial dynamism were more formalistically radical in their departure from conventions of realism, perspective and depth. Most radical of all were the Cubists, although their art tended to be more analytical and less obviously emotional than that of most of their pre-World War I contemporaries, whether Fauves, Futurists, or German Expressionists. All of the artists working under these rubrics were not anarchists, but a surprising number were. Between 1890 and 1914 perhaps even a majority of those working in Paris were anarchists or sympathizers, and they had counterparts in Greenwich Village, Munich, Milan, and elsewhere.

What this panoply of modernist art movements suggests is that there was no one anarchist style, but rather that anarchism gave avant-garde artists the freedom to experiment with a great many stylistic possibilities. Nor were artists enjoined to depict the starving masses, though a number of

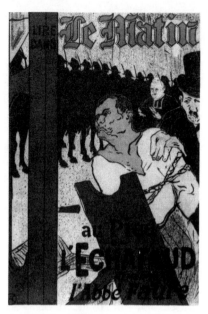

*Henri de Toulouse-Lautrec,* At the Foot of the Scaffold, *1893. Unlike Maurin, Lautrec did not choose to heroicize the person facing the guillotine. (Courtesy of the Musée Toulouse-Lautrec, Albi.)*

committed artists contributed socially radical illustrations to anarchist journals. Admittedly some major anarchist intellectuals, such as Proudhon and Kropotkin, did have more traditional notions of how artists might serve the cause, and might have had difficulty in understanding just how a Signac pointillist landscape of the harbor of St. Tropez contributed to the social revolution. But because of the lack of centralized direction of the movement, no anarchist "leader" was ever able to dictate a prescribed artistic style as did the socialists. In fact the center of gravity went the other way, to the degree that culture was itself central to the anarchist movement. No one style, but rather the avant-garde demand for

destruction of the old and continual renewal, for unbridled creativity, autonomy, and freedom, became the link between art and anarchism. This link was far more profound than historians and art historians have imagined until very recently. All of the movements cited above contained large numbers of artists who were either active anarchists or at least sympathizers. This connection between avant-gardism and anarchism was broached three decades ago in Eugenia Herbert's book *The Artist and Social Reform*, and has more recently been developed in Joan Halperin's book on the Neo-Impressionist critic Félix Fénéon, in my book on *Anarchism and Cultural Politics in Fin de Siècle France*, and in Patricia Leighten's *Reordering the Universe: Picasso and Anarchism, 1897–1914*.

Of all the political movements which have emerged since the early nineteenth century, anarchism has been the most comfortable with the continual impetus toward stylistic radicalism known as modernism. This is a remarkable phenomenon for several reasons. Firstly, there has long been a myth that the formal innovations made by avant-garde artists were purely aesthetic, with no social or political implications. The books cited above have begun to challenge that assumption. Secondly, names such as Impressionism and Cubism are more familiar to the general public than is that of anarchism, and are certainly better understood. Restoring the place of anarchism in the genesis of modernism will help refurbish the image of anarchism so long tarnished by its exclusive association with terrorism and bombs. This historical restoration will also clarify the value and meaning of cultural politics that was so much a part of turn-of-the-century anarchism. It will offer another example of how art can signify social change besides that of the mostly unhappy marriage of art and leftist politics usually called Socialist Realism. And it may even help to identify how anarchism is unique among modern political ideologies.

If culture, in both its popular and avant-garde incarnations, really has played such an important role, this differentiates anarchism from all other political movements. Only anarchists can claim that not the state, not the military, not even the economy, but rather culture is central to it both as movement and as ideal. This is in part for negative reasons, since anarchists have eschewed other forms of organization, especially those linked to the state. The only major rivals would be the union for anarcho-syndicalists, and possibly the small terrorist cell for conspiratorial types. In the long run, however, especially if we bring the history of anarchism up to date and include the counterculture of the 1960s and recent radical feminism and ecology (see my book, *Anarchism* [Twayne, 1992] for a discussion of these movements) cultural change remains at center stage. In the May, 1968 mini-revolution of Paris the unions were only a hindrance to spontaneous revolution, while terrorists who emerged in the 1960s and 1970s were socialist, nationalist, and anti-imperialist but never anarchist.

Anarchism has embraced culture for positive reasons as well, as fundamental to its humanist orientation. If states, armies, and factories all signify domination and dehumanization, culture stands for creativity, individuality, free expression. The artist more than the worker and certainly the professional revolutionary is the model of the kind of human being envisioned by anarchists. He or she operates by what the French leftist students called *autogestion*, self-management or self-direction. For Marx, humans only realize themselves through their labor, by acting on the world. This implies the need to dominate nature, transforming it, humanizing it through work, enlarging the human sphere by diminishing the Other. Anarchists are less other-directed and more inner-directed, more concerned with realizing their own potential as full human beings than with transforming the material world. The costs of such transformation are painfully evident in the ecological devastation rife in Eastern Europe and the former Soviet Union; the fruits of creativity by contrast may be most evident in the non-purposeful realm of art (and perhaps in the equally non-purposeful realm of play).

There remains a problem in the above description of anarchist cultural politics, in the division between popular and avant-garde art. The latter has appealed primarily to educated cognoscenti while anarchism has found support among peasants, workers, artisans, and other less-than-privileged social groups. Avant-gardism, furthermore, has often exulted in the incomprehension of the masses, defining itself agonistically by the hostility of, to return to Matthew Arnold's terms, the philistines. Modernist artists have only thrived in bourgeois societies, living off their art while others provide the material basis for their existence. The solution to the dichotomies of popular/avant-garde, material/aesthetic, hand/brain, was suggested long ago by Kropotkin, as well as by William Morris and other advocates of craftsmanship. In the anarchist utopia the boundaries between manual and intellectual labor, between art and craft, dissolve. People are free to express themselves through their work. Artistry pervades life, rather than being restricted to museum walls and bohemian artist studios. All people have a right to artistic values of self-expression and self-development, and the more these values pervade their daily lives the less alienated they will be. This expressive union of art and life would, theoretically at least, obsolesce the avant-garde, since art would no longer be marginalized, nor would artists assume a combative stance. Instead, the anarchist avant-garde that existed to *épater* the bourgeois would work to renew and to beautify society. The tension between individuality and community would be overcome; all would be at home. This utopian project is worth enunciating if it provides a basis for contrasting contemporary mass-based, consumerist passivity (Nutrasweetness and Lite?) with real human potential. Such a transformation would indeed constitute a cultural revolution of which even Matthew Arnold might have approved.

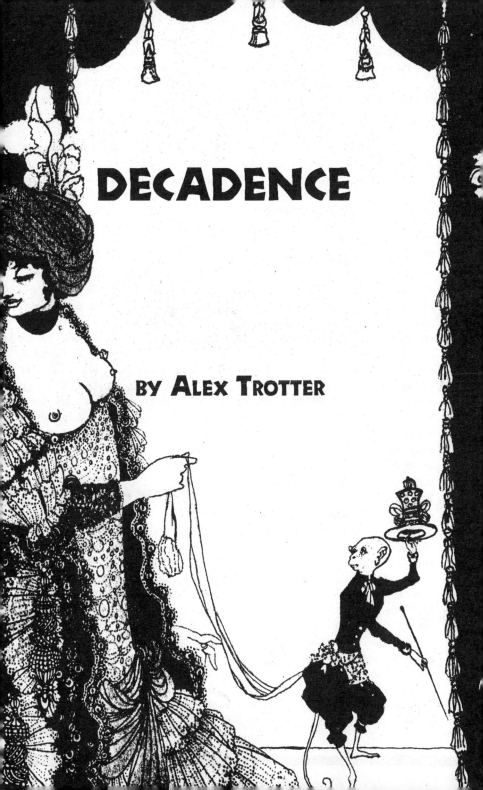

# DECADENCE

## BY ALEX TROTTER

> *There is no decadence from*
> *the point of view of humanity.*
> *Decadence is a word that*
> *ought to be definitively banished*
> *from history.*
> *— Ernest Renan*

The word "decadence" has been thrown about so much it has become a banality. Authorities or would-be authorities of all kinds (religious or political ideologues, the media) lecture to us about the decline of western civilization. On close examination the meaning of this term, whether used as an epithet or as a badge of honor, turns out to be elusive. In a general sense decadence seems to be connected to fatalism, anomie, malaise, and nostalgia. It describes a falling away of standards of excellence and mastery associated with a bygone age of positive achievement; heroism yielding to pettiness; good taste yielding to vulgarity; discipline yielding to depletion, corruption, and sensuality. A decadent world is one in which originality has ended and all endeavors are derivative, in which pioneers and geniuses have given way to epigones. Decadence has connotations of (over) indulgence in carnal appetites, derangement of the senses, and violation of taboos. It is supposed to be a frivolous pursuit of exotic and marginal pleasures, novelties to serve jaded palates. Decadence makes you think of sin and overripeness.

Physics recognizes a law of decay and decline with universal application to all natural processes. It is called the second law of thermodynamics, or "entropy," as it was dubbed by the German physicist Rudolf Clausius in 1850. According to this law, there is a natural and increasing tendency in the universe toward disorder and the dissipation of energy. Efforts to arrest the process of decay and create or reestablish order are only temporary in effect and expend even more energy. Through this inexorable process of entropy, astronomers tell us, the sun will eventually burn out, and the entire universe may well collapse back upon itself in a "Big Crunch" that will be the opposite of the theorized "Big Bang" with which it supposedly began. There's nothing anyone can do about this cosmic decadence, but the time frame involved is so immense that there's no point worrying about it, either. Besides, it's just a theory. For the purposes of this essay, I will restrict myself to a consideration of the earthbound and largely historical dimensions of decadence.

## HEALTH AND DISEASE

In a grand historical sense, the concept of decadence has been used to describe epochs of civilization in biological metaphor, as beings that are born, come to maturity, then sink into senescence and die because they have been condemned "by History" (or God). In this sense decadence is connected to a moralistic as well as a fatalistic vision. The word implies judgment of human experience on a scale of values and measures it against a 'correct' or 'healthy' standard. Decadence first appeared as a

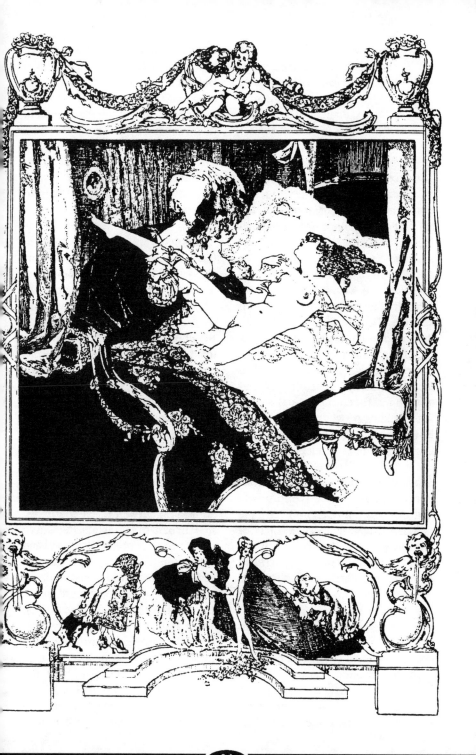

word during the Renaissance (1549 in the English language, according to Webster's) but its use remained sporadic until the nineteenth century. It can therefore be thought of as primarily a modern concept, and as such it is inescapably linked to the notion of Progress, as its opposite and antagonistic complement.

What lies on either side of Decadence, before or after it, is the myth of a golden age of heroism and (near) perfection. The ancient civilizations tended to place the golden age of their mythologies in the past. Judaism and Christianity (and by extension, Islam) also have a golden age, the Garden of Eden, located in the past. But it is with the monotheistic religions that the dream of cosmic completion was first transferred to the future, in an eschatological and teleological, semihistorical sense. After holding people's minds in nearly undisputed thrall for centuries, Christian theology underwent a long decay through Renaissance humanism, the Reformation (in particular its unofficial, suppressed antinomian and millenarian currents), and the rationalist, materialist philosophy of the Enlight-enment. The French and American revolutions partially destroyed the Christian time line and opened up the horizon of a man-made history. The violent irruption of the bourgeois class into terrestrial political power replaced the inscrutable cosmic narrative written by God and shrouded in grandiose myth with a historical narrative authored by abstract Man and wallowing in the Reason of political ideologies. The

dogma of determinism survived, however. Apocalypse, Heaven, and Hell were shunted aside by capitalism, which offered instead its absurd dialectic of revolution and reaction, progress and decadence. As the nineteenth century unfolded, liberalism, Marxism, and leftism continued the identification of progress with industrial development and the expansion of democracy.

All of the great epochs of civilization (slavery, Oriental despotism, feudalism, and capitalism) are considered by Marxist and non-Marxist historians alike to have experienced stages of ascendancy, maturity, and decline. The Roman Empire is one of the chief paradigms of decadence, thanks largely to the eighteenth-century English historian Edward Gibbon, the most well known chronicler of its decline and fall. The reasons for the end of the ancient world are not so obvious, in spite of a familiar litany of symptoms, most of which have been attributed to economic causes: ruinous taxes, overexpansionism, reliance on mercenary armies, the growth of an enormous, idle urban proletariat, the slave revolts, the loss of the rulers' will and purpose in the face of rapid change, and—the most obvious and immediate reason—military collapse in the face of the 'barbarian' invasions. These facts don't explain everything. Can it be said that Christianity's rise to power amid the proliferation of cults was an integral part of the decay, or was it rather part of a "revolution" that transcended decadence? It is not at all clear that the Roman

Empire ended according to an iron law of historical determinism. If that were the case, it is not likely that decadence could be imputed to 'moral decay.' The actual collapse of the Western Empire came centuries after the reign of the most depraved emperors, such as Nero and Caligula. And should it be said that the Empire was decadent, while the Republic was not? Both were supported by the slave-labor mode of production, and both were systems of extreme brutality and constant warfare. The notion of progress and decadence, retrospectively applied to this case, implies that the civilization based on slavery was not only tolerable and acceptable, but indeed healthy, in the bloom of its historical youth, and only later became poisoned and morbid.

The same observation applies, of course, to the other ancient civilization of the West—Greece, which was superior to Rome in so many ways because of its democracy and its fine achievements in art, literature, science, and philosophy. The Athens of Pericles is usually considered to have been the high point of that civilization, in contrast to the "decadence" of the Alexandrian or Hellenistic age. But there would have been no Greek art or Athenian democracy without Greek slavery. There is the great tragedy: The beautiful things of civilization have always been built on a foundation of bloodshed, mass suffering, and domination.

The other great classic of decadence in the grand historical sense is the *ancien régime* in France. This example serves as the core vision, dear to the modern Left, of a tiny handful of identifiable villains, the corrupt, obscenely privileged, and sybaritic aristocrats, oblivious to the expiration of their heavenly mandate, partying away on the backs of the impoverished and suffering masses, but who get their just deserts in the end. This was of course a partial truth, but it was built into a myth that has fueled similar myths well into our own time, the classic modern example being that of the Russian Revolution. The great revolution that chases out decadence has been multiplied more than a dozen times since. But this dream that has been played out so many times is still a bourgeois dream, though draped in the reddest 'proletarian' ideology. It is the dream of the Democratic Republic, which replaces one ruling class with another, and it has always turned into a nightmare.

Against the decadence of the old world of the feudal clerico-aristocracy, the Jacobins proclaimed the Republic of Virtue. The mode of cultural representation with which the revolutionary bourgeoisie chose to appear at this time—as a reincarnation of the Roman Republic—deliberately broke with Christian iconography. But it set a precedent for conservative, and eventually fascist, cultural ideology—the identification of social health with the classical, the monumental, and the realistic. The Jacobin regime of emergency and impossibly heroic ideals quickly fell, and the entire political revolutionary project of the bourgeoisie in France was rolled back (more than once) by a resilient aristocracy. But the reign

of Capital was assured, for its real power lay in the unfolding, irresistible juggernaut of the economy. This juggernaut was already much further under way in England, while in Germany the bourgeoisie advanced only under the banner of philosophy and the arts.

## PARIS, CAPITAL OF THE NINETEENTH CENTURY

The triumph of 'ascendant' capitalism in the nineteenth century brought forth an unending cultural and human crisis as the bourgeoisie and its allies in the patriot aristocracy, even while continuing their struggle with absolute monarchy and the remnants of feudalism, fought also to contain the utopian liberatory impulses unleashed by their own initial revolutionary impossibilism. The vaunted progress of the bourgeoisie—technological conquest of nature, industrial pollution, dull-minded positivist rationalism, and philistine demand for the proof of usefulness—had resulted not in a best of all possible worlds, but rather in a massive degradation of human experience. In addition to the proletarians enslaved in the factories, there were rebellious souls from more privileged social strata (the bourgeoisie itself, very often the aristocracy, and the middle classes) who revolted against the new conditions of alienation, in which Modernity and Progress were leading to disintegration of the self and nausea at the corrosion of spiritual values. These people looked to the demimonde of *La Bohème* ("the realm of the gypsies")

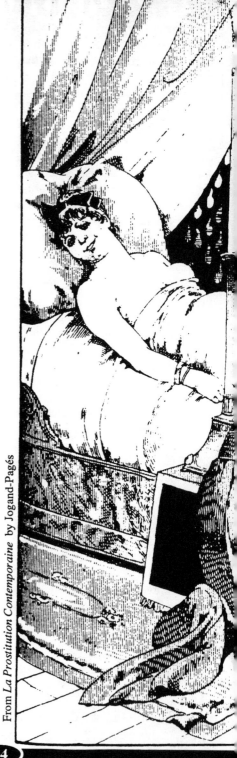

From *La Prostitution Contemporaine* by Jogand-Pagés

as an escape from and protest against bourgeois life. Art, no longer in service, as it had been for centuries, to autocratic and ecclesiastical patronage, became "for itself." France, and more particularly Paris, became the great cosmopolitan laboratory of social and cultural experiment outside the margins of respectability. Here began the march of artistic "isms" seeking to negate the commercial reality of the bourgeois reign and always succumbing to recuperation by that commercial reality.

The term *La Décadence* refers specifically to a period of European cultural history covering roughly the last two decades of the nineteenth century and sometimes the beginning of the twentieth century as well. This period, also commonly known as the *fin de siècle* or the *belle epoque*, encompassed such movements as Symbolism, Art Nouveau (*Jugendstil* or *Modernismo*), Post-Impressionism, and the Parnassian poets, as well as those referring to themselves as Aesthetes or Decadents. The phenomenon of Decadence is best understood as the continuation and denouement of an earlier movement— Romanticism. Decadence and Romanticism are of a piece.

The Romantic movement began definitively late in the eighteenth century as a largely aristocratic revolt against the soulless, destructive engine of Capital's Industrial Revolution. The countries principally affected by these developments were England, France, and parts of the German-speaking world. (The second wave of the Industrial Revolution

occurred later in the nineteenth century and involved Germany, Japan, Northern Italy, European Russia, and the United States.) Although Romanticism, and later Decadence, resonated throughout Europe and the United States, their main centers of activity were always Paris and London. Throughout the course of the nineteenth century there was a lively exchange of influence between French and English poets, writers, and painters. In this essay I am concerned mostly though not exclusively with developments in France.

## MORE DEFINITIONS

The word "romantic" is often contrasted with the word "classical." The distinction between the two, originally drawn by Goethe and Schiller, consists basically in this: Classical is associated with naturalness, intellect, balance, universality, and rationalism; romantic with the revolt of worldly ideas, passions, and spontaneity against conservative, ascetic, chastened ("uptight") ideals. This is strikingly similar to the distinction Nietzsche was later to make between the Dionysian and the Apollonian sensibilities. The reference in that case was to the Dionysiac movement of sixth-century B.C. Greece, which saw itself as a revolt of mystical, chthonic nature against the solar divinities of the Dorians. Dionysus was the god of wine and revelry (originally of mushrooms); Apollo the god of the sun and the leader of the muses. From this example it can be seen that Romanticism has precursors going back to antiquity. (Another example of ancient revelry with contemporary survivals was the Roman holiday of Lupercalia, a time of riotous feasting, fornication, and fun. The Catholic church found itself obliged to co-opt many of the pagan holidays because it could not suppress them. This was the case with Lupercalia, which persists to this day in such forms as the Mardi Gras of New Orleans and the Carnival of Rio de Janeiro.) Although there may be an antagonism between the classical and the romantic, classicism can be a moment of romanticism (i.e., in the attempt at reviving pagan antiquity or any vanished civilization). Nietzsche saw both the Apollonian and the Dionysiac worldviews as essential elements of human nature.

"Romantic" first appeared in English around the middle of the seventeenth century and originally meant "like the old romances." It looked back with nostalgia to the chivalrous and pastoral world of the Middle Ages, when the Romance languages were becoming differentiated from Latin, or, going back still further, to the epic tales of ancient Greek heroes. The sensibility connoted by the word as used at that time stood in contrast with the growing rationalism of the Enlightenment, which, as the brother of commerce, was obsessed with the mundane and the quantitative. Many of the major themes that were to preoccupy the Romantics—the fantastic, the macabre, the wild and mysterious, the satanic and infernal—were also prefigured in the works of Dante, Shakespeare, and Milton. As a flight of the imagina-

tion, Romanticism found expression in all the arts, but was perfectly suited to the medium of literature. It is significant that the English word "novel" has as its equivalent in both French and German the word *roman*. "Romantic" has affinities with other words such as "romanesque," "gothic," "baroque" (all used to describe successive styles of architecture since the fall of the western Roman Empire and meaning by turns, fabulous, chimerical, grotesque, and flamboyant); and *pittoresque* (picturesque).

That last word, French but Italian in origin (*pittoresco*), described not only a scene (a landscape in particular) but also the emotions it induced in the observer. It was the feeling sought by young English gentlemen of the eighteenth century who were sent by their families on the "Grand Tour" of Italy to round out their education. (This practice preceded but may very well have launched the era of mass tourism.) Here they would admire classical ruins, Renaissance art treasures, and the wild beauty of the Alps and perhaps hope to meet an intriguing princess or countess. Italy was also attractive to German intellectuals and artists. Goethe, Felix Mendelssohn, and Nietzsche are among those who either traveled or lived there.

The most influential and archetypal figures of Romanticism were George Gordon, Lord Byron and D.A.F. de Sade (the "divine Marquis"). These men pursued with uncommon vigor the beauty of the perverse and explored the mysterious bond between pleasure and pain. They were the two most visible incarnations of aristocratic monstrosity and excess. The figures of vampire, Satan, demon lover, sadist, evil genius, and noble bandit they represented became much-imitated sources of inspiration to later generations of writers, among whom were Baudelaire, Huysmans, Swinburne, D'Annunzio, and many others too numerous to list.

There are some distinctions between High Romanticism and Decadent Aestheticism, in spite of their essential affinity. In Romanticism, Man is strong and cruel (e.g., the Byronic, Promethean, or Faustian hero) whereas Woman is weak and victimized; in Decadence the roles of the sexes are reversed. Romanticism is concerned with action and furious passion; Decadence is passive and contemplative. Romanticism often championed revolutionary social ideals, represented most notably by the English Romantics' initial identification with the Great French Revolution, and also by support for national liberation or unification movements in Italy, Poland, Hungary, Greece, and the Latin American republics. Wagner and Baudelaire both turned up on the barricades in 1848–49. These kind of commitments had largely faded by the time of the Decadence, which occurred in an unusually extended epoch of relative social peace and which tended for the most part to disdain politics in favor of *l'art pour l'art*. Baudelaire himself disavowed political involvement in favor of

dandyism. Those artists of the later nineteenth century most concerned with social critique were of the realist and naturalist schools and identified with socialism, such as Courbet and Zola. This situation began to change, however, in the 1890s, as I will discuss later.

The Decadent esthetic can be summarized as follows: the quest for the rare, sublime, and ultrarefined; the rejection of natural beauty; antifeminism; and the celebration of 'perversion' and artificiality.

## GOTTERDÄMMERUNG

A salient feature of the *fin de siècle* was the advent of a great religious crisis that had been building up steadily since the Revolution. The Roman Catholic church, indeed all of Christianity, which had been losing ground for a long time (since Copernicus), saw its authority decay more rapidly than ever before the advances of nineteenth-century positivist science, crowned by Darwin's theory of evolution. The spiritual vacuum produced by this led to what could be called the first stirrings of the "New Age": the resurrection of heterodox spiritual practices from previous epochs, such as Satanism, occultism, and Rosicrucianism, fascination with vampires, werewolves, etc., and a burgeoning interest in Eastern doctrines, such as Mme Blavatsky's Theosophical Society, which was imported into France by way of Britain and the United States. Many French and English (or Irish) writers and poets adhered to Roman Catholicism as a purely esthetic ritual

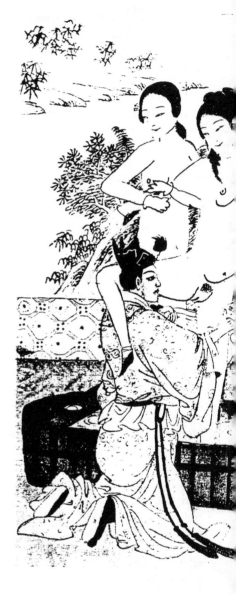

emptied of faith. Needless to say, they were scorned by the Church.

The spirit of gloom and decline among the Decadents was fed by the writings of Arthur Schopenhauer, a philosopher of passive nihilism *par excellence* who became more popular

of Buddhist or Hindu doctrine, he said that it is best to renounce sexual and all other desire; the Ideal is the nirvana of nonexistence. The Decadents followed this prescription for stone-cold reverie and agreed with his profound misogyny, as well.

The wish for annihilation found expression in a great lament over the decline of Latin civilization. The Decadents sought to reconstruct poetically the vanished worlds of ancient Rome, Byzantium, and the Hellenized Orient. They had a keen sense that Paris and London were the new Byzantium or Babylon. In France especially the feeling of decline was acute because of the humiliation of defeat at the hands of Prussia in 1871, coupled with the knowledge of lagging behind England in economic power and development.

## SEX, DRUGS, ROCK 'N' ROLL

The use of drugs, which previously had been the exotic vice of a few (e.g., De Quincey's and Coleridge's indulgence in laudanum) became widespread at the end of the nineteenth century. Absinthe, also known as the "green fairy," was one of the most popular, and for a long time legal, alcoholic drugs. Morphine had been used extensively for the first time as a surgical anesthesia by both sides during the Franco-Prussian War, and the French conquest of Indochina in the 1870s and '80s brought in a large quantity of opium. Many literary productions of this time were concerned with descriptions of drugged,

in France than he had ever been in his native Germany. Schopenhauer's central concept was that life is pointless suffering and that the only pleasures are cerebral, fleeting, and negative. His advice to humanity was to drop dead, literally. In a strong echo

hallucinatory states of consciousness, though none measured up to De Quincey's *Confessions of an English Opium-Eater* (1822).

The Romantics and Decadents emphasized eroticism as the driving force of culture. The expression of Desire as power, deceit, cruelty, and unlimited egotism and love of crime was first explored in excruciating detail by Sade and by his contemporary, Choderlos Laclos. From the late eighteenth century on, the assertion of the sexual nature, in all its 'polymorphous perversity,' of the human animal was used to blaspheme Christian dogma and tweak the noses of the Catholic church in France and the Protestant churches in England (though the great majority of the bohemian rebels in question, including many of the English ones, were Catholic, either by upbringing or by conversion). The themes of narcissism, male homosexuality, lesbianism, sadomasochism, incest, and hermaphroditism or androgyny that appear frequently in the literature of Romanticism sometimes provoked wrath and repression from the authorities. The Marquis de Sade spent the greater part of his adult life in prison, having been sentenced repeatedly by both *ancien régime* and Revolutionary courts, not so much for his deeds as for his unacceptable imagination; Oscar Wilde was broken by the scandal, trial, and prison sentence that resulted from his love affair with another man.

The Decadent era was one of expanding knowledge about human sexuality (part of a process, going on since the Renaissance, of recovering the eroticism that had been so freely accepted in the ancient world), and the art and literature of the time seemed to have an understanding of the unconscious basis of the sexual drive. In the 1880s Sigmund Freud was a student in Paris, studying under the neurologist Charcot, who conducted research on a condition that was then known as "hysteria." Other pioneering efforts at a more or less scientific understanding of the psychology of sex included Richard von Krafft-Ebing's inventories of perversions, Havelock Ellis's classifications, and the writings of Leopold von Sacher-Masoch. In light of contemporay views, some of these efforts may seem to have been fruitful (or at least interesting); others may be seen as faulty or inadequate due to Victorian, bourgeois, and patriarchal biases. At the time they served chiefly to debunk romantic love.

The Decadents took a dim view of love between men and women. Much of the time they made Woman the target of their spleen (nearly all the artists were male). Women were held in contempt as creatures enslaved to nature and instinct and incapable of reason. This trend was part of an overall fascination with and fear of nature as a dark, fecund, and devouring force. One of the most familiar motifs of the Decadence was that of the *femme fatale,* sphinx, and "Belle Dame sans Merci" (Keats), who victimized men, tearing them to pieces or otherwise luring them to madness, ruin, and death. Cleopatra, the Queen of Sheba, Carmen, Helen

of Troy, and many versions of the Judith/Salomé theme were familiar characters in the art and literature of the *fin de siècle*. The connection between pleasure and pain was extended into a bond between love and death. This eventually reached the point of becoming a mirrored inversion of Christianity's war against the body and its equation of sexual pleasure with sin and damnation. Pissing on the altar was another form of worship, as Vaneigem put it, and indeed, some rebels and apostates became prodigal sons and returned to the bosom of the Mother Church or some other 'true faith,' (as was to be the case among the Surrealists and the Lettrists as well).

## MANNERISM, MYTH, AND LEGEND

The cult of artificial beauty led the Decadents to prefer plants made of jewels to real vegetation and to admire the icy beauty of crystals, metals, and precious stones. The more rare, refined, or fragile something was, the better, in their estimation. The taste for baroque ornamentation and metamorphosis inspired the Art Nouveau movement, which included such works as the drawings of Aubrey Beardsley, the posters of Alphonse Mucha, and the fantastic architecture of the Spanish (Catalonian) visionary Antonio Gaudí. Art Nouveau cultivated a craft sensibility, often employing floral designs, that opposed modern machine mass production. In a similar vein, the Arts and Crafts movement led by the English artist and utopian socialist William Morris sought to revive medieval guild craftsmanship in the arts in a time that saw the advent of automobiles, cinema, mass advertising, and machine guns.

The Romantics and Decadents loved the fabulous and the fantastic and considered the dream superior to reality in all respects. Their quest for artificial paradises included a resurgence of interest in the traditional mythologies of many cultures: Greco-Roman, Nordic, Egyptian, Jewish, and Hindu. Arthurian legends—Avalon, Merlin, Guinevere, and the Holy Grail—were great favorites, as were Shakespeare's fairy-tale comedies. Richard Wagner, whose operas drew upon German, Nordic, and Celtic legends for their source material, was the object of a cult of admiration in the nineteenth century. To many, it seemed, the only fit remedy for an unpleasant contemporary reality was escape into a medieval fable world of dragons, unicorns, troubadors, noble ladies, and chivalrous, heroic knights.

## ORIENTALISM

Besides the Anglo-French Byzantium of decadent democracy, the "civilized world" at the end of the nineteenth century included five great autocratic empires that were all in a much more serious stage of decline: the Romanov dynasty in Russia, the Hohenzollern-Junker dynasty of Prussia, the Hapsburg monarchy of Austria-Hungary, the Ottoman Turkish empire, and the Qing

Dynasty of China. All of them contributed certain features of *La Décadence* as it was produced and experienced in western Europe. Berlin and Moscow were, as cultural centers, completely in the shadow of Paris until the twentieth century. Vienna, though also subordinate to Paris, was the cosmopolitan capital of a great multinational Catholic empire and a hot spot of bohemian activity in its own right at the turn of the last century. (Its political ferment also served at that time as the incubator of both Nazism and Zionism.)

The Ottoman Empire provided an important source of Romantic and Decadent imagery, particularly as England and France were in the process of dismembering it piecemeal and making colonies out of the Arab portions of it. The occidental fascination with, fear of, and desire for control over Africa and the Orient (Arab and Turkic lands, Persia, India, and China) had been of long standing going back earlier than the Crusades and continuing through the Eastern contacts made by traveling adventurers and merchants from Portugal, Spain, England, France, Holland, and the Northern Italian republics. This fascination became magnified in the nineteenth century as the Napoleonic wars continued British and French imperial rivalry in the East. The wild and colorful Arabs made a significant appearance in European art at this time (e.g., in the paintings of Eugène Delacroix in the 1830s, after France had taken possession of the Algerian coast). In the nineteenth century there were also numerous paintings and lit-

Illustration by Clara Tice for Pierre Louÿs' *Aphrc*

erary descriptions of harem scenes and the opulent court life of the sultans, beys, and pashas. These images were steeped in the mystique of "Orientalism," a colonial vision, either overtly or subtly racist, of the East as a region cruel, lustful, and exotic; alluring for its real or potential riches; and populated by inferior peoples practicing weird religions and customs, who may once have had great civilizations of their own (which had helped make this one possible) but who were now in need of the paternal, Christian capitalist guiding hand of the "white man's burden" or *la mission civilisatrice*.

## AFTERNOON OF A FAUN

The era of the Decadence or late Romanticism ended approximately around 1900. In the 1890s reaction to Decadence began to set in. Apparently the unrelenting pessimism, nostalgia for extinct civilizations, and indulgence in pure fantasy became wearisome. In their place appeared a tendency toward pantheism and a rehabilitation of nature and women. In the work of artists such as Eric Gill, Félix Valloton, and Pierre Bonnard the female body and sensuality were celebrated. The end of the last century also produced movements of incipient modernism (e.g., Symbolism into Expressionism; Post-Impressionism into Cubism). Paul Gauguin was one of many artists not specifically connected to Decadentism who became interested in the culture of the Breton people, an "Other" society in modern France,

which, by retaining its traditional language and culture and refusing to assimilate, seemed closer to nature and therefore to authentic experience. Gauguin was to seek his paradise as far away from civilization as possible (or so he thought), in Tahiti.

The 1890s saw a significant increase in political activity on all sides. The Dreyfus Affair was a principal catalyst for the awakening from anomie and revery and a renewed confrontation with history. Suddenly France was more politicized than it had been since the days of the Commune of 1871. The Left (which by this time meant nascent Social Democracy; Jacobinism and Blanquism were obsolete) championed the causes of parliamentary socialism, trade unionism, anticlericalism, and civil rights for Jews, a highly assimilated but widely despised minority in France. Its leading literary figure was Emile Zola, who supported Captain Dreyfus. The right wing of the bourgeoisie, on the other hand, was becoming fiercely nationalistic and wanted restoration of French *gloire,* which entailed a strong desire for revenge on Germany for the stinging military defeat of 1870–71. For this purpose France, once the revolutionary beacon unto all of Europe, built an alliance with archreactionary czarist Russia. From the perspective of the French Right, the Third Republic and the Catholic church were both weak and contemptible; only a strong leader in the tradition of Caesar or Napoleon (i.e., a 'republican monarch') could restore order and greatness.

The revolutionary current, now dominated by anarchism, reemerged from underground to avenge the bloody destruction of the Commune. Terrorist acts were numerous in France as they were around the capitalist world. The most spectacular of these deeds were a bombing in the Chamber of Deputies in 1893 and the assassination of Carnot, president of the republic, in 1894. Sympathy for anarchism was widespread in the Parisian bohemia. Louise Michel, a great heroine of the Commune, was friendly toward the Decadents and Symbolists. But the commitment to anarchy on the part of the bohemians was, in most cases, in the nature of a fashion, and (sensibly enough) it did not extend to a willingness to commit acts of violence that would entail almost certain martyrdom when the state retaliated with stern repressive measures, which included executions of *attentat* militants.

A further indication of the collapse of the Decadent scene was the fall of Schopenhauer's philosophical pessimism from favor. It was replaced by theories that stressed life, energy, action, and individualism. The newly favored thinkers included Henri Bergson (vitalism), William James (pragmatism), the Russian novelist Fyodor Dostoyevsky; and Friedrich Nietzsche, whose writings were just beginning to be translated into French at the end of the 1890s.

Nietzsche believed in individual greatness, human self-power, and the cult of Dionysus. He declared himself an enemy of decadence and rejected suffering, sacrifice, and asceticism.

After denouncing Schopenhauer, who had been one of his key early influences, Nietzsche repudiated his other erstwhile mentor, Richard Wagner, in large part because of Wagner's anti-Semitism. Nietzsche had a sweeping definition for the word "decadence"—he used it to describe Christian morality, nationalism, the socialist (and anarchist) labor movement, and to a large extent rational thought. And nothing was more decadent to him than the modern democracy of herd-thinkers and -doers. His was a definition of the word that stood its usual meanings and targets upside down while retaining it as an epithet, a pejorative and abusive term.

Thus, the twentieth century dawned on an increasingly mechanistic and godless capitalist world haunted by its prehistory. Radical insurrectionist tendencies with certain common characteristics—hatred of Christianity and bourgeois democracy, a yearning for rebirth or renewal (often defined as a return to nature, to the soil, to ancient myth and community), and a desire to replace the big business commodity economy with corporatist guilds or syndicates—produced an uncanny similarity of anarchist and protofascist ideas. The quest for adventure and estheticism in the twentieth century led some European artists, like Marinetti, to celebrate war and fascism; some English and American writers, most notably Ezra Pound, followed their lead. Already in the early years of this century the seeds were sown for the great dialectical modern nightmare—counterrevolution in the name of revolution, tyranny in the name of freedom.

## THE LEGACY

The Romantic/Decadent currents produced repercussions that have persisted well into the twentieth century. The most obvious heir to the tradition was Surrealism. The Surrealists explicitly endorsed and claimed as forebears (or saints, as some would have it) such figures as Sade, Rimbaud, Lautréamont, and Jarry. Like the Decadents, the Surrealists valued subjectivity, the quest for absolute freedom, dreams, the perverse and irrational, the transgressive, and the strange beauty of crystals, minerals, birds, and the vegetable kingdom.

But Surrealism had a historical perspective the earlier movements lacked. Surrealism developed a more coherent and consistent attack on Christianity and shed no tears for the legacy of the Roman Empire. In fact, it turned its back on the Latin roots of French bourgeois civilization (i.e., Gallicanism or Chauvinism) and took its influences more from English literature and German philosophy, as well as from the culture of nonwhite and nonwestern peoples. Its immediate precursor was Dada, which had been a thoroughly international movement. In the 1920s the Surrealists were among the first in France to recognize and make use of Hegel, Marx, and Freud (in that combination) in addition to rediscovering Charles Fourier. They identified their project with the proletarian revolution and denounced the imperialism of the western capitalist powers (such as the

colonial war waged in 1925 on the Rif people of Morocco by France and Spain), but they stumbled by getting caught up in sympathy for the authoritarian dogmas of Bolshevism and Trotskyism.

Another significant difference between Surrealism and its forebears lay in its image of women: However problematic this image may have been (sometimes in the spirit of Sade, more often in that of Goethe's concept of *das Ewig Weiblich,* or the "eternal feminine") it was nonetheless a labor of love and not of contempt. Women in the Surrealist movement were obscure objects of desire (and representation), but often they were also active participants and creative subjects as well; if not to the extent of full equality, then much more so than in previous cultural movements.

Though saturated with Romantic influences, Surrealism was, as Rimbaud would have put it, "absolutely modern," and hinted at the supersession of art and culture as categories separate from life. This is why the Situationists hailed it, along with Dada (though critically), for having laid the groundwork for the "revolution of everyday life." The extent to which Surrealism became, in spite of its better intentions, another *art movement* is the best indication of its ultimate failure.

Another major legacy of literary Romanticism are the modern genres of science fiction/horror/fantasy, which received a major impetus from Mary Shelley's magnum opus, *Frankenstein* (1818), and the weird tales of Edgar Allan Poe; developed further with Jules Verne, H.G. Wells, and H.P. Lovecraft; and have continued vigorously in the twentieth century. But what goes under the name of "romance" in our time is for the most part a frivolous, cryptopornographic phenomenon of Hollywood, television, and mass- market publishing.

## THE AMERICAN WAY OF DECADENCE

Thus far I have discussed Romanticism and Decadence mainly as a function of the legacy of Greco-Roman antiquity and western European feudalism. These worldviews also made an impression in the U.S.A., which is today the home of the postbourgeois, real domination of capital in its purest form. From its early colonial history North America was conceived as a new Eden. Some of the initial settlers, such as the Puritans, were narrow-minded authoritarians; others represented the most enlightened antinomian currents of the Protestant Reformation. Most of the revolutionary 'Founding Fathers' were Freemasons who, like their French bourgeois counterparts, briefly rejected Christianity and saw their newly created republic as a renascence of the Roman republic and of Hellenic science.

In the early period of America's existence as a nation, European Romanticism found its parallel in the romance of the wilderness and the frontier. The natural beauty of the land was celebrated in art even as it was made to retreat before the

onslaught of civilization's "manifest destiny." James Fenimore Cooper, Nathaniel Hawthorne, Edgar Allan Poe, and Herman Melville were among the most illustrious of the American Romantics. As in Europe, the creative soul and the free imagination found themselves at odds with the reigning bourgeois society. The United States became the site of various experiments in the creation of utopian communities either actual (New Harmony, Oneida, Brook Farm) or planned (Coleridge's and Southey's 'Pantisocracy'). But the 'flowers of evil' did not seem to grow very well in American soil, probably because the country remained largely agrarian and because of the rising tide of evangelical Protestantism. The Southern plantation aristocracy resembled in some ways effete European absolutism, but its total destruction in the Civil War, like the destruction of the French monarchy, did little to establish the kingdom of virtue on earth. The slaves were indeed liberated—only to become wage slaves, and the power of the U.S. federal government was vastly increased.

After the Civil War, heavy industrialization, the closing of the frontier, and the beginnings of overseas empire, the focus of romantic sensibility among educated Americans of the Northeast shifted even more to Europe. Such artistes as Mary Cassatt, James M. Whistler, and Henry James elected to spend most of their time in western Europe (Paris, London, and Northern Italy) to escape the staid small-mindedness of utilitarian bourgeois society at home and also to participate in the artistic ferment of the European Decadence, Symbolism, Impressionism, and so on. The practice of voluntary expatriation continued on a significant scale through the 1930s (and again, less brilliantly, through the 1950s) though by World War I New York City had emerged as the home of America's own cosmopolitan bohemia.

The 1960s represented the most recent mass explosion of the utopian as well as dystopian elements of the Romantic legacy in the western world. This can be seen in the spiritual movements of that time, as well as in the political movements. As in France of the late nineteenth century, the power of Christianity in the United States began to decay rapidly and become replaced in some quarters by cults derived from Eastern religion. This, combined with elements of popular psychology (particularly à la Carl Jung), became the basis of the contemporary New Age movement, which has become an expression of flaky, confused, upper-middle-class liberals. In the political (or antipolitical) realm the 1960s saw a significant resurgence of romanticism in the back-to-the-land hippie communes and the revival of interest in folk music, as well as in the naive tendency, among students especially, to idealize the Third World peasant guerilla movements. Many young leftists were all too eager to follow Mao's injunction to "serve the people" in a self-abnegating tradition that went back to the French revolutionaries' submission to Rousseau's concept of the "general will."

## THE DECADENCE OF CAPITAL

Much of what we have come to hear spoken of in the twentieth century as decadent has come from those calling themselves Marxists. For decades it was routine to hear the Soviet or Chinese leadership pontificating about the decadence of the West. They use(d) the word in a definitely moralistic sense, usually to condemn popular music from jazz onward or to attack the most blatant contradictions of modern capitalism, those attributes left over from its prespectacular stage, such as the grossness, ostentatious display and consumption of the idle rich contrasted with poverty in the ghettoes of the metropolis and starvation in the Third World. This brand of condemnation coming from Marxist-Leninists recalled, in however degraded a fashion, the Jacobin Republic of Virtue, and boasted that red bureaucrats were somehow morally superior to the non-Stalinist bureaucrats of the West (a lie even on that level). The moralism of Leninist bureaucrats is a class ideology, and as such it is an inheritance of Judeo-Christian (or in the case of the Chinese, Confucian) moralism and bourgeois positivism.

But, some will protest, this is not real Marxism at all, it is vulgarized, perverted, recuperated. They have a point; Leninism, Trotskyism, Stalinism, etc. *are* departures from the original communist project. Very well then, let us cast aside the 'false' Marxism and consider Marxism at its best, in its 'Western' variants. These currents would include (besides the work of Marx and Engels themselves) a tradition coming out of the ultraleft of German and Dutch Social Democracy (Rosa Luxemburg, the council communists), Italian communism (Bordiga), and in more recent times, the Situationist International and its imitators. Of these currents, only that represented by Luxemburg promoted the theory of the decadence of capitalism. Her views were paralleled to some extent by Lenin during the early period of Bolshevism. These two leading theoreticians of the left of international Social Democracy in the early twentieth century saw capitalism as a historically decadent mode of production. Marx himself had been for the most part an amoralist and had never spoken explicitly of "decadence," although he had hinted that capitalism had a potential to destroy humanity. The theory of capitalist decadence, building on Marx's study of the economic crises of capital as "fetters on the development of the forces of production," was tied to theories

Illustration by Alistair for *Manon Lescaut*.

of imperialism as the "highest and final" stage of capitalism, completing the global expansion of the system, liquidating precapitalist economies, and saturating the markets, leading to intensifying competition and war between the great powers.

The decadence, or stagnation, in the devel-

opment of productive forces was thought to lead mechanically to stagnation in the total life of society (following Marx's theory of the determining relationship of the material productive base of society to its cultural and ideological superstructure). Here is a concept of decadence that appears furthest from morality, though it is still moralistic, because it offers an alibi for the work ethic and for the development and socialization of bourgeois society during its early, "historically progressive" phase. The theory of a new historical period beginning sometime in the years before the world war of 1914–18 (seen in the catastrophist view as the definitive onset of decadence) and requiring "new tasks" for the proletariat rescues a glorious past for the Social Democratic reformism of the Second International. It even defends a "progressive" role, albeit however briefly, for the Third International.

In reality both the Second and Third Internationals ultimately served to strengthen and extend capitalism. This outcome was an entirely logical outgrowth of progressivist ideology in the founders of "scientific socialism." Marx and Engels saw democratic reformism as a necessary transitional phase (i.e., building of the productive forces by capitalism laying the groundwork for socialism and communism). Marxist defense of the labor ethic became an apology for its continuation during the transition stage. The ultralefts broke with the parliamentarism, social-patriotism, and trade unionism of mainstream Social Democracy; nonetheless they defended the principles of organization, discipline, and political consciousness that were carried to fetishistic extremes by the Bolshe-

viks. The mystique of the Proletariat was preserved. The original theorists of capitalist decadence, such as Luxemburg, underestimated Capital's subsequent ability to expand; it has in fact expanded more in the twentieth century than ever before in its history. Economic crises recur (we are certainly living in one now), but it remains to be seen whether this is the final and fatal plunge. Nostradamus and Chicken Little have been wrong before. Socialism or barbarism? The specter of nuclear holocaust has faded, but the prospect of global environmental devastation looms ever larger.

There is no proof that human beings necessarily have to be prodded by a precipitous drop in material living standards in order to struggle for freedom. The experience of Paris in 1968 is the best example of this. Nor is there any proof that the conquest of bread in itself brings freedom, or that a vanguard leadership

Greek painting of courtesans on bowl. (Museo Arqueologico Nacional, Madrid.)

with 'correct' or 'advanced' ideas can raise the moral and spiritual condition of the 'masses.' The revolt against work is anathema to Marxists because they cannot understand why humans should want to rebel against their 'essence' as producers. The "revolutionary party" can exist only to control and thwart the human revolt against Capital. For more complete, detailed arguments against Marxist theories of capitalist decadence, I refer the reader to the writings of John Zerzan, Jacques Camatte, and the French group Interrogations (for the Human Community). It is true that not all Marxists speak of "decadence" or defend "scientific socialism." Debord, for example, stated in *Society of the Spectacle* his view that what was best in the theory of Karl Marx was beyond scientific thought (i.e., beyond 'scientism,' or the naturalistic evolutionism that Engels, Kautsky, Bernstein, Plekhanov, and Labriola were so fond of). The

situationists too, it should be remembered, were of all Marx-ists the most in tune with the great Parisian tradition of decadence.

## DECADENT MODERNISM

The meaning of the word "decadence" seems to change considerably depending on who uses it. Decadence used as an epithet has been harnessed by both Right and Left ideological camps to attack bourgeois democracy. In the twentieth century the term has been employed by totalitarian ideologues to condemn and justify the suppression of libertarian mores and modernist cultural experimentation. Fascist, Nazi, and Stalinist regimes all described as "decadent" thought, behavior, and culture that, far from being stagnant, was actually the most vital and interesting of its time. These regimes, after exhibiting an initial toleration of or even flirtation with modernism, all settled on a preference for neoclassical architecture and the kitsch realism of genre painting with its banality, literalness, and mandatory good cheer. Subjective imagination, on the other hand, became a matter for the police. For the Nazis (and not for them only) war was healthy and virile; pacifism effeminate and decadent. Marshal Pétain, leader of the collaborationist Vichy government during World War II, vowed to cleanse France of "Judeo-Marxist decadence." The contemporary society of the spectacle, whose "end of ideology" is officially democratic but contains strong residues of fascist influence, permits all artistic movements of the past, including the most critical and negative currents, to coexist as co-opted cultural commodities to be consumed cafeteria style, usually by impressing them in the service of the fashion and advertising industries. Christianity, though moribund, staggers on and remains the bedrock belief of broad sections of society in modern capitalist states, particularly alas in the United States, but the instauration of an "age of faith" is out of the question (even after the fall of Stalinism). The operative justification for the "new world order" will probably continue to rely, as it has for much of this century, on technorationalism and various conflicting, recycled, and ever more vulgar modernist ideologies.

## "LONG LIVE DECOMPOSITION"

Is there any sense in which decadence is a valid concept? This rotten civilization, the "air-conditioned nightmare," is certainly not going anywhere and indeed appears to be dying. If decadence can be defined as a function of the human species' increasing separation from nature, then ours is definitely a decadent age. And true enough, mediocrity reigns. But if we must speak of the decay of the system, the question arises, was not the decadence built right into it from the start? When was this society ever "healthy"? Do you yearn for the days when law and order prevailed, authority was respected, and the reigning ideology was vigorous and unchallenged? Do we really need master-

pieces in our own time if we don't need God, the Pope, the Emperor, the Republic, Democracy, Socialism (or any other abstraction of alienation) to dedicate them to? It wasn't "revolutionary preservation" of the cultural achievements of past epochs of domination that dadaist Marcel Duchamp had in mind when he suggested using a Rembrandt as an ironing board! The collapse in the modern era of the distinction between high and mass culture is among other things an indication that the proles either want, or think they want, their own "decadence." After all, the fetishism of commodities in a mass society operates through a large degree of complicity from its victims, the worker-consumer citizens. For the realization of decadence (meaning basically the "good things in life"), however, workers need the kind of leisure that was previously enjoyed by aristocrats or ancient Greek citizens in spacious pastoral settings. And then of course they wouldn't be workers (i.e., domesticated human animals) any longer. Everyone can indeed live in his or her own cathedral (or mosque, for that matter). But this Arcadian idyll of anarchic, universal human community can only come about through the supersession of civilization along with its cultural blandishments. Is this really possible? Who knows, but look not for another renaissance.

Counterculture and estheticism as means of fighting or escaping from the system apparently reached the point of historical exhaustion decades ago, and as I have attempted to show, there was much about Romanticism and Decadence that was contradictory: It could be for either revolution or reaction, freedom or unfreedom. But everyone dreams of the love, adventure, and authenticity that the world of work and commodities can never fulfill and the world of art and literature as well as the modern spectacle of pop culture can only represent. As long as the false community of Capital, indeed civilization itself, continues to exist, it will continue to generate multifaceted modes of revolt, many of them in the tradition of bohemian decadence. Whatever the shortcomings of that may be, it is nonetheless more fun and more real than the Republic of Virtue or the posturing of secret societies of spartan heroes. "Decadence" can be a good thing if it gives us breathing space against biblical, Marxist, or in many cases feminist moralism. Romanticism, one of whose definitions is the desire of overcivilized and domesticated humans to recapture a feral existence, will never be suppressed until it is realized in the social insurrection. It's time for a real Roman holiday, so bring on the barbarians!

# IMMEDIATISM

by HAKIM BEY

**I**

**A**ll experience is mediated by the mechanisms of sense perception, mentation, language, etc. & certainly all art consists of some further mediation of experience.

**II**

However, mediation takes place by degrees. Some experiences (smell, taste, sexual pleasure, etc.) are less mediated than others (reading a book, looking through a telescope, listening to a record). Some media, especially live arts such as dance, theater, musical or bardic performance, are less mediated than others such as TV, CDs, Virtual Reality. Even among the media usually called media, some are more & others are less mediated, according to the intensity of imaginative participation they demand. Print & radio demand more of the imagination, film less, TV even less, VR the least of all—so far.

**III**

For art, the intervention of Capital always signals a further degree of mediation. To say that art is commodified is to say that a mediation, or standing-in-between, has occurred, & that this betweenness amounts to a split, & that this split amounts to alienation. Improv music played by friends at home is less alienated than music played live at the Met, or music played through media (whether PBS or MTV or Walkman). In fact, an argument could be made that music distributed free or at cost on cassette via mail is LESS alienated than live music played at some huge We Are The World spectacle or Las Vegas niteclub, even though the latter is live music played to a live audience (or at least so it appears), while the former is recorded music consumed by distant & even anonymous listeners.

**IV**

The tendency of Hi Tech, & the tendency of Late Capitalism, both impel the arts farther & farther into extreme forms of mediation. Both widen the gulf between the production & consumption of art, with a corresponding increase in alienation.

**V**

With the disappearance of a mainstream & therefore of an avant-garde in the arts, it has been noticed that all the more advanced & intense art-experiences have been recuperable almost instantly by the media, & thus are rendered into trash like all other trash in the ghostly world of commodities.

Trash, as the term was redefined in, let's say, Baltimore in the 1970s, can be good fun as an ironic take on a sort of inadvertent folkultur that surrounds & pervades the more unconscious regions of popular sensibility, which in turn is produced in part by the Spectacle.

Trash was once a fresh concept, with radical potential. By now, however, amidst the ruins of Post-Modernism, it has finally begun to stink. Ironic frivolity finally becomes disgusting. Is it possible now to BE SERIOUS BUT NOT SOBER?

Illustrated by James Koehnline.

(Note: The New Sobriety is or course simply the flipside of the New Frivolity. Chic neo-puritanism carries the taint of Reaction, in just the same way that postmodernist philosophical irony & despair lead to Reaction. The Purge Society is the same as the Binge Society. After the 12 steps of trendy renunciation in the 90s, all that remains is the 13th step of the gallows. Irony may have become boring, but self-mutilation was never more than an abyss. Down with frivolity. Down with sobriety.)

Everything delicate & beautiful, from Surrealism to Break-dancing, ends up as fodder for McDeath's ads; 15 minutes later all the magic has been sucked out, & the art itself dead as a dried locust. The media-wizards, who are nothing if not postmodernists, have even begun to feed on the vitality of Trash, like vultures regurgitating & re-consuming the same carrion, in an obscene ecstasy of self-referentiality. Which way to the Egress?

### VI

Real art is play, & play is one of the most immediate of all experiences. Those who have cultivated the pleasure of play cannot be expected to give it up simply to make a political point (as in an Art Strike, or the suppression without the realization of art, etc.). Art will *go on,* in somewhat the same sense that breathing, eating, or fucking will go on.

### VII

Nevertheless, we are repelled by the *extreme* alienation of the arts, especially in the media, in commercial publishing & galleries, in the recording industry, etc. And we sometimes worry even about the extent to which our very involvement in such arts as writing, painting, or music implicates us in a nasty abstraction, a removal from immediate experience. We miss the directness of play (our original kick in doing art in the first place); we miss smell, taste, touch, the feel of bodies in motion.

### VIII

Computers, video, radio, printing presses, synthesizers, fax machines, tape recorders, photocopiers, these things make good toys, but terrible *addictions*. Finally we realize we cannot reach out and touch someone who is not present in the flesh. These media may be useful to our art but they must not possess us, nor must they stand between, mediate, or separate us from our

animal/animate selves. We want to control our media, not be Controlled by them. And we should like to remember a certain psychic martial art which stresses the realization that the body itself is the least mediated of all media.

### IX

Therefore, as artists & cultural workers who have no intention of giving up activity in our chosen media, we nevertheless demand of ourselves an extreme awareness of *immediacy*, as well as the mastery of some direct means of implementing this awareness as play, immediately (at once) & immediately (without mediation).

### X

Fully realizing that any art manifesto written today can only stink of the same bitter irony it seeks to oppose, we nevertheless declare without hesitation (without too much thought) the founding of a movement, IMMEDIATISM. We feel free to do so because we intend to practice Immediatism *in secret,* in order to avoid any contamination of mediation. Publicly we'll continue our work in publishing, radio, printing, music, etc., but privately we will create *something else,* something to be shared freely but never consumed passively, something which can be discussed openly but never understood by the agents of alienation, something with no commercial potential yet valuable beyond price, something occult yet woven completely into the fabric of our everyday lives.

### XI

Immediatism is not a movement in the sense of an aesthetic program. It depends on *situation,* not style or content, message or School. It may take the form of any kind of creative play which can be performed by two or more people, by & for themselves, face-to-face & together. In this sense it is like a game, & therefore certain rules may apply.

### XII

All spectators must also be performers. All expenses are to be shared, & all products which may result from the play are also to be shared by the participants only (who may keep them or bestow them as gifts, but should not sell them). The best games will make little or no use of obvious forms of mediation such as photography, recording, printing, etc., but will tend toward immediate techniques involving physical presence, direct communication, & the senses.

### XIII

An obvious matrix for Immediatism is the party. Thus a good meal could be an Immediatist art project, especially if everyone present cooked as well as ate. Ancient Chinese & Japanese on misty autumn days would hold odor parties, where each guest would bring a homemade incense or perfume. At linked-verse parties a faulty couplet would entail the penalty of a glass of wine. Quilting bees, *tableaux vivants,* exquisite corpses, rituals of conviviality like Fourier's Museum Orgy

(erotic costumes, poses, & skits), live music & dance—the past can be ransacked for appropriate forms, & imagination will supply more.

### XIV

The difference between a 19th century quilting bee, for example, & an Immediatist quilting bee would lie in our awareness of the practice of Immediatism as a response to the sorrows of alienation & the death of art.

### XV

The mail art of the 70s & the zine scene of the 80s were attempts to go beyond the mediation of art-as-commodity, & may be considered ancestors of Immediatism. However, they preserved the mediated structures of postal communication & xerography, & thus failed to overcome the isolation of the players, who remained quite literally out of touch. We wish to take the motives & discoveries of these earlier movements to their logical conclusion in an art which banishes all mediation & alienation, at least to the extent that the human condition allows.

### XVI

Moreover, Immediatism is not condemned to powerlessness in the world, simply because it avoids the publicity of the marketplace.

Poetic Terrorism and Art Sabotage are quite logical manifestations of Immediatism.

### XVII

Finally, we expect that the practice of Immediatism will release within us vast storehouses of forgotten power, which will not only transform our lives through the secret realization of unmediated play, but will also inescapably well up & burst out & permeate the *other* art we create, the more public & mediated art.

And we hope that the two will grow closer & closer, & eventually perhaps become one.

## IMMEDIATISM VS CAPITALISM

Many monsters stand between us & the realization of Immediatist goals. For instance our own ingrained unconscious alienation might all too easily be mistaken for a virtue, especially when contrasted with crypto-authoritarian pap passed off as community, or with various upscale versions of leisure. Isn't it natural to take the *dandyism noir* of curmudgeonly hermits for some kind of heroic Individualism, when the only visible contrast is Club Med commodity socialism, or the gemutlich masochism of the Victim Cults? To be doomed & cool naturally appeals more to noble souls than to be saved & cozy.

Immediatism means to enhance individuals by providing a matrix of friendship, not to belittle them by sacrificing their ownness to groupthink, leftist self-abnegation, or New Age clone-values. What must be overcome is not individuality per se, but rather the addiction to bitter loneliness which characterizes consciousness in the 20th century (which is by & large not much more than a re-run of the 19th).

Far more dangerous than any inner monster of (what might be called) negative selfishness, however, is the outward, very real & utterly objective monster of too-Late Capitalism. The marxists (R.I.P.) had their own version of how this worked, but here we are not concerned with abstract/dialectical analyses of labor-value or class structure (even though these may still require analysis, & even more so since the death or disappearance of Communism). Instead we'd like to point out specific tactical dangers facing any Immediatist project.

▌

Capitalism only *supports* certain kinds of groups, the nuclear family for example, or the people I know at my job, because such groups are already self-alienated & hooked into the Work/Consume/Die structure. Other kinds of groups may be *allowed,* but will lack all support from the societal structure, & thus find themselves facing grotesque challenges & difficulties which appear under the guise of bad luck.

The first & most innocent-seeming obstacle to any Immediatist pro-ject will be the busyness or need to make a living faced by each of its associates. However there is no real innocence here, only our profound ignorance of the ways in which Capitalism itself is organized to prevent all genuine conviviality.

No sooner have a group of friends begun to visualize immediate goals realizable only thru solidarity & cooperation, then suddenly one of them will be offered a good job in Cincinnati or teaching English in Taiwan—or else have to move back to California to care for a dying parent—or else they'll lose the good job they already have & be reduced to a state of misery which precludes their very enjoyment of the group's project or goals (i.e. they'll become depressed). At the most mundane-seeming level, the group will fail to agree on a day of the week for meetings because everyone is busy. But this is not mundane. It's sheer cosmic evil. We whip ourselves into froths of indignation over oppression & unjust laws when in fact these abstractions have little impact on our daily lives—while that which really makes us mis-

erable goes unnoticed, written off to busyness or distraction or even to the nature of reality itself (Well, I can't *live* without a *job*! ).

Yes, perhaps it's true we can't live without a job, although I hope we're grown-up enough to know the difference between *life* & the accumulation of a bunch of fucking *gadgets*. Still, we must constantly remind ourselves (since our culture won't do it for us) that this monster called WORK remains the precise & exact target of our rebellious wrath, the one single most oppressive *reality* we face (& we must learn also to recognize Work when it's disguised as leisure).

To be too busy for the Immediatist project is to miss the very essence of Immediatism. To struggle to *come together* every Monday night (or whatever), in the teeth of the gale of busyness, or family, or invitations to stupid parties, that struggle is *already* Immediatism itself. Succeed in actually physically meeting face-to-face with a group which is not your spouse-&-kids, or the guys from my job, or your 12-Step Program—& you have *already* achieved virtually everything Immediatism yearns for. An actual project will arise almost spontaneously out of this successful slap-in-the-face of the social norm of alienated boredom. Outwardly, of course, the project will seem to be the group's purpose, its motive for coming together, but in fact the opposite is true. We're not kidding or indulging in hyperbole when we insist that *meeting face-to-face is already the revolution*. Attain it & the creativity part comes naturally; like

the kingdom o' heaven it will be added unto you. *Of course* it will be horribly difficult — why else would we have spent the last decade trying to construct our bohemia in the mail, if it were easy to have it in some *quartier latin* or rural commune? The rat-bastard Capitalist scum who are telling you to reach out and touch someone with a telephone or "be there!" (where? alone in front of a goddam television??) these lovecrafty suckers are trying to turn you into a scrunched-up blood-drained pathetic crippled little cog in the death-machine of the human soul (& let's not have any theological quibbles about what we mean by soul !). Fight them—by meeting with friends, not to consume or produce, but to enjoy friendship—& you will have triumphed (at least for a moment) over the most pernicious conspiracy in EuroAmerican society today, the conspiracy to turn *you* into a living corpse galvanized by prosthesis & the terror of scarcity—to turn you into a spook haunting your own brain. This is not a petty matter! This is a question of failure or triumph!

**II**

If busyness & fissipation are the first potential failures of Immediatism, we cannot say that its triumph should be equated with success. The second major threat to our project can quite simply be described as the tragic success of the project itself. Let's say we've overcome physical alienation & have actually met, developed our project, & created something (a quilt, a banquet, a play, a bit of eco-sabo-

tage, etc.). Unless we keep it an absolute secret, which is probably impossible & in any case would constitute a somewhat poisonous selfishness, *other people* will hear of it (other people from hell, to paraphrase the existentialists) & among these other people, some will be agents (conscious or unconscious, it doesn't matter) of too-Late Capitalism. The Spectacle—or whatever has replaced it since 1968—is above all *empty*. It fuels itself by the constant Moloch-like gulping-down of everyone's creative powers & ideas. It's more desperate for *your* radical subjectivity than any vampire or cop for your blood. It wants your creativity much more even than you want it yourself. It would die unless you desired it, & you will only desire it if it seems to offer you the very desires you dreamed, alone in your lonely genius, disguised & sold back to you as commodities. Ah, the metaphysical shenanigans of objects! (or words to that effect, Marx cited by Benjamin).

Suddenly it will appear to you (as if a demon had whispered it in your ear) that the Immediatist art you've created is so good, so fresh, so original, so strong compared to all the crap on the market—so *pure,*— that you could water it down & sell it, & *make a living* at it, so you could all knock off WORK, buy a farm in the country, & do art together forever after. And perhaps it's true. You *could...* after all, you're geniuses. But it'd be better to fly to Hawaii & throw yourself into a live volcano. Sure, you could have success; you could even have 15 seconds on the Evening News, or a PBS documentary made on your life. Yes indeedy.

<center>III</center>

But this is where the last major monster steps in, crashes thru the living room wall, & snuffs you (if Success itself hasn't already spoiled you, that is).

Because in order to succeed you must first be seen. And if you are *seen,* you will be perceived as wrong, illegal, immoral, different. The Spectacle's main sources of creative energy are all in prison. If you're not a nuclear family or a guided tour of the Republican Party, then why are you meeting every Monday evening? To do drugs? illicit sex? income tax evasion? satanism?

And of course the chances are good that your Immediatist group *is* engaged in something illegal, since almost everything enjoyable is in fact illegal. Babylon hates it when anyone actually enjoys life, rather than merely spends money in a vain attempt to buy the illusion of enjoyment. Dissipation, gluttony, bulimic overconsumption, these are not only legal but mandatory. If you don't waste yourself on the emptiness of commodities you are obviously *queer* & must by definition be breaking some law. True pleasure in this society is more dangerous than bank robbery. At least bank robbers share Massa's respect for Massa's money. But you, you perverts, clearly deserve to be burned at the stake & here come the peasants with their torches, eager to do the State's bidding without even being asked. Now *you* are the mon-

sters, & your little gothic castle of Immediatism is engulfed in flames. Suddenly cops are swarming out of the woodwork. Are your papers in order? Do you have a permit to exist?

Immediatism is a picnic, but it's not *easy*. Immediatism is the most natural path for free humans imaginable, & *therefore* the most unnatural abomination in the eyes of Capital. Immediatism will triumph, but only at the cost of *self-organization of power,* of *clandestinity,* & of *insurrection*. Immediat-ism is our delight, Immediatism is *dangerous*.

## IMAGINATION

*There is a time for the theatre. If a people's imagination grows weak there arises in it the inclination to have its legends presented to it on the stage: it can now* endure *these crude substitutes for imagination. But for those ages to which the epic rhapsodist belongs, the theatre and the actor disguised as a hero is a hindrance to imagination rather than a means of giving it wings: too close, too definite, too heavy, too little in it of dream and bird-flight.* (Nietzsche).

But of course the rhapsodist, who here appears only one step removed from the shaman (...dream and bird-flight ) must also be called a kind of *medium* or bridge standing between a people and its imagination. (Note: we'll use the word imagination sometimes in Wm. Blake's sense & sometimes in Gaston Bachelard's sense without opting for either a spiritual or an aesthetic determination, & without recourse to metaphysics.) A bridge carries across (translate, metaphor) but is not the original. And to translate is to betray. Even the rhapsodist provides a little poison for the imagination.

Ethnography, however, allows us to assert the possibility of societies where shamans are not *specialists* of the imagination, but where everyone is a special sort of shaman. In these societies, all members (except the psychically handicapped) act as shamans & bards for themselves as well as for their people. For example: certain Amerindian tribes of the Great Plains developed the most complex of all hunter/ gatherer societies quite late in their history (perhaps partly thanks to the gun & horse, technologies adopted from European

culture). Each person acquired complete identity & full membership in the People only thru the Vision Quest, & its artistic enactment for the tribe. Thus each person became an epic rhapsodist in sharing this individuality with the collectivity.

The Pygmies, among the most primitive cultures, neither produce nor consume their music, but become *en masse* the Voice of the Forest. At the other end of the scale, among complex agricultural societies, like Bali on the verge of the 20th century, everyone is an artist (& in 1980 a Javanese mystic told me, Everyone *must be* an artist!).

The goals of Immediatism lie somewhere along the trajectory described roughly by these three points (Pygmies, Plains Indians, Balinese), which have all been linked to the anthropological concept of democratic shamanism. Creative acts, themselves the outer results of the inwardness of imagination, are not *mediated* & *alienated* (in the sense we've been using those terms) when they are carried out BY everyone FOR everyone, when they are produced but not reproduced, when they are shared but not fetishized. Of course these acts are achieved thru mediation of some sort & to some extent, as are all acts, but they have not yet become forces of extreme alienation between some Expert/ Priest/ Producer on the one hand & some hapless layperson or consumer on the other.

Different media therefore exhibit different degrees of mediation, & perhaps they can even be ranked on that basis. Here everything depends on reciprocity, on a more-or-less equal exchange of what may be called quanta of imagination. In the case of the epic rhapsodist who mediates vision for the tribe, a great deal of work or active dreaming still remains to be done by the hearers. They must participate imaginatively in the act of telling/hearing, & must call up images from their own stores of creative power to complete the rhapsodist's act.

In the case of Pygmy music the reciprocity becomes nearly as complete as possible, since the entire tribe mediates vision only & precisely for the entire tribe; while for the Balinese, reciprocity assumes a more complex economy in which specialization is highly articulated, in which the artist is not a special kind of person, but each person is a special kind of artist.

In the ritual theater of Voodoo & Santeria, everyone present must participate by visualizing the loas or orishas (imaginal archetypes), & by calling upon them (with signature chants & rhythms) to manifest. Anyone present may become a horse or medium for one of these *santos,* whose words & actions then assume for all celebrants the aspect of the presence of the spirit (i.e. the possessed person does not represent but presents). This structure, which also underlies Indonesian ritual theater, may be taken as exemplary for the creative production of democratic shamanism. In order to construct our scale of imagination for all media, we may start by comparing this voodoo

theater with the 18th century European theater described by Nietzsche.

In the latter, nothing of the original vision (or spirit) is actually present. The actors merely re-present, they are disguised. It is not expected that any member of troupe or audience will suddenly become possessed (or even inspired to any great extent) by the playwright's images. The actors are specialists or experts of representation, while the audience are laypeople to whom various images are being transferred. The audience is passive, too much is being *done for* the audience, who are indeed locked in place in darkness & silence, immobilized by the money they've paid for this vicarious experience.

Artaud, who realized this, attempted to revive ritual voodoo theater (banished from Western Culture by Aristotle), but he carried out the attempt *within* the very structure (actor/audience) of aristotelian theater; he tried to destroy or mutate it from the inside out. He failed & went insane, setting off a whole series of experiments which culminated in the Living Theater's assault on the actor/audience barrier, a literal assault which tried to force audience members to participate in the ritual. These experiments produced some great theater, but all failed in their deepest purpose. None managed to overcome the alienation Nietzsche & Artaud had criticized.

Even so, Theater occupies a much higher place on the Imaginal Scale than other & later media such as film. At least in theater actors & audience are physically present in the same space together, allowing for the creation of what Peter Brook calls the invisible golden chain of attention & fellow-feeling between actors & audience, the well-known magic of theater. With film, however, this chain is broken. Now the audience sits alone in the dark with nothing to do, while the absent actors are represented by gigantic icons. Always the same no matter how many times it is shown, made to be reproduced mechanically, devoid of all aura, film actually *forbids* its audience to participate, film has no need of the audience's imagination. Of course, film does need the audience's money, & money is a kind of concretized imaginal residue, after all. Eisenstein would point out that montage establishes a dialectic tension in film which engages the viewer's mind, intellect & imagination, & Disney might add (if he were capable of ideology) that animation increases this effect because animation is, in effect, completely made up of montage. Film too has its magic. Granted. But from the point of view of *structure* we have come a long way from voodoo theater & democratic shamanism, we have come perilously close to the commodification of the imagination, & to the alienation of commodity-relations. We have almost resigned our power of flight, even of dream-flight.

Books? Books as media transmit only words—no sounds, sights, smells or feels, all of which are left up to the reader's imagination. Fine... But there's nothing democrat-

ic about books. The author/publisher produces, you consume. Books appeal to imaginative people, perhaps, but all their imaginal activity really amounts to passivity, sitting alone with a book, letting someone else tell the story. The magic of books has something sinister about it, as in Borges's Library. The Church's idea of a list of damnable books probably didn't go far enough, for in a sense, all books are damned. The *eros* of the text is a perversion, albeit, nevertheless, one to which *we* are addicted, & in no hurry to kick.

As for radio, it is clearly a medium of absence, like the book only more so, since books leave you alone in the light, radio alone in the dark. The more exacerbated passivity of the listener is revealed by the fact that advertisers pay for spots on radio, not in books (or not very much). Nevertheless radio leaves a great deal more imaginative work for the listener than, say, television for the viewer. The magic of radio: one can use it to listen to sunspot radiation, storms on Jupiter, the whizz of comets. Radio is old-fashioned; therein lies its seductiveness. Radio preachers say, Put your haaands on the Radio, brothers & sisters, & feel the heeeeaaaling power of the *Word*! Voodoo Radio?

(Note: A similar analysis of recorded music might be made: i.e., that it is alienating but not yet alienated. Records replaced family amateur music-making. Recorded music is too ubiquitous, too easy, that which is not present is not *rare*. And yet there's a lot to be said for scratchy old 78s played over distant radio stations late at night, a flash of illumination which seems to spark across all the levels of mediation & achieve a paradoxical presence.)

It's in this sense that we might perhaps give some credence to the otherwise dubious proposition that radio is good, television evil! For television occupies the bottom rung of the scale of imagination in media. No, that's not true. Virtual Reality is even lower. But TV is the medium the Situationists meant when they referred to the Spectacle. Television is the medium which Immediatism most wants to overcome. Books, theater, film & radio all retain what Benjamin called the utopian trace (at least *in potentia*), the last vestige of an impulse against alienation, the last perfume of the imagination. TV however *began* by erasing even that trace. No wonder the first broadcasters of video were the Nazis. TV is to the imagination what virus is to the DNA. The end. Beyond TV there lies only the infra-media realm of no-space/no-time, the instantaneity & ecstasis of CommTech, pure speed, the downloading of consciousness into the machine, into the program, in other words, hell.

Does this mean that Immediatism wants to abolish television? No, certainly not, for Immediatism wants to be a game, not a political movement, & certainly not a revolution with the power to abolish any medium. The goals of Immediatism must be positive, not negative. We feel no calling to eliminate any means of production (or even re-production) which might

after all some day fall into the hands of a people.

We have analyzed media by asking how much imagination is involved in each, & how much reciprocity, solely in order to implement for ourselves the most effective means of solving the problem outlined by Nietzsche & felt so painfully by Artaud, the problem of alienation. For this task we need a rough hierarchy of media, a means of measuring their potential for our uses. Roughly, then, *the more imagination is liberated & shared, the more useful the medium.*

Perhaps we can no longer call up spirits to possess us, or visit their realms as the shamans did. Perhaps no such spirits exist, or perhaps we are too civilized to recognize them. Or perhaps not. The creative imagination, however, remains for us a reality, & one which we must explore, even in the vain hope of our salvation.

Note: A significantly longer version of this essay is now available in pamphlet form from the Libertarian Book Club, (339 Lafayette, Suite 202, NY, NY, 10012) for $4.

# MAN RAY & THE FERRER CENTER:

## ART AND ANARCHY IN THE PRE-DADA PERIOD

BY EDWARD M. NEWMANN

In most historical evaluations of the Dada period in New York, it is assumed that relative to Dada in Europe and its reception there during the First World War, the New York Dada movement had less significance and held very little interest for most Americans, who did not directly experience the ravages of war on their own soil. If nothing else, these historians usually contend, the Dada movement in New York was motivated more by a desire to establish an aesthetic alliance with Europe's vanguard artists than to identify with their anarchistic leanings, intensified by the horrors of a war which literally surrounded them. Neither anarchism nor the outbreak of the war in Europe, however, can be dismissed as influential factors in determining the ideological framework upon which were built the most advanced manifestations of the arts in New York during the second decade of this century. Indeed, the early works of Man Ray—generally considered to be America's only full-fledged Dadaist—were profoundly shaped by these very factors. His brief though intimate association with an anarchist group in New York, and his deeply sympathetic regard for the suffering in Europe, placed Man Ray in a position which closely paralleled that of many European artists in the pre-Dada period.

One of the most important influences in the development of Man Ray's early work was his association with members of the Ferrer Center, a liberal school of child and adult education located on East 107th Street in New York's Spanish Harlem.[1] The Ferrer Center was organized and run by a number of free-spirited individuals who came from highly diverse cultural and professional backgrounds, men and women whose pedagogical talents were allied by a common commitment to the ideological tenets of anarchism. Just as the members of this organization sought to abolish the oppression of political authority, as teachers at the Ferrer Center they attempted to create an atmosphere of complete freedom for the students, providing an alternative to the structured and often inhibiting approach imposed by the more traditionally disciplined classroom.

Shortly after it was established in 1911, the Ferrer Center, or Modern School as it was also called, became known as the gathering place for a number of New York's most celebrated cultural and political radicals—Leonard Abbott, Alexander Berkman, Will Durant, Emma Goldman, Margaret Sanger, Upton Sinclair, Lincoln Steffens, and a host of others—each of whom either lectured or offered courses at the school. The art classes were an especially important part of the curriculum, for here, rather than follow the slow and methodical approach stipulated through academic training, students were strongly encouraged to explore the impetus provided by their own fertile imaginations. This open and unrestricted atmosphere was prompted by Man Ray's teachers—Robert Henri and George Bellows—and enthusiastically shared by his fellow students—Ben Benn, Samuel

Halpert, Abraham Walkowitz, Max Weber, Adolf Wolff, and William Zorach—all of whom would become better known for their artistic accomplishments in the years to come.

Upon his first visit to the life drawing class at the Ferrer Center, Man Ray was particularly impressed by the sketching technique taught to the students, for they were instructed to rapidly execute their drawings and color sketches from the model within the time period of a twenty-minute pose, an approach that differed sharply from the slower, more studied method he had been familiar with from the various academic institutions he had previously attended. Robert Henri, his most memorable teacher at the center, instructed Man Ray to freely assert his individuality, even at the risk of being misunderstood. Years later, Man Ray recalled that Henri's ideas were even more stimulating than his artistic criticism: "he [Henri] was against what most people were for, and for what most were against."[2]

While Henri's rebellious and pioneering position in the history of American painting has been well established, until recently his more radical, anarchist sympathies have been either overlooked or suppressed by historians and biographers.[3] His interest in social reform dates from his family's support for the Democratic Party, but his humanitarian concerns were more definitively aroused as a result of the government's poor treatment of the American Indian and by the injustices of the Homestead Steel strike in 1892.[4] As the leader of the Eight, he encouraged his fellow painters to seek inspiration in the dynamism of the city, whose ethnic groups and lower-class inhabitants succinctly embodied the vitality of life in its most dignified and uncorrupted state. But even more than his socialist inclinations, it was the dynamic preaching of Emma Goldman that drew Henri to the Ferrer Center in 1911 and converted him to the cause of anarchism, a philosophical doctrine that he embraced and supported until his death in 1929.

Henri taught without pay at the Ferrer Center for nearly seven years, and also managed to enlist the talents of his friend and former pupil George Bellows, whose anarchist leanings were quickly replaced by patriotic instincts when America entered the war in 1917 (at which time Bellows quit teaching and joined the military).[5] Together, Emma Goldman later noted, "they [Henri and Bellows] helped to create a spirit of freedom in the art class which probably did not exist anywhere else in New York at that time."[6]

The "spirit of freedom" is clearly reflected in the sketches Many Ray produced in the life drawing classes at the Ferrer Center. Independent of medium—whether charcoal, ink wash, or a densely applied watercolor pigment—his results were always consistent: the model is given visual definition by means of a rapid, though confident and fluid, application of line or color.[7] Because the drawings in this course had to be completed within a twenty-minute

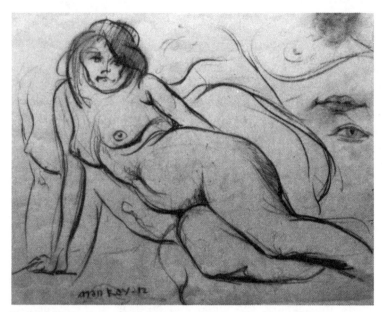

*Figure 1*. Untitled. *Ca. 1912. Charcoal on paper. 43 x 35.5 cm. Estate of the Artist, Paris.*

time limit, there was little opportunity for the students to render precise details in the fashion customarily demanded by more academic approaches. Consequently, with few exceptions, Man Ray's figure studies from this period are characterized by a lack of definition in the extremity of their appendages (fingers and toes), though—as in the example of a skillfully rendered, slightly foreshortened figure of a reclining nude (Fig. 1) these details were sometimes worked out in the surrounding space on the drawing page.

Most of the sketches of nudes that survive from this period record the same buxom young female model—probably fourteen-year-old Ida Kaufman—who at age fifteen married the school's director, Will Durant, and later, as coauthor of many books with her husband, became well-known under the name Ariel. "Her figure, quite stocky, with firm, fully developed breasts," Man Ray recalled some fifty years later, "resembled one of Renoir's nudes."[8] While his subjects may very well recall the works of this well-known Impressionist painter, the technique Man Ray adopted for the application of paint was far more dependent upon the bravura brushstroke and intense palette of Fauvism. The artist frequently accentuated these figure studies with open washes of bright, near luminous choices of pigment, where flesh tones can range from pale rose to fiery orange. In some cases it almost appears as if Man Ray has consciously reacted against the adverse criticism he had once received as a child for his arbitrary

application of color, for most of these figure studies are highlighted with an assortment of bright, sometimes unmixed hues, seemingly selected from his palette in a random fashion and applied in quick, expressionistic gestures of pure color.

Occasionally, Man Ray would direct his attention away from the model to subjects in his immediate environment. The resulting works—usually rendered with brush and India ink and probably intended as illustrations for one of the school's publications—provide a sampling of the activities that took place in the life drawing classes at the Ferrer Center. One drawing documents the great variety of individuals who took advantage of classes at the Modern School (Fig. 2): a middle-aged woman, and elderly man, and a

*Figure 2.* Untitled. *Ca. 1912. India ink on paper. 40 x 28.5 cm. Estate of the Artist, Paris.*

young boy are each shown diligently at work on their drawings. Another sketch shows two older men reviewing drawings as their students attentively look on (Fig. 3). The mustachioed gentleman in the foreground was probably meant to represent Robert Henri, while the bearded man to his right may have been based on the features of Adolf Wolff, a sculptor and friend of Man Ray's whose most distinguishing feature was a sharply trimmed beard.[9] The scene was probably meant to record one of Henri's well-known "quiet" critiques. "Passing around from drawing to drawing," as Man Ray described in sessions years later, "he [Henri] made gentle, encouraging remarks but never touched the drawings nor criticized adversely."[10]

The year 1912 marked a period of intense activity for Man Ray at the Ferrer Center: by the winter months this young, twenty-two-year-old student from Brooklyn was ready to participate in the first group exhibition organized by the artists associated with the Modern School, which was held at the Ferrer Center from December 28, 1912, through January 13, 1913.

It is difficult to establish with precision the works by Man Ray that were shown in this exhibition, although a painting entitled *A Study in Nudes* (Fig. 4), signed and dated 1912, was reproduced in a review of the show that appeared in *The Modern School*, the magazine published by the Ferrer Association.[11] Despite the poor quality of this black-and-white illustration, it can be seen

*Figure 3.* Untitled. *Ca. 1912. India ink on paper. 40 x 28.5 cm. Estate of the Artist, Paris.*

and compositional arrangement given to several paintings in the bather series of Cézanne, the Post–impressionist painter whose works were just then becoming associated with the most advanced developments of modern painting on both sides of the Atlantic.[12] That the works Man Ray showed in this exhibition did not conform to a unified approach, however, is confirmed by the comments published by his friend and fellow exhibitor Adolf Wolff: "Man Ray is a youthful alchemist forever in quest of the painter's philosopher's stone. May he never find it, as that would bring an end to his experimentations which are the very condition of living

that the harsh delineation usually associated with more academic modeling has been entirely replaced by a softer, more color-oriented approach to the definition of form. Moreover, the seven female nudes—in addition to a small baby clutching the thigh of a kneeling figure on the right—are somewhat reminiscent of the postures

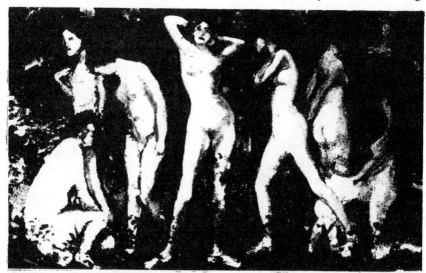

*Figure 4.* A Study in Nudes. *Ca. 1912. Oil on cancas. Location unknown; reproduced in* The Modern School, *Spring 1913.*

art expression."[13]

Man Ray's stylistic oscillations in this period were aptly matched by the diversity of subjects incorporated in his work, evidenced in part by the range and variety of titles given to the paintings and drawings he showed in the next group exhibition at the Ferrer Center—held only four months after the first—from April 23 to May 7, 1913. This second showing appears to have been a more ambitious undertaking, for over sixty-five works were exhibited and virtually every art student associated with the school participated, including the children, whose works were exhibited alongside those of the adults. The show was even accompanied by a small catalog, containing a brief introduction by Max Weber and a simple handlist of the titles provided for each work.[14]

It is difficult to securely identify with known works any of the paintings, drawings, or watercolors shown by Man Ray in this exhibition. Their titles, however, indicate that the subjects were not always derived from tangible elements in the artist's immediate environment nor faithfully recorded in a traditional, representational method. Indeed, certain titles suggest that at this time Man Ray was becoming more and more aware of the potential inherent in a less figuratively dependent approach for the generation of images. Along with works simply entitled *Nude, Portrait, Bridge, New York*, and *The Copper Pot*, for example, he showed works with such diverse titles as *Amour, Fantasy, Decoration*, and *Tchaikows-*

*ky* (the latter of which was most likely an abstract or "abstracted" composition, meant, I suspect, to represent the music of the composer, rather than a portrait likeness of the composer himself).[15]

Even before his introduction to the Ferrer Center, Man Ray recalled, he engaged in many long conversations with an unnamed, aspiring young musician-friend, who argued that music was superior to painting because it was "more mathematical, more logical and abstract." Man Ray remembered assenting to this notion, but he claimed that at the time he did not know quite how this principle could be applied to his work, though he acknowledged that it was the germinating factor that later led to his involvement with abstraction. "I agreed," he remarked, "but intended later to paint abstractedly (sic)."[16]

At the Ferrer Center, Man Ray could hardly have avoided continuing conversations along these lines, for the interrelationship of music and art was a favored topic of his friend Manuel Komroff, who was both an artist and musician. Komroff not only participated in most of the exhibitions held at the center, but on Monday evenings he also held piano recitals at the school, playing "selections from the great masters."[17] Komroff was the only artist to be represented by more works than Man Ray in the 1913 exhibition at the Ferrer Center, and most of the titles he gave to his paintings and watercolors invoked an analogy to music: *Etude in F Minor, Study in C Sharp Minor, Study in the Key of C*, and so

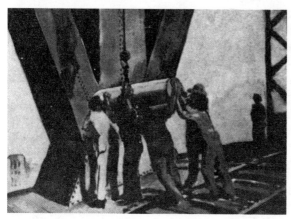

*Figure 5*. Bridgebuilders. *Ca. 1912. Oil on canvas (?). 24 x 28 cm. Location unknown.*

on. In fact, at the time when the exhibition was being held at the center, Komroff published an article in the school's magazine tiltled "Art Transfusion," by which he meant that sculpture, painting, and literature were becoming more and more like music, while at the same time, modern music was increasingly sharing qualities with the visual arts. "As each art is striving to include all the others," he observed, "they are all becoming one." He further postulated that "Nature and art have very little in common," concluding that "true art...is as far removed from earth as space itself."[18]

The potential inherent in abstraction was further expounded upon in the introductory essay to the catalog, which, it has been noted, was written by Max Weber, one of the older, more established artists who began frequenting the center in 1912, and an artist who was to have a pronounced influence on Man Ray's earliest experiments with Modern Art.

Although a more thorough discussion of Weber's stylistic influence on Man Ray will be reserved for a future study, it should be noted that by the time of this exhibition at the Ferrer Center, Weber's familiarity and understanding of the Cubist and Futurist movements in Europe was considerably in advance of his contemporaries, and he had already begun to experiment with the principles of abstraction in his own work. In his introduction to the catalog, Weber indicates that he and his fellow painters were on the threshold of a new artistic reality. "Surely there will be new numbers, new weights, new energy, new and bigger range of our sense capacities," he wrote; "we shall paint with the mind eye, the thought eye...we shall not be bound to visible objects....We shall put together that which in a material sense is quite impossible."[19] Weber later recalled that he also urged his fellow students "to take time off from the life-class," and, like Henri, he suggested that if they wished to capture the energy and heroism of modern times, they should "go out among the people who toil in the mills and shops, go to scenes of bridge construction, foundries, excavation."[20]

On at least one occasion, Man Ray appears to have taken Weber's advice literally. In a lost painting from 1912 entitled *Bridgebuilders*

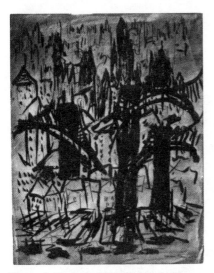

*Figure 6.* Skyline. *1912. Pen and ink on paper. 10 x 8 in. Location unknown; photograph courtesy Naomi Savage.*

(Fig. 5), the artist has faithfully recorded a group of workmen in the process of hoisting a large cylindrical drum during the construction of a bridge. If we can judge solely by the titles of works shown in this exhibition, Man Ray may have relied on themes drawn from city life in a number of other paintings and drawings from this period. Although the work that was entitled *New York*, for example, cannot be securely identified with an extant paining by the artist, a semblance of its spirit and perhaps even its style might be garnered from two works whose subjects were meant to encompass the overcrowded vitality of the city and its complex transportation network: *Skyline* (Fig. 6), a small pen and ink sketch of 1912, and *Metropolis* (Fig. 7), a more highly finished watercolor dating from early 1913.[21]

In *Skyline* the city's many bridges are shown as if uprooted from their moorings and impacted into the cityscape itself, serving to join the low-lying houses near the piers in the foreground of the image with the towering skyscrapers defining the city's skyline at the upper summit of the drawing. In a similar fashion, *Metropolis* records a somewhat detached, distant view of the overcrowded city—perhaps the logical viewpoint of the Brooklynite who commuted to Manhattan every day. Indeed, the basic theme of this drawing appears to emphasize the city's various methods of transportation; nestled against the skyline in the lower left portion of the composition is an oval-shaped ferryboat, which appears to be making its way upriver in the presence of two large steamships docked between piers in

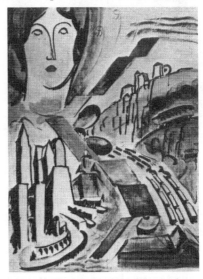

*Figure 7.* Metropolis. *1913. Watercolor and pencil on paper. 51 x 46 cm. Galerie Alphonose Chave, Vance.*

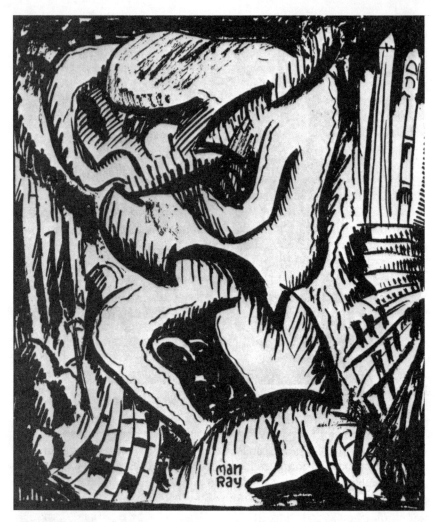

*Figure 8.* Untitled. *Ca. 1913. Pen and ink (woodcut?). Location unknown; reproduced in* The Modern School, *Autumn 1913.*

the harbor. Issuing forth from a large, low-lying brick building in the right corner—probably meant to represent the central train station—are a series of commuter lines disappearing into the center of the composition, while a sole trolley car makes its way over a viaduct in the center ground on the right side of the drawing. The most prominent element of this composition takes the form of a large woman's head looming above the entire ensemble in the upper left-hand corner of the work. The sharply juxtaposed scale and detached positioning of this head—along with its cold, expressionless features—suggest the possibility of a symbolic interpreta-

tion for this element; Man Ray may have intended this head to represent some kind of mythic goddess of metropolitan life. Finally, the most prophetic element of this intriguing watercolor comes in the form of seven abstract planes of color, rendered as two-dimensional strips winding their way through the center of the composition. The first plane begins as a single blue rectangle issuing forth from the depths of the river in the central foreground, while the last two planes are rendered as olive-green shapes merging with cloudlike formations in the sky above.

Man Ray's assimilation of modernism in this period was so pervasive and inspiring that it did not prevent him from occasionally incorporating two distinct styles in a single work of art. An untitled ink drawing (or woodcut?) reproduced in *The Modern School* magazine in the fall of 1913 (Fig. 8) appears to have drawn its inspiration from a number of sources. A crouching, distorted, and anonymous figure is shown bending into the confines of an overcrowded rectangular space, much in the manner of Weber's large-scale nudes or in certain examples of French Cubist painting. But the background landscape is here replaced by sharply rendered architectonic forms, which, together with the work's basic graphic qualities, recall Man Ray's earlier ink drawing *Skyline* (Fig. 6). Certain passages in this work, however, reveal a more direct reliance on specific details in *Metropolis* (Fig. 7), the watercolor based on the theme of New York's

bewildering transportation network. The ferry boat and commuter lines, for example, have become more abstracted and are placed in reversed positions in the illustration, while the triple-stacked steamers, which were earlier shown docked at the piers, are now represented by a series of sharp, otherwise unintelligible lines. Finally, the entire image is unified by the presence of a heavy black crescent-shaped line zigzagging in the shape of an S-curve through the center of the composition, assuming a position parallel to that of the rectangular planes interwoven through the center of *Metropolis*.

The possible significance of these abstract shapes is made clearer in the enlargement and elongation of this image in a work entitled *Tapestry Painting*, a large nine-foot-high, oil-on-canvas picture, which, if we can judge by the title, was meant to be displayed in the fashion of a wall hanging.[22] In this second version of the image, it becomes clear that the large figure in the center of both compositions was meant to be shown playing a guitar, the upper neck of which is represented by one of many dark crescent shapes. The repetition of these shapes throughout the image may have been intended to symbolize the sound emanating from this musical instrument, a detail that unites the theme of this picture with other musical analogies, which, as we have seen earlier, preoccupied Man Ray and his friends during these years at the Ferrer Center—one among many concerns that would eventually lead Man Ray to explore the potential

inherent in more abstract imagery.

On May 3, 1913, Man Ray addressed a letter to the editor of the *New York Globe*, reproaching the newspaper's art critic, Arthur Hoeber, for publishing an insufficiently prepared review of this exhibition. Among his objections, Man Ray accuses Hoeber of never having actually seen the exhibition, further asserting that the critic's entire review was based only on his reading of the catalog introduction, which was written by Max Weber and which Man Ray felt was not intended to express the full variety and diversity of ideas that were in the exhibition. "Mr. Hoeber's notice proves," he amusingly concluded, "that even a critic can become creative if only he neglect natural representation."[23]

In the stimulating environment of the Ferrer Center, Man Ray was exposed to the most progressive and revolutionary ideologies of his day; even more than the artistic instructions of his teachers, these ideas would serve to nurture the revolutionary attitude already assumed by this rebellious young painter. But the artist who would have the most profound effect on the formation of Man Ray's political ideologies, as well as decided impact on his personal life, was the Belgian-born anarchist Adolf Wolff (1993-1944), self-proclaimed "poet, sculptor and revolutionist," and, as he himself emphasized, "...mostly revolutionist."[24]

Man Ray met Wolff (or "Lupov," as he is barely disguised in Man Ray's autobiography) at the Ferrer Center. Like Man Ray, after only a few months of exposure to the workings of the school, Wolff became one of its most active participants. In the evenings he gave a course in French for adults, while on Thursday afternoons he taught art to the children. Learning that Man Ray was unhappy living at home, Wolff offered his young friend a place in which to work, in a small studio he rented on Thirty-fifth Street. Man Ray, however, did not find the space very comfortable, as Wolff left the floor wet and dirty from his work, and the studio was filled with sculptures, drawings, and oil paintings. One morning, moreover, Man Ray entered the small studio only to discover the older artist and a young woman lying together on the studio couch. Wolff laughingly explained that the woman was a model, and they were only trying out a new pose for a sculpture. Man Ray later learned that Wolff had been recently divorced from a young Belgian named Adon Lacroix, with whom he shared a child and still maintained a close friendship. Unbeknownst to Man Ray at this time, Wolff's ex-wife was to have a decisive effect on his immediate future. Shortly after this incident occurred, Wolff introduced Man Ray to Lacroix, an encounter that was to be of some consequence for the young couple, for they immediately fell in love and married within a year.

During the mid to late teens Wolff participated in a number of anarchist demonstrations, several of which resulted in his arrest and imprisonment. This dedication to

THE

# INTERNATIONAL

May 1914        Price 15 Cents

*Edited by* GEORGE SYLVESTER VIERECK

*CONTRIBUTORS TO THIS NUMBER:*
Anton Tchekhov, John Laurence McMaster, Alexander Harvey, Barret H. Clark, Benjamin De Casseres, T. Everett Harré, Joseph Bernard Rethy and others.

*Figure 9.* The International, *May 1914* .

anarchism was succinctly incorporated in his poems and sculpture of this period. Like his personality, Wolff's poetry was characterized by a crude, unrefined power that reflected his militant temperament, while his sculpture clearly paralleled the most advanced sculptural expressions of the day. The more figuratively dependent works of ca. 1913-14 are characterized by a basic reduction and simplification of form,[25] doubtlessly inspired by Cubist painting and sculpture, examples of which Wolff would have known from the Armory Show or from exhibitions of progressive European and American art in the New York galleries. We know he frequented these exhibitions during the 1913-14 gallery season, for at that time he served for a brief period as an art reviewer for the socialist magazine *The International*. To this monthly publication he contributed a

series of articles entitled "Insurgent Art Notes," presenting his somewhat unorthodox and prosaic review of current exhibitions, from a small show at the Ferrer Center to important larger exhibitions of modern art at the well-known galleries.

In the same period when Wolff was writing for *The International*, Man Ray provided the cover illustration for at least three numbers of this socialist review, with a design that is repeated (with a different-colored background) on the March, April, and May, 1914, issues of the magazine (Fig. 9).[26] Within the circular frames defined by the outstretched and supporting arms of three anonymous, symmetrical, and architecturally suggestive figures (somewhat reminiscent of Wolff's Cubist-inspired sculpture), Man Ray has supplied two ink drawings, one of an ocean steamer about to pass through the opening doors of a lift lock, and the second of pyramids and a sphinx in the shadow of a sun-drenched palm. These two seemingly unrelated views may in fact have been a subject of some political importance in 1914, for it was in that year that the Panama Canal was informally opened, the most important man-made waterway in the Western Hemisphere to open since the Suez Canal in 1869; together, these two canals created a single round-the-world sea passage, regarded strategically as an especially important transportational route during the war.[27]

While these covers for *The International* may provide some indications of Man Ray's support for socialist issues, his only other known

contribution to leftist politics came in the form of two political cartoons he designed for the covers of *Mother Earth,* the radical periodical edited by Emma Goldman and Alexander Berkman, whose offices were just a few blocks away from the Ferrer School.[28] The first of these covers (Fig. 10) shows a giant two-headed dragon tugging at opposite ends of a figure labeled "HUMANITY," while the separate heads of the monstrous beast are identified by the labels "CAPITALISM" and "GOVERN-MENT." The illustration makes it clear that Man Ray considered the individual powerless against the larger ideological forces that ultimately control humanity's destiny. It should be noted that this drawing appeared on the cover of the August 1914 issue of the magazine, precisely the month it became clear that the European war would reach world-wide proportions. This issue also carried on its title page a poem by Adolf Wolff entitled simply "War," where, in a strongly anarchist tone, law and order are denounced as the very causes of death and destruction.[29] The next issue of *Mother Earth* carried Man Ray's drawing of two prisoners in striped garb (Fig. 11), positioned in such a fashion that their uniforms complete the stripes of an American flag, the staff of which is a crucifix and whose stars are composed of mortar blasts in a violent battle scene. More than the obvious reference to the plight of political prisoners evoked by this image, it is the visual pun incorporated in its design that lends the drawing such strength.

Man Ray's heightened political awareness in this period coincided with a thoughtful reexamination of painting's more formalistic quali-ties—both from a historical and mod-ern perspective—resulting in a radi-cal departure from his earlier work. Having already experimented suc-cessfully with the fragmented, inter-secting planes of Analytic Cubism (such as in his *Portrait of Alfred Stieglitz,* 1913 [Yale University Art Gallery]), Man Ray decided that "for the sake of a new reality," in both approach and techinique, the modern artist should make every effort to acknowledge the inherent two-dimen-sional quality of the canvas surface.[30] To this end, he was led to investigate the various solutions offered to this problem by the art of the past, look-ing for inspiration to Byzantine and Early Renaissance sources. These historcal precedents, combined with his pacifist reaction toward the out-break of war in Europe, were doubtlessly the most significant fac-tors to influence the selection of tech-nique and subject in Man Ray's most important politically inspired pictures of this period: *War (ADMCMXIV)* (Fig. 12) and *Madonna* (Fig. 13).

Measuring just under six feet in width, *War (ADMCMXIV)* remains Man Ray's most monumental Cubist composition. According to his recol-lections, the unusual size of this can-vas was determined by a space he had to fill in this living room, and its inor-dinate scale and positioning reminded him of the kind of problems that must have confronted the wall painters of the Renaissance. In emulations of

these earlier masters, he prepared the canvas with a base of fish glue and plaster dissolved in water, to provide a matte and chalky surface reminiscent of the intonaco use in fresco.[31] The subject, he then claims, was inspired by a reproduction of Uccello's famous battle scenes. but rather than allow the recessional effect created by a strict application of the rules governing Renaissance perspective systems—of which Uccello was a well-known master—Man Ray rendered the figures and background shapes in his composition as if they were reflections of one another. The blunt, angular, and unarticulated forms of horses and soldiers are echoed into their surrounding environment, creating a uniform surface tension that serves to reassert the painting's inherent physicality. Modeled almost entirely with a palette knife, the figures are rendered as overbearing, cylindrical forms— their severe geometry and lack of

articulation recalling the sculptures of Adolf Wolff—while their positions and frozen postures seem to imply the frustration and inevitability of their struggle. Locked into never-ending combat with their oppressors, these soldiers are rendered as mere automatons, mindlessly engaged in their struggle, obeying without question the futile orders of their commanders.

According to Man Ray, the title given to this painting—*War*—was suggested by his wife, Adon Lacroix, who was especially affected by the European conflict, for her parents were still living in the country of her birth—Belgium—which, despite its position of neutrality, was ruthlessly invaded by German troops in August of 1914. To the lower right corner of his painting, Man Ray then dated the picture by adding the Roman numerals "ADMCMXIV," employing stencil-styled letters that were later overpainted and replaced by a more calligraphic inscription. While Lacroix may have

*Figure 12.* War (ADMCMXIV). *1914. Oil on canvas. 37 x 69 in. Philadelphia Museum of Art; A. E. Gallatin Collection.*

# MOTHER EARTH

Vol. IX.    August 1914    No. 6

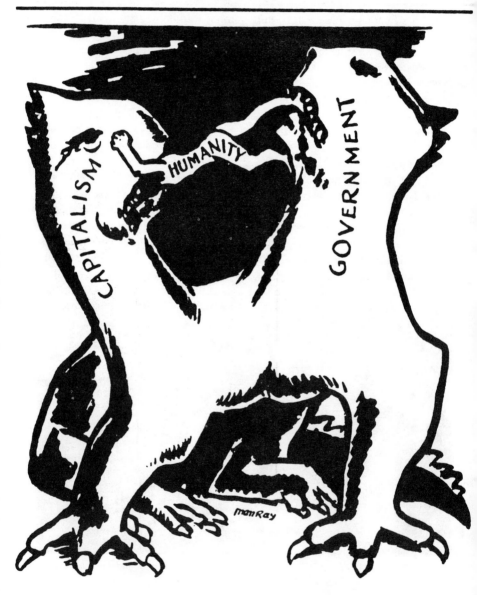

# MOTHER EARTH

Vol. IX.    September, 1914    No. 7

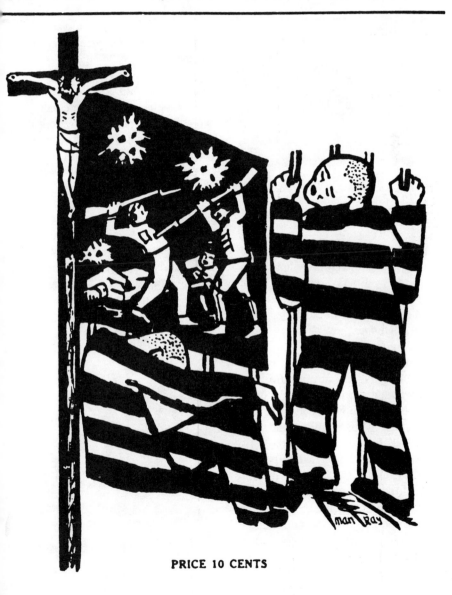

PRICE 10 CENTS

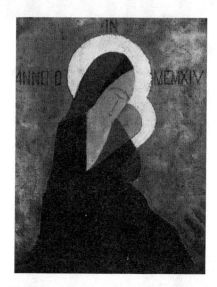

Figure 13. Madonna. *1914. Oil on canvas. 20 ⅛ x 16 ⅛ in. Columbus Museum of Fine Arts; gift of Ferdinand Howald.*

suggested the title *War*, the prominent dating of this picture may have been inspired by Frank Stephens' "A.D. 1914," a poignant antiwar poem that was published in the October 1914 issue of *Mother Earth*.[32]

Arranged symbolically in a cruciform format, an even more prominent display of Roman numerals declares the year of Man Ray's quiet though powerful Madonna (Fig. 13), a painting whose subject and flat, unarticulated forms evoke the religious icons of the Byzantine period. The artist later subtitled the picture "In Mourning—War I,"[33] but the relationship of this image to the war in Europe can only be understood when we examine a preparatory study for the picture (Fig. 14). Here, it is revealed that the tapering black shape used to describe the Madonna's arm

in the finished paining was actually derived from the neck of a large black cannon, while the halos given to the figures are taken from billowing, cloudlike formation issuing from the cannon's smoldering mouth. "Perhaps the idea was to express my desire for peace as against war," the artist later remarked; "there were no religious intentions."[34]

In the ensuing years, Man Ray's inclination toward anarchist politics would find more casual expression in two ephemeral publications, both of which he edited and privately printed, *The Ridgefield Gazook* in 1914, and *TNT* in 1919. The first of these publications consisted of a single hand-printed sheet folded to form four pages. Reproduced on the cover of the first and only issue of this magazine to appear was a drawing by Man of two insects engaged in the act of mating, captioned "The Cosmic Urge—with apologies to PIcASSo."

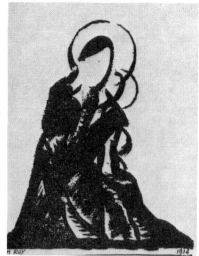

Figure 14. Study of Madonna. *A1914. Charcoal (?). Location unknown.*

The remaining contents were devoted primarily to parodies of his friends Adolf Wolff["Adolf Lupo"], Adon Lacroix ["Adon La+"], Hippolyte Havel ["Hipp O'Havel"], and Manuel Komroff ["Kumoff"]. But, other than for a passing reference to the Czech anarchist Joseph Kucera ["Mac-Kucera"], the only portion of this publication referring specifically to anarchist activities is found in a poem entitled "THREE BOMBS," illustrated by Man Ray and allegedly written by Wolff. The poem consists of nothing more than a series of blank lines, two exclamation marks, and a sequence of seemingly arbitrarily distributed letters, all of which is enveloped by the spoke of three sizzling explosives placed in a dish, flanked by accompanying knife and fork, located below the poem. While the literary contribution of this poem is problematic, the three bombs are undoubtedly a reference to the three young anarchists from the Ferrer School who were killed in July of 1914 when a bomb they were preparing accidently blew up.[35] Wolff knew the three young men, and immediately after their deaths he dedicated a poem to their memory; but he was best known in anarchist circles for his design of a bronze urn that was used to contain their ashes.

Man Ray and Wolff remained friends throughout the teens and saw one another nearly every week, beginning from the time Man Ray and Adon Lacroix [Wolff's ex-wife] began sharing quarters in 1913.

Every Saturday afternoon Wolff would bring over his daughter Esther to visit her mother, and on these occasions the two artists would frequently discuss ideas and exchange casual comments about their work. The last evidence of their collaboration dates from 1919, when in March of that year an untitled abstract bronze sculpture by Wolff appeared as the cover illustration for Man Ray's *TNT*, the single-issue publication Man Ray later describes as "a political paper with a very radical slant," which he also claimed was "a tirade against industrialists, the exploiters of workers."[36] But other than the magazine's explosive title— which ran across the cover in large black letters—there was little in the publication that could be even remotely construed as a reference to anything politically subversive.

Although exceptionally few works by Man Ray—outside of those discussed in the present context—can be said to have been specifically motivated by anarchist leanings or pacifist sentiments, there can be little doubt that the artist's early exposure to these libertarian ideals served to prepare him for the acceptance of Dada's more radical, nihilistic, and unconventional qualities. In his interviews and various published statements, throughout his life Man Ray would frequently acknowledge the importance of his training at the Ferrer Center, an experience that would form the background and framework for his most successful Dada productions.

# Notes

1. On the Ferrer School, see Paul Avrich, *The Modern School Movement: Anarchism and Education in the United States* (Princeton: Princeton University Press, 1980) and Ann Uhry Abrams, "The Ferrer Center: New York's Unique Meeting of Anarchism and the Arts," *New York History*, 59, No. 3 (July 1978), 306-25.

2. Man Ray, *Self Portrait* (New York and London: Andre Deutsch, 1963), p. 23.

3. Noteworthy exceptions are William Innes Homer, *Robert Henri and His Circle* (Ithaca: Cornell University Press, 1969), pp. 179-82, and Avrich, *Modern School*, pp. 145-53.

4. The Homestead Steel strike was one of the most bitterly fought labor disputes in U.S. history. In June of 1892, workers belonging to the Amalgated Association of Iron and Steel Workers struck the Carnegie Steel Company at Homestead, Pennsylvania, to protest a proposed wage cut. Later renowned in the art community for his extensive collection of old master paintings, as general manager of the steel company Henry C. Frick ordered three hundred Pinkerton detectives to protect the plant and the strike breakers, a policy that resulted in an armed battle between the workers and the detectives. Deeply disturbed by such a crushing victory over labor, on July 23, 1892, the Russian-born anarchist Alexander Berkman made an unsuccessful attempt to assassinate Frick. After serving fourteen years of a twenty-two-year sentence, Berkman was released and returned to New York, where he resumed his association with Emma Goldman and became involved in the activities of the Modern School. Fifteen years after the Homestead incident occurred, Henri would serve on a committee to prevent Berkman's extradition on charges of complicity in a bombing case (see Avrich, *Modern School*, p. 147).

5. On Bellows' association with anarchists and anarchism, see Charles H. Morgan, *George Bellows, Painter of America* (New York: Reynal & Company, 1965), pp. 153-54, and Avrich, *Modern School*, p. 149. In 1917, Bellows so sympathized with the American war effort that he volunteered for service in the Tank Corps and devoted his artistic efforts to illustrating the atrocities of the European conflict (see the exhibit catalog *George Bellows and the War Series of 1918* [New York: & Adler Galleries, March 19-April 16, 1983]).

6. Emma Goldman, *Living My Life* (New York: Alfred A. Knopf, 1931), pp. 528-29 (quoted in Avrich, *Modern School*, p. 149).

7. Seven figure studies from this period are illustrated in *Man Ray: 60 Years of Liberties*, ed. Arturo Schwarz (Paris: Eric Losfeld, 1971), pp. 9, 12, and 63. Many figure studies of this type have appeared in auction (see, for example, the catalog for Sotheby's, London, December 5, 1983, lot no. 518, illus.), and others are preserved in the artist's estate (collection Juliet Man Ray), Paris.

8. *Self Portrait*, p. 23. Man Ray thought of illustrating his autobiography with one of these drawings, but told Ariel Durant that he had decided against it for fear that it might offend her or her husband (see Will and Ariel Durant, *A Dual Autobiography* [New York: Simon & Schuster, 1977], pp. 83 and 390).

9. The basis for establishing the identities of these figures is primarily circumstantial, although their indistinctly rendered features bear a vague resemblance to photographs of these artists from this period; see the photograph of Henri instructing art students in a night class at the New York School of Art, 1907 (reproduced in Homer, *Robert Henri*, fig. 19), where coincidentally, Henri strikes a pose remarkably similar to the position given in the Man Ray drawing; a photographic portrait of Wolff appears in an article by André Tridon, "Adolph Wolff: A Sculptor of To-Morrow," *The International*, 8, No. 3 (March 1914), 86. Wolff's politics and art had a profound effect on the ideas and work of Man Ray in this period.

10. *Self Portrait*, pp. 22-23.

11. See Adolf Wolff, "The Art Exhibit," *The Modern School*, No. 4 (Spring 1913), p. 11; this work was brought to my attention by Paul Avrich.

12. A book tracing the history of the literature, exhibitions, and acquisition of paintings by Cézanne in America is currently being prepared for publication by John Rewald.

13. Adolf Wolff, "Art Notes," *The International*, 8, No. 1 (January 1914), 21.

14. *Exhibition of Paintings and Water Colors at the Modern School*, 63 East 107th Street, New York, April 23-May 7, 1913, unpaginated (a copy of this rare catalog is pre-

served in the Papers of Forbes Watson, Archives of American Art, microfilm roll no. D57, frames 474-76).

15. *The Copper Pot* may refer to the large brass bowl filled with dried foliage, a motif that became a trademark of Alfred Stieglitz's gallery, "291," which Man Ray had begun to frequent at this time (see William Innes Homer, *Alfred Stieglitz and the American Avant-Garde* (Boston: New York Graphic Society, 1977, p. 46; for an illustration of this vessel, see p. 198, fig. 93).

16. *Self Portrait*, p. 14.

17. Noted in Avrich, *Modern School*, p. 90.

18. Manuel Komroff, "Art Transfusion," *The Modern School*, No. 4 (Spring 1913), pp. 12-15.

19. Max Weber, Introduction to the Modern School catalog (see n. 14 above).

20. Quoted in Lloyd Goodrich, *Max Weber* (New York: Whitney Museum of American Art, 1949), p. 46 (also cited in Avirch, *Modern School*, p. 155).

21. *Metropolis* is signed and dated 1913, but I would be inclined to place it early in the year because it reveals little or no dependency upon the angularization or fragmented space of Cubism—the stylistic direction to which Man Ray's work would momentarily evolve after his exposure (or at least reaction) to the vast display of modern art at the Armory Show in February of 1913. Moreover, the general theme of metropolitan life is one that is prominent in drawings that can be securely dated to 1912, and it is a subject that must have persisted in his work at least until early in 1913, if we can judge by the titles given to the paintings and watercolors he exhibited in the second Modern School exhibition.

22. A photograph of this painting is preserved in a cardfile kept by the artist of works dating from the New York and Ridgefield years (Estate of the Artist, Paris). A complete inventory of the paitings and sculptures recorded in this cardfile will form an appendix to the author's dissertation, "The Early Works of Man Ray, 1908-1921," currently in preparation at the Graduate Center of the City University of New York.

23. Arthur Hoeber's review appeared in his column, "Art and Artists," *The New York Globe*, May 2, 1913, p. 10; Man Ray's letter was printed in the May 9, 1913, issue of the newspaper (p. 10).

24. See Francis M. Naumann and Paul Avrich, "Adolph Wolff, 'Poet, Sculptor and Revolutionist, but Mostly Revolutionist,'" *The Art Bulletin*, 66, No. 3 (September 1985) and *Drunken Boat* No. 1, (1992). Many of the biographical details that follow are excerpted from this study.

25. For illustrations of these sculptures see "Adolph Wolff: Sculptor of the New World," *Vanity Fair*, 3, No. 2 (October 1914), p. 54.

26. *The International*, April (vol. 7, No.4), March (vol. 7, No. 3) and May (vol. 8 No. 5), 1914.

27. Although it was not until August of 1914 that the Panama Canal was informally opened, the United States had been engaged in its excavation since 1906.

28. *Mother Earth*, August (vol. 9, No. 6) and September (vol. 9, No. 7), 1914; while Man Ray designed only these two covers of the magazine, the logo he designed for its title was retained throughout the duration of the publication.

29. Adolf Wolff, "War," *Mother Earth*, 9, No. 6 (August 1914).

30. This subject is more extensively explored in Francis M. Naumann, "Man Ray: Early Paintings 1913-1916; Theory and Practice in the Art of Two Dimensions," *Artforum*, 20, No. 9 (May 1982), 37-46.

31. From an interview with the artist conducted by Arturo Schwartz; quoted in Schwartz, *Man Ray: The Rigour of Imagination* (New York: Rizzoli, 1977), p. 32.

32. Frank Stephens, "A.D. 1914," *Mother Earth*, 9, No. 8 (October 1914), 254.

33. Information provided in the artist's cardfile (see n. 22 above).

34. Statement by the artist published in *Mother and Child*, ed. Mary Lawrence (New York: Thomas Y. Crowell, 1975), p. 64; my interpretation of the painting and preparatory drawing is based on the artist's description of *Madonna* provided in this statement.

35. For a detailed account of this incident, see Avrich, "Lexington Avenue," ch. 6 in *Modern School*, pp. 183-216.

36. From an interview with Arturo Schwarz, "This is Not For America," *Arts magazine*, 51, No. 9 (May 1977), p. 120.

# ANARCHISM, EXPRESSIONISM AND PSYCHOANALYSIS

## Zur Ueberwindung der kulturellen Krise

Von Otto Gross

Diese Zeilen sind e            Antwort auf einen
Angriff, den Landaue            zialist" gegen die
Phychoanalyse und g            chtet hat und den
ich damals unbeantwor           e, da Herr Gustav
Landauer meinem Auf            kation in seinem
Blatte verweigert. Ic           nur auf das Sach-
liche des Angriffs ein.          sönliche anbelangt,
so könnte ich nur sage          er hat infam die
Wahrheit verdreht.

Im übrigen soll                 giert
und vertreter                   ab
Juni zusamm                     ill.

Die Psycholo                    hi-
losophie der                    n,
das zu werder                   ng
innerhalb de                    m
eigenen Un                      li-
tät. Sie ist                    ig
zu machen,                 der
Revolution.

## BY ARTHUR MITZMAN

**A**n alliance of anarchists and literary bohemians in Berlin was noted in German literary criticism almost eighty years ago. But systematic approaches to the phenomenon have appeared only recently, in the work of Helmut Kreuzer and Ulrich Linse.[1] Particularly significant for this relationship were the expressionist subcultures of artists and writers in Berlin and Munich between roughly 1910 and 1920.

To these German cities, and a handful of others, flocked thousands of youthful aspirants to cultural immortality. In them, they lived by the principles of hostility to all external authority, liberation from the conventions of bourgeois society and frequently, in the circle they formed, by the somewhat contradictory impulses of communitarian brotherhood.

This was the cultural milieu from which arose the explosions of color and form that characterized the first groups of expressionist painters in Munich and Dresden around 1905— *Der Blaue Reiter* and *Die Brücke*— and from which, a few years later, emerged also the first expressionist poets, essayists and novelists, with their unique devotion to the ideals of self-expression and their abjuration of the more representational ideals of literary naturalism. Thus it is understandable that Expressionists showed a degree of sympathy and support for anarchist ideas and movements which were nowhere to be found in their attitude toward the far more powerful, but bureaucratized and to them philistine Social-Democracy.[2]

Once established in their café subcultures, the bohemian intellectuals tended to develop an autonomous aesthetic and intellectual dynamic, which led them along exceedingly daring lines of cultural, moral and intellectual innovation. In fact, some of the Expressionists, mixing Freud, Nietzsche, Stirner and Marx, developed a political concern with problems of authority and anti-authority, of sexual liberation and generational revolt that seems better suited to the social issues of the 1960s and 1970s than of their own day.

During World War I such concerns led a small group of Berlin intellectuals into a mixture of anti-art aesthetics and revolutionary anarchism which ultimately jelled into Berlin Dada, and which channeled their apolitical hatred for German society into apocalyptic visions at the end of the war. This can be seen with particular clarity in the social ideas expressed in 1919 by an intellectual triumvirate who contributed a total of eleven articles to the bi-weekly *Die Erde*. Franz Jung, during the war a journalist for business periodicals, had been before the war a member of the *Tat* group in Munich—the local branch of Gustav Landauer's *Sozialistischer Bund*. Raoul Hausmann was with Jung one of the founders of the Berlin Dada Group. Otto Gross was a wayward disciple of Freud, whose interactions with the anarchist movement began about 1910.

If Jung was the unifying central figure, whose personal evolution from the prewar anarchist movement through wartime Expressionism and Dadaism to the independent commu-

OTTO GROSS AS A BOY, IN HIS FATHER'S WEALTHY AND
RESTRICTIVE ENVIRONMENT. TWO DECADES LATER GROSS WAS A
CONVINCED ANARCHIST AND ADVOCATE OF FREE LOVE.

nist Left (KAPD) of the postwar period embodies and reflects much of the intellectual ferment of the era, Otto Gross, as Jung's guru throughout most of this evolution and a man capable of exerting a remarkable charisma among the Bohemian artists and outcasts in Munich, Berlin, Ascona and Vienna, must be considered the principal source of the ideas inspiring Jung and his friends in the decade before 1920. This essay, then, will discuss first Gross' unhappy pilgrimage across the bohemian landscape of Germany between 1906 and his death in 1919, with particular attention to the central role played by Franz Jung from 1911 on; secondly, the parallel evolution of Gross' underlying assumptions about human nature, and how they laid the basis for a novel form of psychoanalytic radicalism during this period; thirdly, the view expressed by Gross, Jung and Hausmann in 1919, an effort to render the ideas of anarchism, Marxism and psychoanalysis jointly serviceable in a revolutionary crisis, which precedes by half a century similar attempts in the student upheavals of the late 1960s.[3]

In the autobiographical documents of his contemporaries, no one recorded an acquaintance with Otto Gross before 1906. In that year and the following two, half a dozen important figures from the worlds of scholarship and literature noted his presence, frequently as the charismatic center of a circle of literary and artistic free-love advocates in Munich.[4] Thus we know little about his earlier life. We do know that he was born in 1877, the son of Hans Gross, a professor of criminal psychology at the University of Graz, that he became a physician and a psychoanalyst, probably under Freud's tutelage in Vienna, and returned to Graz as a *Privat-Dozent*.

Judging by his explicit willingness to follow his father in applying social-darwinist assumptions to the study of psychopathic inferiority, we can infer that the relationship to the father must have been relatively cordial while Otto Gross was still in Graz and perhaps for the first few years in Munich.[5] There must nonetheless have also been a good deal of antagonism arising from Gross' early teaching career at his father's university, and such an assumption would go far to explain why Gross, who came to Munich ostensibly as an assistant in the psychiatric clinic at the university, quickly dropped out of respectable society into the company of bohemian outcasts who were virtually all at odds with their social origins,[6] and why the denunciation of despotic patriarchalism is prominent in the few articles he wrote for a broader public.[7]

When Leonhard Frank, an aspiring painter whose real talent was to lie in literature, arrived in Munich in 1906, he found Gross firmly established in the Cafe Stephanie. His friends and followers included Johannes Nohl, a friend of Erich Mühsam who was later to play an active role in organizing and financing Mühsam's anarchist circle in Schwabing, the painter Carlo Holzer, a woman who Frank called Spela,[8] a girl named Sophie Benz, a Swiss

anarchist named Karl, a very tall Russian, an impoverished student dropout named Fritz and Gross' wife.

Frank was then about twenty years old, fresh from a miserable effort to earn a living as an itinerant painter and with an earlier experience as an apprentice locksmith.[9] Bewildered by esoteric discussions of Nietzsche and Freud in Gross' circle, he allowed himself to be matched with Sophie, like himself an aspiring artist, and promptly fell in love with her. After two years, Gross seems to have decided that their practically monogamous relationship was unhealthy for Sophie; he told her so, and offered her free therapy in the Cafe Stephanie, an abundance of cocaine, and Fritz, whom he now considered a more suitable mate. Either Sophie had been miserable with Frank (and he suggests only the contrary) or Gross must indeed have had charismatic power of persuasion, for she accepted all three offers. Frank's discovery of the psychiatrist's new prescription for Sophie's happiness almost brought Gross to an early end, for the future novelist, a revolver in his pocket, soon went to Gross' quarters with murderous intent, only to find that his quarry had left town, together with Sophie and Fritz. Two years later in Ascona, Sophie, weakened physically and emotionally by constant prescriptions of narcotics, died of an overdoes of morphine, in Frank's bitter works, "the first sacrifice to the applied insights of Sigmund Freud, who has changed the face of the earth."[10] The day after hearing the news in the Cafe

Stephanie from Mühsam's friend Nohl, Frank left Munich for Berlin.

Gross' cocaine habit produced unpleasant physical and psychological effects, of which he himself must have been aware, since he repeatedly institutionalized himself in vain efforts to end his habit.[11] According to Frank, Gross could write only under the influence of cocaine, and Ernest Jones mentions an around-the-clock treatment of Gross by Carl Jung in 1908, at the end of which they were both reduced to "nodding automatons." (Shortly after, Gross fled the sanatorium and wrote Jung to ask him for hotel money.)[12]

In 1909, Erich Mühsam organized a local branch of Landauer's *Sozialistischer Bund* in the cafés of Schwabing, which called itself *Tat-Gruppe*. Landauer, the only intellectual of stature in the German anarchist movement, had separated himself from the more revolutionary *Anarchistische Föderation Deutschland* because of his stand for communitarian rural experiments and had begun in that year to organize a loosely coordinated network of anarchist groups around his journal, *Der Sozialist*. Mühsam, a bohemian intellectual himself, had a confidence in the revolutionary potentiality of young dropouts and lumpenproletarians not altogether shared by Landauer, but the latter, from his base in Berlin, nonetheless helped Mühsam hold his group together until 1912.

There seems to have been an underlying compatibility between the theory of the *Tat-Gruppe* and the

praxis of the circle around Gross, for about half of the nineteen persons whose connection with the *Tat-Gruppe* has been established were also friends, supporters or adherents of Gross' circle as well. (Curiously, the anarchist theorist whose ideas were most congenial to the organization of young bohemians and social outcasts, Bakunin, is barely mentioned in the literature concerning the *Tat-Gruppe* or the Gross circle.)

The key figure mediating between Gross and bohemian anarchism was Franz Jung, who provided a semi-organized following for the psychoanalyst's ideas—and at times, a defense of his person—among the political Expressionists of Munich and Berlin. Why Gross, who seemed remarkably successful at running his own show before 1910, judging by the accounts of Leonhard Frank, Ernest Jones and Marianne Weber, should have needed Jung's assistance in maintaining a personal following after 1910, is probably comprehensible in terms of the disruptive impact of narcotics on his personality, and of his increasing exclusion from psychoanalytic circles because of his doctrinal eccentricity, which according to Franz Jung undermined the cohesion of Gross' personal following.

In Munich and, from 1913 on, Berlin, Jung seems to have formed around himself a small sub-group of writers and artists, who were politically inclined to anarchism, aesthetically to Expressionism (and, from 1917, Dadaism), and intellectually inclined to psychoanalytic theories of Gross.

When Jung arrived in Munich, Gross had already moved his following to Acona, which around the turn of the century had become a refuge for free spirits of all sorts; anarchists, vegetarians, free-love advocates, mystics, and poets. There, according to Jung, he had intended "to found a free college from which he thought to attack Western civilization, the obsessions of inner as well as outer authority, the social bonds which these imposed, the distortions of a parasitic form of society, in which everyone was forced to live from everyone else to survive."

Gross' Ascona experiment was haunted from the beginning by the suicide of the girl Frank loved; moreover, psychoanalysts' followers became involved in the saccharin smuggling operation between Zurich and Munich organized by anarchist artists and students. Franz Jung, who met Gross and his followers on one of their numerous return visits to Munich in 1911 and 1912, developed a considerable friendship. Meanwhile, Jung was living largely by selling his friend's books, particularly those of his rather intimidated younger friend, Oskar Maria Graf.

Jung's activities in Munich were not entirely confined to sponging off his friends. Though he laments the fact that the Schwabing he knew was past its prime, the anarchist movement was not, and he records one febrile attempt to convert theory into praxis when the tiny syndicalist group tried to call a general strike in the building trades. Mühsam's effort to address a union meeting for this purpose ended in the near-lynching of

himself and his frail following by muscular social-democratic construction-workers, a denouement which may have had something to do with the demise of the *Tat-Gruppe* in 1912 and Jung's departure shortly thereafter for Berlin, where he resumed his work as a trade journalist.

While Jung had a promising literary career before him, Gross' fortunes were all downhill from 1910 on. In 1911, Landauer launched a bitter attack on his psychoanalysis journal, *Der Sozialist*, the thinly disguised object of which was Gross and the *Tat-Gruppe*'s susceptibility to his ideas. Gross wrote a reply to Landauer's attacks during yet another of his periodic cures in a sanatorium, but Landauer, who had personal reasons for disliking Gross, refused it publication, with the somewhat reluctant agreement of his editorial adviser Martin Buber.

In April 1913, Gross published his reply to Landauer in Franz Pfemfert's *Die Aktion*. Probably eased into print through the mediation of Franz Jung, *"Zur Uberwindung der kulturellen Krise."* ("On Overcoming the Cultural Crisis") was Gross' first publication in an expressionist journal, indeed his first programmatic article of any sort.

It stated in very general terms the importance of revolutionary change of the new psychology of the unconscious—which he attributed to Nietzsche as well as Freud—particularly insofar as this psychology undermined the authoritarian patriachalism of the existing society, and it ended by declaring that the coming revolution would be a revolution for matriarchy (*Mutterrecht*). At about the same time Gross moved to Berlin, where he roomed a good part of the time with Jung, and planned with him

**ONE OF OTTO GROSS'S DISCIPLES, ERNST FRICK.**

the publication of a monthly. A notice published jointly by the two men in *Die Aktion* said that the new journal would start in July 1913, would deal with problems of cultural and economic life on the basis of an individualist psychology, and would propagandize for a new ethic as the preliminary (*Vorarbeit*) for a social revaluation.

The journal only appeared two years later, by which time Europe was plunged into the savagery of World War I; and Jung himself was the principal editor. Meanwhile, during the months that followed this initial notice, Gross labored at his "new ethic" under the watchful eye of Jung, Jung's wife and mother-in-law, and other new friends from the *Aktion* circle. He also wrote replies to attacks on psychoanalysis directed at him in *Die Aktion* by one of the leading Berlin expressionists, Ludwig Rubiner.

On Nov. 9, 1913 this new life collapsed, when Prussian police officials arrested Gross, at the behest of his father, in Franz Jung's apartment, and deported him to Austria; there he was committed to an asylum on the basis of an affidavit describing him as a dangerous psychopath, which was signed by Carl Jung.

According to Franz Jung, the institutionalization of Otto Gross resulted from a conscious decision by his father—a well-known professor of criminology—to force him back to a respectable academic position or to destroy him. Gross himself was convinced that his father meant to prevent him from publishing an article in a psychoanalytic journal which analyzed the examining magistrate in terms of sadism—about which his father had written an internationally known textbook—and referred to someone remarkably like his father as a prime example of the quality. (That Gross should have been convinced that someone close to him had sent a copy of this article to his father reflects a paranoia which Johannes R. Becher had also noted in Gross, particularly during his cocaine intoxication.) Erich Mühsam mentions a letter sent by one of Gross' patients to his father which contained information Gross had communicated to the patient about his own trouble in the course of treatment, apparently a blackmail attempt. Other reasons for his deportation advance by the authorities when pressed by Gross' friends were his excessive use of cocaine and his lack of proper documents (remember, Gross was an Austrian citizen.)

Jung organized a highly effective journalistic campaign for Gross' liberation among his friends. Pfemfert repeatedly editorialized on the issue in *Die Aktion*; even Ludwig Rubiner, who had publicly polemicized against Gross, came vehemently to his defense. Franz Jung was able to take over the fifth number of a new (and short-lived) Munich journal, *Die Revolution*, in which he published an editorial of his own, protests from Ludwig Rubiner and Blaise Cendrars in Paris and Erich Mühsam in Munich, and literary contributions dedicated to Gross by Johannes R. Becher, Ernest Blass, Jakob van

Hoddis, Alfred Lichtenstein, Rene Schickele, Else Lasker-Schüler and Richard Hülsenbeck. To attack Hans Gross on his own ground, Jung sent a thousand copies of his number of *Die Revolution* to cafés in Vienna and Graz, university addresses, libraries and bookstores. Mühsam took up the cudgels for Gross in *Kain* after some prodding from Pfemfert (and possibly counter-prodding from Landauer). Richard Ohring, one of Jung's new friends in Berlin, used the *Wiecker Bote* as a platform to demand Gross' release.

There were two main approaches used by the Expressionists in the Gross case. Those trying to influence liberal and socialist opinion stressed the dubious legality and the dangerous precedent established by his arrest and deportation. But those from the bohemian underworld who empathized with Gross as a victimized son directed their indignation to their peers. The Gross case became a catalyst for the generational revolt exemplified in these years by the youth movement and Expressionism, insofar as it illuminated sharply the mutual support and mutual dependence of paternal and political authoritarianism. This significance of the Gross case to the younger generation emerged clearly in a defiant protest by his intellectual opponent Rubiner: "The throttling of Dr. Gross by his father is typical. We will destroy this type....In the Case of Dr. Gross, a significant son, we take up the cause of the many insignificant sons, who unnoticed, are destroyed in broad daylight. We intellectuals, we sub-prole-

tarians are strong—the professor in Graz is only anxious....The madhousekeepers, administrators of property and state officials stick together. We, who have nothing to lose, stick together too. We are getting past them, annihilating their positions, burying their honor, destroying their wealth. Our pamphlets are more powerful than their connections." Unquestionably the theme of the sons against fathers was a potent one among the Expression-ists and it is likely that the institutionalization of Otto Gross lurks in the background of a number of the dramas and novels built around the theme of sadistic schoolmaster, father-son conflict and parricide between 1914 and 1920. Nonetheless, the conclusion of the campaign organized by Franz Jung was no jacquerie of vengeful sons but rather a tactical retreat on the father's part. Hans Gross, after an attack on him in a Vienna newspaper, broke a long silence to say that it had all been a mistake; Otto was in the asylum voluntarily and could leave when he liked. When Jung traveled to the asylum in the spring of 1914 to pick up Otto Gross, he found that his friend had been elevated from the status of incurably insane to that of attending intern.

Very little can be determined about Gross' activities during the years that soon followed his institutionalization. We know only that he joined the Austrian army as a doctor, was released for reasons unknown in the middle of the war, lived the concluding years of the war in Vienna, where he developed a new circle with

Franz Werfel as his leading acolyte, and returned to Berlin in December 1918, where he died a few months later of the combined effects of starvation and disease.

Nonetheless, Gross' impact continued to be felt most strongly not in Vienna, but in Berlin, where, though he must have been rarely if at all present in the war years, his ideas, mediated by the energetic Franz Jung, dominated the six numbers of *Die Freie Strasse* edited by Jung between 1915 and 1917, inspired the original Berlin Dada group of 1917-1919 and were heavily represented in 1919 in the journal *Die Erde*. I shall discuss the *Erde* articles in a separate section; here I should like only to mention briefly the significance of *Die Freie Strasse* as a vehicle for continuing, under wartime conditions, at least a part of the anarchist tradition among the Berlin Expressionists.

With contributions by three former members of the *Tat-Gruppe*, the Jung, Graf and Schrimpf, by Richard Ohring, the new Berlin disciple of Jung and Gross, by Gross himself and by Max Hermann-Neisse, an old friend of Jung who was one of the stalwarts of the Berlin expressionist scene, *Die Freie Strasse* often took recourse, presumably to avoid the military censors, to very cloudy discussions of moral and psychological questions, particularly the liberation of women and an ethical system based on psychoanalysis. Indeed the nebulousness of much of the discussion—when compared with pre and postwar political Expressionism—suggests that, in general, *Die Freie*

*Strasse* seems to have functioned primarily as a social refuge for wartime literary radicals while the holocaust raged outside, rather than as a serious effort at literary or political expression. Many of their comrades were being decimated in the trenches and it was only by simulating madness after induction that Jung and Graf managed to evade their fate. Nonetheless, Ulrich Linse, a recent historian of German anarchism, has declared Richard Ohring's essay on "Compulsion and Experience" in *Die Freie Strasse* to be a classical example of the bond between anarchism and Expressionism, and since Ohring also provides an important clue to the intellectual evolution of Jung and Gross, its contents merit recapitulation.

Ohring describes "experience" and "compulsion" as psychological antitheses. "Experience" represents the anarchist creative force of personality, the potentiality for which is innate. "Compulsion" is every external or internal barrier to the free development of experience. External compulsions exist in the laws of nature and in the laws, morals and customs of society. After infancy, the external compulsions become internalized through the attributes of obedience and obligation. Thus, "from the first month of our life (*Erwachen*), everything is aimed at establishing compulsion against our experience, against our tendency to self-expression, and at forcing us to fit into the existing scheme." Against this process of integration Ohring asserts that "every new doctrine,

every alteration of the world is the breakthrough of a compulsion by free experience." To pose the question of freedom then, leads to a counter-process of "breaking away, to a new enforcing of one's own experience against compulsion."

So far this is little more than a restatement of Stirner's individualist anarchism, which in fact had been quite popular among the literary and intellectual anarchists before the war and was the anarchist doctrine closest to the prewar ideas of Otto Gross. Ohring, however, also had a commitment to the idea of community and, in a verbose incantation, tried to link the idea of a new community not to compulsion or social restraint, with which it was usually associated, but to individual experience: "When the yearning of belief calls forth the source of hidden communality from the dead landscape of compulsion, then the belief will become unshakable that all community is only that of experience." This shift in ground from Stirnerian individualism to a communitarian ideology, or rather the attempt to make the two compatible, also characterizes a fundamental turning point in Gross' ideas during the war, and is intimately related to the brief revival of Bachofens's matriarchal theory in the circles of Gross' followers after the war.

Gross' psychoanalytic writings were conditioned by his training as a neurologist and psychiatrist. For the most part they are only marginally related to his influence on the anarchist Expressionists and free spirits who became his personal followers.

In his last, posthumously published, contributions to psychoanalytical theory, however, there is clearly an effort to transform psychoanalysis from an essentially conservative to a potentially revolutionary body of ideas through a fundamental revision of Freudian instinct theory.

Gross' line of attack was twofold. In the first place, he denied that aggressive behavior and the closely related phenomena of sadism and masochism were instinctual in the species and that therefore the suppression of instinct by reason and conscience was uniformly a precondition for civilization. Secondly, he denied the common tenet of Freud and his followers that innate differences in the nature of men and women accounted for the dominance of the aggressive-sadistic character in man and the passive-masochistic character in women. The apparent character differences of men and women, the widespread aggressiveness about which Freud passed such melancholy comment during and after World War I, as well as virtually all neurotic, anti-social behavior, Gross attributed not to instinct but to the deformation of instinct by the existing organization of society, which he viewed as modelled on the patriarchal family and as ultimately an instrument of male domination. But in undertaking this revision of Freudian precepts, Gross was also compelled to modify some of his own earlier ideas, which he had expressed in essays of 1907 and 1909. For in these earlier essays, the differences with Freud were not nearly so marked.

In these earlier studies, Gross had indeed already advanced the notion that the eternal conflict between the individual and society was more founded in the oppressiveness of society than in the iniquity of raw instinct. But he had nonetheless partly accepted both the Freudian characterology of male aggressiveness and female passivity, and the notion that the aggressive character of the male was basically anti-social. His latent differences with Freud in 1909 centered around two points. In the first place, basing himself on a blend of Nietzsche, Darwinism and vitalism, he saw only the degeneration of the species resulting from the increasing social sanctions against the expression of violent, anti-social impulses. This point of view must have made Gross particularly well appreciated among the individualist anarchists who followed Nietzsche and Max Stirner. Secondly, he attributed to female sexuality a positive and active quality that Freud had rejected.

The late work sees a revision of instinct theory which postulates the compatibility of instinct with social organization, and rejects so completely the notion that masculine-feminine character differences are innate as to suggest an androgynous solution to the war between the sexes. This late evolution in Gross' work occurs in the framework of the gathering revolutionary storm in German society towards the end of World War I and has as its function the adaptation of Gross' ideas to the need of his followers for a libertarian communal ideology that might give some better

justification for participating in and attempting to direct the emerging mass struggles than the Stirnerian individualism of the prewar years.

The first detailed formulation of Gross' ideas appeared in *Über psychopathische Minderwertigkeiten* (1909), where he tried to explain the phenomenon of psychopathic inferiority through the fusion of the then fashionable school of social Darwinism with the ideas of Nietzsche and Freud. The inevitable conflict between society and the inborn predispositions of the individual, he argued, results in pathogenic injury to the individual.

Since individuals internalize the standards of society, conflict does not, in general, occur openly between the individual and society, but rather within the individual psyche. (I shall follow Freud's later usage of the term superego to describe this internalized voice of society.) For women, but not for men, Gross sees the characteristic conflict between innate impulse and internalized convention and the corresponding repression of instinct by superego, as centering on the sphere of sexuality: "The suggestions which make up the ethical milieu of women from childhood on—this dominating set of values is incompatible with the strongest and most pressing drives and impulses." On the one hand, to the extent that repression of sexuality is effective, and he finds repression generally mandated by the monogamous family structure of his day, it has two effects. The forbidden sexual energies tend to find their way back into the conscious personality in the

form of generally anti-social perversions, neuroses and inclinations to petty forms of forbidden or anti-social behavior, such as kleptomania, cruelty and the tendency to make oneself ugly. Furthermore, Gross notes that the dominant characteristic of the psychological development of women, particularly of the upper class, "is the incapacity to create a comprehension and connected unity of the inner process, an uninterrupted continuity of psychological life"—again, because of the continual frustration and repression of the sexual impulses central to such continuity.

On the other hand—and here Gross' use of social Darwinism is evident—if repression is ineffective, the woman prepared to behave according to the mandate of her nature, rather than that of society, finds herself boycotted by men, and is unlikely to find a husband and have children. Thus, women equipped with the most powerful nature impulses are likely, by the principle of selection, to be ostracized by society and not permitted to reproduce, while those women who, from the standpoint of natural instincts, are most impoverished will be favored, cultivated and protected by society and thus become the dominant type. "Natural selection is repressed and replaced by *another new process* of breeding, whose tendencies and effects are precisely opposed to the natural selection of the strongest and most fit and result in a situation where a by nature abnormal and inferior (feminine) type has in the course of time become the norm."

The characteristically masculine instinct is that of struggle or aggression, and it is inhibited by the moral disapproval of society in the same way that sexuality is in women. There is, however, a difference in the magnitude and degree of internalization of this inhibition. Aggressive desires are not so subject to the censorship of superego as are sexual ones, with the result that the internal psychic struggle between aggressiveness and restraints imposed by the social order may occur and be resolved more or less consciously. To the extent that this possibility of conscious conflict is curtailed by the intensity of internalized social inhibitions against aggression, the pathological character of the conflict increases. In general, the social code imposes ever stricter sanctions against the innate aggressiveness of man. Gross quotes Nietzsche's scornful definition of "progress" as the road to a condition where "nothing need any longer be feared," and comments that if Nietzsche is correct, then "the suppression of aggressive tendencies must become...an ever more abundant source of neurotic cleavages within the personality," a point which he immediately buttresses by reference to the most recent work of Freud.

Shortly after this passage, Gross somewhat modifies his rather categorical statements about the different instinctual characteristics of male and female. He stresses that in the masculine case, the conflict is to be understood primarily in terms of strength of the aggressive impulse; in the

Auflage 5000     Zweiwochenſchrift     Preis 10 Pfg

Nummer 5     20. Dezember     Jahrgang 1913

## Sondernummer für Otto Groß

Herausgegeben von Franz Jung im Verlag von Heinrich F. S. Bachmair in München NW. 13

**freigegeben!** Die vor 2 Monaten auf eine Denunziation hin beschlagnahmte Nummer 1 der „Revolution" wurde ſoeben im objektiven Verfahren freigegeben, nachdem bereits vorher auf Antrag des Staatsanwaltes das Strafverfahren gegen Verfaſſer, Herausgeber und Verleger eingeſtellt worden war.

**Der Preis dieſer Nummer 1 wurde auf 50 Pfg. erhöht.**

### Inhalt

#### Herr Kriminalprofeſſor Hans Groß in Graz!

Die Autoren dieſes Heftes widmen ihre Beiträge Otto Groß und erheben gleichzeitig damit gegen deſſen Internierung Proteſt. Dieſes Heft, ſowie das Otto Groß-Heft der „Aktion", ſind Manifeſte der **Eroberung**. Dieſes Unternehmen, ins Leben gerufen von Simon Guttmann und Franz Jung, wird zunächſt auch in weiteren Publikationen die Befreiung von Otto Groß zur Aufgabe haben.

female, in terms of the inhibiting power of an anti-sexual morality. (It is well to bear in mind that Gross' perceptions were undoubtedly in large measure a reaction to the moral code of central European society before World War I.) He also goes on to present more conventionally the notions of Freud concerning the repression of childhood sexuality. But it is in the passages presented above that we find the most original part of Gross' doctrine and the revolutionary core of his ideas, which cannot but have given a clearer sense of identity to many of the anti-social anarchists and bohemians to whom he administered daily doses of doctrine and therapy in the years before World War I.

When Gross wrote *Über psychopathische Minderwertigkeiten*, he as yet acknowledged no overt disagreement with Freud. In his last publication, *Drei Aufsätze uber den inneren Konflikt*, probably written between 1917 and his death in 1919, he separated himself from Freud in his interpretation of instinct theory and moved closer to the psychoanalytic school of Alfred Adler.

In the *Drei Aufsätze*, Gross redefines his thesis that inner psychological conflict is the struggle of one's nature against the internalized values of society (*"der Kampf des Eigenen und Fremden in uns"*). Most importantly, he redefines his notion of sexuality so as to make the innate sexual impulse an impulse toward contact with the other and in a larger sense, toward social community, and he removes from the primal Ego-drive for self-preservation any suggestion of an aggressive will to power or mastery over others. Thus he ascribes to Alfred Adler the psychoanalytic version of the will to power as "the driving principle of the individual to assert his Ego at all costs" and "to protest from the unconscious against external suppression." In Adler's terms, sexual neuroses are only the symbolic expression of "that revolutionary but also aggressive and violating" protest.

Gross now denies that this will to power, with its aggressive-violating tendency, is an innate characteristic. He considers it a secondary, basically pathological phenomenon; "it is a hypertrophied form, distorted by age-old suppression, of that original drive which I have designated as 'drive for the preservation of one's own individuality in its own established character'."

The source of this suppression, however, must for Gross be an inner conflict with another drive, and this is where the sex-drive enters his account. For it is in a deformation of the sex-drive—which Gross sees as originally based on a need for physical and psychological contact with others and in this original form as completely compatible with the healthy drive for self-preservation—that Gross sees the source of the deformation of the drive for self-preservation in the will to power. The initial deformation of the sexual contract-drive is masochism, and Gross sees it arising naturally from the total dependence of the child on his parents and the resulting tendency for

the infant to surrender his own inclinations for the retention of the parents' approval and contact. "Because infantile sexuality internalized the impulse to surrender one's own Ego to others, to subjugate it for the purpose of avoiding isolation, it has become characterized by the masochistic impulse." And masochism after infancy signifies "the striving for restoration of the infantile situation with regard to adults." It is in necessary conflict with this passive masochistic sexuality that the originally defensive Ego-drive becomes the sadistic, aggressive-violating will to power.

Thus under the pressure of external circumstances two internally antagonistic hybrids—masochism and sadism—arise out of the originally harmonious instinctual duality, self-preservation and sexuality. Masochism emerges from the infant's need to dissociate its desire for contact from its own character and individuality in order to avoid isolation. Self-preservation of the infant as well as sexual contact can only be obtained at the price of conformity to the demands of society, which frequently dictates masochistic surrender of individuality. This surrender, however, is opposed by the drive for self-preservation, which, in the course of resisting masochistic surrender, comes to identify the maturity of the dominating, seemingly secure adult with the opposite of masochism, the society's ability to force sexual response and impose its will on the helpless infant. In this way the drive for self-preservation is distorted into the sadistic, dominating will to power.

Then there follows an analysis, irrelevant to our purposes, of the fourfold relationship of heterosexuality and homosexuality to masochism and sadism. We note that until this point in Gross' argument, which so far covers the basic instinctual disposition as well as the process by which it has made no mention of the masculine-feminine dichotomy with which he had earlier identified the distinction between a basically aggressive and a basically sexual character. Again paying homage to Adler, he now reexamines the relationship of gender and character, no longer in terms of instinctual inclination but strictly in terms of socially caused character differences, and it is striking how similar the results of this reexamination are to the views of contemporary feminists: "The concepts 'man' and 'woman,' as a reflection of the existing institutions in society and family, tend to assume the significance for the Unconscious of 'superior' and 'inferior.' As a psychological result of existing conditions, the mutual relations of the sexes come to symbolize domination or subjection....Both sexes identify the leitmotiv 'masculine inclination' with 'Ego-drive,' will to power and violation, sadism; they identify 'feminine inclination' with the need for surrender and contact, the tendency to subjection and masochism (in distinction to its original symbol, child-inclination). Thus in the man, the sadistic component has a heterosexual orientation, the masochistic, a homosexual one. In the woman, the masochistic

component is heterosexual; the sadistic, or more accuratley, the active component which aims at preservation of the personality, is homosexual." In short, Gross developed a theory of sado-masochism, of aggressive male and submissive female character types, which found their roots not in human instinct but rather in the deformation of instinct by the social organization of the family.

There are three distinct solutions which Gross suggests as a means of repairing the damage, of restoring the relationships between sex and self-preservation as well as that between male and female to their original healthy and harmonious potentialities. In the work under discussion, he suggests that it might be accomplished by a therapeutic encouragement of unconsciously motivated efforts to overcompensate for the socially based masochism and sadism. For example, an emotional attachment between a masochistic man and a lesbian—to the extent that it produced some degree of identification of each partner with the other—would "signify a striving not only for equalization but also for the *reversal* of the existing relationships of domination and subjection." Whether this approach preceded or followed from Gross' intimate acquaintance with bohemian subcultures, there can be little doubt that it was the basis for his involved, manipulative and putatively therapeutic relationship to his followers.

The second solution appears in a brief essay "On Loneliness," which deals with the child's need for contact and the way in which its manipulation to force his submission to the authoritarian family cripples his personality. To this problem, which precedes and underlies the difficulties analyzed in his longer article on sadism and masochism, he suggests a solution of radical permissiveness: "Love must be given absolutely unconditionally to the child, freed from any possible connection with demands of any sort, as a pure affirmation of individuality for its own sake and of every nascent originality." Gross has no hope that his recommendation will be followed in the near future because, he acknowledges, "it is incompatible with the principle of authority, in the family as well as elsewhere."

This pessimism withered rapidly in the intoxicating revolutionary climate that accompanied the collapse of the central powers in 1918 and it is not surprising that the rather self-contained psychoanalytic observations of the *Drei Aufsätze* exploded, in the last months of Gross' life, into an eschatological manifesto for a sexual revolution. Thus Gross' third prophylaxis for the problem of socially conditioned neuroses is best comprehended in the context of essays by his disciples Jung and Hausmann, which likewise mingle psychoanalytic insight with social chiliasm.

Gross' posthumously published "*Protest und Moral im Unbewusstsein*," intended for an unspecialized, political audience, supplements this *Drei Aufsätze* in a number of ways. In the first place his break with Freud here goes to the

point of arguing that Freud and the classical psychoanalysts were unable to penetrate beyond socially deformed character types to their healthy instinctual substratum because the revolutionary implications of this basic nature, its implicit threat to the existing structure of authority, was equally a threat to the analysts' own status and authority.

In the second place he now makes clear the political implications of his earlier redefinition of the sex-drive as a drive for physical and psychological contact with others when he implicitly identifies this redefined sex-drive with Kropotkin's instinct of mutual help.

Furthermore we find a conception of history underpinning the notion that a revolution based on such a celebration of instinct is now—1919—possible. It is a three-stage eschatology in which a free, primitive golden age without patriarchy is thought to precede an agricultural epoch which enabled the subjection of wife and children to the father. This tyranny of the *paterfamilias*, however, loses its economic basis in an urban civilization and the result is the gradual disintegration of the moral order which prevailed in rural cultures.

Gross must have identified the Wilhemian and Austro-Hungarian empires with this rural, patriarchal authoritarianism, because he seems to have equated the collapse of these empires with the transition to a new urban culture, with a new morality and new institutions, based on the liberation of the instincts repressed by paternal despotism. Among these new institutions he mentions the acceptance by society—rather than the family—of the economic costs of motherhood, and an educational system based on the principles of the rediscovery and preservation of "the innate, eternal values."

Jung's and Hausmann's versions of Gross' ideas are diluted by their simultaneous concerns with the ideological issues of the moment: in Jung's case, the arguments within the new Communist Party over the meaning of the class struggle raging in the streets of Berlin; in Hausmann's, a heated polemic with a position close to his own, the individual anarchism advanced in those tumultuous days by followers of Max Stirner. What is common to both men is the conviction that the communist revolution then apparently in progress would remain dangerously incomplete if it did not expand from the economic sphere to the sexual. In Hausmann, the Freudian and the Marxian revolutions had to go together. "The world economic revolution alone is insufficient. The total condition of man in the psycho-physical (material) sense must be fundamentally changed ... The doctrine of Freud (and Adler) is ultimately as important a means for the understanding of petty-bourgeois individualist society as the economic doctrine of Marx-Engels." And: "This revolution would be short, were it only a question of an economic transformation. It is long, it will be the greatest revolution ever seen on political and familial—as characterized by a hierarchical, pyramidal

structure of authority which was basically an instrument of male domination. "...The capitalist oppresses the workers; the general, the soldiers; the man, the woman, regardless of all rights and capacities of the oppressed. All are sick and crazy, because the suppressed and falsified spheres of life continually drive them to transgress their own laws.... And here the man alone is guilty....The weakness of a tragic culture rests on a tendency to self-destruction...which is alien to woman. Organizational man will perish from this tragic cultural attitude if he is unable to liberate, in the course of the world revolution, the counter-powers...." The counter-powers would appear to be the capacity for direct democracy represented by the council system ("the first state idea not based on stratification"), and Hausmann, who pleads for sexual as well as economical justice, believes women are better able to implement it than men. In fact the "transformation of bourgeois society" was inseparable from "the formulation of a feminine society which leads to a new promiscuity and also to matriarchy (against the patriarchal family of masculine imprint)." The family itself would shed its authoritarian character and would dissolve into voluntary groups, relationships and families; and feminine sexuality would cease to be defined by the masculine personality which had long subjugated it and would develop its own forms of friendship and comraderie.

Franz Jung was more politically involved than Hausmann in the early German communist movement. He organized a band of armed Spartacists in postwar Berlin, and when the revolt was quelled and the communists set about building a legal mass party on Leninist lines, he split from them—ever the heretic—for the left-oppositional Communist Worker's Party (KAPD).

Thus Jung's four essays of 1919 on means and ends in the class struggle ("*Zweck und Mittel im Klassenkampf*") have to be comprehended within the framework of an ongoing civil war which, for most of those on Jung's side had one meaning only: the life and death struggle of the revolutionary working class for the overthrow of capitalism. It is no wonder then that Jung is less focused than Hausmann or Gross on the sexual revolution, and that when he does discuss it, he does not argue, like Hausmann, that it must be simultaneous with the economic one. He nonetheless does insist that a number of anti-authoritarian "class struggles," not yet generally recognized as such, would remain to be fought out even after the victory of the proletariat, and he devotes most of his second essay to just this subject.

Most important among these is the struggle of woman for liberation from man. "The history of this class struggle" writes Jung, "dates from the collapse of matriarchy, i.e., from the usurpation, from the property seizure of the family by the husband, which came to expression in the proclamation of patriarchy and the suppression of matriarchy." The result, Jung claims, has been a general loss in the

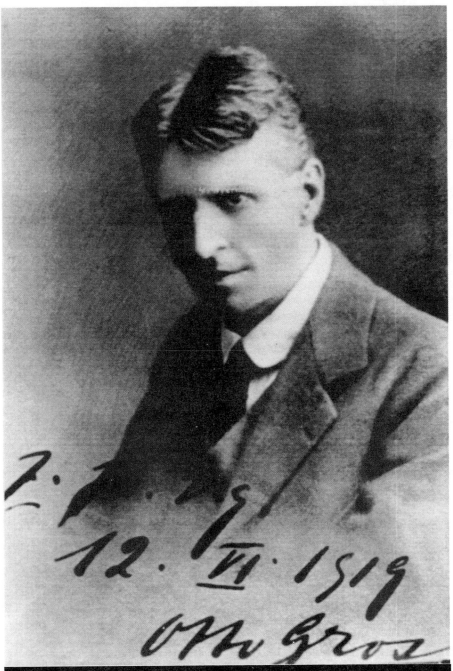

PORTRAIT OF OTTO GROSS, 1919. PHOTOGRAPHER UNKNOWN.

intensity of experience and the sum of happiness, and he is convinced that women are subconsciously aware of this loss.

A similar form of struggle is the generational, that of youth against age. Youth perceives injustice and "violation" (the word is one of Gross' favorites) in the educational system and the claimed superiority of the adult against the young.

Jung's last example of a not yet articulated "class struggle" is one which haunts the entire 50 years history of the movement whose birth pangs he attended behind the barricades of Berlin: "The struggle of those who are concerned with a knowledge of the conditions of their lives against those who are content to use a knowledge of authoritarian doctrines in order to defend their acquired positions from their opponents, the doubters, the anti-authoritarians. Naturally this can only occur through violent suppression, and the struggle of religion, of Church, of 'true believers' against the intellect, the free idea, displays uncounted examples of bloody suppression."

Nonetheless, Jung is certain that once the conflict of proletarian and capitalist has been overcome, and communism has guaranteed everyone's material existence, these new struggles for the fights of women, children and anti-authoritarians in general, with new forms of mass solidarity, will bring men closer to "the final struggle for the human community."

The phenomenon of Gross and his matriarchal ideology raises a number of questions about the social and intellectual history of twentieth century Germany.

In the area of intellectual influences, one would want to know first the magnitude of the debts, if any, owed by Gross to the Klages-Schüler matriarchal ideology, to Bachofen, to Morgan and to Bebel. One would like more clarity on the precise circumstances attending his fall from grace in the Freudian camp, on his intellectual and/or personal relations to Carl Jung and Alfred Adler, and particularly important, on his possible influence on Wilhelm Reich, whose theories come remarkably close to those of Gross at certain points. One would also like to know more about how his psychoanalysis affected the literature of his day. The impact is clearest in two of Werfel's stories from the immediate postwar period: *Die schwarze Messe* and *Nicht der Mörder, der Ermordete ist schuldig*. How much of the psychological insight of Leonhard Frank's early novels derives from his love-hate relationship to Gross? What, apart from Franz Jung's short story of 1920, *Der Fall Gross*, was the impact on the literary output of Gross' principal disciple? And what about Berlin Dada, which directly descends from *Die Freie Strasse*? Did Gross' influence go beyond the theoretical and political articles of Hausmann and Jung to affect the visual aesthetics of that movement?

The social and psycho-social questions are also legion. First of all, we need to know much more about Gross' own background. The avail-

able information to date is trivial and unreliable compared with what is know about Rathenau, Sombart, Scheler, Weber, or Simmel. What experience and what knowledge gave this man his charismatic power over so many of the talented youth of his day? What, if anything, did his adherents have in common? Kreuzer compares Gross' impact to that of Stefan George, but almost no one had heard of Gross, much less studies him, while the literature on the *George-Kreis* fill yards of shelf space.

The larger questions concern the general significance of Expressionism as a social movement. The vitalist irrationalism of Expressionism has not infrequently been associated with Nazi barbarism, despite the Nazi's denunciation of most Expressionists —certainly of the vast majority who refused to make the transition to *Blunt und Boden* nationalism—as degenerate cultural bolsheviks. Indeed there is little but the accident of birth of some of their leading figures that can relate the anarchist Expressionists, with their contempt for flag and fatherland, to the *völkisch* nationalism endemic to the *Mittelstand* that followed Hitler in the 1930s. For the *Mittelstand* movements, even when they were most rebellious against the "liberal" culture of the nineteenth and twentieth centuries, maintained a piety for precisely that traditional patriarchal morality which the Expressionists were determined to destroy, along with the bourgeois morality they viewed as subservient to it. Nor can we relate the expressionist movement to proletarian socialism, despite the enthusiasm of many Expressionists for the revolution of 1918/1919. Unlike the Naturalists of the 1890s, and their corrupt descendants, the later Socialist Realists, the Expressionists neither pretended nor attempted an "objective" indictment of social misery, but felt compelled to express the hell they felt in themselves, in their own mutilated lives, much though they believed the existing order of society to be responsible for that hell.

In this capacity for extrapolating introspection, the Expressionists might best be viewed as part of the bourgeois consciousness of the Central European *fin-de-siècle*, provided we bear in mind the basic turning of bourgeois consciousness from its earlier western rationalist belief in progress to a highly sophisticated, introverted form of anti-modernism. The clear line of affinity, then, could well be to the politically impotent bourgeois anti-modernism that one finds among the early celebrators of Dostoevsky, the poets of the *George-Kreis* and the critical sociology of Weber, Simmel, Sombart and Scheler.

A related problem is that of the long-term cultural significance of the matriarchal ideology of Gross and his group. It is simple to refute the matriarchal theory from an anthropological or historical standpoint; what nonetheless is cause for reflection is the significance of the idea as a modern myth.

The traditional matriarchal mythology, as well as the extant

anthropological evidence, only confuse the issue if we try to see Gross' ideas in their terms rather than in the terms of his own situation. All the extant myths associate matriarchy with fertility, earth goddesses, early agricultural society, and Lewis Mumford has argued cogently that the city is the seat of patriarchal systems of domination. The explanation for Gross' location of patriarchy in agricultural civilization and the dissolution of patriarchy in urban civilization must be found in his own condition and that of his bohemian followers.

Johannes R. Becher, though far from any Gibraltar-like reliability in his account of his youthful experience of Gross' Munich circle, does offer one extremely illuminating example of the city-mother connection which somehow has the ring of truth to it. Leonhard Frank, according to Becher, had a dream of moving into a three-room apartment facing the English Garden which Gross analyzed in the following terms: "...the three room flat which you think of as the beginning of a new life is the symbol of your return to you mother, as your associations clearly demonstrate. Munich. That was your mother when as a bricklayer you fled from your father in Pirmasens to Munich. So you're about to celebrate with your mother."

Very pat, very stereotyped, as Becher intends it to be. Yet, is a fact that youth of all classes did find the paternalistic authoritarianism of German society in this epoch a source of humiliation which drove the more spirited among them to personal revolt and sometimes flight from their homes; it is a fact that this oppressive patriarchal culture was epitomized in small town and rural society; it is a fact that wherever the revolt achieved the level of social organization of counter-community, this counter-community inevitably (because of the markedly patriarchal character of the authoritarianism that bedevilled the young) carried the mythical connotation of a form of sexual organization antagonistic *Männerbund* characteristic of the Youth Movement and the *George-Kreis*. Or it could carry the matriarchal *leitmotiv*, as in the Klages-Schüler split from the *George-Kreis,* or the circle around Gross.

Indeed, Klages' view around 1900 of the archetypical significance of Munich makes explicit what Gross saw as the latent meaning of Frank's fantasy. As one of the dominant symbols of Munich he identifies the color blue in the roof of the Frauenkirche: "Blue is—or was supposed to be— the mantel of the mother of God. In antiquity, cities had a feminine meaning. Today there are masculine as well as feminine cities: i.e. Florence, Zürich and Berlin are masculine; Venice, Berne and Paris are feminine. Munich stood in the sign of the virgin mother." The matriarchal symbolism thus suggests meanings highly relevant to the situation of Gross and his followers. It should be clear, however, that such bohemian circles related primarily not to a city as a whole, but rather to the artists and students' quarter, of which Munich's Schwabing was and is the closest

equivalent Germany could offer to the *quartier latin*. In one sense, the relationship was a passive, dependent, oral one: all the accounts of the café life on these circles of aspiring artists and writers reveal the common themes of avoiding work, begging money from strangers, scrounging from friends, and endless talk, as much a means of securing one's berth in a small group as of communicating ideas. It was essentially a form of second childhood which these men were enjoying without the disturbing presence of the father. Munich, or rather Schwabing, was their mother, which nurtured them without making demands.

In another sense, however, this blissful dependency was merely a supportive framework within which artists and intellectuals developed a sense of common purpose that led not only to some of the most exciting departures in modern art and literature, but to new and more egalitarian forms of community. From the revolutionary councils of 1919 to the Paris uprising of May, 1968, with its slogan *l'imagination au pouvoir*, to the Provo and Kabouter movements of contemporary Amsterdam, bohemian communities of outcasts have functioned as a libertarian yeast at moments of social ferment; while extrapolating from their own condition an alternative vision of society they have assumed the historical obsolescence of the struggle for survival and have demanded the replacement of authoritarian and bureaucratic social structures by self-governing communes. If this vision was doomed by the poverty and social chaos at the end of World War I, it has become a less unrealistic goal in recent years. For parallel with increasing dissatisfaction over the bureaucratic character of modern life has risen a great questioning, based on the coming ecological crisis as well as the continued menace of nuclear armageddon, of the whole ethic rational mastery and domination which has underlain the material progress of western man up to his present questionable condition. Nietzsche wrote in *The Will to Power*, "whoever pushes rationality forward also restores new strength to the opposite power, mysticism and folly of all kinds." Historians have noted the accuracy of this observation in particular to the recrudescence of witchcraft that followed the efforts of the Reformation to exorcise magic from Christianity. In fact, much of the chaotic social and cultural history of the twentieth century, reflecting the corrosive impact on local, traditional societies of the new industrial order and the rejuvenated bureaucratic state, also conveys the impression of a chthonic return of the repressed on a mass scale.

It is arguable that this return is inevitable and that where, as in the circles of free intellectuals of the kind this paper has discussed, people have devoted their lives to the great adventure of discovering and giving form to such forces in their work and in their relations to each other, it is less likely to lead to disaster when it becomes a social force than where it has been generally rejected by a social order bent either on the preser-

vation of endangered tradition or on the execution of a presumably rational Realpolitik. The café literati of Munich, for example, including former followers of Gross and Mühsam, who rallied to the Council Republic in 1919, were in no sense the precursors of the Nazi barbarism; but the *Freikorps* volunteers who slaughtered them by the dozens in the name of traditional values were. The rebellious youth of the 1960s, so often responsible for turning their universities upside down and for evoking sentiments of anguish among their teachers, nonetheless, by their experimentation with new art forms and new forms of community, gave America visions of an alternative culture and alternative values which might have pointed the way to a viable, peaceful and creative society. Certainly in conventional politics the resort to what are supposed to be the unsentimental principles of rational statecraft, the attempt to establish the mastery of goal-oriented Ego over unconscious impulse and conventional morality, was less than a smashing success, whether applied to the quagmire politics of Southeast Asia or the cities of North America. Rarely has such well-advertised restraint and calculated reasonableness been accompanied by such rivers of blood and storms of violence.

I am in no sense suggesting a return to the hairy ape as the solution to our problems, nor would I attempt to argue the correctness of Gross' theories. I must, however, insist that they merit more than the total oblivion in which they have been shrouded

for half a century and that, in general, a closer examination of the libidinally rebellious underside of German thought in the early decades of this century, in particular the celebration of sexuality, femininity and childhood, may not only provide important clues to the underlying malaise of their culture, but might give us some useful ideas to chew over while considering the less than inspiring countenance of our own.

## Notes

1. Helmut Kreuzer, *Die Boheme: Analyse und Dokumentation der intellektuellen Subkultur vom 19, Jarhundert bis zur Gengenwart* (Stuttgart, 1971), pp. 42-60, 269-352; Ulrich Linse, *Organisierter Anarchismus im Deutschen Kaiserreich von 1871* (Berlin, 1969), pp. 79-116.

2. Kreuzer, pp. 292-4. Georg Fuchs, "Ein Vorschlag zur Bekampfung der Social-demokraten," *Die Aktion*, III:7 (Feb. 12, 1913), 199-201.

3. The sources used in this study are principally of three sorts: a number of recent monographs have added much value to our understanding of the general evolution of and relationships between literary Expressionism, anarchism and Bohemian subcultures. I think particularly of the works of Walter Sokel, *The Writer in Extremis* (Stanford, 1959), Linse and Kreuzer. Secondly, there are biographies, autobiographical novels or memoirs, and the letters of those who know Gross and Jung. These include Marianne Weber's biography of Max Weber (*Max Weber En Lebensbild*, 1916), which discusses Gross' impact on Heidelberg society around 1907, Ernest Jones' *Free Associations* (1959), Frieda Lawrence's *Not I But the Wind*, and *Memoirs and Correspon--dence* (1964), Erich Mühsam's *Unpolitische Erinnerungen* (1958), Gustav Landauer, *Sein Lebensgang in Briefen* (2 vols., 1919), edited by Martin Buber; Franziska zu Reventlow's *Briefe* (1928) and *Tagebucher* (1971), Oscar Maria Graf's *Prisoners All* (1938), Leonhard Frank's *Links wo das Herz ist* (1967), Franz

Jung's *Der Weg nach unten* (1961), Johannes R. Becher's *Abschied* (1965) (rather unreliable, but in his youth he did know Gross in Munich), Franz Werfel's *Barbara, oder die Frömmigkeit* (1919), and Raoul Hausmann's autobiographical fragment "Club Dada" in Paul Raabe, ed. *Expressionismus: Aufzeichnungen und Erinnerungen der Zeitgenossen* (1965). Finally, there is the literature from the period itself: Gross' few professional articles and brochures (only one of his works exceeded a hundred pages: the rest are article size); his rather more relevant articles in the periodicals of his day, published, with the exception of two unimportant contributions to *Die Zukunft*, in the expressionist journals *Die Aktion, Die Reie Strasse* and *Die Erde*, all with the exception of *Ser Sozialist*, expressionist journals with an anarchist outlook.

4. Ernest Jones supplies one of the rare, explicit references to Otto Gross in English in his autobiography *Free Associations* (pp. 173-4), where he describes Gross (whom he encountered in a Munich café on a trip to the continent in 1908) as "the nearest approach to the romantic ideal of a genius I have ever met." In fact Gross, by his informal on-the-spot analysis of his friends among the Schwabing bohemians, gave Jones his first experience of psychoanalytic practice. Leonhard Frank in his autobiographical novel *Links wo das Herz ist* (pp.19-80), discusses his encounter with Gross in the years 1906-1910 at greater length, for he met—and lost—his first love through Gross' mediation, Erich Mühsam, the anarchist essayist who was with Gustav Landauer and Ernst Toller, one of the leaders of the Bavarian Council Republic in April 1919, also dated his acquaintance with Gross, whose influence he acknowledged, from about 1906 (see Mühsam's contribution to *Die Revolution*, Dec. 1913, 5 and his *Unpolitische Erinnerungen*, pp. 303, 150, 184, 195); and Franziska Grafin zu Reventlow, a well-known phenomenon of turn-of-the-century Schwabing, records her initial acquaintance with Gross in her diary for July 1907. Max Weber and Frieda Weekley—D.H. Lawrence's first wife—also recorded encounters with Gross in 1907.

5. See Otto Gross, *Ueber psychopathische Minderwertigkeiten* (Wien and Leipzig, 1909), p. 115.

6. Cf. Mühsam, *Unpolitische Erinnerungen*, p. 17: "I recall an evening in the old Cafe Des Westens, at the artists' table, which was full. Writers, painters, sculptors, actors, musicians, with and without reputation, sat together: then Ernst von Wolzogen raised the question, who among us came to his life-style without conflict and in harmony with his family. It turned out that we were all, without exception, apostates from our heritage, black sheep."

7. Cf. Gross, "Zur Ueberwindung der Kulturellen Krise," *Die Aktion*, III (April 2, 1913), 386; "Protest und Moral im Uberwindung der Kulturellen Krise" *Die Erde* (Dec. 15, 1919), 681-685. A translation is published in *New German Critique*, No. 10 (Winter 1977), pp. 105-110.

8. Probably the Munich café singer of that name. See Richard Seewald, "Im Cafe Stephanie," in Raabe, ed., *Expressionismus*. With the exception of Gross himself, who Frank refers to as Dr. Kreuz, all the other names of those Frank lists in his circle seem to be genuine.

9. Frank, *Links*, pp. 12-16.

10. *Ibid*, p. 80, also Reventlow's *Briefe* (1928), p.184 (to Franz Hessel, dated April 1, 1911); and Gross' letter printed in *Die Zukunft*, 86 (Feb. 28, 1914), 305.

11. Frank mentions one cure in June 1908 (p. 53), Ernest Jones refers to another in 1911 (*Lebensgang in Briefen*).

12. Jones, *Free Associations*, p. 173f. Frank claims that Gross wrote a brilliant synthesis of his ideas in 1906 during one of his cocaine intoxications, had a hundred copies printed, and asked his wife to send a copy to a rival psychoanalyst who seems, by Frank's description, to have been Carl Jung. The other 99 copies were traded in by Gross' landlady as wrapping paper to a butcher in return for a pork cutlet, but Carl Jung, according to Frank, made more elegant use of Gross' brochure and, unbeknownst to the world of science, "built his teachings, which in some points deviated from Freud's, on the early insights and decisive points of his one-time opponent, Dr. Otto Kreuz" (Frank, *Links*, p. 54). One of the advantages of wrapping hamburger in psychoanalytic treatises is that this problem is unlikely ever to become the subject of learned controversy. There is no doubt, however, that Carl Jung

found Gross' early work of 1902, "Uber cerebrale Sekundarfunktion," important, for he built a chapter of his massive *Psychological Types* on this essay with high praise for the author. Freud, who "distributed references to other analysts' writings on the same principle as the emperor distributed decorations," (Rank according to Jones quoted by Paul Roazen in *Brother Animal: The Story of Freud and Tausk*, New York, 1969, p.193), refers to another of Gross early articles in *Wit and the Unconscious* (1906).

13. Largely through police spies: See Linse, *Organisierter Anarchismus* (Berlin, 1969), pp. 93-94, fn 81.

14. Mühsam knew Gross and generally admired him as "Freud's most significant disciple," whose "ideas...on the significance of jealousy and the authoritarian character of the father-centered family came quite close to my own." Müsham, *Unpolitische Erinnerungen* (Berlin, 1958), pp. 150, 303. Mühsam's friend and fellow-organizer, Johannes Nohl, appears prominently in Frank's account of the Gross-circle, and he defended psychoanalysis against Landauer in the pages of *Der Sozialist*, though he may also have kept from total involvement in it. Fritz Klein probably participated in both groups, and on the basis of Jung's account, we may assume Karl Otten, Ernst Frick and Eduard Schiemann also did. Two other members of the Tat-group were connected to Gross and his ideas primarily though Franz Jung: Georg Schrimpf, an artist, and Oscar Maria Graf, then a very young ex-baker's apprentice who soon was to have some success as an expresionist poet and novelist.

15. Cf. Paul Avrich "The Legacy of Bakunin," *The Russian Review* (1970).

16. Cf. Jung, *Der Weg nach unten*, Graf, *Prisoners All*, Müsham, *Unpolitische Erinnerungen* Linse, *Organisierter Anarchismus*. This could be because Bakunin was so obviously the bête-noire of the German authorities that interest in him was considered unnecessarily provocative before 1918. It could also stem from the non-violent and reformist inclination of Landauer's and Mühsam's organization. Gross, who shows little sign of political sophistication in the few articles he wrote for a more more general public, never mentions Bakunin, though two of his

less sympathetic acquaintances attribute to fictional representations of Gross an almost sterotypically Bakuninist fascination with the prospect of total destruction (Johannes R. Becher, *Abschied*, Wiesbaden, 1965, pp. 360. Franz Werfel, *Barbara, oder die Frömmigkeit*, Berlin, 1929, pp. 471-72.

17. Frank saw Gross' cocaine habit as so debilitating in 1910 that he seems to have forgotten that Gross survived until 1919, and writes in his autobiographical novel that after Sophie's suicide, "Der Doktor ging bald danach am Kokain zugrude." (*Links*, p. 80)

18. Cf. F, Jung, *Der Weg nach unten*, pp. 71-73. The destructive results of intellectual independence for those of Freud's disciples not powerful enough to establish their own schools, like Carl Jung and Alfred Adler, have been strikingly presented in Paul Roazen's *Brother Animal: The Story of Freud and Tausk* (New York, 1969).

19. Mühsam, *Erinnerungen*, Curt Reiss, *Ascona* (1964), Marianne Weber, *Max Weber*.

20. Jung, *Der Weg nach unten*, p. 72. Though Jung was not part of Gross' original Munich circle, he quickly joined Erich Mühsam's Tat-goup, and probably because of the increasing congruence of Mühsam's and Gross' groups, he soon became acquainted with four adherents of Gross. In any case, he knew three as members of the Tat-group: Karl Otten, b.1889, a poet and essayist; Ernst Frick, b. 1881, and Eduard Schiemann, b. 1885, both artists. Cf. Jung, p.71, Linse, p. 94. Otten edited a two-volume anthology of expressionist literature in 1957, in which Gross is mentioned, in Otten's introduction, with Freud and Alfred Adler, as one of the founders and elaborators of psychoanalysis who influenced his generation (*Ahnung und Aufbruch: Expressionistische Prosa*, Darmstadt, 1957, p. 14). The fourth adherent of Gross mentioned by Jung was Leonhard Frank, who had already broken with Gross by 1910. Jung (p. 74f.) also mentions Fritz Klein, Otten's roommate, who, other evidence indicates, was affiliated to the Tat-group and was the "Fritz" mentioned by Frank in the circle around Gross (Linse, p. 94, Frank, pp. 19, 119).

21. On participation of Gross' adherents, see Jung, p. 72. On anarchist involvement, see Linse, p. 113.

22. Graf was 17 or 18 at the time. (See Graf, *Prisoners All*, pp. 65-67). Jung did not think enough of Graf to mention him in his autobiography, but judging by Graf's description of Jung in *Prisoners All*, and by the participation of Graf and his artist friend Schrimf in the journal edited by Jung in 1915 and 1916, *Die Freie Strasse*, we can infer a certain dependency of Graf and Schrimpf on the more experienced Jung dating back to their common involvement in the Tat-group (Graf, pp. 108-10, 187-90). Graf writes that Jung rejected his contributions to *Die Freie Strasse* with such ill-tempered notes as "Send the product of your unequaled stupidity and your sexual repression elsewhere. We have nothing in common"; but the first issue of *Die Freie Strasse* (1915) does contain an autobiographical story by Graf, and one of his poems appears in the third.

23. Jung, pp. 78-82

24. Johannes Hohl, "Fichtes Reden an die deutsche Nation und Lanauer's Aufruf zum Sozialismus," *Der Sozialist (May 15, 1911), 84; Landauer, "Ausrufe," Soz.* (July 1, 1911); Ludwig Berndl, "Einige Bemerkungen uber die Psychoanalyse," *Soz.* (July 1, 1911).

25. Gustav Landauer, *Sein Lebensgang in Briefen*; Letters to Buber of Sept. 1 and Sept. 18, 1911, pp. 381-84. Landauer's assertion that Gross wrote his reply "in irgendeiner Nervenanstalt" is indirectly confirmed by Franz Jung in *Die Revolution* (Dec. 20, 1913). Landauer's grudge against Gross, apart from Gross' attempt to prevent Margarette Fass-Hardegger, a close friend and associate of Landauer, from removing her daughter from his care. In Landauer's *Lebensgang in Briefen*, we discover that she is the parent Gross referred to in his article in *Die Zukunft* of Oct. 10, 1908 ("Elterngewalt," 78-80). Landauer's "Von der Ehe" (*Der Sozialist*, Oct. 1, 1910 and *Der werdende Mensche*, Potsdam, 1921, pp. 56-69) contains a general argument against the use of matriarchal theory to justify free love and the dissolution of the family. For a brief description of German anarchist attitudes toward free love, see Linse, pp. 97-98.

26. *Die Aktion* (April 16, 1913).

27. Jung, pp. 88f. Gross had left his wife in Ascona, where she lived with her child and the Swiss anarchist Karl, known to us from Leonhard Frank's book. See Marianne Weber, *Max Weber*, pp. 494-502.

28. See Richard Öhring, *Wiecker Bote* (March 1914). To strengthen the hand of the police, Hans Gross further alleged, in Franz Jung's words, "that his son has fallen into the hands of dangerous anarchist elements, presumably a band of extortionists who will use earlier investigations of Otto Gross on homosexuality to blackmail him—the father." (Jung p. 89).

29. Graf, p. 109, Jung p. 94.

30. Ludwig Rubiner in *Die Revolution*, 5 (Dec. 20, 1913), 2.

31. For a discussion of the expressionist literature embodying this theme see Sokel, *The Writer*. The most obvious possibility was Walter Hasenclever's *Der Sohn*, the first important expressionist drama, written, according to its author, in the fall of 1913.

32. Jung. p. 91

33. See Werfel's autobiographical novel, *Barbara, oder die Frömmigkeit* (1929).

34. I have only been able to examine the first and sixth numbers of *Die Freie Strasse*, both edited by Jung; but this is also the impression received by Jung's friend Graf, living in Munich at the time and one of the contributors. See his *Prisoners All*, pp. 188-89. According to Jung, publication was assisted by Franz Pfemfert, and much of the editorial work was done by Clare Öhring, then living with Jung. See *Der Weg nach unten*, p. 109.

35. Cf. Jung, pp. 99-102; Graf, pp. 135-66. Indeed two future collaborators of Jung in the Dada movement, Georg Grosz and Johannes Baader, were also dismissed from the army for psychiatric reasons (Jung, pp. 101-111). At least three other prominent Expressionists left the army for psychiatric reasons during World War I: Kurt Hiller (cf. Hiller's *Leben gegen die Zeit*, pp. 76-78); Jakob van Hoddis (*ibid.*, p. 85) and Ernst Toller (Sokel *The Writer*, p. 182). Given this considerable presence of certified madmen among the Expressionists, it is not likely that Gross' repeated institutionalization for narcotic addiction prejudiced many people against him during his final surge of influence at the war's end.

36. I follow Linse's summary, p. 103.

37. Linse, p. 106.

38. Gross, *Ueber psychopathische Minderwertigkeiten*, pp. 49-52.

39. *Ibid.*, pp. 117-118.

40. *Ibid.*, pp. 53-54.

41. The central importance in Gross' theory of the arguments above until at least 1914 is established by the fact that most of the eight pages in which it appeared were reprinted, with insignificant excisions, as an article in *Die Aktion*, shortly after Gross' arrest and institutionalization in 1913, presumably to represent his most important ideas. (The likelihood is that Franz Jung did the excerpting and arranged, through Pfemfert, for its publication.) See Gross, "Die Einwirking der Allgemeinheit auf das Individuum," *Die Aktion* (Nov. 22, 1913).

42. *Drei Aufsätze uber den inneren Konflikt*, a scant 39 pages, was published in 1920, the year after Gross' death. The argument for its prewar composition rests on the lack of any clear reference to World War I or to literature published after 1913. On the other hand, the references to Alfred Adler appear in none of Gross' prewar writings; the treatment of homosexuality in the second part of the first essay "Ueber Konflikt und Beziehung" seems considerably more developed than the discussion in Gross' "Anmerkingen zu einer neuen Ethik," published in *Die Aktion* (Dec. 6, 1913) as his most recent work on the subject. The reference to Stekel's *Onanie und Homosexualität* as "Das Meisterwerk" (p. 18) is probably to Stekel's book of 1917 rather than his essay of 1913. And there is a close line of continuity between the ideas in the *Drei Aufsätze* and his clearly very late essay "Protest und Moral im Unbewusstsein" (posthumously published in *Die Erde*, Dec. 15, 1919).

43. *Drei Aufsätze*, p. 4.

44. E.g. Kate Millett, *Sexual Politics* (New York, 1969),

45. Gross, *Drei Aufsätze*, p. 16.

46. Cf. Franz Jung: "For me, Otto Gross signified the experience of a first and great, deep friendship; I would have unhesitatingly sacrificed myself for him...For Gross himself, I was perhaps no more than a figure on the chessboard of his intellectual combinations, which could be moved back and forth," *Der Weg nach unten*, p.91.

47. *Die Erde* (1919).

48. Hans G. Helms, in his massive work on Stirnerian influence, *Die Ideologie der anonymen Gesellschaft* (1966), falsely reckons Hausmann to the Stirnerian camp on the basis of his "Pamphlet gegen die Weimarische Lebensauffassung" published in Anselm Ruest's *Der Einzige* in 1919. Hausmann accused Ruest of altering his article to make it conform to Strinerian views in his "Der individualistische Anarchist und die Diktatur" (Die Erde, May 1, 1919, p. 276) and he fiercely denounced Stirner in his "Schnitt durch die Zeit" (*Die Erde*, Oct. 1, 1919, p. 542).

49. Raoul Hausmann, "Schnitt durch die Zeit," *Die Erde* (Oct. 1, 1919), 542-43.

50. Raoul Hausmann, "Schnitt durch die Zeit," *Die Erde* (June 15, 1919), 368.

51. For a discussion of the KAPD and Jung's role in it, see Hans Manfred Bok, *Syndikalismus und Linkskommunismus von 1918-1923* (Meisenheim a.d. Glan, 1919), pp. 225-262.

52. Franz Jung, "Zweck und Mittel im Klassenkampf, Die Erde (August 1, 1919).

53. *Ibid.*, 428-29.

54. Cf. H. Stuart Hughes, *Consciousness and Society* (1958), passim, and Carl Schorske, "Politics and the Psyche in fin-de-siécle Vienna: Schnitzler and Hofmannsthal," *American Historical Review*, 66 (July 1961), 930-46.

55. H.E. Schröder, *Ludwig Klages: Die Geschischted seines Lebens. Erster Teil. Die Jugend* (1966), pp. 163-64. On Klages' and Schuler's use of Bachofen, see pp. 225, 230, 235, 237.

# OCCULTISM, ANARCHISM AND ABSTRACTION:

## KANDINSKY'S ART OF THE FUTURE

## BY ROSE-CAROL WASHTON LONG

**A**s art historians in recent years have examined the development of modern art, it has become more and more apparent that the interest in occult and mystical knowledge evinced by many artists was often part of a search for alternatives to restrictive social and political attitudes and outworn conventions. For solutions to the problems created by an increasingly industrialized and commercialized society, many artists explored heretical metaphysical concepts, fringe political systems, and deviant sexual patterns and, in the process, discovered new artistic methods for themselves. Yet the varied anarchistic, socialistic, and sexual theories that engaged these artists in conjunction with occultism and mysticism have too often been neglected by scholars. Although the quests for a spiritual utopia and a secular one have often been closely related, many art historians have equated artists' interest in mysticism with hostile attitudes towards social and political change.

A few scholars have noted that both social concerns and mystical thought provided stimuli to modern artists interested in abstraction. Although Donald Drew Egbert's *Social Radicalism and the Arts* focused primarily on artists with clearly indicated political interests, he suggested that anarchism and socialism as well as mysticism and occultism influenced the development of twentieth-century abstract art.[1] His study illuminates connections between various occultists, anarchists, socialists, and artists in the late nineteenth century and the early years of the twentieth. For example, before Annie Besant's conversion to Theosophy, she had been an active Fabian socialist and birth-control advocate. Just prior to her meeting in 1889 with Helena P. Blavatsky, the founder of the modern Theosophical Society, Besant, along with the English socialist designer William Morris and the Russian anarchist-communist or communalist Piotr Kropotkin, had spoken at a demonstration in London in support of the American anarchists accused of bomb throwing in Haymarket Square, Chicago.[2] Drawing from the work of Eugenia Herbert and others, Egbert stressed the role Kropotkin played in persuading socially concerned artists and critics in the late nineteenth century to support a style that was not based on the realism of past art.[3]

According to Egbert, Kropotkin had called upon artists, poets, and intellectuals to create works that would deal with the struggle of the masses, urging artists to ignore previously discovered sources in antiquity, Renaissance art, and nature in order to search for a style that could infuse their work with revolutionary fervor. Egbert discussed the impact of Kropotkin on Neoimpressionists such as Signac and on Symbolists such as Fénéon and Mallarmé, and he noted the concern of Gauguin and the Nabis with Theosophy. Although Egbert did not discuss the now-acknowledged interest of Symbolists in occultism,[4] he emphasized that the Theosophical belief in a universal brotherhood of

man and its attack on the evils of commercialism were part of its appeal to socially concerned artists. Egbert also referred to Frantisek Kupka's interest in spiritualism and anarchism as a prelude to his development of abstraction.[5] Virginia Spate, in *Orphism*, examined Kupka's interest in mysticism and, somewhat more briefly, in anarchism, mentioning Kupka's illustrations for the anarchist-geographer Elisée Reclus's study *L'Homme et la terre*.[6]

There has been far more written in the past twenty years on the importance of Theosophy and Symbolism for Wassily Kandinsky's development of an abstract style of painting before World War I.[7] Yet, the influence of anarchistic attitudes[8] in conjunction with occultism on Kandinsky's ideas and their possible reflection in the structure of his work have not received serious consideration. In fact, Kandinsky used the term "anarchistic" in the *Blaue Reiter* almanac to describe the direction of his own work and that of other contemporary artists whom he admired.[9] Many artists, poets, and intellectuals with whom Kandinsky associated before 1914 in Germany and Russia found inspiration in both occult thought and various anarchistic attitudes for their search for an underlying, unifying force that would emerge after the artificial structures of society were removed. Overlapping circles of intellectuals who were willing to explore new processes of thought in religion, science, art, and politics created a climate in which experiment in the arts could be envisioned as a challenge to the established authoritarian societies in both countries.[10] Before turning to an examination of Kandinsky and his relation to others searching for a better society, it may be helpful to suggest why the interconnections of mysticism-occultism, anarchism, and artistic change have often been ignored.

For most art historians, turn-of-the-century mysticism, occultism, and anarchism have been considered too irrational and chaotic to be viewed as serious influences on modernist artists. Reports of spiritism and seances led to much distrust of occultists, and the terrorists acts of some anarchists brought disapproval to anarchism as well. In addition, the frequency with which various occultists and anarchists moved from one group to another, or formed factions within a larger group, lent itself to much confusion over their activities and programs. Before World War I, although certain occult groups, such as the Theosophists and the Rosicrucians, agreed that knowledge of esoteric wisdom could help mankind to advance to a higher state, they frequently disagreed over the significance of various Christian and Eastern sources. Arguments of this nature led, for example, to the formation of the Anthroposophical Society in 1913 when Rudolf Steiner, the head of the German Theosophical Society, broke with the International Theosophical Society after disagreeing with Annie Besant, its director.

Although anarchists, envisioning

themselves as inspiring the masses to remove authoritarian and repressive structures, were more specifically concerned with direct social and political change than were occultists, they shared with the occultists a similar tendency towards internationalism and anticommercialism as well as towards factionalism.[11] Frequently disagreeing with the Socialists, with whom they were at first allied, a number of anarchists rejected Marx's analysis of historical change. In addition, they disagreed with one another as to the direction and nature of their new society. Some argued for a moral revolution arising from strict libertarian individualism, while others argued for violent change arising from militant workers' units. Still other anarchists emphasized the nonviolent restructuring of society into decentralized rural communes or small autonomous Christian groups. Kropotkin, whose ideas were drawn from French utopian socialism and from the Russian populist tradition, exerted considerable influence on artists and writers in Germany and Russia[12] as well as in France and England at the end of the century. Tolstoy's ideas also had considerable prominence in the years before World War I. Nonetheless, the resistance of most anarchists to clearly structured organizations made their existence not only perilous but also subject to derision.

In the 1920s and 1930s, German political groups of the left and right used the terms "anarchism" and "mysticism" to ridicule modern art, particularly abstraction. Critics on the left, abandoning the notion that vanguard art should be nonrealist, began to attack the perceived elitist direction of Expressionism and abstraction.[13] From the right, modernist artists and schools, such as the Bauhaus, were denounced as "full of mysticism" and were charged with artistic Bolshevism, responsible for anarchy and disorder.[14] By the late thirties, while the National Socialists were characterizing modernism as "entartete" (degenerate) as well as anarchistic,[15] the left was attacking modernism, particularly Expressionism and abstraction, for its decadence, anarchism, mysticism, and bohemianism.[16] The Marxist critic George Lukács, reflecting the Stalinist rejection of modernism in favor of socialist realism and a determination to extend a "popular front" to all the arts, suggested in 1934 that the bourgeois bohemianism, anarchism, and mysticism of the avant-garde had contributed to the rise of fascism by creating such chaotic conditions.[17]

After World War II, critical thinking was marked by a clear retreat from the politicalization of the arts that had characterized the thirties. In Germany, for example, the utopian political interests of many artists who had actively committed themselves to reformist and radical politics after World War I were ignored as was their interest in mysticism.[18] In addition, historians such as George Mosse, who wrote in the sixties about the supporters of National Socialism who had been involved with mystical utopian groups before their involvement with fascism, contributed inad-

vertently to the already present tendency of artists and their admirers to ignore past explorations of mysticism.[19] It should not be surprising then that accounts of Expressionism and studies of Kandinsky written in the fifties and after did not mention his interest in occultism and anarchism.[20] Even the Symbolist sources were overlooked, perhaps because both occultism and anarchism were so much a part of Symbolist thought.

Despite the negative associations of mysticism, anarchism, and abstraction in the 1920s and 1930s and the later denials of this influence by scholars, much evidence indicates that an artist such as Kandinsky was familiar not only with occultism, particularly Theosophy, but also with contemporary thought on socialism and anarchism in both Germany and Russia.[21] From the time he arrived in Munich in 1896 until he left Germany in 1914, and during his return visits to his native land, Kandinsky associated with artists, poets, writers, and critics who explored occultism, medieval mysticism, anarchism, pacifism, and socialism to find ways to change the direction of society. In a 1914 letter to Franz Marc, his collaborator on the Blaue Reiter almanac, Kandinsky recalled their days together in the artists' quarter—Schwabing—in Munich, when the "genuine Schwabingers living in their farmhouses" had no idea what "was growing" in the earth near them.[22]

During this period, occultists and mystics, anarchists, socialists, and pacifists did not exist in completely separated camps. Theosophists such as Rudolf Steiner, whom Kandinsky praised in *On the Spiritual in Art*, had worked with German socialists and anarchists. Steiner had lectured several times a week from 1899 to 1904 at the school for workers' education, founded by Wilhelm Liebknecht, one of the organizers of the German Social Democratic Party.[23] He was friendly with John Henry Mackay, who had written the book *Die Anarchisten* and had studied the individualist-anarchist theories of the mid-nineteenth-century German Max Stirner. Steiner had also lectured on the monist theories of the Darwinian biologist Ernst Haeckel at the Liebknecht school and had led a literary group, Die Kommende, where young artists such as Else Lasker-Schuler and Herwarth Walden read their works.[24]

Intellectuals who espoused various communalist aspects of anarchism, such as the political theorist Gustav Landauer, who was to become in 1919 one of the leading members of the Bavarian Socialist Räterepublik, and the Russian Symbolist poets and critics Georgii Chulkov and Viacheslav Ivanov, were also interested in mystical thought. Landauer, for example, who translated Kropotkin into German for publication in 1904, had a year earlier edited the writings of the German mystic Meister Eckhart.[25] Chulkov and Ivanov, who sought to combine individual freedom with collective responsibility, were known to be

interested in the occult[26] and shortly after the brief Russian revolution of 1905 referred to themselves as mystical anarchists.[27]

Although they were all concerned with the radical transformation of a society they considered too materialistic and authoritarian, these intellectuals differed in the areas they felt would most affect change. Steiner advocated study of Eastern religions as well as the major Christian mystics, believed in meditation, and emphasized that artistic activity growing out of these studies would assist with the regeneration of society. Chulkov and Ivanov, whose friend the poet Mikhail Kusmin contributed to the Blaue Reiter almanac,[28] were determined to have a direct effect on Russian life after the revolution of 1905. They urged that the artificial restraints of governments, religious dogma, and traditional morality be removed in order for a new society based on the natural law of voluntary service and sexual love to evolve. Viewing political activity as petty, they believed the theater could increase communion between the artist and the "crowd" by evoking the mystical unity that existed among all people. They encouraged experimental plays in which music, color of sets, and costumes would reflect the universal and timeless elements of the national myths on which they believed much of the theater should be based.[29]

Landauer, who moved among writers and poets whom Kandinsky knew,[30] was more directly involved with radical politics than was Chulkov or Ivanov. Although Landauer called Marx "the curse of the Socialist movement,"[31] he wanted the terms "socialist" as well as "anarchist" connected to his ideas and formed in 1908 an activist group he called the Socialist Bund. Martin Buber, who was part of the circle of Karl Wolfskehl,[32] a neighbor of Kandinsky's since 1909, was one of the leaders of Landauer's Bund in Berlin. The Munich leader was the anarchist writer Erich Mühsam, who in 1909 organized a group of impoverished café outcasts into meetings called Die Tat, which Wolfskehl is reported to have attended.[33] For Landauer, the basic question was how to revive the communal spirit in the modern world, and he advocated restructuring society into small, autonomous rural communes. Like Kropotkin, he viewed writers, poets, artists as having the vision to lead the people, and equated realism with the decline of spirituality. In *Die Revolution*, published in 1908, Landauer praised the Middle Ages, and set the medieval guild as a model of communitarian organization. He also discussed in that work how medieval spirituality declined as realism in the arts became predominant.[34]

In 1908, Kandinsky returned to Germany after a year long stay in Paris, during which he had agonized over his goals and direction. After a period of rest, Kandinsky began to work increasingly in oil, with larger-scaled canvases, brighter colors, and looser, more blurred images. It was during 1908 that he is reported to have heard Steiner lecture in

Berlin.[35] In Munich, he renewed his friendship with Wolfskehl, and began developing a series of compositions for the stage with the Russian composer Thomas von Hartmann, who was also interested in occult phenomena.[36]

During the summers of 1909 and 1910, Kandinsky (Fig. 1) and his companion Gabriele Münter shared their house in rural Murnau with Alexei Jawlensky and Marianne von Werefkin, two other Russians living in Munich. Both Jawlensky and Von Werefkin were interested in Steiner as well as in the writings of many Russian Symbolists such as Chulkov, about whom Von Werefkin made notes in a journal.[37] During the summer of 1909, Münter became interested in Bavarian folk art, particularly the religious *Hinterglasmalerei* and began to collect them and to experiment herself with painting on glass. Kandinsky, too, soon collected these examples of folk art as well as Russian *lubki*. (Fig. 2) Both provided him with simplified and primitivizing interpretations of apocalyptic motifs, which he was beginning to use in a veiled, nonnaturalistic manner in his major paintings and in his theatrical compositions to suggest the themes of struggle and regeneration so central to his world view.

During this period, Kandinsky maintained close ties with the Russian avant-garde.[38] In June 1910, he began to correspond with Nikolai Kulbin, the music and art theorist, exhibition organizer, and painter.[39] In the fall of that year, he made a lengthy trip to Moscow, and visited

*Fig. 1* Wassily Kandinsky in Bavarian clothing, Murnau, c. 1908-09. Gabriele Münter—Johannes Eichner Stifung, Städtische Galerie, Munich.

Saint Petersburg as well. He referred in *On the Spiritual in Art* to the innovative production of a Maeterlinck play in Saint Petersburg that forced the imagination of the spectator to complete the scenery.[40] This production may have been at Ivanov's "tower" apartment, where experimental plays and productions were occasionally performed, an activity in keeping with Ivanov's belief in the religious and communal power of the theater.[41] In Saint Petersburg, Steiner's Russian emissaries, many of whom had lived in Germany, could be found at Ivanov's apartment, where the intelligentsia of that city gathered.[42] By 1910, Steiner's name

and writings had become more widely known in Russia, and his focus on the Apocalypse as the significant document for modern times coincided with the assumption of many Russian intellectuals, intensified by the 1905 revolution, that the Apocalypse was nearing.[43]

Nearly a year after his trip to Russia Kandinsky prepared two messianic documents: *On the Spiritual in Art*, completed in 1911, (Fig 3) and the Blaue Reiter almanac, published in 1912. (Fig. 4) Both were conceived for the purpose of awakening the spiritual in all mankind[44] through the suggestion of alternatives to the decadence and darkness of contemporary life. Kandinsky blamed materialists, positivists, scientists unwilling to seek information outside established sources and "recognizing only what can be weighed and measured"[45] for

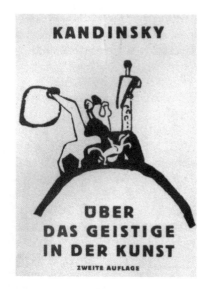

Fig. 3 Wassily Kandinsky, cover of *On the Spititual in Art*, 1911.

the anxiety and insecurity of the people around him, and for the confusion of his age. Although he believed that art had the potential to lead the way to the future, he described most artists as savagely competing with one another for success with a small group of "patrons and connoisseurs"[46] who were searching for profits.

To avoid such self-centered degradation, and to move away from blind uncertainty, Kandinsky suggested that the public turn to the Theosophical Society, which he described as "one of the greatest spiritual movements" of his day.[47] Although he explained that some were wary of its "tendency to theorize," he emphasized that it offered "a note of salvation" that touched many who were "enveloped in darkness and

Fig. 2 Wassily Kandinsky in his studio in Ainmilerstrasse, Munich, 1913. Gabriele Münter—Johannes Eicher Siftung, Städtische Galerie, Munich.

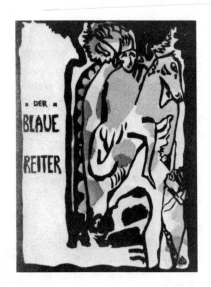

*Fig. 4* Wassily Kandinsky, cover of the *Blaue Reiter* almanac, 1911, woodcut.

night."[48] According to Kandinsky, a few artists could understand these "new truths," and he compared his and his friends' absorption of the lessons of folk, medieval, and primitive art to the Theosophists' search for sustenance in the cultures of other civilizations such as India.[49] For the almanac, Kandinsky and his coeditor, Franz Marc, drew on an international array of artists, writers, dramatists, and musicians who represented all that was new and unconventional— "the anarchistic" tendencies in the various arts, as Kandinsky explained in an essay in the almanac. In this text "On the Question of Form," Kandinsky wrote that "contemporary art, which . . . may rightly be called anarchistic, reflects not only the spiritual standpoint that has already been attained, but also embodies as a mate-

rializing force that spiritual element now ready to reveal itself."[50]

Kandinsky's use of the term "anarchism" is related to his messianic determination to change society not only by exploring religions, such as Theosophy, that the establishment considered heretical but also by examining other attitudes, such as anarchism, that were also considered taboo. Both of these intentions supported his quest to turn to artistic sources such as folk, medieval, and primitive art, examples of which filled the pages of the almanac, by their concentration on areas outside conventional doctrines. Anarchistic thought especially supported Kandinsky's abhorrence of artificial rules and his commitment to free choice as a way to enlightenment and as a means of overcoming the limitations of the present age.

Kandinsky was remarkably well read, and his writings indicate his familiarity with late-nineteenth- and early-twentieth-century political theory. He believed that political institutions, like nature, science, and art, had their own timeless law, and he stated that each of these separate realms would at some point in the future work together to "constitute that mighty kingdom" which at present could only be imagined.[51] But Kandinsky viewed politicians and political parties with skepticism. When discussing the socialists, he commented on their "various shades" and their tendency to use multiple quotations to support every concept.[52] He gave socialists a low position in his well-known spiritual trian-

gle in *On the Spiritual in Art*. He explained that they wished "to deal the fatal blow to the capitalist hydra and cut off the head of evil," but that they could not themselves solve problems since they would accept nothing less than "infallible remedies."[53] He revealed his respect for anarchism when he attacked politicians for directing their hatred against it: he claimed they knew "nothing save the terrifying name."[54] Kandinsky insisted that the popular definition of "anarchy" as "aimlessness" or "lack of order" was incorrect. In "On the Question of Form," he wrote: "Anarchy consists rather of certain systematicity and order that are created not by virtue of an external and ultimately unreliable force, but rather by one's feeling for what is good."[55] His interpretation reflects a central anarchist tenet that an underlying law of nature or truth lies hidden beneath the artificial structures imposed on mankind by established, authoritarian systems.

Kandinsky did not normally refer to political events in either Russia or Germany, but he did mention in his 1913 "Reminiscences" the significance the student protests had for him when he was at the university in Moscow in the 1880s. His memoirs indicate that he was radicalized by this event: he explained that the government ban on the university's international student organization made him much more sensitive and more receptive to new ways of looking at his country.[56] Indeed, these memoirs suggest that even in 1913 Kandinsky viewed disruption and discord as powerful tools for change. In the discussion of his student days, Kandinsky praised activism whether it was individual or collective, stating that it would "undermine the stability of our form of existence."[57] Committed to making ordinary people receptive to change, he stressed his support for actions that contributed to stirring up "a critical attitude toward accustomed phenomena."[58] Without critical stimuli, Kandinsky believed that change would be difficult. But for Kandinsky, it was the artist, not the politician or the political theorist, who could most powerfully evoke these discordant stimuli. At the end of *On the Spiritual*, Kandinsky reminded the artist that he had "great power," but that he also had "great responsibilities."[59]

Although he viewed the artist as a prophet, like a Moses leading his people to the promised land, Kandinsky drew moral sustenance and visual strength from indigenous peasant cultures, particularly from the Russian peasant, whose love of color and ornament he called "magical" and whose flexible attitude to legal matters he much admired.[60] As a student, Kandinsky had studied economics and ethnology and had traveled to the remote Vologda region. He later recalled the religious feeling he had experienced in the homes of these peasants, particularly from their icon corners, and he compared this somewhat mystical experience to the feelings he had in the great Moscow churches and more recently in

Bavarian and Tyrolean chapels.[61] That Kandinsky preferred the intuitive Russian peasant law to codified law reflects not only his abhorrence of centralized authority and rule but also his knowledge of anarchist theories such as Kropotkin's and Landauer's that praised the natural law of the peasant in contrast to the artificial law of the state.

Kandinsky's discussion of the natural or internal law of the peasant is related to his belief in an underlying law or principle for all art forms that counters the superficial rules "discovered in earlier art, together with those discovered later."[62] He called this basic principle the "internal necessity," explaining that it grew from "three mystical necessities" that allowed art to move beyond time and space, beyond the personal and the national, to the eternal and the universal.[63] Although he made his own commitment to abstraction as the most transcendental and universal of art forms very clear in all his essays written before World War I, Kandinsky insisted that contemporary painting could also move in the direction of the "Great Realism." He also suggested that the artist could work towards both ends.[64]

Kandinsky refused to demand a fixed style for other artists. He was committed to the individual artist's freedom of choice, explaining that the artist should know "best by which means he can most clearly put into material form the content of his art."[65] But he did suggest that the artists look for a guide to evocative form in their own age, which he described as one of "clashing discords," "stress and longing," "opposites and contradictions." He urged artists to reflect these discordant qualities of their time by using contrasting stimuli or the "principles of contrasts."[66] Drawing from French Fauve, German Brücke, and Russian Neo-Primitivist experiments with color, Kandinsky used brilliant, clashing colors placed over images to create spatial dislocations and feelings of chaos in his paintings. During this period, Kandinsky also used repetition of increasingly dematerialized images, many derived from folk art both to heighten the sense of mystery and to intensify the evocation of the themes of conflict and hope so central to his beliefs. His embrace of a theory of contrasts is revealed not only in his choice of opposing colors but also in the arrangement of his compositions. A number of large oils, for example, *Improvisation 28* (Figs. 5 and 6) and *Black Spot of 1912*, have remnants of motifs derived from folk-art depictions of the Last Judgment and of Paradise, arranged beneath veils of startling color, on opposite sides of the canvas.[67]

Kandinsky believed that the constraints artificially imposed on artists were loosening in all the arts, and he wrote in the almanac that this "ever increasing freedom ... opens the way for further revelations."[68] The essays and the illustrations in the Blaue Reiter almanac make it clear that composers, dramatists, and choreographers, as well as painters, could

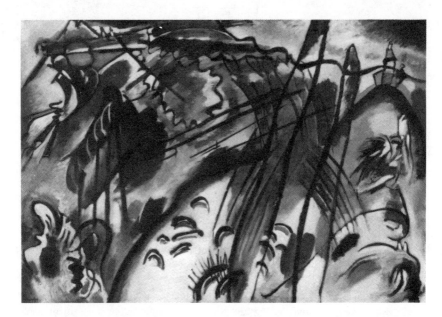

*Fig. 5* Wassily Kandinsky, *Improvisation 28*, 1912, oil on canvas, 43 ⅛ x 63 ⅞".
New York, The Solomon R. Guggerheim Museum.

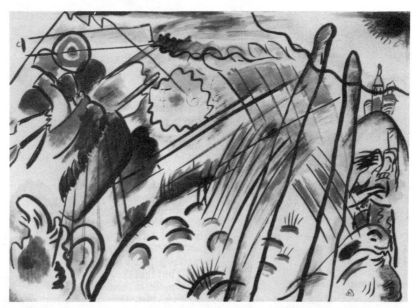

*Fig. 6* Wassily Kandinsky, Study for *Improvisation 28*, 1912, watercolor 15 ¼ X
22". New York,The Hilla von Rebay Foundation, The Solomon R. Guggenheim

free themselves from the academic requirements of basing their work on a narrative or an anecdote and from conventional notions of beauty and harmony. He found musicians most responsive to the stimuli of contrast of his age, and as a result, he included several articles on contemporary music, including one by Von Hartmann, one by Kulbin,[69] and one by the Austrian Arnold Schoenberg, whom Kandinsky praised in several essays.[70]

All three musicians argued for the right of the artist to use certain combinations of notes and chords that might at first seem discordant or unpleasant but that would, they hoped, eventually lead the audience to a new understanding of their work. The titles of Hartmann's and Kulbin's essays—"On Anarchy in Music" and "Free Music," respectively—are particularly revealing of their authors' point of view. Schoenberg, in his essay on relating texts to music, argued against strict parallels between text and music by comparing such a rule to one that limited the painter to copying from nature.[71] Kulbin, who believed that "discord" was the principle that excited and aroused mankind, focused in his essay on the musical intervals that could create this effect.[72] Hartmann urged the reader to "welcome" the principle of anarchy in art: he explained that the composer must "shock" the audience by using "opposite sound combinations" to make the observer react strongly.[73] Hartmann emphasized the numerous possibilities that could result from a variety of methods, and, like Kandinsky, he referred to the judgment of the mystical "inner necessity." Moreover, he did not argue for one "absolute" direction in art, but urged the use of both conscious and unconscious elements and suggested that discovery of unconventional approaches to music would lead to a "new Renaissance."[74] Each of these artists believed that the abandonment of past conventions would lead to the enriching freedom necessary for the creation of a work of art that could have a regenerative effect on all mankind.

Kandinsky found the concept of dissonance in music as liberating as the student disturbances at the university. Like Kandinsky, Schoenberg, Kulbin, and Hartmann advocated the use of contrasting stimuli. For Kandinsky, the parallelism of Wagner was too rooted in the past,[75] and he advised painters not to find exact correspondences of color and motifs but to use opposing colors and motifs in addition to "'forbidden' combinations, the clash of different colors"[76] to produce effects equivalent to dissonance in music.

In *On the Spiritual*, Kandinsky noted that the first effect of his painting might be one of chaos, of "forms apparently scattered at random upon the canvas, which—again apparently—have no relationship one to another." But he emphasized that "the external absence of any such relationship" constituted "its internal presence."[77] Hoping the viewer would be startled by the conflicting colors, the disorienting space, the remnants of barely decipherable

apocalyptic and paradisiacal images, Kandinsky wanted the viewer to be shocked into meditating on the mysterious themes of struggle and regeneration in the paintings. In so doing, Kandinsky believed he could involve the viewer in the process of replacing confusion with understanding. If both content and form were too readable and the painting did not reflect the chaotic conditions of the time, Kandinsky believed, the work could not have the impact on the public that he envisioned.

Kandinsky was an internationalist and a universalist. Believing that nationalism brought "decline,"[78] he was sympathetic to the interests of friends in forming a transnational union of art and politics. Correspondence from 1914 with the Serbian writer and lecturer Dimitri Mitrinovic, who referred to Kropotkin's works and planned to visit the English socialists Wells and Shaw,[79] and with the Berlin writer Erich Gutkind,[80] who would meet with Buber, Landauer, and other pacifists in June of 1914,[81] suggests his involvement. But Kandinsky indicated that he could be of the greatest assistance through his artistic efforts. He hoped to create a new edition of the almanac, one not only for the arts but for "all spiritual fields," and he wrote to Marc about using Mitrinovic to assist with the new edition.[82]

Above all, Kandinsky believed his approach to art would lead to a better future. The anarchist vision of a revolution that not only would avoid capitalism but also would transform values and regenerate humanity was not in conflict with the Theosophical vision of a coming utopia—a paradise—where all mankind would live in harmony and love. Both viewed the materialism and acquisitiveness of modern civilization as pitting man against man in artificial strife where collective humanitarianism was lost. Both were part of a confluence of messianic thought that contributed to convincing Kandinsky that the discovery of basic truths or natural laws that lay hidden beneath the artificial structures of established governments, religions, and art would change the direction of human life. Theorists of both groups gave support to Kandinsky's interest in folk art, in an art emanating from the indigenous, unspoiled people of all countries, as a powerful transforming source for his work. The emphasis of anarchist and occult groups, in all their varied guises, on opposing traditional conventions to create an appropriate climate for change also gave support to Kandinsky's search for a new way to "shock" his audience out of lethargy into involvement, to prepare them for the struggle for the great utopia.

### Notes

1. Donald Drew Egbert, *Social Radicalism and the Arts. Western Europe: A Cultural History from the French Revolution to 1968*, New York, 1970, p. 435.

2. Ibid.

3. Ibid., p. 226 See also: Eugenia W. Herbert, *The Artist and Social Reform: France and Belgium, 1885-1898*, New Haven, 1961, esp. pp. 5-6, 13-28; and John Rewald, *Post-*

*Impressionism: From Van Gogh to Gauguin*, New York, 1962 (2nd ed.) pp. 154-58

4. See: Alain Mercier, *Les Sources ésotériques et occultes de la poésie Symboliste (1870-1940)*, 2 vols., Paris, 1969, 1974; and Filiz Eda Burhan, "Vision and Visionaries: Nineteenth-Century Psychological Theory, the Occult Sciences, and the Formation of the Symbolist Aesthetic in France (Ph.D. diss., Princeton University, 1979).

5. Egbert (cited n.1), pp. 281-83

6. Virginia Spate, *Orphism*, Oxford, 1979, pp. 85-159.

7. For a survey of some of the literature on the influence of Theosophy and Symbolism on Kandinsky's thought and work, see: Rose-Carol Washton Long, *Kandinsky: The Development of an Abstract Style*, Oxford, 1980, pp. viii, 5, 14-46. See also: Sixten Ringbom, "Die Steiner-Annotationen Kandinskys," *Kandinsky und München: Begegnungen und Wandlugen, 1896-1914*, exh. cat., Munich, Städtische Galerie im Lenbachhaus, 1982, pp. 102-5.

8. Peter Jelavich, in "Theater in Munich, 1890-1914: A Study in the Social Origins of Modernist Cultue" (Ph.D. diss. Princeton University, 1982), discusses Kandinsky's theatrical experiments in the contexts of the political and social upheavals in Germany, see: pp. 366-368. In his 1985 book, *Munich and Theatrical Modernism: Politics, Playwriting, and Performance, 1890-1914*, Cambridge, Mass., 1985, pp. 217-34, he refers more specifically to anarchism and Kandinsky.

9. Wassily Kandinsky, "Über die Formfrage," *Der Blaue Reiter*, Munich, 1912; English translation in *Kandinsky: Complete Writings on Art*, ed. Kenneth C. Lindsay and Peter Vergo, Boston, 1982, vol. I, p.242.

10. For a summary fo some of these overlapping groups in Berlin, see: Janos Frecot, "Literatur zwischen Betrieb und Einsamkeit," *Berlin um 1900*, exh. cat., Berlin, Akademie der Künste, 1984, pp. 319-47, 351-53.

11. Literature on European anarchism of the late-nineteenth and early-twentieth centuries emphasizes the multiple direction of anarchists, ranging from the ego or individualist anarchism of Max Stirner and John Henry Mackay, the anarcho-communism or communalism of Kropotkin, the Christian anarchism of Tolstoy, and anarcho-syndicalism. For a general introduction, see: Andrew Carlson, *Anarchism in Germany*, Vol. I, *The Early Movement*, Metuchen, N.J., 1972, pp. 1-11. Ulrich Linse, in "Indidvidualanrchisten, Syndikalisten, Bohémiens," *Berlin* (cited n. 10), mentions that all these various anarchist groups in Germany offered a leftist "ideological and organization alternative" to the Social Democratic Party, p. 440.

12. For a discussion of Kropotkin's influence in Russia and for a survey of the varied anarchist groups that developed there in the early years of the century, see: Paul Avrich, *The Russian Anarchists*, Princeton, 1967, pp. 3-119.

13. See: Rose-Carol Washton Long, "Expressionism, Abstraction, and the Search for Utopia in Germany," *The Spiritual in Art: Abstract Painting 1890-1985*, exh. cat., Los Angeles, Los Angeles County Museum of Art, 1986, pp. 201-17. See also: Ida Katherine Rigby, *An alle Künstler! War-Revolution-Weimar*, exh. cat., San Diego, San Diego State University, 1983, pp. 35-7, 65-66.

14. "Die staatliche Bauhaus in Weimar," *Beilage zur Thüringer Tageszeitung*, January 3, 1920, Bauhaus Archiv, Berlin. See also: Istvan Deak, *Weimar Germany's Left-Wing Intellectuals: A Political History of the Weltbühne and Its Circle*, Berkeley, 1968, pp. 1-5.

15. See the guide to the 1937 exhibition, *"Entartete" Kunst*, reprinted in Franz Roh, *"Entartete" Kunst: Kunstbarbarei in Dritten Reich*, Hannover [1962].

16. The "Expressionist debate" in the German emigré periodical *Das Wort* of 1937-38 reflects some of these attitudes. Most of the essays are reprinted in *Die Epressionismusdebatte. Materialien zu einer marxistischen Realismuskonzeption*, ed. Hanz Jurgen Schmitt, Frankfurt am Main, 1973. For the clearest discussion of the "debate," see: Franz Schonauer, "Expressionismus und Fascismus: Eine Diskussion aus dem Jahre 1938," 2 parts, *Literatur und Kritik* 7 & 8 (Oct. and Nov. 1966), pp. 44-54, 45-55.

17. Geog Lukács, "'Grösse und Verfall' des Expressionismus," *International Literatur*, 1 (1934); English translation in *Georg Lukács, Essays on Realism*, ed. Rodney Livingstone,

Cambridge, Mass., 1980, pp. 77-113

18. For example, Lothar Gunther Buchheim in *The Graphic Art of German Expressionism*, New York, 1960, focused his discussion of Max Pechstein on his work done before World War I and reproduced none of his politically inspired prints such as the cover of the November gruppe publication *An alle Künstler!*

19. G.L. Mosse, "The Mystical Origins of National Socialism," *Journal of the History of Ideas*, Vol. 22, No. 1 (1961), pp. 81-96.

20. For a brief overview of the reservation of scholars about the influence of Theosophy on Kandinsky, see: Long (cited n.7), p.159 n. 17, and p. 160 and n.27.

21. Anarchism and mysticism have recently been connected with Kandinsky's abstract painting in *Arnold Schönberg—Wassily Kandinsky: Briefe, Bilder und Dokumente einer aussergewohnlichen Begegnung*, ed. Jelena Hahl-Koch, Munich, 1983. However, in the introductory essay, "Kandinsky und Schönberg: Zu den Dokumenten einer Künstlerfreundschaft," Hahl-Koch characterizes their work as "instantly subjective and anarchical" and as reflecting "mystical negativity," pp. 184, 185. This essay had been translated into English, London, 1984; see: pp. 142-143. Hartmut Zelinsky's essay, "Der 'Weg' der 'Blauen Reiter': Zu Schönbeg Widmung an Kandinsky in die 'Harmonielehre,'" pp. 223-70, which was not reprinted in the English edition, refers more specifically to the influence of Theosophy and anarchism upon Schoenberg and Kandinsky. But he overemphasises the significance of the German ego-anarchism of Stirner and Mackay to the exclusion of anarchist communalism and other communitarian and internationalist interests. In addition, he does not discuss Russian anarchist thought.

22. Kandinsky to Marc, March 10, 1914, in *Wassily Kandinsky/Franz Marc—Briefwechsel*, ed. Klaus Lankheit, Munich, 1983, p. 254.

23. Johannes Hemleben, *Rudolf Steiner*, Reibeck bei Hamburg, 1963, p. 71; and also Walter Kugler, "Rudolf Steiner in Berlin," *Berlin* (cited n.10), pp. 394-404.

24. Frecot (cited n. 10), pp. 337-38. Walden, whose Sturm Gallery would feature Kandinsky's works before World War I, also knew the poet Paul Scheerbart and the anarchists Gustav Landauer and Erich Mühsam from these early years. See also: Erika Klüsener, *Else Lasker-Schüler*, Reinbek bei Hamburg, 1980, pp. 44-68.

25. Landauer attacked private ownership of property and bureaucratic authority in favor of a local, grass-roots, and communitarian socialism. Eugene Lunn's *Prophet of Community: The Romantic Socialism of Gustav Laundauer*, London, 1973, offers a clear summary of Landauer's sources; see: pp. 3-16, and passim.

26. Aleksei Remizov, *Kukkha: Rozanovy pis'ma*, Berlin, 1923, p. 23; and James West, *Russian Symbolism: A Study of Vyacheslav Ivanov and the Russian Symbolist Aesthetic*, London, 1970, pp. 76-81.

27. Bernice Glatzer Rosenthal, in "The Transmutation of the Symbolist Ethos: Mystical Anarchism and the Revolution of 1905," *Slavic Review*, Vol. 36 No.4 (Dec. 1977), pointed out that Chulkov attacked individualism and referred to Max Stirner's theories as decadent, p. 613, and passim.

28. Andrei Belyi in *Nacholo veka*, Moscow, 1933, stated that Kusmin lived at Ivanov's apartment, p. 322. Kandinsky translated a 1908 poem by Kusmin for the Blaue Reiter almanac. For a discussion of others such as Aleksei Remizov in Ivanov's circle whom Kandinsky knew, see: Long (cited n. 7), pp. 36-39.

29. See: Rosenthal (cited n. 27), pp. 608-27; and idem, "Theatre as Church: The Vision of the Mystical Anarchists," *Russian History* 4, pt.2 (1977), pp. 122-41.

30. Landauer, for example, introduced Kandinsky's friend Dimitri Mitrinovic to the writings of Kropotkin; see: Mitrinovic to Kandinsky, June 19 (?), 1914, Gabriele Münter-Johannes Eichner Stiftung, Städtische Galerie im Lenbachhaus, Munich. Landauer knew Walden from the Berlin Neue Gemeinschaft circle, and he also knew Walden from the Berlin Neue Gemeinschaft circle, and he also knew Martin Buber and Erich Mühsam from the early years of the century; see: Frecot (cited n. 10), pp. 337-38; and Lunn (cited n. 25), pp. 142-47. Iain Boyd White believes Landauer influenced the communalist idea of Bruno Taut; see: *Bruno Taut and the Architecture of Activism*, London, 1982, pp. 9-12, 53-

57. For additional discussion of the influence of mysticism and anarchism on Taut and his connection with Kandinsky, see: Marcel Franciscono, *Walter Gropius and the Creation of the Bauhaus*, Urbana, 1971, pp. 101-26; and Rosemary Haag Bletter, "The Interpretation of the Glass Dream—Expressionist Architecture and the History of the Crystal Metaphor," Journal of the Society of Architectural Historians, Vol. 40, No. 1 (March 1981), pp. 20-43.

31. Gustav Landauer, *Aufruf zum Sozialismus*, Berlin, 1911, as quoted in Lunn (cited n.25) p. 201. Since the mid-1890s, especially after the Social Democrats excluded anarchists from the International Socialist Congress, and the Stirner followers such as Mackay insisted that anarchism and socialism were not connected, Landauer wanted to justify the anarcho-socialist label. He wrote numerous articles in defense of this concept; see: Lunn, pp. 104-5, 190-4, and passim.

32. Buber, a lifelong friend of Landauer's, was admired by the Wolfskehls, who were interested in Jewish mystical writings, see: *Karl Wolfskehl, 1869-1969: Leben and Werk in Dokumenten*, exh. cat., Darmstadt, Hesse Landesbibliothek, 1969, pp.164-65, 231. For a discussion of Wolfskehl's relation to Kandinsky and other members of the Blaue Reiter, see: Long (cited n. 7), pp. 17-25. See also: Peg Weiss, *Kandinsky in Munich*, Princeton, 1979, pp. 81-91.

33. Ulrich Linse, *Organisierter Anarchismus im Deutschen Kaiserreich von 1871*, Berlin, n.d., p. 92. Will Grohmann reports that Mühsam's name appears in Kandinsky's notebooks; see: *Wassily Kandinsky, Life and Work*, New York, 1958, p. 36.

34. Lunn (cited n. 25), pp. 178-86.

35. Alexander Strakosch, *Lebensweg mit Rudolf Steiner*, Strasbourg, 1947, pp. 22-24. Emy Dresler, who had been a schoolmate of Strakosch's wife, and who exhibited with Kandinsky's Neue Künstlervereinigung, became interested in Steiner in 1908 and painted stage scenery for several of his plays.

36. Hartmann is most well known for the music he composed for Kandinsky's *Yellow Sound*. In two interviews (June 18, 1965, and Sept. 8, 1965) with Olga von Hartmann in New York, she recalled her husband's and Kandinsky's interest in extrasensory phenomena, their reading of Steiner and Blavatsky, and their experiments with writing to friends in Russia and receiving answers although the letters were not mailed. Kandinsky felt very close to the Hartmanns and in a letter of 1911 he compared the warm feelings he had towards Franz Marc and his wife to the feelings he experienced when he was with the Hartmanns. See: Kandinsky to Gabrielle Münter, Aug.10, 1911, Gabriele Münter—Johannes Eichner Stiftung, Städtische Galerie im Lenbachhaus, Munich.

37. Notes dated c. 1909-1913 and reprinted in Jelena Hahl-Koch, *Marianne Werefkin und der russische Symbolismus*, Munich, 1967, pp. 96-101. For a discussion of Steiner's impact on Jawlensky and Werefkin, see: Clemens Weiler, *Alexei Jawlensky*, Cologne, 1969, pp. 68, 70-73.

38. For a summary of the many links, see: John E. Bowlt, "Vasilii Kandinsky: The Russian Connection," *The Life of Vasilii Kandinsky in Russian Art: A Study of "On the Spiritual in Art,"* ed. Bowlt and Rose-Carol Washton Long, Newtonville, Mass, 1980, pp. 1-41.

39. Kandinsky's letters to Kulbin beginning June, 1910, have been edited by E.F. Kovtun in *Monuments of Culture, New Discoveries*, Academy of Sciences of the USSR, Leningrad, 1981, pp. 399-410.

40. Kandinsky, *Über das Geistige in der Kunst*, Munich, 1912; English translation in Lindsay and Vergo (cited n. 9), I, p.146.

41. Mark Slonim, *Russian Theater from the Empire to the Soviets*, Cleveland, 1961, pp. 184, 191, 196, 204.

42 Margarita Woloschin, *Die grüne Schlange*, Stuttgart, 1956, pp. 173ff, 180ff, 207; and Nikolai Berdiaev, *Sampoznanie; Opyt filosofskoi avtobiografi*, Paris, 1949, p. 207.

43. Nikolai Berdiaev, "Tipy religioznoi mysl v Rossii. Teosofiia i antroposofiia. Dukhovnoe Khristianstvo. Sektanstvo," *Russkaia mysl*, Vol. 37, No. 11 (Nov. 1916), p. 1. See also: letter from Andrei Belyi to Aleksandr Blok, 1/14 May 1912, *Aleksandr Blok—Andrei Belyi, Perepiska*, Munich, 1969, p. 295.

44. Kandinsky explained his goals for both

books in "Rückblicke," Berlin, 1913, English translation in Lindsay and Vergo (cited n. 9), I, p. 381. He believed his essay, "On the Question of Form," in the almanac to be an updated and freer continuation of ideas begun in *On the Spiritual in Art*; see: foreword to the second edition (cited n. 40), p. 125.

45. Kandinsky, *On the Spiritual in Art* (cited n. 40), p. 140.

46. Ibid., p. 137.

47. Ibid., p. 143.

48. Ibid., p. 145.

49. Ibid., p. 143.

50. Kandinsky, "On the Question of Form" (cited m. 9), p. 242.

51. Kandinsky, "Reminiscences" (cited n. 40), p. 242.

52. Kandinsky, *On the Spiritual in Art* (cited n. 40), p. 140.

53. Ibid., p. 139.

54. Ibid. Although Kandinsky did not like Tolstoy's emphasis on naturalism in art (p. 130), he was in Moscow at the time of Tolstoy's death. He commented on the peacefulness and order of the civil funeral service, explaining that even the police couldn't arouse disorder. Kandinsky letter to Münter, 10/23 Nov. 1910, Gabriele Münter—Johannes Eichner Stiftung, Munich.

55. Kandinsky, "On the Question of Form" (cited n. 9), p. 242.

56. Kandinsky, "Reminiscences" (cited n. 44), p. 361. For a brief discussion of student protests in Russia in the late 1880s, see: Avrich (cited n. 12), p. 13. Peter Jelavich points out that Kandinsky came from a family with a heritage of political protest. His father had lived in eastern Siberia where his ancestors had been forced to move. Jelavich velieves that Kandinsky first studied law and economics rather than art from a commitment to become closer to the Russian people; see: "Theater" (cited n. 8), pp. 367-68.

57. Kandinsky, "Reminiscences" (cited n. 44), p. 361. Jelavich parallels Kandinsky's directions in *The Yellow Sound* and in his painting with Mühsam's call for "chaos," see: "Theater" (cited n. 8), pp. 432-34. It is interesting to note that Kandinsky's "Reminiscences" were written during the year in which Mühsam published the short-lived journal *Revolution,* where he listed some metaphors for revolution:

"God, life, lust, ecstasy, chaos," Vol. I, No. 1 (1913), p. 2.

58. Kandinsky, "Reminiscences" (cited n. 44) p. 362.

59. Kandinsky, *On the Spiritual in Art* (cited n. 40), p. 214.

60. Kandinsky, "Reminiscences" (cited n. 44) pp. 362, 368.

61. Ibid., p. 369.

62. Kandinsky, "On the Question of Form" (Cited n. 9), p. 248.

63. Kandinsky, *On the Spiritual in Art* (cited n. 40), p. 73.

64. Kandinsky, "On the Question of Form" (cited n. 9), p. 242. Kandinsky also mentions both possibilities very briefly in *On the Spiritual in Art* (cited n. 40), p. 248.

65. Kandinsky, "On the Question of Form" (cited n. 40), p. 248.

66. Kandinsky, *On the Spiritual in Art* (cited n. 40) pp. 193-94. Harriet Watts suggests that the principle of contrast in Kandinsky's work reflects the approach of the German mystic Jakob Böhme. She believes that Steiner's emphasis on the Christian mystic contributed to the interest among many intellectuals of this period in both Böhme and Meister Eckhart; see: "Arp, Kandinsky, and the Legacy of Jakob Böhme," *The Spiritual in Art* (cited n. 13), pp. 239-55.

67. For a discussion of Kandinsky's concept of hidden imagery, his utilization of folk art, and for specific analysis of *Improvisation 28* and *Black Spot*, see: Long (cited n. 7), pp. 66-67, 77-87, 131-33.

68. Kandinsky, "On the Question of Form" (cited n. 9), p. 242.

69. A fourth essay, on Scriabin's *Prometheus*, was written by Leonid Sabaneer, a music critic who frequented Russian Symbolist circles.

70. Kandinsky first wrote to Schoenberg on January 18, 1911; see *Schönberg—Kandinsky* (cited n. 21) p. 21. He may have been aware of Schoenberg's writings before this; see: "On Parallel Octaves and Fifths," Salon 2, Odessa 1910-11, in Lindsay and Vergo (cited n. 9), I, pp. 91-95. Schoenberg, like Hartmann and Kulbin, was also interested in social issues and in the occult; see, for example: Schoenberg's letter to Richard Dehmel of Dec. 13, 1912, where he wrote of moving from "materialism,

socialism, anarchy" to "becoming religious," in *Arnold Schoenberg Letters*, ed. Erwin Stein, New York, 1965, pp. 35-36.

71. Arnold Schönberg, "Das Verhältnis zum Text," *Der Blaue Reiter*, Munich, 1912; English translation in *The Blaue Reiter Almanac*, ed. Klaus Lankheit, London, 1974, pp. 90-102. Hahl-Koch (cited n. 21), pp. 135-70, believes that Schoenberg's concept of dissonance had the greatest impact of all the contemporary composers on Kandinsky. But the influence of Kulbin needs also to be evaluated, since he was a major source for the Russian avant-garde, especially the Cubo-Futurist Alexei Kruchenykh; see: Charlotte Douglas, "Evolution and the Biological Metaphor in Modern Russian Art," *Art Journal*, Vol. 44, No. 2 (Summer 1984), pp. 154, 160; see also: Long (cited n. 7), pp. 63-64.

72. Nikolai Kulbin, "De freie Musik," *Der Blaue Reiter* (cited n. 71). pp. 141-46. Kulbin's essay is an abridged version of one that appeared in 1910 in *Studiia impressionistov*; an English excerpt appears in *Russian Art of the Avant-Garde: Theory and Criticism, 1902-1934*, ed. John E. Bowlt, New York, 1976, pp. 11-17.

73. Thomas von Hartmann, "Über Anarchie in der Musik," *Der Blaue Reiter* (cited n. 71), pp. 114-16.

74. Ibid., p. 118.

75. In his essay, "Über Bühnen-komposition," in the almanac (cited n. 71), p. 195, Kandinsky criticised Wagner for using "parallel repetition," although in *On the Spiritual in Art*, which was written earlier, he had briefly but clearly praised Wagner.

76. Kandinsky, *On the Spiritual in Art* (cited n. 40), p. 194.

77. Ibid., p. 209.

78. Letter with no salutation in Münter's handwriting, July 30, 1914. Gabriele Münter—Johannes Eichner Stiftung, Munich. Münter wrote drafts for almost all of Kandinsky's correspondence.

79. Mitrinovic to Kandinsky, June 25, 1914, June 30, 1914, and undated. Gabriele Münter—Johannes Eichner Stiftung, Munich. Mitrinovic also referred to D.S. Merezhkovsky, whose concept of a "third revelation" had become increasingly important to Kandinsky.

80. For a discussion of Kandinsky's relationships with Gutkind, who, under the pseudonym of Volker, wrote *Siderische Geburt*, urging humanity to end its isolation and acquisitiveness through a transcendent sexuality, see: Long, "Kandinsky's Vision of Utopia as a Garden of Love," *Art Journal*, Vol. 43, No. 1 (Spring 1983), pp. 50-60.

81. For a discussion of this conference, see: Lunn (cited n. 25), p. 245.

82. Kandinsky to Marc, March 10, 1914, *Briefwechsel* (cited n. 22), p. 253.

# SAN FRANCISCO 1952:

## PAINTERS, POETS, ANARCHISM

# BY PATRICK FRANK

The "Beat Era" in San Francisco poetry has been much studied, often to the detriment of the immediately preceding period. The city in the years 1950-54 was no mere stagnant pool awaiting the arrival of a fresh New York stream in the form of Ginsberg and Kerouac. Anarchists will be aware that Kenneth Rexroth led a weekly discussion group called the Libertarian Circle, but even a chronicle of his considerable activity does not account for the entire backdrop to the culminating 1955 subversive outburst at the Six Gallery where Ginsberg read "Howl." There had been five years of particularly intense Abstract Expressionist activity at the California School of Fine Arts (CSFA), just up the hill from North Beach. Under the leadership of Clyfford Still and Mark Rothko between 1945 and 1950, the School had been party to many of the same stylistic and cultural influences that had created AE in New York. The local poetry community included, besides Rexroth, Philip Lamantia, James Broughton, Madeleine Gleason, William Everson, and, most important for our purposes here, Robert Duncan. Duncan and former CSFA student Jess (who never used his last name) were at the center of a new circle in the early fifties that would be an important foundation for the San Francisco Beats. The aesthetic of the "King Ubu Period" (1950-54) had important tendencies in common with some concerns of the high period of abstraction at CSFA. These included strong disaffection from the culture of the time, and the belief that the vatic, mystical, and archetypal modes were the preferred forms of expression. There are enough important connections between artists and poets at this time that it is difficult to discuss the one without the other, and anarchist philosophies provided a catalyst at many key points. The anarchism that was espoused most often in the Bay Area was tolerant and non-doctrinaire, while at the same time neither communitarian nor socialist nor syndicalist. Oriented much more toward Stirner than Kropotkin, Bay Area anarchism in the art community was in some ways a logical outgrowth of the cultural climate of the times. In the ideologically burned-over landscape of the postwar years, only a radically personal and preferably outrageous art style would do, and this found expression in literature as well as painting.

One of the most certain effects of the depression and the war on American culture was to undercut severely the traditional American belief that individual life mattered. In the economic crisis, millions had been impoverished through no apparent fault of their own. Bank and business failures left many with the belief that the economy was not merely the aggregate of the combined wills of individuals, but an impersonal force which seemed impervious to human will or action. Many American literary works of the thirties treated the American Dream of individual progress and success as "rotten, a fantasy, impossible," according to one account.[1] Nathaniel West's *Day of the Locust* presented the dream as a wasteland. Eugene

Facing page: A "poets seminar" sponsored by the Poetry Center in the mid 1950s, Robert Creeley reading. Listeners include, Helen Adam (at left) and Robert Duncan.

ROBERT DUNCAN AS A YOUNG ANARCHIST IN THE 1940s.

O'Neill in *The Iceman Cometh* held it to be an illusion. John Steinbeck in *The Grapes of Wrath* and other works portrayed the dream as bankrupt. Such political optimism as found expression during the decade in either literature or painting was based far more often on some kind of collective action, on the idea of working together to set America right again. According to one historian, the Depression "disrupted the educational, marital, and child-rearing plans of many young Americans; it abruptly ended careers and forced many able-bodied men and women to question their own abilities and dignity."[2]

The War furthered this undercutting of the sense of individual worth. There was a regimentation of many sectors of American society, as rationing, conscription, and price management were undertaken by the national government. Through the National Resources Planning Board and, later, the Office of War Mobilization and Reconversion, the government was involved as never before in what had been private sector economic decisions, placing private good second to the need to win the war.

The conflict itself was brought to a close only with the help of atomic devices which cheapened life on an unprecedented scale. The victory that these weapons made possible brought with them, according to one editorial, "a curious sense of insecurity, rather incongruous in the face of a military victory."[3] Three days after the second atomic bomb was dropped on Japan, Edward R. Murrow mused in a radio broadcast: "Seldom, if ever, was a war ended leaving the victors with such a sense of uncertainty and fear, with such a realization that the future is obscure and that survival is not assured."[4]

The atomic horrors seemed to be so enormous as to overpower the sensibilities, both of those directly involved and of observers. The colonel on the crew of the *Enola Gay* who activated the first bomb recalled, "I felt no particular emotion about it." Novelist John Hersey visited Hiroshima on the first anniversary of the explosion and wrote a series of articles for *The New Yorker* which treated the catastrophe in coolly descriptive, even methodical terms. Mary McCarthy criticized him at the time for treating the atomic bomb as one of the "familiar order of atrocities—fires, floods, earthquakes." Hersey's articles were "an insipid falsification of the truth of atomic warfare," she lamented.[5] Randall Jarrell wrote to a friend shortly after the bombs, "I feel so rotten about the country's response to the bombings of Hiroshima and Nagasaki that I wish I could become a naturalized cat or dog."[6]

Moreover, the atomic bombs had led not to world peace, but to a tense new international order. The wartime alliance of the Big Three—the Soviet Union, England, and America—fragmented into a Cold War by the close of the decade in which the world split into two camps, each competing for power in "unclaimed" areas of Europe and Asia. This international tension reverberated at home, as President Truman began his program

of loyalty checks as early as 1946. Individuals were even more at the mercy of large, impersonal organizations as the awesome threat of nuclear war clogged the arteries of a more traditional sense of American individual freedom. Secretary of State Dean Acheson noted in 1946 that the foreign policy problems that America was then facing were not mere "headaches," for which "you take a powder and they are gone." The current pains, he said, "are not like that. They will stay with us until death. We have got to understand that all our lives the danger, the uncertainty, the need for alertness, the need for effort, for discipline will be upon us. This is new for us. It will be hard for us."[7]

The constant, nagging problems of Depression, war, and tense peace were threatening to lead America into a state of "perpetual crisis," said sociologist Harold Lasswell. A "garrison-prison state" is the "distinctive peril of our historical epoch":

> Beginning as advisers of the civilian arm of government, soldiers and policemen gain stature even in states which possess strong traditions of civilian supremacy. In the

name of security the soldier is permitted to impose restrictions upon the free flow of information and comment. The policeman is authorized to look into the loyalty of government employees, and of ever enlarging circles of persons who might under any conceivable set of circumstances prove dangerous to the state.[8]

C. Wright Mills pointed to an increasing rationalization and bureaucratization of work and business, as formerly personal enterprises, managed by those who owned them, gave way to modern corporations run by "expert managers." If mechanization of labor had long ago alienated the blue-collar worker from the product, bureaucratization of structure alienated the white-collar worker from the process of decision-making:

> The enterprise is not the institutional shadow of great men, as perhaps it seemed under the old captain of industry; nor is it the instrument through which men realize themselves in work, as in small-scale production. The enterprise is an impersonal and alien Name, and the more that is placed in it, the less is placed in man . . . Work becomes a sacrifice of time, necessary to building a life outside of it.[9]

One cultural historian of the period said that the forties are characterized by a "yearning for withdrawal" from an "unmanageable and hellish world":

> The desire to withdraw suggests a felt threat to the integrity of the self. The pervasive play of the forces of depersonalization during the forties constitutes the most significant and substantive generalization that can be made about the period.[10]

These factors led to a widespread questioning of that part of the "American dream" which held that individuals are masters of their own destiny and can have a significant impact on the world. Commenting on the tattered state of American

HASSEL SMITH, UNTITLED OIL PAINTING, 1950, 70" x 120"; THE OAKLAND MUSEUM, LENT BY PAULE ANGLIM.

individualism in postwar literature, one author states, "Popular novelists, sometimes without recognizing it themselves, either rejected the dream outrightly or questioned its validity." An industrial leader, speaking in 1950, was alluding not to the Communist threat in Greece but to the American economy when he said, "The greatest issue of today is the survival of individual liberty."[11] The picture that emerges of the immediate postwar years is of an extremely unsettled time in which previous orthodoxies are of highly questionable value, when the world is an unpredictable and unstable place, and the most urgent questions have to do not with politics or causes but with the self and its survival. Other concerns gave way during the forties to "the greatest need in the period—the need to know who one was."[12]

These pressures were both felt and acted upon in artistic circles in the Bay Area after the War. In 1946 Kenneth Rexroth founded the Libertarian Circle, a weekly discussion group whose purpose was to sift through the wreckage of ideologies left behind after the conflict. In weekly, leaderless meetings whose general topic was chosen in advance by a steering committee, the circle was an attempt to "refound the radical movement after its destruction by the Bolsheviks, and to rethink all the basic principles and to subject to searching criticism all the ideologies from Marx to Malatesta."[13] The group rented the top floor of a house on Steiner Street, and anarchist themes soon came to dominate the discussion subjects, among which were the following: "Mystical Opposition to the State by William Blake, D.H. Lawrence and Henry Miller;" "Mutualist Anarchism in America;" "The I.W.W."; and "Andalusian Agricultural Communes."[14] The group was heavily attended by poets, among them Robert Duncan, William Everson, Philip Lamantia, Jack Spicer, and Josephine Miles, and art students Ronald Bladen and Knute Stiles were also members.[15] Once a month, the group held dances, and every other week a Poetry Forum met to read and discuss members' work.

In the spring of 1947, Sanders Russell and Philip Lamantia produced the single-issue magazine *Ark*, which contained contributions by most of the leaders of the Libertarian Circle. This magazine represents the clearest statement of anarchist views of the time in the Bay Area, and in many ways the positions taken reflect the postwar stresses on the individual sense of self. The editors reprinted George Woodcock's pamphlet "What is Anarchism?" as a basic introduction. Woodcock also saw (and dreaded) the recent rapid increase in centralized power:

> Today the State is assuming a more dangerous and powerful form than ever before. In every country power is passing steadily into the hands of the growing bureaucrat class founded by the needs of the state. Political and economic control are coalescing into one body, so that the state and its ruling class can maintain more efficiently their control and exploitation.

While Woodcock was not optimistic

about the new anarchist state dawning anytime soon, he did feel a danger in governments and bureaucracies taking advantage of the postwar leveling of values: "This is a period when the old social forms are passing away, when forms of power are changing, when the State itself seems to be driving humanity towards the chaos of a new dark age."[16]

The magazine was illustrated with three reproductions of works by Bladen; all were dark abstractions that owed influence to Clyfford Still and Bladen's fellow student John Grillo. Bladen also contributed linoleum block prints in a style that is descended from Surrealist automatic writing.

Ammon Hennacy, a veteran of the Catholic Worker movement, argued for Christian Anarchism with a strongly individualist bias that seemed to capture the imagination of many in the Bay Area. Drawing about equally on William Lloyd Garrison and Leo Tolstoy, he claimed the individual's right to secede as the basis for future anarchism:

> All connection with the Government is anti-Christian; that taking part in military service or paying taxes to the State supports the tyranny of the State; that it is not by Peace Treaties and Congresses that war will be overcome, but by the refusal of individuals to support war and its parent, the State.

Hennacy was bold enough to refuse to pay his taxes, and stated his position in a letter to the Internal Revenue Service in which he pointed out what he saw as the moral duplicities inherent in the Allied cause during the War:

> The traditional "American Way of Life," the Four Freedoms and the Atlantic Charter used as window dressing for this war, has degenerated into the revengeful Morgenthau plan of starvation for Germany, the giving in to the Stalinist dictatorship on vote power, [and] rule in Baltic and Balkan countries ... The deceit of rubbing off the "USA" on the munitions used to reestablish English, French, and Dutch imperialism in the Far East is worthy of that product of Kansas City gangsterism now vainly trying to solve domestic and foreign problems by drifting and compromise. But the crowning achievement of the "American Way of Death" is Atomic Bomb. Wealthy, arrogant, unrepentant, we shall soon reap what we have sown ... our so-called Christian civilization is doomed to die. Perhaps then light and peace will endure only among those, such as the Hopi Indians, from whom we have stolen this country.

Like the Libertarian Circle, the editors of *Ark* called for "a thorough revaluation of the relations between the individual and society." They too saw a rapid recent growth in centralized state authority, along with a "debasement of human values made flauntingly evident by the war":

> Present day society, which is becoming more and more subject to the State with its many forms of corrupt power and oppression, has become the real enemy of individual liberty. Because mutual aid and trust have been coldly, scientifically destroyed; because love, the well of being, has been methodically parched; because fear

and greed have become the prime ethical movers, States and State-controlled societies continue to exist.[17]

Traditional anarchist thought has been divided on exactly where future hope lies. Some theorists, such as P. J. Proudhon and Peter Kropotkin, saw mutual aid, voluntary cooperation, and other kinds of local organization as holding the key for the future stateless society. Syndicalist labor movements also held this as an ideal, and this cooperative emphasis has been the dominant mode of such anarchist political organization as has existed since the mid-19th century.

However, Russell and Lamantia did not issue any specific call for group or collective action. They wanted to avoid the pitfall of the "workers' state," with its intimations of Marxist utopianism. They drew rather on the radical individualist strain of anarchist thought, whose 19th century pioneer was Max Stirner. Unlike Garrison, Tolstoy, or Hennacy, Stirner was an atheist; he confessed no authority higher than himself. Yet his very individualism was influential after the War. In turgid rhetoric, Stirner denounced political organization of whatever stripe as "inorganic," impersonal, and alien to the self's concerns:

> I am owner of my own strength when I am aware of myself as an individual. In the individual even the owner returns to his creative nothingness out of which he was born. Every higher being over me, whether God or man, weakens the feeling of my own individuality,

and only pales before the sun of my consciousness.[18]

When Russell and Lamantia say, "Any inorganic thing made authority over the organic is morally weakening and makes annihilating warfare inevitable," they betray Stirner's influence. Russell and Lamantia hesitated to draw too specific a picture of the society they had in mind, but they thought it must begin with an act of withdrawal by each individual, in order to preserve the self from the corrupting influence of politics, however well-intentioned:

> Only the individual can cut himself free from this public evil. He can sever the forced relations between himself and the state, refuse to vote or go to war, refuse to accept the moral irresponsibility yoked onto him.

The editors claimed that "There is rising among writers in America, as elsewhere, a social consciousness which recognizes the integrity of the personality as the most substantial and considerable of values," and they cited the journals *Retort, Freedom, Why?*, and Dwight Macdonald's *Politics* as others allied with them.

The Poetry Forum, biweekly offshoot of the Libertarian Circle, sponsored readings in art galleries in 1947 and 1948. First there was a performance at the Lucien Labaudt Gallery, organized by James Broughton, Madeleine Gleason, and Duncan; this trio later held readings at the San Francisco Museum of Art. Broughton recalled these gatherings: "It was so exciting. It was poetry, music, and painting—a whole burst of creative

EDWARD CORBETT, UNTITLED OIL PAINTING, 1950, DIMENSIONS UNKNOWN; PHOTO COURTESY SAN FRANCISCO ART INSTITUTE LIBRARY.

energy."[19] Duncan was at that time earning his living as a typist in Berkeley. First he worked for U. C. Berkeley anthropologist Paul Radin in his preparation of African folktales for publication, then for Henry Miller's old friend the Jungian storyteller Jaime de Angulo, who had been recently diagnosed with cancer and was collecting his literary remains. Duncan, perhaps through these connections with researchers on tribal cultures, investigated for himself the writings of Antonin Artaud, the French Surrealist poet and playwright who had made a trip to Mexico in the thirties. Artaud's "Voyage to the Land of the Tarahumara," an essay on the mystical experiences of the shamans of the tribe, appeared in English in 1948 in a version which Duncan said "became an underground text for us in San Francisco."[20]

In 1949, as the Libertarian Circle was disbanding, Duncan gathered together the Poetry Conference in Berkeley, which included students from the University, though it had no official status there. Duncan and Jack Spicer, whom Duncan had met through Angulo, were the principal organizers of this group, which met weekly for readings and discussion of each other's work; CSFA students Brock Brockaway and Jess also attended these readings. In the spring of 1950, according to Jess, "the professors at U.C. banned the Poetry Conference readings from the campus, saying they led to the corruption of the students." This led, Jess recalled, to "an immigration from Berkeley to San Francisco" which included poets Spicer and Robin Blaser along with painter Lynn Brown.[21] Duncan soon wrote "A Play of Masks," a farce about the dispute which was acted out at CSFA that summer, with poets and artists sharing the cast. Duncan and Jess also began a relationship which led to their moving in together in early 1951. Together with Duncan, Jess helped to establish the climate for early fifties avant-garde art in San Francisco.

Born in Long Beach, California, in 1923, Jess's education at the California Institute of Technology was interrupted in 1943 when he was drafted into the Manhattan Project. He worked in uranium production at Oakridge, Tennessee, until the close of the War, when he returned to Cal Tech to finish a B. S. degree in radiochemistry in 1948. He worked for about a year on the Hanford Project in Washington state, also in plutonium production, but during that time began painting on the side as, he recalled, "an antidote to the scientific method."[22] He changed his vocation to artist in late 1949, and began attending CSFA under the G. I. Bill. Though he was a student of Clyfford Still, Mark Rothko, and David Park, he made few abstract paintings; heavily brushed figural works characterize his CSFA years, which ended in 1951, shortly after he and Duncan set up house.

The problem of where to exhibit was acute. Lucien Labaudt was only intermittently committed to showing young artists, and two other venues had closed in 1950. Painter Harry Jacobus, also a former CSFA student,

JESS, SEVENTY XXTH SUCCESS STORY, COLLAGE, 1953, 59" x 42½"; UNIVERSITY ART MUSEUM, UNIVERSITY OF CALIFORNIA AT BERKELEY; PURCHASED WITH THE AID OF A GRANT FROM THE NATIONAL ENDOWMENT FOR THE ARTS, MONIES RAISED BY THE UAM COUNCIL, AND FUNDS DONATED BY THE TURNBULL FOUNDATION FUNDED BY WILLIAM D. TURNBULL AND PAULE ANGLIM.

heard that a theater company was vacating a small space in a converted 19th century carriage house in San Francisco's Marina district, and the rent would be low. The place had an eighty-foot-long hallway which was suitable for art exhibitions, and in the back was a small stage with floodlights which the previous occupants had left behind. Duncan, Jess, and Jacobus took it over in late 1952 as a cooperative project for artists and poets and named it King Ubu, after Alfred Jarry's 1896 absurdist play *Ubu Roi*. [23] The name of the gallery was significant: Jarry was a noted Paris anarchist (and friend of Picasso) whose anti-statism was strong enough to cause him to wear a revolver on his hip, cowboy-style, and to speak the Breton dialect, which the government had declared illegal. The theme of *Ubu Roi* is how authorities and governments inhibit the free expression of individual feeling and impulse, and the King Ubu gallery was likewise to serve as a refuge for modes of expression that found no outlet elsewhere. They agreed when they established it that it would last only a year. In that brief space there were many significant events held there. There were a total of fifteen art exhibitions which emphasized the latest San Francisco Abstract Expressionism. Hassel Smith, Edward Corbett, and Jess all had shows.

Smith, a self-confessed World War II draft dodger, had been politically radicalized by serving as a Farm Security Administration caseworker among migrant fruit pickers during the war. A teacher of painting at CSFA from 1945-52, he at first painted in a social realist style the bars and hangouts of North Beach. In 1948, he edited a version of *The Communist Manifesto* for a local radical bookshop, and printed it with woodcut illustrations by fellow artists. That same year, he plunged headlong into Abstract Expressionism under the twin influences of the jazz improvisation he heard in the clubs, and the dramatic abstract paintings of Clyfford Still. Smith recalled his theory of painting in a way that highlights his love of chaos: "Thinking of your white, unworked-upon canvas as being in its ordered condition, the only possible action you can take in respect to it is to destroy that static order and replace it with something disordered and alive."[24]

In the 1950 work illustrated, Smith's paint application is thick and drippy. The color scheme is garish, with blues, magentas, and blacks predominating. Some indeterminate figures seem to hover in a horizontal array across the middle; one item at the far right suggests a wine flask, or (more likely) sex organs. The subtle hints that point to a still life do not quite congeal, nor do they fit this work's huge 6' x 10' dimensions. This canvas is fairly typical of Smith's brash, outrageous style, with one notable exception: for his King Ubu show, Smith gave many of his works satirical titles, such as *You May Go Now* and *Tiptoe Down to Art*.

Corbett had lived in New York during the war, and had joined the Mondrian-influenced group American Abstract Artists through the

influence of Ad Reinhardt, whom he knew. Even as Corbett too joined the legions of compass-and-ruler abstract painters in search of perfect beauty and spiritual proportions in art, he privately confessed grave doubts about the entire enterprise. In the third person, he raged:

> The streets of London are dripping with the blood of little children. Fascists are slaughtering Jews as fast and savagely as they can. The Marines are isolated on Guadalcanal. The world is a glob of shit from a hemorrhoidal asshole—so he thinks. And this painter, who, mind you, considers it his job on earth to produce things of beauty . . . finds himself suddenly face to face with this question: How can this be?[25]

Coming to San Francisco at the close of the war, Corbett began teaching at CSFA and reading existentialism. Particularly drawn to the bleak freedom of Jean-Paul Sartre, whom the painter said he found "intelligent and meaningful," Corbett began gradually to loosen his formerly rigid painting style.

By 1950, he was producing completely abstract works such as the one illustrated, in which large masses collide and jostle each other. The overwhelmingly tarry surface of the work is broken by blank canvas and what seem hovering clouds. As with Smith, paint drips testify to the work's spontaneous, explosive execution. In 1951, the year before his King Ubu show, Corbett issued a statement that speaks of the tightly circumscribed postwar sense of self and the hope that art can become "the critical work of individuals in a static and institution-ridden society ... proof, at any rate, that specific virtues may grow from vast conglomerates of evil."[26]

Of Jess's work from this time, only the less interesting pieces are preserved. *The Seventy XXth Success Story* (pictured) is a painted collage mounted on a wooden frame. The painting contains flat, curving forms in a shallow space reminiscent of Cubism; paint drips testify to its spontaneous facture. In the interstices of color, the artist glued down what appear to be randomly selected phrases from magazines. Some of these clippings come from headlines ("NEW WORLD/Comes to a Summer/Ball Game with Grath"), and some are taken from advertising ("Solve your beauty problems; Choose the Shade you want/that never talks back"). The antecedents for this type of collage include German dada of the World War I period, when artists assaulted social and artistic proprieties with a vigor similar to that which Jess displays here; Picasso's cubism is another antecedent, especially his collaged paintings from just before the First World War. Both of these sources share anarchist influences, a factor which may have been an influence on Jess.[29] Also, Duncan and Jess had recently bought a book by pioneer Surrealist Max Ernst which contained many such illogical juxtapositions. Jess's destroyed pieces from the King Ubu period include a series of "Necrofacts," which the artist described as "jammed and interlocked assemblies made up of real junk off

the rubbish pile. One was a drawing on a piece of toilet seat Protecto with a battered toilet seat for a frame."[28]

There were, in addition, many poetry readings in the gallery. Duncan read H.D.'s poems along with own work. Rexroth, Spicer, Lamantia, Gleason, and Weldon Kees also did readings from their current work. Stan Brakhage, recently arrived from Colorado, showed his first two films, *Interim* and *Unglassed Windows Cast a Terrible Reflection*. According to the organizers, attendance at these events was never large. Thirty to forty people would come to openings. During the week, Jess recalled, "You'd sit there a whole day with only one or two coming in. I got a lot of reading done." Jacobus said, "Some people would poke their heads in and run out again. Quite a few interior decorators did that."[29]

Yet King Ubu was the seed of what would eventually become the Bay Area Renaissance. Poet Michael McClure came to San Francisco from Kansas City with the desire to study painting with Clyfford Still, not knowing that Still had left. "The mystique of Abstract Expressionism fascinated me," he recalled.[30] He made several visits to King Ubu while studying at San Francisco State College. Rexroth told him that San Francisco was going to be for the arts what Barcelona had been for Spanish anarchism. McClure's recollection of the early fifties in San Francisco is flavored with the earlier antiwar tradition in the city:

There was no way, even in San Francisco, to escape the war culture. We were locked in the Cold War and the first Asian debacle— the Korean War . . . We hated the war and the inhumanity and the coldness. The country had the feeling of martial law.[31]

From Los Angeles came Wallace Berman, one of the founders of the Assemblage style. A largely self-taught artist, Berman did album covers for "race" musicians Slim Gaillard and Harry "The Hipster" Gibson in the late forties. An avid reader of the Surrealist magazines *View* and *VVV*, he read in them work by Duncan and Lamantia, and late in 1953 he made a trip north to San Francisco to meet them. He failed to see Lamantia, but his visit to Duncan and Jess turned out to be important in a number of respects, because on his visit north Berman learned about ideas that had been common currency among poets and artists in the Bay Area for years. Duncan related, for example, that they told Berman about Jung's book *Integration of the Personality*, in which the psychoanalyst had "seen extreme disintegration as the condition for the psyche-work of a radical reintegration of all elements, a conjunction of opposites." Duncan described his and Jess's apartment as

transformed into another world with its suite of rooms painted by Jess, its assemblage of association, its beginnings of a life exploration of the Romantic spirit—for us, a wisdom of old folk magics, of wondertales and mysteries, and a keeping open the inspiration of Nature, of Cosmos, and of fantasy worlds in the work of art.

Duncan said, "There was in the course of the afternoon an unfolding recognition that we were possibly fellows in our feeling of what art was."[32]

Berman returned to Los Angeles and began using cast-off furniture parts, brought home from his work in a factory, in assemblages that bespoke the same concern with myth, ritual, and magic that he had read about in the magazines and seen in the work of Duncan and Jess. He also began producing the underground newsletter *Semina* on a 5" x 8" handpress at irregular intervals. The first issue contains several drawings, a photograph of Berman's wife, and this short, Surrealist lyric by Marion Grogan, which is typical of *Semina* in its heavy reference to myth and magic:

When it was warned
That ancient tides are not polite
As beasts wary with sudden grace
Before the fleshed iceburning moon;
When it was learned
Boneloose as dance or fingers' sight
Leaves one or thousand aspects still
Untouched in Brilliant noon.[33]

Berman would later be at the center of a group of assemblagists at the Ferus Gallery in Los Angeles that included George Herms and Edward Kienholz.

Meanwhile, the year allotted to King Ubu ran out, and Duncan and Jess closed the space at the end of 1953. They soon left for Spain, but not before meeting Allen Ginsberg, who had been living in San Jose for the previous several months. In October of 1954, Ginsberg introduced himself in San Francisco, attending Friday evening gatherings at Rexroth's and visiting local galleries and readings.

In the middle of that year, the old King Ubu space was taken over by a new cooperative of artists who were committed to a vision similar to that of Duncan and Jess. The Six Gallery was run by a group of six that included assemblagist Wally Hedrick, former CSFA student Deborah Remington, and poet Jack Spicer. Again, art shows shared the space with poets reading from their work. The most notable event in the history of the Gallery, of course, was the night of October 13, 1955, in which Ginsberg read "Howl," and which inaugurated the Beat movement. The story of this evening, which included Allen Ginsberg, Kenneth Rexroth, Philip Whalen, Gary Snyder, Michael McClure, and Philip Lamantia, has been well told elsewhere;[34] here I merely want to point out some ways in which the spirit of King Ubu lingered over the evening.

On display in the gallery that night were sculptures by Fred Martin, who had studied at CSFA in 1949 and 1950 with Rothko and Still. He was exhibiting assemblages in organic, dancing shapes which Michael McClure described as "pieces of orange crates that had been swathed in muslin and dipped in plaster of paris to make splintered, sweeping shapes like pieces of Surrealist furniture."[35] McClure retained a strong sympathy for Abstract Expressionist painting, and saw it as allied to his own quest for a pure, unmediated expression. He

is best known for reading that evening his "Point Lobos: Animism," which is a tribute to Artaud; the best expression of his goals at that time, however, is in his "Hymn to St. Geryon," a four-page lyric which is named for a monster in the Hercules myth.[36] The theme of the poem is his struggle to achieve the purest expression of himself, and make what he called "THE GESTURE":

To clothe ourselves in the action,
to remove from the precious to
    the full swing.
To hit the object over the head.
    To step
into what we conjecture. Name it
    the *stance*. Not politics
but ourselves—is the question.

The poem, which is published with all lines centered on the page, contains obscure grammar, idiosyncratic punctuation, and bursts of capitalization for emphasis in several places. McClure's model in this quest for emotional immediacy, of course, is Clyfford Still, whom McClure quotes at some length and without alteration:

Clyfford Still: "We are committed
to an unqualified act,
not illustrating outworn myths
or contemporary alibis. One must
accept total responsibility for what
he executes.
And the measure of his greatness
will be the depth of his
insight and courage in realizing
his own vision. Demands for communication are presumptuous and irrelevant."

This epigram points to the most important idea that was nourished at King Ubu and shared by the poets, painters, and anarchists: that the best utterance is an "unqualified" one, which, as far as possible, does away with the exigencies of convention, custom, and circumstance, in an effort to translate purely the flash of insight from within. When Allen Ginsberg read that night the well-known lines about "the best minds of my generation,"

who wandered around and around
at midnight in the railroad yard
wondering where to go, and went,
leaving no broken
    hearts,
who lit cigarettes in boxcars box-
cars boxcars racketing through
snow toward lonesome farms in
grandfather night
who studied Plotinus Poe St. John
of the Cross telepathy and
    bop kaballa because the cosmos
instinctively vibrated at their feet
in Kansas . . .

he was seeking the vatic, prophetic, oracular voice that had been an important concern for both painters and poets in the Bay Area for the previous ten years. Ginsberg found that voice in San Francisco, where, Rexroth recalled, "He inhaled the libertarian atmosphere and exploded."[36]

## Notes

1. See Charles R. Hearn, *The American Dream in the Great Depression* (Westport, Conn., 1977), ch. 3.

2. James Gilbert, *Another Chance: Postwar America* (New York: Knopf, 1981), p. 9.

3. Editorial in *New Republic*, Aug. 1945; in Paul Boyer, *By the Bomb's Early Light* (New York, 1985), p. 7.

4. Murrow, Radio broadcast of Aug. 12, 1945; quoted in Boyer, p. 7.

5. Mary McCarthy quoted in Richard Pells, *The Liberal Mind in a Conservative Age* (Middletown CT, 1989), p. 46.

6. Jarrell to Margaret Marshall, Sept. 29, 1945; quoted in Boyer, p. 146.

7. Quoted in Goldman, *The Crucial Decade—And After: America, 1945-1960* (New York, 1965), p. 125.

8. Harold D. Lasswell, "The Universal Peril: Perpetual Crisis and the Garrison-Prison State"; *Perspectives on a Troubled Decade: Science, Philosophy, and Religion, 1939-1949*, ed. Lyman Bryson et al. (New York, 1950), pp. 323-328.

9. C. Wright Mills, *White Collar: The American Middle Classes*, New York, 1951; quoted in Chester Eisinger, *The 1940s: Profile of a Nation in Crisis* (Garden City, NJ, 1969), pp. 183, 185.

10. Chester Eisinger, ibid., p. xv.

11. Donald G. Baker, "Postwar American Fiction;" Carroll M. Shanks, "The Common Man in an Uncommon Decade," speech at the Executives Club of Chicago; both quoted in Donald G. Baker and Charles H. Sheldon, *Postwar America: The Search for Identity* (Beverly Hills, 1969), pp. 19, 28.

12. Eisinger, *The 1940s*, p. xvii.

13. Rexroth, *An Autobiographical Novel II*; quoted in Linda Hamalian, *A Life of Kenneth Rexroth* (New York 1991), p. 149.

14. Ekbert Faas, *Young Robert Duncan: Portrait of the Artist as a Homosexual in Society* (Santa Barbara CA, 1983), p. 192.

15. Jess, letter to the author, Dec. 17, 1991.

16. George Woodcock, "What is Anarchism?" *Ark* 1 (1947): 21, 22.

17. Quoted passages from Philip Lamantia and Sanders Russell, "Editorial"; ibid., p. 3.

18. Max Stirner, *Der Einzige und sein Eigentum* (The Ego and Its Own), first published 1845; quoted in James Joll, *The Anarchists* (Boston, 1964), p. 171.

19. Quoted in Faas, *Young Robert Duncan*, p. 236.

20. Duncan, "Wallace Berman, The Fashioning Spirit"; Otis Art Institute, *Wallace Berman Retrospective* exh. cat. (Los Angeles, 1978), p. 20.

21. Jess, letter to the author, Dec. 17, 1991.

22. Quoted in Michael Auping, "Songs of Innocence"; *Art in America* 75 (Jan. 1987): 120.

23. The story of the founding is told in Christopher Wagstaff, *An Art of Wondering:*

*The King Ubu Gallery, 1952-53* privately printed exhibition booklet, Davis, CA, 1989.

24. Hassel Smith, "The San Francisco School"; typescript (1956?) in Hassel Smith Papers, Archives of American Art, Smithsonian Institution (AAA).

25. Edward Corbett, "Certain Concepts Relating to Art and Artists in 1944," typescript in Edward Corbett Papers, AAA.

26. Edward Corbett in *SFAA Bulletin* 17 (Jan. 1951), n.p.

27. For anarchist influence on German early Modernism, see Eric Bronner (ed), *Passion and Rebellion: The Expressionist Heritage* (South Hadley, MA, 1983); on Picasso and early Cubism, Patricia Leighten, *Re-ordering the Universe: Picasso and Anarchism, 1987-1914* (Princeton, 1989).

28. In Wagstaff, *An Art of Wondering*, p. 9.

29. ibid., p. 9.

30. Michael McClure interviewed by David Meltzer in *Golden Gate: Interviews with Five San Francisco Poets* (Berkeley, 1971), p. 195.

31. Michael McClure, *Scratching the Beat Surface* (San Francisco, 1982), p. 12.

32. Robert Duncan, "Wallace Berman: The Fashioning Spirit"; *Wallace Berman Retrospective*, p. 19.

33. Marion Grogan, untitled, *Semina* 1 (1955), n.p. Berman exhibited several assemblages in his first solo exhibition at the Ferus Gallery in Los Angeles in 1957, but the show closed after the police arrested the artist for obscenity because of a drawing of a nude woman in one of the pieces. When a fellow artist paid the fine for him, Berman moved to San Francisco, where he continued to produce assemblages along with his newsletter.

34. Allen Ginsberg, *"Howl" :Original Draft Facsimile* (New York, 1986); Michael McClure, *Scratching the Beat Surface*; Jack Kerouac, *The Dharma Bums* (New York, 1958), a fictionalized version.

35. McClure, *Scratching the Beat Surface*, p. 13.

36. McClure, "Hymn to St. Geryon," *Hymns to St. Geryon* (San Francisco, 1959); all citations come from this source.

37. Quoted in Hamalian, *A Life of Kenneth Rexroth*, p. 410 n. 33.

# VIGO'S ANARCHY REVISITED

## BY RICHARD PORTON

**P**erhaps inevitably, an "anarchist aesthetic" has proved elusive. While the work of writers such as Emma Goldman and Rudolph Rocker represent concerted attempts to define the contours of an anarchist imagination, these efforts seem partial and schematic despite the authors' considerable erudition. In many respects, the films that Jean Vigo directed during his brief lifetime, as well as the manifestos that accompanied them, are more successful examples of a continually evolving anarchist aesthetic than treatises that invariably reflect the artistic biases of another era. Although Goldman and Rocker's entirely understandable respect for nineteenth-century realists such as Tolstoy and Ibsen now seem slightly musty, Vigo's "social cinema," which good naturedly spits in the face of the linear narratives and facile teleologies associated with traditional social realism, seems infinitely more contemporary.

While it is well known that Vigo was the son of a renowned anarchist, Miguel Almereyda, the depoliticization of Vigo's career has been the implicit project of many of the subsequent critics and filmmakers who have championed him. This tendency is probably best exemplified by the late Francois Truffaut and his cohorts at *Cahiers du Cinéma,* a magazine that was resolutely apolitical at its inception, although it subsequently exchanged militant aestheticism for an inchoate form of Maoism after May '68. Truffaut's Francophiliac version of Vigo reduces him to a traditionally French exponent of "poetic cinema" and childhood reverie. Similarly, many recent critics and directors have a near-reverential regard for Vigo, but neglect the political impetus that makes works such as *Zéro de Conduite* (*Zero for Conduct,* 1933) and *L'Atalante* (1934) such incendiary works of art. The most grotesque outgrowth of this trivialization of Vigo's legacy is unquestionably Leos Carax's recent *Les Amants du Pont Neuf,* a twenty-five million dollar paen to "the homeless" that incorporates an explicit *hommage* to *L'Atalante.* Carax's vacuous film transforms Vigo's anarchist salvos into "art cinema," and nothing becomes rancid faster than a bloated commercial film masquerading as radical art.

Vigo once observed that a "social cinema would mean saying something to people which would awaken other reactions than just the burps of those who go to a movie because its good for their digestion." This sort of cinematic provocation is embodied by Vigo's notion of "social documentary—the study of endlessly self-renewing topics drawn from everyday life." This stance undermines the supposed opposition between committed social art and avant-gardist innovation. Like Rimbaud, Vigo suggests a path to an avant-garde (if the term need be used) that is not intransigently elitist or perversely hermetic. In addition, Vigo's interest in the nuances of "everyday life" that would subsequently consume the energies of the Situationists prevented him from embracing the empty self-referentiality of many avant-gardists.

For Vigo, artistic play is never nar-

Facing page: Jean Vigo directing *L'Atalante,* ca. 1933.

cissistic, but always an incentive for the audience to participate in films that function both as critiques of bourgeois mores and poetic documents that have a vital relationship to the more radical strains within the French Romantic tradition.

Given the fact that the term "critical pedagogy" has become a bureaucratic catchphrase in recent years, it is instructive to view *Zero for Conduct* as an example, as well as an espousal, of anarchist pedagogy. The film defies summary, since it consists of a succession of lyrical moments that cannot be accurately reduced to narrative exegesis. While the squalid provincial boarding school that serves as the film's backdrop has an autobiographical component, *Zero for Conduct* employs memories of boyhood anguish in order to offer a general indictment of the method of incarceration commonly known as schooling. Yet in the manner of truly effective counter-pedagogy, Vigo's riposte is thoroughly undidactic: the film is the polar opposite of Brechtian *lehrstücke*. A liberatory antidote to classroom anomie is posed with

Vigo's oneiric use of camera movement and slow motion, thus avoiding the heavyhanded pleadings of much political cinema, whether of the social-realist or avant-gardist variety. *Zero for Conduct* may be the most vehemently anti-authoritarian film ever made, yet Vigo's disdain for entrenched power is conveyed entirely through imagery that is possible only in the cinema. An ineffectual teacher's Chaplinesque strut, an androgynous boy's dreamy stare, and an autocratic headmaster's frenzied ravings suggest the boredom, longing, and misery inspired by the average educational institution in ways a mere manifesto never could.

*Zero for Conduct's* famous final sequence—the schoolboys' concluding gesture of revolutionary defiance—crystallizes what may have seemed like random vignettes from a glum childhood into a specifically anarchist critique. At a staid Alumni Day celebration with representatives of the Church and State (a Bishop and Governor) in attendance, recalcitrant students interrupt the proceedings with catcalls, hurl shoes and homemade

*Zéro de Conduite:* 'making their way into the sky, into freedom'.

*L'Atalante:* Jean and Juliette.

weapons at the guests of honor, and make their escape to freedom through the school's roof. This joyous rebellion does not merely represent a negation of one school's dismal regimen, but unites Vigo's indictment of authoritarian pedagogy (undoubtedly influenced by the tenets of Francisco Ferrer, the Spanish libertarian educator and ally of Vigo's father) with anti-clerical and anti-statist motifs. Despite the fact that *Zero for Conduct's* influence can be discerned in films such as Lindsay Anderson's *If* and Marco Bellochio's *In the Name of the Father,* these classroom parables seem tame when contrasted with the insurrectionary fervor of Vigo's brief film.

*L'Atalante,* Vigo's last film, is often stereotyped as an introspective work which retreated from the more radical implications of *Zero for Conduct.* Yet *L'Atalante,* with its moving delineation of erotic love which is first thwarted and later fulfilled, can be considered a companion piece to *Zero for Conduct,* since the film's promotion of the "education of the senses" continues the previous film's adherence to the precepts of militant deschooling.

The plot is deceptively simple. Jean (Jean Dasté) and Juliette (Dita Parlo), a newlywed couple, take an excursion down the Seine on a dilapidated barge. When Jean, the barge's skipper, is separated from Juliette, the couple is reunited through the intervention of Jean's curmudgeonly colleague, Père Jules (Michel Simon). Despite the film's ostensible preoccupation with personal fulfillment rather than social transformation, Jean and Juliette's amorous progress is actually inextricable from the particularities of the social fabric. When Juliette becomes separated from her husband in Paris, Vigo's camera pans to the unemployed workers who were certainly an unavoidable presence in Depression-era France. Vigo's consistently anti-authoritarian perspective is illustrated in a sequence which highlights a thief's attempt to steal Juliette's purse as she purchases a railway ticket. For a short time, Vigo's focus is diverted from his protagonists to events more conventional directors would consider peripheral. The middle-class crowd swoops downs upon the thief as if they meant to lynch him: the well-fed take their revenge upon a scruffy renegade. Vigo's empathy seems to be split between the downcast Juliette and her pathetic assailant; his ability to extend his compassion beyond a narrow universe of discourse makes this film complex as well as radical.

If the frequently fractious lovers provide *L'Atalante* with its amatory center, Père Jules, played by the extravagantly eccentric Michel

Simon, seems to serve as Vigo's benignly grotesque alter ego. Père Jules speaks nostalgically of his days in Caracas "during the revolution" and a tattooed nude on his body contains initials for the slogan "Mort aux Vaches" (death to the cows, French slang for police) which P.E. Salles Gomes, Vigo's biographer, informs us was a motto cherished by the poor and adopted by "anarchists in the 1890s." Simon's garbled diction seems only to enhance the character's childlike exuberance; Jules's characteristically anarchist gusto has a kinship with the transgressive revelry of *A Propos de Nice* and *Zero for Conduct*. Whether Jules is modeling an apron for Juliette or balancing a cigarette in his navel, he exemplifies a life force which is congruent with Vigo's penchant to thumb his nose at all things respectable. Père Jules's magnificently cluttered cabin—with its dusty gramophone and unclassifiable bric-a-brac—serves as a metaphor for a film that is defiantly unclassical and proudly disorganized.

Boris Kaufman's exquisite black and white cinematography helps to orchestrate the film's mood of sometimes comic and often melancholy passion; the dreamlike meld of whites and grays transforms otherwise bleak landscapes into luminous alternative worlds. Like the surrealists, Vigo has a tendency to idealize "the feminine" in a way that is decidedly prefeminist. Yet the thoroughgoing misogyny of many of the surrealists is alien to Vigo, and his egalitarian spirit certainly does not preclude the vision of a community in which men and women would be equals.

True to his anarchist origins, Vigo presents an ambiguous portrait of urban life. A certain anarchist tradition spurns the metropolis as an embryonic "necropolis." Another important current which extends from the Paris communards of 1871 to contemporary Lower East Side squatters maintains that urban milieux can be reclaimed and revitalized through concerted direct action. Despite the aforementioned economic ravages that Vigo alludes to in *L'Atalante,* the film is something of an urban pastoral. Père Jules expresses a certain ambivalence toward cities when he moans that "the less time we spend in a town the better." Yet even he sings the praises of "Paris, city of sin and delight." Jean and Juliette are completely captivated by Paris. A peddler flirting with Juliette, the glittering store windows that beckon her, the cabarets, street urchins, and fortune-tellers that the direction lovingly depicts, are all emblems of a utopian affirmation that coexists with the poverty and sordidness that is never repressed.

In an era before postmodernist kitsch became a pathetic excuse for an avant-garde, Vigo clung to the now seemingly naive hope that art could perform a utopian function. Ken Kalman reiterates the fact that "liberation is with Vigo a public rather than an esoteric function," and Vigo's work, together with his exemplary precursors Rimbaud and Jarry, should continue to serve as a reprimand to those who embrace the conformist banalities of academic theory and pseudo-populist "popular culture."

# THE LIGHTHOUSE

BY ANDRÉ BRETON

It was in the black mirror of anarchism that surrealism first recognized itself, well before defining itself, when it was still only a free association among individuals rejecting the social and moral constraints of their day, spontaneously and in their entirety. Among the higher spheres in which we encountered each other in the days following the war of 1914, and whose rallying power never failed, was Laurent Tailhade's "Ballad of Solness," which ends:

*Strike our hearts in thorough-*
*fares in tatters,*
*Anarchy! O bearer of torches!*
*Drive away the night! Crush the*
*vermin!*
*And raise into the sky, be it even*
*with our tombs,*
*The Lighthouse that towers*
*above the waves!*

At that time, the surrealist refusal was total, and absolutely incapable of allowing itself to be channeled at a political level. All the institutions upon which the modern world rested—and which had just shown their worth in the First World War—were considered aberrant and scandalous by us. To begin with, it was the entire defense apparatus of society that we were attacking: the army, "justice," the police, religion, psychiatric and legal medicine, and schooling. At that time, both collective declarations and individual texts (by Aragon; by Artaud, Creval, Desnos, and Eluard; by Ernst, Leiris, Masson, Peret, Queneau and myself) attested to our shared willingness to see them recog-

nized as plagues, and to fight them as such. But to fight them with some chance of success, it was still necessary to attack their armature, which, in the final analysis, was of a *logical* and *moral* kind: the so-called "reason" which was in current use, and, with a fraudulent label, concealed the most worn-out "common sense," the morality falsified by Christianity for the purpose of discouraging any resistance to the exploitation of human beings.

A very great fire smoldered there—we were young—and I believe I must insist on the fact that it was constantly fanned by what was taken from the works and lives of the poets:

*Anarchy! O bearer of torches!*

whether they were named Tailhade, or Baudelaire, Rimbaud and Jarry—whom all our young libertarian comrades should know, just as they should all know Sade, Lautréamont and Schwob (of the *Livre de Monelle*).

Why was an organic fusion unable to come about at this time between anarchist elements proper and surrealist elements? I still ask myself this twenty-five years later. It was undoubtedly the idea of efficiency, which was the delusion of that period, that decided otherwise. What we took to be "triumph" of the Russian Revolution and the advent of a "workers' State" led to a great change in our perspective.

The only dark spot in the picture—a spot which was to become an indelible stain—consisted of the crushing of the Kronstadt rebellion

on March 18, 1921. The surrealists never quite managed to get beyond it. Nevertheless, around 1925 only the [Trotskyist] Third International seemed to possess the means required to transform the world. It was conceivable that the signs of degeneracy and repression that were already easily observable in the East could still be averted. At that time, the surrealists were convinced that a social revolution which would spread to every country could not fail to promote a libertarian world (some say a surrealist world, but it is the same thing). At the beginning, everybody saw it this way, including those (Aragon, Eluard, etc.) who, later on, abandoned their first ideal to the point of making an enviable career out of Stalinism (from the point of view of businessmen). But human desire and hope can never be at the mercy of traitors:

*Drive away the night! Crush the vermin!*

We are well enough aware of the ruthless pillaging to which these illusions were subjected during the second quarter of this century. In a horrible mockery, the libertarian world of our dreams was replaced by a world in which the most servile obedience is obligatory, in which the most elementary rights are denied to people, and in which all social life revolves around the cop and the executioner. As in all cases in which a human ideal has reached this depth of corruption, the only remedy is to reimmerse oneself in the great current of feeling in which it was born, to *return to the principles* which allowed it to take form. It is as

this movement is coming to its very end that we will encounter anarchism, and it alone. It is something that is more necessary than ever—not the caracature that people present it as, or the scarecrow they make of it—but the one that our comrade Fontenis describes "as socialism itself, that is, the modern demand for dignity of humans (their freedom as well as their well-being). It is socialism, not conceived as the simple resolution of an economic or political problem, but as the expression of the exploited masses in their desire to create a society without classes, without a State, where all human values and desires can be realized."

This conception of a revolt and a generosity inseparable from each other and (with all due respect to Albert Camus) each as limitless *as the other* —this conception the surrealists make their own, without reservation, today. Extricated from the mists of death of these times, they consider it the only one able to make appear again, to eyes more numerous with every passing moment,

*The Lighthouse that towers above the waves!*

January 11, 1952

*This text was translated from French by Doug Imrie and Michael William. It appeared originally in the French Anarchist paper* Le Libertaire, *and an earlier version of the translation was published in the Canadian anarchist publication* Any Time Now. *This translation has since appeared in* Mesachabe. *The translators note that the poet who wrote "The Ballad of Solness," Laurent Tailhade, was blinded in one eye by a bomb thrown into a café by an anarchist during the turbulent period of the 1890s which saw widespread despair and resort to "propaganda of the deed." Yet Tailhade wrote his "Ballad" in praise of anarchism only four years later, in 1898.*

# KEEP AN EYE OUT FOR

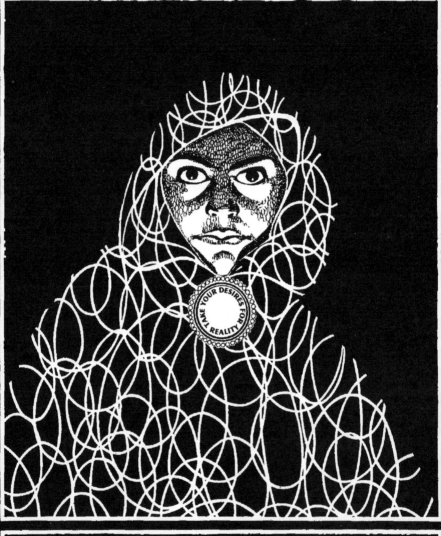

TAKE YOUR DESIRES FOR REALITY

# DRUNKEN BOAT 3

# "WE HAVE PIPED UNTO YOU . . ."

## BY ROBERT REISS

To what degree of fluency can "The Dance of Life" (the title of Havlock Ellis' treasure of a book[1]) be repossessed by the daily, laboring industrial citizen? It may be said, at the risk of patronizing, "We have piped unto you and yet ye have not danced.[2]" Will the dancer contribute to addressing this problem? Can the political and artistic areas which must be scrutinized for once prove unantagonistic? Let us extract fresh vitality from the imperative identified with Emma Goldman: "If I can't dance, I don't want to be a part of your revolution."

The crowded, vertiginous, streets of the work-a-day world are streets in which workers, unlike the studio-bound performer, take hurried steps and seem never to have recorded equilibrium. If risk is part of our natural rythm, the "the dance of life" does not seem to have let the urban laborers win this risk. The dancer can aid them and be of them. The dichotomy of art and life is false says Ellis and he reminds us that the social conditions which led Nijinsky[3] to confess in his madness: "I am a clown of God" also menace those who barely hold on under economic depression. So burdensome is this oppression that "the dance of life" is hardly experienced by the many who have not had the opportunities of developing the expressive gesture of grace. It is to the dance, that people must in part turn. May the dancer be worthy of his or her new devotees.

Martin Buber[4] spoke of Nijinsky and said he saw ". . . the power of surplus and of possibility surge through him." It is this which the modern worker celebrates, too, and, world wide, is celebrating more and more in victorious modes. A beast once horrified a primitive man ("It cast a firebrand glance upon him"[5]). The primitive transformed the impulse of the beast and made dance. This power of transformation integral to dance is also its political base. Edwin Denby[6] says "a formal path involves electing a base from which to move, it involves giving a spot an imaginative value. It is a feat of imagination essential to dancing." All I would add is this: essential, too, for genuine revolution. The imaginative values involved in selecting bases of thesis, antithesis, which lead to synthesis, in the great dialectical dance, if you will, of industrial workers are gained from powers held in common by, say, Isodora Duncan in one realm and, again, say, Eugene V. Debs in another. The transformative vision held in common by their respective traditions can, at the least, break apart arbitrary notions of separate realms.

Buber again: "Around every gesture that the body makes there whirls a glimmering vortex—the possible." Worker and dancer share in life the same time and space and together they could make "the glimmering vortex of the possible visable in a barely noticable undulation in the outline of a *movement*." (Emphasis mine.) If the dancers" body is "only" "a vehicle for artistic form[7]" imagine the situation if the mass-body of a revolutionary movement itself might

Facing page: Isadora Duncan standing in the west door of the Parthenon, 1920.

"Very little is known in our day of the magic which resides in movement, and the potency of certain gestures . The number of physical movements that most people make through life is extremely limited. Having stifled and disciplined their movements in the first states of childhood, they resort to a set of habits seldom varied. So, too, their mental activities respond to set formulas often repeated. With this repetition of physical and mental movements, they limit their expression until they become like actors who each night play the same role. With these few stereotyped gestures, their whole lives are passed without once suspecting the world of the dance which they are missing."

"Oh, she is coming, the dancer of the future: the free spirit, who will inhabit the body of new woman; more glorious than any woman that has yet been; more beautiful than . . . all women of past centuries—the highest intelligence in the freest body."

Isadora Duncan

Abraham Walkowitz: Isadora Duncan

be perceived by dancers as the "final object" of artistic interest. Rudolph Arnheim: "Expression must involve the totality of what is presented." The dancer like everyone else, is presented with a world-essence containing revolutionary impulses and imperatives,; his expression-in-the-world should respond to this I believe.

"The awareness of tension and relaxation within his own body, the sense of balance that, distinguishes the proud stability of the vertical from the risky adventures of thrusting and falling—these are the tools of the dance," explains Arnheim. And they are tools of importance which position in the front ranks of social-action and work the person of the dancer. For does not Arnheims' description of the dancers' tools provide as well a clear depiction of the dialectical tool of historical-materialism?

Today "We have piped unto you and ye have unto dance" can mean very much: "We have spoken revolution; yet where is it now?" In the primordial vortex which lingers for us still, this is the question of the gods. Buber in his article says of the dancer in whose self repose the impulses of the beast whom nature had forced near him: "He had announced the animal to his comrades, to the gods, to himself." This is the ardent and timeless response to "We have piped unto you and ye have not danced" ("ye have not revolted.") Today the dancer must again impart the full deep measure of this meaning to his/her sisters and brothers, that they may so respond again themselves truly.

**Notes**
1. Ellis, Havlock: *The Dance of Life*, New York: Modern Library 1929
2. ibid. p.41
3. Nijinsky, Vaslav: *The Diary of Vaslov Nijinsky*; University of California Press, 1973
4. Buber, Martin: from *Brother* in *Salmagundi* Magazine, a quarterly journal of the social sciences, No. 33-34, 1976, pp. 98-101
5. ibid.
6. Edwin Denby: from *Forms in Motion and in Thought* in *Salmagundi* pp. 115-132 (*Salmagundi* published at Skidmore College, N.Y.)
7. Arnheim, Rudolph from *Concerning The Dance* in *Salmagundi* pp.89-97

# BUDDHIST ANARCHISM

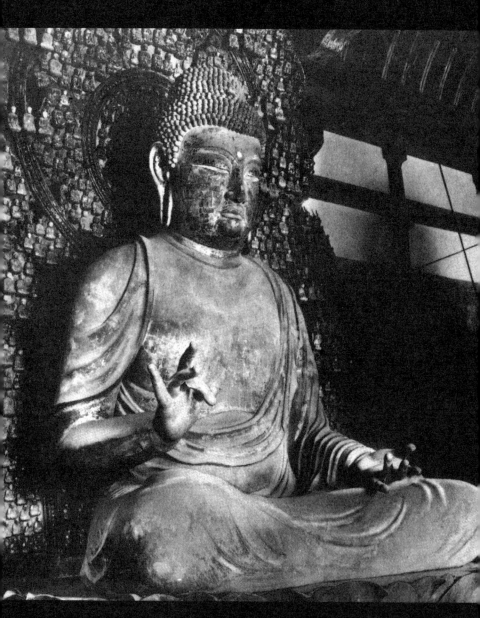

## BY GARY SNYDER

**B**uddhism holds that the universe and all creatures in it are intrinsically in a state of complete wisdom, love, and compassion, acting in natural response and mutual interdependence. The point of being a "Buddhist"—or a poet, or anything else for that matter—is to follow some way of life that will bring about personal realisation of the from-the-beginning state, which cannot be had alone and for one "self"—because it cannot be fully realised unless one has given it up, and away, to all others.

In the Buddhist view, what obstructs the effortless manifestation of this natural state is ingnorance, fed by fear and craving. Historically, Buddhist philosophers have failed to analyse-out the degree to which human ignorance and suffering is caused or encouraged by social factors, and have generally held that fear and craving are given facts of the human condition. Consequently the major concern of Buddhist philosophy is epistemology and "psychology" with no attention paid to historical or sociological problems. Although Mahayana Buddhism has a grand vision of universal salvation and boundless compassion, the actual achievement of Buddhism has been the development of practical systems of meditation toward the end of liberating individuals from their psychological hangups and cultural conditionings. Institutional Buddhism has been conspicuously ready to accept or support the inequalities and tyrannies of whatever political system it found itself under. This is death to Buddhism, because it is death to compassion. Wisdom without compassion feels no pain.

No one today can afford to be innocent, or indulge himself in ignorance about the nature of contemporary governments, politics, social orders. The national polities of the modern world exist by nothing but deliberately fostered craving and fear—the roots of human suffering. Modern America has become economically dependent on a fantastic system of stimulation of greed which cannot be fulfilled, sexual desire which cannot be satiated, and hatred which has no outlet except against oneself or the persons one is supposed to love. The conditions of the cold war have turned all modern societies, Soviet included, into hopeless brain-stainers, creating populations of "preta"—hungry ghosts—with giant appetites and throats no bigger than needles. The soil, and forests, and all animal life are being wrecked to feed these cancerous mechanisms.

A human being is by definition a member of a culture. A culture need not be mindless and destructive; full of contradicitions, frustration, and violence. This is borne out in a modest way by some of the findings of anthropology and psychology. One can prove it for himself through Buddhist practice. Have this much faith—or insight—and you are led to a deep concern with the need for radical social change and personal commitment to some form of essentially non-violent revolutionary action.

The disaffiliation and acceptance of poverty by practising Buddhists becomes a positive force. The tradi-

tional harmlessness and refusal to take life in any form has nation-shaking implications. The practise of mediation, for which one needs "only the ground beneath one's feet" wipes out mountains of junk being pumped into the mind by "communications" and supermarket universities. The belief in a serene and generous fulfillment of natural desires (not the repression of them, a Hindu ascetic position which the Buddha rejected) destroys arbitrary frustration-creating customs and points the way to a kind of community that would amaze moralists and eliminates armies of men who are fighters because they cannot be lovers.

Avatamsaka (Kegon) Buddhist philosophy—which some believe to be the intellectual statement of Zen—sees the universe as a vast, inter-related network in which all objects and creatures are necessary and holy. From one standpoint, governments, wars, or all that we consider "evil" are uncompromisingly contained in this illuminated realm. The hawk, the swoop, and the hare are one. From the "human" standpoint, we cannot live in those terms unless all beings see with the same enlightened eye. The Bodhisattva lives by the sufferer's standard, and he must be effective in helping those who suffer.

The mercy of the west has been rebellion; the mercy of the east has been insight into the basic self. We need both. They are both contained in the traditional three aspects of Buddhist practise: wisdom (prajna), meditation (dhyana), and morality (sila). Wisdom is knowledge of the mind of love and clarity that lies beneath one's ego-driven anxieties

and aggressions. Meditation is going into the psyche to see this for yourself—over and over again, until it becomes the mind you live in. Morality is bringing it out in the way you live, through personal example and responsible action, ultimately toward the true community (sangha) of "all beings."

This last aspect means supporting any cultural or economic revolution that moves clearly toward a free, international, classless society; "the sexual revolution," "true communism." The traditional cultures are in any case doomed, and rather than cling to their good aspects hopelessly it should be realised that whatever is or ever was worthwhile in any culture can be reconstructed through meditation, out of the unconscious. It means resisting the lies and violence of the governments and their irresponsible employees. Fighting back with disobedience, poetry, poverty—and violence, if it comes to a matter of clobbering some rampaging redneck or shoving a scab off the pier. Defending the right to smoke pot, eat peyote, be polygamous, polyandrous, or queer—and learning from the hip fellaheen peoples of Asia and Africa attitudes and techniques banned by the Judaeo-Christian West. Respecting intelligence and learning, but not as greed or means to personal power. Working on one's own responsibility, no dualism of ends or means—never the agent of an ideology—but willing to join in group action. "Forming the new society within the shell of the old." Old stuff. So is Buddhism. I see it as a kind of committed disaffiliation: "Buddhist Anarchism."

# THOUGHTS ON REVOLUTIONARY THEATRE:

## FROM MAY '68 TO THE PRESENT

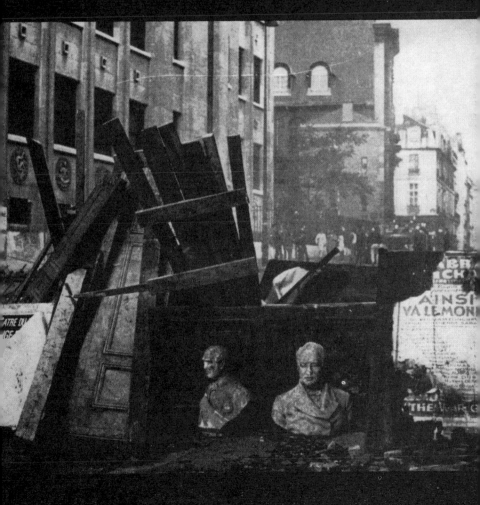

# BY JUDITH MALINA

In 1963 we did a play called The Brig which showed the conditions inside a Marine corps brig in a very realistic and naturalistic style, as a paradigm of the human condition showing the military as the epitome of our punitive structure. In 1964 our theatre was closed, because the play was offensive to the Marines. Allegedly we were shut down for taxes which we later proved we didn't owe. But we had a terrific theatrical court battle here that was a big drama, at the end of which we were put on a five year probation period. It was the beginning of the Vietnam War and it meant that if we went out on a demonstration and got busted we would have had to do 5 years because we were on parole. We refused the parole and went to Europe and our theatre started its voluntary exile. This long tour went on more or less into the early eighties when we came back to New York.

In that period the Living Theatre developed from an off-Broadway theatre group into a collective and a community. We managed to live together, to travel together, and finally to break down this terrible artificial distinction between private life and public life and artistic life and sexual life and domestic life and economic life, and we were really able to integrate, as a community, all those factors. We had many children in the company, we traveled from city to city, we went through feast and famine, sometimes we went through terrible times economically but we managed for almost thirty years to support a traveling theatrical anarchist commune, using ourselves very consciously as an experiment in the possibility of such survival. We were aware of the problems of the anarchist principles in terms of collective creative process, and of group dynamics. One of the problems which arose immediately, for instance, was that Julian Beck and I were older and had more experience in the theatre than the others, and how does that then work in terms of creative energy? What happens? We were very aware, very analytical, we had more meetings than one could believe. Sometimes we would meet six hours a day, seven days a week, and just rap it through...everything, everything. Our lives, our meaning and purpose, from the divine ends of revolutionary utopianism to who's going to clean the kitchen and bathroom—and it almost became the same thing, that's what was good about it. It created a group of people that was already, by May '68, at a very high pitch of revolutionary energy. In a way, that burgeoning sense, that simmering sense is the height of the movement's creativity. Because we see from the events of May '68, and the fall of the Berlin Wall, that the highest point of the energy which seems at the moment to be a beginning, is in fact the end. That is, every revolutionary force breaks itself on the enthusiasm of its first wave, and we're left with the motto "La Lutte Continue." We should learn from history and understand that rhythm, and next time we should be prepared.

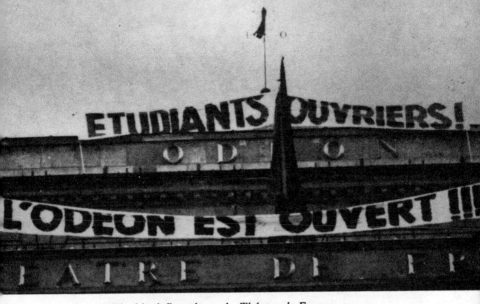

*The black flag above the Théâtre de France.*

After May '68 we tried to create alternative structures, presses, communes, day-care centers and women's centers, but we didn't know how to sustain these. The wonderful anarchist food co-ops became what they too often now are, which is a discount shopping center for relatively well-to-do people. The food co-ops of the early '70s were intended for the poor. All those structures weren't sustainable because we made a revolution on the enthusiasm of getting rid of the old shit without having an equal or even greater enthusiasm for creating the new structures which aren't shit! Now that's what we have to concentrate on.

When The Living Theatre arrived in Avignon in May '68, we were given an old school building which once housed 400 students. A little later, when the Enragés in Paris were thrown out of the Beaux Arts and the Odéon, they came to Avignon to live with us. Our original commitment when we became a collective was to go to where the revolution was. We always wanted the privilege of being where the action was, and we always kept our group small enough, flexible enough, and mobile enough that we could do that. What ensued in '68 of course was enormous, but it was a very small group of people that started it: The Situationists (who were opposed to the Living Theatre's "utopianism" and "problematic anarchism"). They hit the nerve, I think, with their pamphlet on the misery of student life. When the students saw that their schooling was miserable for the same reason that the workers' conditions were miserable, that they were both "niggers" in the same sense that they were both tied to a subservient existence, they took the streets and went to the workers. I've

always been an admirer of the Situationists' boldness, their style, their vigor, but we never developed even an adversarial friendship. Ideologically, they would have nothing to do with us.

Anyhow, we were in Avignon performing Paradise Now, a play that ends with the declaration that theatre is in the streets, and at the end of each performance we went out of the theatre, some of us naked and joyous, and confronted the police. It's an audience participatory work in which we were insistent upon the participation of the audience; we tore the chairs out from the floors of the theatre to the horror of the management, and insisted on a certain level of physical contact with the spectators. Many fled, but those who stayed went to paradise!

After our Avignon performance we went to Paris on the 13th of May and headed straight for the barricades. We lived in five or six different apartments with comrades who put mattresses and sleeping bags on their floors. I had no idea what the strategies were behind the events of May until I participated in the planning sessions for the occupations of buildings. Mostly it was about trying to pick certain liberated territories where the police couldn't or wouldn't enter. So we organized around the Left Bank, the Sorbonne, and the area around the Odéon, then called the Théatre de France. There were ad hoc councils that decided to organize certain aspects of the occupations. A kind of cultural council was formed, including, Jean-Jaques Lebel and many other participants, that was trying to decide what the artists could do. There were hours of

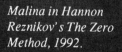

*Malina in Hannon Reznikov's The Zero Method, 1992.*

discussion in which we talked about occupying a cultural site. There was some debate about taking the Eiffel Tower, but that was in an area heavily guarded by the police and we would not have been able to hold it very long. Eventually we decided on the Odéon. The night that we were going to take over the theatre we got together with the Enragés and we headed toward the Odéon with lots of street scenes with the police on our way there—back and forth with paving stones and tear gas. There was a crowd at the theatre (a performance had just ended) and we made our way in just as the audience came out. It was just the right moment when the police couldn't get between us because there were all these well dressed bourgeois who were coming out in their finery. The black flag went up above where it said Théatre de France and the theatre was occupied. We had a hard time deciding what to do now that the theatre was

ours and occupied by thousands of people. For weeks there was an open Forum, with microphones open to all who wanted to speak about the ways and means of the revolution. After a while street battles ensued and for a long time the Odéon became a first aid station for people who were hurt. People were burned by tear gas more than anything else, but there was a lot of clubbing. The police waited until we were tired and then they came in full force one morning at the crack of dawn and evicted all of us.

Of course it's more fun to make revolutionary theatre in a revolutionary period than it is when the political pendulum is at low ebb between revolutionary periods. On the other hand, it may be more important to make revolutionary theatre at the low ebb period because that's when the ideas that will motivate the action are seeded. While we learn from the past and the examples from the past, what's really important today is to see that, as well as being a post-revolutionary period, this is already a pre-revolutionary period. The sooner we begin to feel that under our skins the sooner we'll be able to come up with a new wave of energy politically and socially. We need to promulgate that energy, and that's what the Living Theatre is working on now. With our work with anarchist groups in Brazil in the seventies, our workshops and performances in Italy at the time of the occupations of the factories, and our activities on the Lower East Side with the homeless and squatters today, we continue to work in the movement toward change. We continue to be where there's a hot spot of feeling so that we can put our work on some heartbeat that makes sense to us.

I would like to see the concept of anarchism, which is quite strong in the Lower East Side community, develop into a more cogent consciousness of what the positive, practical aspects of anarchist structures are. I want to do a lot of street theatre down here that involves our neighbors. Because, you know, we always want to be where there's some life, where there's some anarchism, where there's hope. It's much more fun to do revolutionary theatre in a revolutionary time—and I hope we're going to have that fun again soon.

*This essay is an excerpt from an interview I conducted with Judith Malina which covered her activities in the 40s and 50s. Her remarks on the 60s were of an eloquence that seemed to merit publication in essay form. —Max Blechman*

# HOLLEY CANTINE

## FEBRUARY 14, 1916-JANUARY 2, 1977

by DACHINE RAINER

**H**olley Rudd Cantine Jr. was born in New York City into a polyglot family, highly gifted, political and predatory. His mother, Josephina Arosamena, was the daughter of an Anglo-American mother; her Panamanian father was his country's first President, who after his term of office, became Ambassador to the United States. Holley Sr., one of the first "suitable" men Jo met after coming out from a Catholic convent girlhood, was the son of Martin Cantine, descended from the persecuted French Huguenot family, Quantain.

Holley Jr.— he discarded the Rudd and Jr. soon after I began to live with him — was thus, in largest measure Spanish (laced with Panamanian Indian probably, although this is not mentioned in the book "The Cantines"). Since colonial times, Anglo-American and Dutch infiltrated the Cantines.

The eldest of three sons, Holley was named after his father, Holley Sr., after an ancestor, Alexander Holley. Holley's middle brother, Robert Livingstone, was an acknowledgement of the Livingstone branch of Jo's maternal family, who owned a good part of upstate New York. They were sent packing as a consequence of the "Down Rent" wars, one of Holley's favorite small revolutions!

Holley's youngest brother, Martin, was named as a nod in the direction of their entrepreneurial grandfather, Martin Cantine, whose ingenuity applied coated paper to some of the nefarious purposes we know, and saw the transition of small agrarian communities along the banks of the Hudson River, into the factory town, Saugerties. By the time Holley was taken by his parents, at the age of two, to live there, his grandfather employed virtually all the able bodied men in the mills.

The chief virtue of the Saugerties was that it was seven miles from Woodstock, which had been founded at the turn of the century as a William Morris socialist-anarchist community of artists and intellectuals. At first, Jo Cantine with her children, lived there for summers and began to paint. By the time Holley was six, she became a Woodstock resident; she met a former merchant sailor and water color painter, Tode Brower, with whom she lived until he died more than half a century later. She became a serious painter. Her work, including a portrait of Holley at the age of ten, is in the N.Y. Metropolitan Museum of Art.

Holley's first formal education was in Woodstock's one room school house (which he never ceased to praise). He had learned to read at three, and remained a prodigious reader in several languages — French, Italian and German and a certain amount of Spanish and Russian.

He had been scheduled for the West Point Academy. By the age of fourteen, he had converted his mother to atheism, pacifism, and radicalism. (She took longer to become an anarchist. She never stopped using her ambassodorial connections to try and influence powerful people, as, for example, during her attempt to pre-

vent, then stop, the Second World War.) Much of her political resistance occured in the West Indies, in Haiti and Mexico where she, together with her companion, Tode, lived half of most years once her sons were nearly adult. She was often under house arrest.

Although West Point was repudiated, nevertheless, Holley's involved childhood games and reading resulted in a permanent fascination with military history. By avid reading, proficiency in languages and an astounding memory, he aquired an encyclopoedic knowledge of ancient and modern European history, including English and that of the various Celtic nations—the Welsh, Scots and Irish, all under English oppression still; he enjoyed a better than ordinary aquaintance with the history of the near and far East, India, Africa, what is now so peculiarly known as "the third world." Owing to his Panamanian ancestry, his was a special interest in South America, and obviously, the United States and its incursions.

Through this training, he continued his studies of "primitive peoples," enjoying most rapport with that of Native Americans.One of Holley's abiding, if half-serious regrets, was the failure of "King Philip's War" (the contemptuous name given to the Native American Chieftain who organized the Indian tribes into an army). Had it occurred only a few years earlier, Holley believed they would have succeeded in driving the Europeans from the U.S.! Holley's masterly story, *Second Chance,* was seeded

early.

Holley's general knowledge was prodigious, whether the subject was the anarcho-pacifist movement internationally, or anthropology, or psychology or the history from its beginnings, of Black Jazz, or the Bible or most of the sciences. His learning was phenomenal. Given audience and inclination, he would speak like a dissertation, but rather more entertainingly. Gifted with an encyclopaedic memory, he continued to add to his formidable store of knowledge all his life. His learning exceeded that of any other person I have known, both within and outside the academic establishment. To it he brought the rare analytical ability of a true scientist and radical.

He went to the ordinary Kingston High School. Biology was a particular interest to him and he made a lifelong friend of his teacher there. He was sent next to the Quaker College of Swarthmore. He left after three years because it gave no courses in anthropology which by then had become his chief study.

At Columbia University, he specialized and was fortunate in studying with several of the major figures in that comparatively new field. While preparing his doctoral thesis, he was overwhelmed by the desire to leave academia in favour of beginning a Thoreauian life style. This he did, from his mid-twenties, with varying degrees of success and periods of distraction, until the end of his life.

Holley's education derived most from his environment, from people and books more than from his formal

HOLLEY AND DACHINE SOMETIME BETWEEN 1946 AND 1950.

AT THE RETORT PRESS PRINT SHOP IN BEARSVILLE, N. Y.

training which was good. He was lucky to be living from early childhood in a cultural milieu, in proximity to some of the best minds and most talented people in the country. The Maverick chamber concerts were of the highest international merit; the art gallery was similarly renowned; the public library was selected as the "best in the U.S. for a town of 10,000 people" (Woodstock had under 1000!). Holley worked, among adults, from the model in his mother's studio (and was an accomplished amateur painter); he listened to their iconoclastic, bohemian, radical talk. He walked the countryside, read, thought and asked questions.

He believed that his earliest convictions derived from reading Hugh Lofting's *Dr. Doolittle* books; and I can confirm its effect when his two daughters were similarly influenced.

On Mt. Tobias, Bearsville, three miles from central Woodstock, he built a log studio house, beginning with felling surrounding trees and stripping the bark. He had some architectural knowledge, taught himself certain necessary techniques and since he had aesthetic sensibility, the building possessed great beauty. While the idea of self sufficiency and the pioneering American spirit came from Thoreau, the artistry was Holley's, influenced by the William Morris, Woodstock school. He added a goat barn a few yards away, which he partitioned in half for my study, when I came there to live. Finally, he dismantled the one room, disused Woodstock schoolhouse, carted it by horse up the mountain on a wood

road, and constructed it in Bearsville as a print shop. In New York City's printing district, Holley found cases of typeface and a Gorden Upright Footpedal Press which had been obsolete since 1875. (His elder daughter, Toni, uses it occasionally still). In 1942 Holley Cantine began to hand set and print *Retort* magazine, devoted to anarchism and the arts. His companion at the time, Dorothy Paul, assisted.

I met Holley in 1945 when he visited the office of *Politics,* where I worked for Dwight and Nancy Macdonald. He began arriving there daily, although it was to be three months before I recognized his oblique courtship technique. Holley was by turns shy and talkative. About his background and personal circumstance, he was silent.

He was just under six feet, slender and had what is called "classic features." He was full bearded at a time when all American men were clean shaven. His hazel eyes were penetrating, arresting and somewhat haunted. He had a quick, shambling walk, which I recognized subsequently as more suitable to the mountainous woodlands of his environment.

He wore dungarees when no one but workingmen in particular jobs did; these were torn or patched (he was an excellent seamstress and was to make some of my clothes; he writes about sewing in "A Short History of the Clothespin Man Industry," published by *Harper's Bazaar* in the '50's). His shirt and jacket (he owned no coat) were worn. On his long hair was a Russian naval

Facing page: Holley Cantine ca. 1950. Retort Press, The Print Shop.

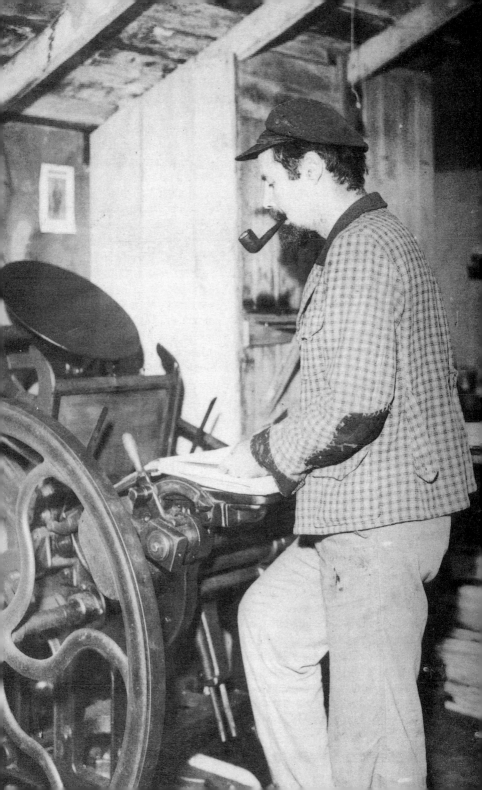

cap — Kronstadt sailor's — subsequently to be made more famous by Nureyev. On formal occasions, he wore the wide brimmed black hat favoured by anarchists and artists; Carlo Tresca, Wyndham Lewis, Ezra Pound...had been wearing this model for some decades. (Holley was vain, particularly intrigued by his erratically curling moustache; if he seemed arrogant to some, this was most often, shyness. I believe he was "alert to his measure.")

He often brought a loaf of Italian bread and a green pepper, offered it to *Politics* staff unsuccessfully, then ate it himself. I thought he was desperately poor, that he might sleep at the Cooper Union Library some days and perhaps on the Bowery streets at night. When he suggested walking me home after work (6th St and Ave A, now the East Village, then a Polish and Ukrainian neighborhood, interspersed with a very occasional radical, artist, student) he said he lived two streets away. His premises for that one winter was a basement, to which he had brought his equipment and was engaged in producing an issue of the magazine, alone. He shared the territory with innumerable coal bunkers culminating in a distant toilet inhabited by a huge grey rat (running from whom precipitated me into Holley's arms and appraised me of his intentions). In the neighboring basement lived Ukrainian housewreckers, given to heavy drinking and audible through the walls, to merry or mournful loud singing.

We returned to Bearsville, where I lived for sixteen years. We expanded Retort Press to include occasional pamphlets and books — *Prison Etiquette* is the best known — and the Woodstock newspaper, *The Wasp*.

We believed in voluntary poverty; I, who had known always the involuntary kind, found its practice often more difficult than he. We were close to Dorothy Day and the Catholic Worker Movement (minus the theology). One year we managed on $500, way below the poverty line, even then. (Our environment was a superlative compensation). We were partially self sufficient. We grew and preserved most of our food (my province; Holley was better at animal husbandry). We had a small herd of goats, a few chickens and a donkey. We had milk, goat cheese, eggs; we baked. We had an exhilarating sense of freedom, although neither of us had sufficient time, moving between these and other domestic activities which presently included a child and her nurturing, to our own writing, editing, typesetting, printing, proofreading, collating...To this I added writing reviews and fiction for liberal magazines, for a little cash. Holley set aside a daily period for practising his trombone, fortunately in the more distant printshop. He found it an aide to relaxation and thought.

Winters could be very cold and hard. Summers we went out (walked) and entertained considerably. Holley's hopes for a commune on the mountain had aspirants, but never materialized.

Holley inherited a very substantial sum when his father died, but

consistent with anarchist views of exemplary behavior, he kept little. He divided it amongst family and friends, and loaned sums at no interest, which he hoped would be returned so that he could continue the process (it seldom was).

A fire claimed his life and destroyed some manuscripts and correspondence. He left little, except two daughters, both in the arts, and his writing. This is considerable in quantity and owing to his highly trained mind, original outlook and rare imagination, is remarkably rich in quality. There are stories, only four of these published; *Second Chance*, printed here, was privately published by e. e. cummings in November 1959, after cummings and his companion, Marion Morehouse, had tried to find a commercial publisher on both sides of the atlantic, as they had for Holley Cantine's *A Short History of the Clothespin Men in Industry*. They had no success for a story which they and others regarded as a masterpiece. The cummings' edition, for which my cousin, Seymour Chwast made the original cover, numbered three hundred copies, half of which we received, half cummings and Marion kept. All were distributed among friends. Chwast has added illustrations for this edition.

Holley left an untitled, alarmingly prophetic novel, post nuclear, a novel in an unfinished draft (another has so far disappeared); a personal memoir of extraordinary psychological importance; two collaborative articles and what remains of the correspondence. His essays and editorials in *Retort* are a marvel of hard headed anarchist reflection, lucidity and style.

It is here, as a political philosopher, that Holley Cantine's contribution has been made. Owing to anthropological and other knowledge unavailable to his mentors - last century's international giant anarchists - Holley Cantine is one of the very few, including Noam Chomsky and e. e. cummings, whose radical american writing is the most valuable since Henry David Thoreau. I trust this will be evident after the publication of his *Collected Writing*, which as his executrix, I expect to have completed editing by the end of 1994.

# SECOND CHANCE

## A STORY BY
## HOLLEY CANTINE

**A**s a child I had little in common with my contemporaries; I preferred natural amusements to mechanical ones—I would much rather go for a walk than take a ride in a car or a plane—and small simple things appealed to me a great deal more than the large complicated gadgets that delighted other children. In those days, the pressure on the individual to conform to the group had not yet reached its full intensity—as it was to do a generation later—and I managed to remain by myself fairly frequently. The ostracism and ridicule of my school mates did not especially trouble me; their company bored me and the less I had to be with them, the better. Had I been born ten years later, I should unquestionably have been forced to spend a large part of my childhood being worked upon by the school psychologists, but in my day, that institution was rather new, and they had their hands full enough with the more aggressive varieties of juvenile delinquency to bother with simple asocial behavior like mine.

To make up for my lack of congenial play-fellows, I created a world of my own, populated with hundreds of little men that I crudely carved out of wood, and with whom I enacted elaborate dramas that fully absorbed me until I was well into my teens. My small subjects usually were savage tribesmen of some distant time and place, and in order to make their appearance and "way of life" as accurate as possible—despite its predominant romanticism, there was a strong literal and scientific side to my nature—I read copiously in elementary books about primitive man.

Almost inevitably, I majored in anthropology in college, and went on to take my doctorate in that subject. I studied under some of the best of the old-school field workers, men who had known real primitives in their own youth, and still regarded anthropology as dealing essentially with primitive man—although the last untouched primitive society had long since been absorbed by the advance of civilization and genuine primitives were only to be found in ethnographic texts.

My idol was "Billy" Watkins, who, despite his comparative youth—he was in his fifties at the time—was considered the greatest authority on the culture of the Plains Indians in the world. He had known and worked with Boas, Kroeber and Lowie, and had, in his own student days, done original research with the last survivors of the men who had fought against the United States Army. The scope of his knowledge of, and sympathy for, the pre-conquest American Indian was almost legendary. He spoke five Plains dialects fluently, was familiar with at least a dozen others, and there was virtually nothing about the cultural institutions and traditions of the entire area that he did not know as thoroughly as most men know the batting averages of the World Series teams. Knowing Watkins was almost an adequate substitute for witnessing those vanished societies in their full vigor. Despite his short, roly-poly figure, and his round pink face, wispy white hair, and

near-sighted eyes that peered through thick lenses, he could conjure up a buffalo hunt or a war party with such vividness and precision of material detail and psychological attitude that one felt almost like a participant.

After I got my doctor's degree, I drifted away from the field, however. My romantic temperament could not adapt itself to the prosaic population studies and acculturation problems that had become the sole remaining subjects for field work, and teaching or library research did not appeal to me at all.

I had come into some money, so I had no immediate need to look for a job, and, by keeping my living expense to a minimum, I managed to stretch my inheritance over several years of travel in all parts of the world. I suppose I was looking vaguely for a place that had not been touched by the spread of civilization, though I knew in advance that such a quest was hopeless. One world had been achieved when I was still an infant, and the material level of all backward peoples had been rapidly brought up to that of the most advanced. Everywhere I went I found automobile factories, Coca-cola bottling plants, television stations, advertising agencies, baseball leagues, and all the other blessings of civilization. The Reader's Digest, in one or more of its many language editions (there were 45 in all) always had the most prominent place on the news-stands, and the movies and telecasts bore a strong family resemblance to those of my earliest recollections.

However, for the benefit of the enormous tourist trade, which had become the balance wheel of the world economy once local self-sufficiency in manufacturing had all but wiped out foreign trade in commodities, each country had retained—or restored—at least a vestige of its ancient heritage. Native songs and dances, traditional forms of local architecture, costumes and cuisine—all meticulously authenticated by huge staffs of experts—were heavily emphasized throughout the world.

Although air-conditioning, two-car garages and deep-freezers were standard equipment on even the remotest coral atoll, the external appearance of every region was as traditionally accurate as painstaking scholarship could make it. In the Arab countries, the women might wear nylon stockings and underwear, and use Elizabeth Arden cosmetics, but her flowing outer garments were straight out of the Arabian Nights; the Venetian gonadolas still plied the canals, unchanged except for the built-in television sets; the beehive huts of Central Africa gave no indication, from the outside, of the tiled bathrooms and electrified kitchens they contained. Likewise, local customs, provided they were sufficiently picturesque, were retained long after they served no genuine need. Italian peasant women still fetched water from the village fountain in ornamental jars, and did their washing in the running water of streams instead of their automatic washing machines whenever there were tourists about. It was both a kind of nostalgic game and an obligation to provide a good show for the foreign visitor. I must

confess that it failed to satisfy me, but clearly I belonged to an insignificant minority.

Finally despairing of finding any place that suited me, and since my money was running low, I returned to the United States. My first visit was paid to Billy Watkins in his office at Columbia. I felt that he would be the most likely person to provide me with a satisfactory occupation.

Although we had not seen one another for five or six years, Watkins greeted me as though I had just stepped out a few hours before. He had not changed in the least.

"The most remarkable thing has just come up," he announced with enthusiasm, before I had a chance to mention the purpose of my visit, or even say hello. "I think it will prove to be the opportunity of a lifetime for the likes of us!" I was flattered that Watkins would consider me in the same category as himself, and was about to make a modest disclaimer, but he went on without giving me an opening. "It's most fortunate that you showed up just now—save me the trouble of hunting you up. You're going to join us, of course?" he added, almost as an afterthought.

I felt a mixture of relief and vague apprehension. I had been dreading this interview—I hadn't the remotest idea of how to go about asking anyone for a job—and here was the job asking for me; on the other hand, although I had complete confidence in Watkins' judgment, it would be nice to know a little bit about the kind of job it was before I committed myself.

"Of course," I replied, rather weakly—my voice has a tendency almost to disappear when I am under tension—"but what's it all about? I just got back from Afghanistan and I'm sort of out of touch."

"Afghanistan?" he inquired brightly, "anything of interest doing out there?"

Shamefacedly I admitted that I hadn't been engaged in professional activities, that I had been merely a tourist—the very word made me cringe.

Watkins didn't even notice my discomfiture. "Well, it's high time you were back in harness. Sit down and let me fill you in."

During the next hour, he gave me a comprehensive picture of our forthcoming role. It seemed that the United States was falling behind the rest of the world in the tourist race. Apart from the Grand Canyon, the giant Redwoods, and a few other natural wonders, there was little in the country in which foreign visitors could take an interest. The very factor which had so disquieted me in my travels—that replicas of Detroit and Newark could be seen everywhere— was deterring foreigners from visiting the original home of most of the material wonders that they now took for granted in their own countries. The Parthenon, the Taj Mahal could not be successfully duplicated, but factories and skyscrapers can be, and were thus no novelty to anyone.

There was but one hope for stimulating interest in visiting the country. Nearly all foreigners—especially those from Central Europe—were anxious to see the Indians when they

come here. Despite all the vast changes that had been going on in the world, they somehow had a naive belief that the American Indian was still the unspoiled savage of their childhood adventure books. As things were at present, they were naturally disillusioned by the reality, and the word was getting back to their homelands, thus more than ever discouraging American-bound tourists to the incalculable loss of America's merchants.

The government in Washington was extremely disturbed by the situation and had called upon the best brains of industry and science to come to the rescue. A huge project had been launched—headed by one of the most eminent film-producers in Hollywood—to restore the Western Plains to their aboriginal condition. The government was determined not only to solve the tourist problem, but also show the rest of the world that it still surpassed all rivals in the scope of its vision and capacity for action on a grand scale. No expense was to be spared; all the resources of the country were at the disposal of the project. The population of several states—the Dakotas, Nebraska, Wyoming, and Montana—was being resettled elsewhere—everyone but the surviving Indians. As soon as the people moved out, an army of demolition workers moved in, tearing down buildings, removing fences, roads—except for a few major arteries—and every other trace of civilization. Great mountains of scrap, whatever could not be burned or buried, were loaded on freight cars and hauled away, after which the railroad tracks were taken up. Several buffalo breeding stations had been established and staffed with expert livestock breeders and geneticists; the buffalo herds were being restored as rapidly as modern science and their own fecundity could operate. At this point, I protested mildly, that in view of the near extermination of the species, and the length of its breeding cycle, this process would take centuries. Watkins assured me that, on the contrary, thanks to the fact that buffalo were able to breed successfully with ordinary cattle, of which there were millions in the area in question, a hybrid species—pure buffalo in the male line, but with the females of the first few generations heavily supplemented with beef cows—had already reached impressive numbers.

As for the Indians—that was our department. Watkins had been appointed head of that branch of the project, and with a substantial budget at his disposal. He was planning to leave for the plains as soon as he had

recruited an adequate staff of associates. His job—certainly the most exacting part of the whole program—was to undo a century of acculturation and return the Indian tribes to their pre-conquest condition.

"But," I again protested, "surely there can't be enough Indians left to restore all those tribes to their original strength. As I remember, many of them nearly died out from neglect and despair after they were subjugated. Isn't that true?"

Watkins smiled mischievously. "Precisely, but that just makes our job more interesting. With the full cooperation of the United States government we are going to undertake the largest controlled experiment in environmental conditioning that has ever been visualized. I've sent out a call for volunteers to all the High School students in the country." With a faintly embarrassed grin he handed me a sheet of paper. "Don't hold me responsible for the text. Our publicity department has, so to speak, translated my original copy into their own peculiar jargon."

The paper read:

"WANTED: FELLOWS AND GIRLS TO BECOME INDIANS!!!

How would you like to ride the Western Plains on a spotted pony, hunting buffalo with a bow and arrow, live in a teepee, wear buckskin clothes and feathers in your hair, dance the war-dance to the beat of tom-toms?

If you are one of the lucky students chosen by the Committee for the Restoration of Indian Culture (CRIC) you will be able to do all these things and many more besides, every summer. All expenses paid. Mail in your application NOW."

"Do you really suppose that you'll get enough response to an appeal of this nature?" I asked somewhat scornfully. "I simply can't see them giving up their television sets, automobiles, drug-stores..."

Watkins broke in jovially. "That's one of the most remarkable developments so far. We've already had many times the number of applications that we can handle. I've got a staff of anthropometrists—Old Oberholzer—you remember him no doubt, a sound man, but rather too conservative in his thinking, in my opinion—has charge of that. They're examining all the applicants and passing only those who have physical features that correspond pretty closely to the Plains Indian type. We can't be too choosy, of course, but we're making sure that they are reasonably tall and dark, with skins that tan easily, and if they happen to have high cheek bones, so much the better. I certainly wouldn't qualify myself," he added with a chuckle. "I don't suppose I've got a single feature right. We've got a medical staff too—to check up on their health and stamina. The government has certainly done well by us. I almost feel like an atomic physicist.

"Well, that's the general layout. To get down to details, I intend to assign a competent ethnologist to each tribe—which one would you like?—with a couple of trained assistants and, of course, a staff of native instructors. The Indians themselves

will need a certain amount of coaching to recover the feel of their old culture—though I don't believe, to judge from certain personal experiences, that part of the job will be very hard; they've never *really* acculturated, you know. On some level, they've always retained a belief that some day they'd return to their old way of life. They're pretty rusty about the *details* but they know the *pattern* and the language. The rest will be up to you. Once they've been thoroughly re-indoctrinated, I think you ought to leave the training of the white students pretty much up to them. Your job will be simply to make sure that there are no glaring departures from the authentic tribal traditions, and to supervise things in general..." he trailed off vaguely. I could see that he was chiefly counting on the Indians themselves, and looked on the necessity of using white ethnologists at all with a certain distaste. I didn't mind especially; the less work I had to do, the better I would like it.

Watkins resumed talking before I could say anything. "For the time being, anyhow, you will be a sort of repository of tribal lore, so the first thing for you to do will be to brush up on all the literature of your particular tribe, get to know the language fluently...what tribe did you say you wanted?"

I hadn't said—it was impossible to break into Billy's flow of words when he was steamed up, and he seldom waited to hear the answer to direct questions. He went on again.

"You'll probably want time to think it over. Here's a list of all the tribes that haven't been spoken for already. You know the field well enough so that you can pick one that you really feel rapport with. But take your time, when you've decided come back and I'll see that you get the proper literature and a language informant. I want everyone letter-perfect before we leave for the Plains."

Feeling somewhat dazed, I left the office. I had hardly said a word, and here I was a full-fledged government employee. There were various formalities to be attended to still, and a few insignificant details like salary to be ascertained, but I was obviously in.

Watkins' authority was unquestioned, and a couple of days, and several dozen government forms later, I was duly enrolled as a tribal ethnologist, at a comfortable salary, and went to work in the library, digging through the ethnographic literature on the Plains tribes on my list. After some consideration, I decided on the Cheyenne. I can't say offhand what especially appealed to me about them—possibly the fact that they were so completely typical of the general Plains culture.

I reported my decision to Watkins; he procured for me copies of everything that had ever been written about the tribe, recordings of their music, and a native informant who spoke the tribal language in its purest form. I had found an apartment and holed up in it, with my Indian, by books and records, for the next couple of months. By the end of that time I knew as much about the Cheyennes as it was possible to know through reading, and I departed for Wyoming,

where I spent the next few weeks feverishly assembling and briefing a trustworthy staff of native instructors. The Indians were extremely cooperative and eager. Although they had, as Watkins mentioned, forgotten many of the details of tribal lore, it took them a surprisingly short time to get it all back. They already knew the language well enough, and a lot more about riding and hunting than I could ever hope to master. We were ready for the students when they arrived in June, shortly after school let out.

There were 1000 students assigned to our tribe the first summer. I divided them into groups of ten, each with an Indian counsellor of the appropriate sex, and gave the latter a free hand, as Watkins had suggested, encouraging them to treat the students as members of the tribe. I must admit that they needed little encouragement; they were pretty rough, treating the students like dirt. If I hadn't known that this was the time-honored Indian method of education, I might have suspected they were getting a little of their own back. Once the students got over their initial shock, and were made to realize that they weren't going to get any help from me, they adjusted much better than I would have believed possible—they even seemed to enjoy the hazing. Perhaps the direct, simple brutality of the Indian technique— derisive laughter whenever they failed at something, and grudging, almost contemptuous approval when they succeeded, was a relief after so many years of being handled by indirection and "psychology"—never

scolded or reprimanded, highly praised for their clumsiest, most casual efforts. The Indians were crude and sometimes even physically painful, but they never left one in doubt about their real opinion. When the time came for the students to return to their homes and schools in the fall, they parted with real regret. It had been a strenuous summer for them, but they had made genuine progress. I was well pleased with the way the program was developing.

During the winter months, I was chiefly occupied attending conferences of the tribal ethnologists, and paying regular visits to the students in their homes. In order to facilitate administrative work, all the students assigned to a particular tribe had been chosen from the same section of the country—mine were all from upstate New York. I was thus able to visit several students at once.

In each town where a group of my budding Cheyennes resided, I found them closely banded together, spending much of their time in an improvised tent community, where they faithfully practiced the techniques they had learned during the summer. No English was spoken, and all the tribal customs were scrupulously observed. Their attitude toward the rest of the population was one of sullen, contemptuous indifference, but this did not discourage the younger children, who flocked to the "Indian camp" and followed the activities of its residents with worshipful adoration.

The most painful aspect of my job was the monthly visit I had to pay

to the principal of each of the schools where my students were registered. The first interview went something like this:

"You know, Mr. Warren, we've been having a lot of trouble with our boys and girls since they spent the summer with you."

I, innocently, "Indeed? In what respect?"

"They seem thoroughly uncooperative. Won't study at all—their attendance records are deplorable—they take no interest in extracurricular activities—it's most discouraging, and perplexing too. Just last year, some of them were among our most promising students. Take Jim Morrison, for example. He was on the football squad, a good all-round athlete; not precisely an honor student, but he did well enough in his grades in all subjects. He was on the banking council, student government—all in all, a very bright, well-adjusted, popular boy. Since he came back this fall, he's completely changed. Refused to consider going out for the team again—even though the coach pleaded with him. Dropped all his other activities—says he hasn't time. In class, he just grunts when he's asked a question, and half the time, he plays truant. The psychologist has talked to him several times, but can't seem to make any headway.

I wish you'd try to reason with him. I'm sure he'd listen to you."

My own unhappy school days were far too vivid in my memory for me to be willing to lend a hand to the authorities. It wasn't my job to supervise that side of my students' career, in any case. To be perfectly frank, I rather enjoyed the alarm of the poor school masters, which mounted from month to month. And when I reported to Billy Watkins, he was rapturous.

"Yes, I know, Warren, I've had the same sort of report from every area. It's almost unbelievable—they act just like the real Indians did when they were first sent to the government schools. Who would believe that a few months' conditioning could be so effective? I'm starting a paper about it. I believe I'll call it "Acculturation Phenomena among Certain American High School Students" though that hardly does full justice to the material. I've never been much good at titles."

That winter and spring, the Committee was deluged with applications, and there were twice as many students the second summer. The veterans of the first session adjusted themselves to tribal life as if they had never been away, so the problem of training the newcomers proved even simpler than I had anticipated. The tribe was functioning perfectly

smoothly now, and I was no longer needed as an arbitrator, or as a repository of tradition. The tribal council had everything under control.

I was therefore free to settle down to a peaceful routine, with hardly anything to do officially. My only companions the greater part of the time were the two graduate students that had been assigned to assist me. The Indians were constantly on the move, sometimes the whole tribe together, at other times breaking up into small bands. They were living entirely by hunting and fishing now. Supplementary rations were needed only in winter time, and the way the game was multiplying, it seemed probable that in another year or two, they could be dispensed with altogether.

My companions were both rather dull youths, and it was a relief when Watkins dropped by in August on an inspection tour. I had not a little trouble finding the tribe for him, even though it was all travelling in a body, for the summer buffalo hunt. I had to travel fifty miles by jeep across the prairie before I managed to track them down. Billy was amused rather than annoyed by the delay. "In a couple of years, you won't be able to find them at all, unless they want you to," he observed with a grin.

"What are the tourists going to do, when they start coming?" I asked a trifle peevishly.

"That remains to be seen," he replied. "Personally, I couldn't care less." At heart, I felt very much the same way, so I left it at that. I somehow doubted if Washington would take the same position, however.

Our first real headache came that fall, when it was time to return the students to their homes. More than half of them couldn't be found anywhere, although we searched for days, with the help of a troop of soldiers who had been flown in when our own efforts were unavailing. Billy, as usual, was delighted. "They're learning even faster than I had expected. I thought it would be years before they were this competent at evasion."

The parents of the missing students—or some of them at any rate—and the government, were not so easily pleased, of course, and I and the other tribal ethnologists whose charges had strayed—it was a widespread phenomenon—were severely rebuked for negligence. Billy's prestige was sufficient to prevent serious repercussions, however, especially since advance booking for tours of the Indian country, which were scheduled to start the following spring, had already reached vast proportions, and the government was anxious to avoid jeopardizing the success of the program by causing a scandal.

Those students who did return to civilization were completely intransigent. Most of them claimed that they had forgotten how to speak English. They would not sleep in beds, cut their hair, or have any part of the normal teenage life they had so recently left. The school authorities had had enough trouble the previous year, and fearing the effect that the Indians had on the other students, made little effort to enforce attendance regulations. The Indians were thus left free

to spend their entire time in their improvised lodges, emerging only to forage for food. A few of them got tired of waiting for spring and made the long journey back to their tribe on foot.

The younger children were more than ever drawn into the orbit of the Indians. Since there were not enough openings in the regular program to accommodate more than a very small fraction of the applications, they were forced to do the best they could on their own. The local tent village became the shrine of a new religion. Every action of its inhabitants was worshipfully observed and imitated by the devotees, and while the Indians, faithful to the training they had received, did not deign to notice the adoring multitude, they did not discourage them, either. The children quickly penetrated the mask of decorum, and made themselves useful in whatever ways they were permitted, smuggling in food, running errands, and doing menial tasks around the camp. By degrees, the Indians accepted their presence with more cordiality and taught them whatever they wanted to know.

The children were so absorbed by the Indians' camp that they had no time or interest in other activities. Spacemen, cowboys, soldiers, athletes were all forgotten, and the manufacturers of toys and sporting goods suffered a serious loss of business. For a brief time there was a boom in synthetic Indian regalia, but presently none but the very youngest children could be induced to have any part of factory-made products, and the boom collapsed. The television networks, in desperation, cancelled all their regular children's programs and substituted Indian stories, but this also did not work. The children were too busy hanging around the Indian camp, or playing in the woods and fields, to watch television. Several breakfast food companies went bankrupt.

Washington finally yielded to the pressure of the lobbyists for the various businesses which had been adversely affected, and a few months before their scheduled departure, ordered the Indian students to be sent back to the plains permanently. It was believed that removing the source of the infection would permit the younger children to recover their other interests, and resume their rightful place in the consumer market, but the remedy either came too late or was inadequate. The children's loyalty to the Indian way of life remained unshaken; a large number ran away from home and joined Indian tribes. Very few of these were ever recovered—the Indians presumably passed them from one band to another, and steadfastly denied knowledge of any runaways.

Intense pressure from parents, the school authorities and especially the psychologists eventually compelled those children who remained at home to relinquish the outward manifestations of their Indian allegiance. The movement continued underground—some kind of grapevine communication with the Plains being maintained.

That spring, when the tourist program was officially opened, was a

very busy time for me and my associates. Washington provided us with an elaborate schedule of events, which we were supposed to communicate to our respective tribes, arranging to have them perform certain ceremonies at the proper times and places. The Indians, whenever I managed to catch up with them, always agreed to fulfill what was requested of them, but I suspected their sincerity—correctly as it turned out. Simply finding them took an awful lot of my time, and on top of that there were the endless search parties looking for runaway children which I was expected to assist. I began to have doubts about continuing in the service. My creative function was completely fulfilled, and all that remained was drudgery. Moreover, I was convinced that sooner or later Washington was going to crack down, and we would be crucified. I told Billy Watkins my misgivings on one of his periodic visits. He tended to agree with most of my arguments, but urged me to stay. If I were to resign, Washington might very well replace me with someone who lacked sympathy for the Indians, he pointed out. Reluctantly, I dropped my intention to resign.

The tourist season opened with only half of the Cheyenne bands notified of the schedule, and I had no confidence in the nebulous promises I had exacted from the rest. I was a nervous wreck, but my fears proved groundless, or at least, premature. The tourists were enthralled by the irresponsibility and undependability of the Indians; it coincided precisely with their ideas about the way savages should behave. They got a far greater thrill from catching a glimpse of a hunting party, or a tribe on the move across the prairie, than from a carefully rehearsed performance of the Sun Dance. Instead of being reprimanded by Washington, as I had fully anticipated, Watkins and his whole staff were highly congratulated on their splendid work, and urged to keep it up. I was somewhat annoyed about all the emotional and physical energy I had wasted trying to follow the original schedule, but on the whole I was much relieved, and glad I had stayed. From that point on, I made no further efforts to coordinate the actions of the Cheyenne. I stayed close to my headquarters and took things easy. Washington was satisfied, the tourists were delighted. We had done our job, and could now look forward to an uninterrupted and unlimited vacation with pay.

Left to themselves, the Indians reverted completely to their aboriginal way of life. All the old religions, the vision quest, the ordeals for testing virility, and other facets of the pre-conquest pattern of culture that had no possible value as tourist attractions quietly revived and flourished.

The first scalping occurred some five years after the Watkins program had been inaugurated. I did not learn the details until long afterwards. The Indians felt that the Committee would probably disapprove and were careful to keep it a secret from us, although word spread from tribe to tribe in a few days. The victim was a young Comanche brave known as Yellow Horse. He had been born James

Morton, and was the son of an automobile dealer in Little Rock, Arkansas. The story, as I eventually heard it once they no longer had any fear of repercussions—the Indians who love to boast about their deeds of valor told it to their tribal ethnologist and he passed it on—was something like this. Yellow Horse had gone out alone to hunt deer, and had wandered a long distance from his band's camp. He was returning, carrying a big buck across his pony, when he was surprised by a party of six Arapaho warriors in full war paint. It was one of these Arapahoes, a former basketball star from some place in Indiana, the son of a hardware merchant, who told the story to my colleague, Larry Thomas, a first-rate ethnologist and folk-lorist, who took it down in his own words. Translated from the Arapaho, the tale ran roughly as follows:

"You had always told us, O learned one (this was the usual Indian form of address for tribal ethnologists) that we must live according to the ways of our ancestors, but you also said that we must not fight one another, and especially not to kill anyone. This we could not understand, for our ancestors were mighty warriors and took many scalps. It was difficult to believe that one so learned as you would be mistaken about so important a matter, so for a long time we followed your orders. But the old men of the tribe kept telling us that the learned ones were not telling us the truth, that he was a white man who took orders from the Great Chief of the White Men in Washington, and did not want the Indians to recover all their former strength and honor. As long as we stayed away from the warpath, we would be like little children, and the white man would have no trouble ruling us. We did not want to believe this, but the old men kept taunting us, and telling us about the great warriors of the old times, so finally we listened to their words and asked them how to conduct a war party. They told us many things, some said one thing, and others said other things. We wanted to ask the learned one which was the right way, but the old men laughed at us, and said we were really babies if we thought the learned one could be trusted to tell us the truth about this. Since the old men only knew about war from stories they had heard from their fathers, we did not think they had any right to laugh at us, but we were ashamed anyhow, and decided to follow their advice. Each of us went separately to the hills, and fasted and beat ourselves with thongs, and slept on the ground without blankets, waiting for the gods

to speak. They would not speak to most of us, but Blue Claw came and told the old men that they had spoken to him in a dream, but he could not understand their message. The old men interpreted the dream for him, and said it was powerful medicine. Blue Claw then got ready for the warpath, and five us went with him. We painted, and purified ourselves and danced a war-dance. Then we took up our weapons and rode off. Two days later we saw a Comanche hunter with a big buck laying across his pony, and Blue Claw signalled to us to attack. We all raced after the Comanche, and his horse was so heavily loaded that he could not get away. Blue Claw, who had the strong medicine that the dream had given him, reached him first, and counted coup before the Comanche was able to shoot at us with his bow. The buck on his horse made it difficult for him to take aim. Then Blue Claw knocked the Comanche off his horse with his tomahawk, and we others faced up and finished him off. He was a brave man and did not beg for mercy. Blue Claw took his scalp and the horse. He was the leader and had counted first coup. We others divided the buck and the other things on the horse. Then we buried the Comanche on the prairie and returned to our people. There was much rejoicing. The old men were pleased with us, and said the gods had shown their approval by rewarding us so quickly, but that we must be sure not to tell the learned one or any other white man, for they would be angry we had found out that they were lying to us. We kept the secret well—no white man has heard of it until now. But the old men said that it was our right to boast to warriors of other tribes, and so the story spread to all of them. There were many more war parties after that, and I have counted coup and become a war chief among my people."

Although this story, and many similar ones that I was told subsequently by Cheyenne warriors, amply confirmed Watkins' belief in the power of the cultural environment, my native skepticism was aroused, and I endeavored, exercising great tact and patience, to penetrate the ceremonious manner and reserve of the young warriors and find out how much of their early conditioning remained buried. It took me some time, but I finally found a youth who was willing to unburden himself. He had been a sort of protege of mine in the early days. He had had difficulty making initial adjustment to Indian life, and frequently came to me for advice and encouragement. Therefore his response may well be atypical.

We were sitting at some distance from the campfire, one night when I had come to pay a visit to his band, out of earshot of the others, and I asked him to tell me about his first war party. He gave me the usual conventional, formal account very similar to the Arapaho story quoted above. But on the strength of our previous close relationship, I continued questioning him.

"Didn't you feel at all strange? Were you nervous, or afraid, or troubled about what you were doing?"

Suddenly he reverted to English,

after looking around apprehensively to make sure that we were in no danger of being overheard, and said:

"You know, it was really like being in a play."

"How do you mean?"

"Well, you know, in a play you get to feel that you are the character you're supposed to be, but every so often you remember that you are just acting and feel kind of silly. Then it passes and you feel like the character again."

"And you felt like that on the war party?"

"Yeah, when we were running down that hill to attack the village, all of a sudden I thought that those guys down there are just ordinary fellows like us. A few years ago, you know, we might be playing football or something with them, and trying like hell to win, but we wouldn't really want to kill them or anything, and I almost called out to the others to stop. I thought maybe we were carrying this thing too far, that we weren't really Indians like in the days the old men told us about. But then I looked around at the others and they looked so intense that I began to feel I was an Indian again, and I knew they'd just laugh at me—I'd probably be really in disgrace—and it wouldn't do any good anyway, so I fought as well as I could when we got to the village."

"Did you kill anybody?"

"Well, no, not that first time. But I don't think it was because I didn't want to. I just didn't have a chance before we pulled out again. I have never had any trouble killing since then, I know." His expression changed abruptly, his features recomposing themselves into a ceremonial mask, and he refused to answer any more questions, either in English or in Cheyenne.

But I anticipate. We of the CRIC did not learn anything at all about the revival of inter-tribal warfare until a party of my Cheyennes, returning from an unsuccessful raid on a Kiowa village, waylaid a bus that was proceeding along one of the superhighways to accommodate tourists, that crossed the territory by laying a barricade of logs on the road. The boys who had taken part in the adventure were sullen and uncommunicative when I questioned them, but I eventually managed to piece together a fairly coherent account.

Feeling frustrated at the failure of their expedition against the Kiowa, and therefore both reckless and mischievous, they had happened upon a number of fallen trees, blown down by a cyclone, quite close to the tourist highway, and one of them suggested it might be fun to snarl up traffic by dragging them across the road. The logs were heavy, but they had horses, and the job was quickly accomplished. The incident might have ended there, except that they noticed a bus approaching in the distance, and hid on top of a nearby hill to see what would happen. After a while they got tired of watching the driver's futile efforts to move the logs, got on their horses, and rushed down to give the tourists a good scare. They were carried away by the emotions of the rush, and almost without thinking massacred the passengers, scalped

them and set the bus on fire.

The bus was missed, traced and its wreckage soon discovered. The authorities had no difficulty deducing what had happened, and decided it was time to take drastic action, although the incident proved very stimulating to the tourist trade—morbidly curious people from everywhere flocked to the scene of the massacre. Opposition to the Indian program had been gaining momentum for years. The manufacturers whose business had been hurt had joined together into a powerful lobby, the parents of runaway children constituted a substantial and articulate pressure group, and there were many officials in the government who had long been waiting for an opportunity to crack down on what they felt was unpardonable laxness in the way Watkins was conducting his Committee. It was widely felt that there was something distinctly un-American about its absence of regulations and strict supervision of the tribes. The extraordinary popularity of the Indians as a tourist attraction had prevented these opponents from striking sooner, but the bus episode, which occasioned a nation-wide storm of indignation, provided them with a perfect pretext for a full dress investigation. Watkins was summoned to Washington, a Senatorial Investigating Committee was established and hearings commenced.

Within twenty-four hours of the wrecking of the bus, I had received instructions by teletype to locate the responsible tribesmen and hold them in custody for the U.S. Marshall. I set out in my jeep with a good deal of trepidation; if the Indians had gotten sufficiently out of control to wreck a tourist bus, there was no telling what they were prepared to do—they might even consider me a legitimate victim. At the very least, I was looking forward to an endlessly protracted and probably futile search. To my surprise, however, I had no difficulty locating the tribe—they actually sent out scouts to meet me—and when I reached the camp everyone was extremely deferential and cooperative. Although it was still early spring, long before the summer buffalo hunt would begin, the whole tribe was camped together, which was most peculiar. I was nervous, of course, but covered it as well as possible by acting angry and imperious. They seemed pathetically eager to placate me.

I convened the tribal council, and when they had assembled, arose and addressed them indignantly. "You know you were forbidden to wage warfare. Yet you have done this stupid thing. All will be made to suffer for this, unless the men responsible give themselves up and come with me."

The paramount chief of the tribe replied, with great dignity and humility. "The learned one has spoken and we will obey. We are sorry that our young men have acted rashly; they are young and did not think. We hope that their punishment will not be too severe. Will the white soldiers come now? Will they kill the buffalo again and make us go back to live on the reservations and eat the government's

beef?" He seemed genuinely anxious.

I told the tribal council that I believed the government would be lenient if the tribe cooperated, and there were no further incidents, but my own apprehensions must have been clearly perceptible to them. At the time, I didn't especially care about this; let them have a good scare. Later, when I thought it over, I began to have misgivings.

The young warriors meekly accompanied me to headquarters. I reported their "capture" by teletype and in a few hours a transport plane arrived and took them away. I had some slight hope that the promptness and cooperation of the Indians would have a favorable effect on the authorities, but I feared the worst. Next week, Watkins was called to Washington and began his testimony before the investigating committee. I expected to be called at any time; after all, I was technically responsible for the Cheyenne tribe.

The weeks dragged on. I spent most of the time nervously watching the televised hearings, and cursing Billy Watkins, the Indians and myself for getting mixed up in this mess. Billy's performance on the stand was anything but reassuring. He simply didn't seem to understand the government's view of the matter, and spent hours enthusiastically explaining the extraordinary success of our acculturation program. He tended to regard the bus episode almost as a triumph. Fortunately, he had not yet learned that inter-tribal warfare had been raging for the better part of a year, or he would no doubt have boasted about that too. It was obvious that the Senators regarded him a dangerous, if fascinating lunatic, and the whole program was going to get the axe as soon as the investigation was finished. However, Billy's platform manner was sufficiently compelling, and his attitude so completely incomprehensible to the assembled senators that the investigation clearly was going to take a long time.

Since I was completely convinced that there was no hope of retaining my job, I paid very little attention to the Indians during the weeks of the investigation. My assistants reported that there were an unusual number of smoke signals being sent, but we were all too preoccupied to bother decoding them. I merely assumed that the Indians were as anxious as we were about the investigation, and not having television themselves were using this method of communicating its developments.

About two months after the bus incident, a group of armed Cheyenne warriors rode up to the hitching rail

in front of my headquarters and their leader dismounted and knocked on the door. I had heard the hoof-beats when they were still some distance away, and had looked out the window to see what was going on, but felt no alarm at the warlike appearance of the band. Rather, I was irritated at being disturbed. Assuming that they had gotten impatient about the fate of their fellow tribesmen and had come seeking information, I sent one of my assistants to tell them that there was nothing to report as yet, and they should go home and put up their weapons—there was sure to be trouble if they persisted in going about armed to the teeth. He returned in a minute, visibly terrified, and told me they insisted on seeing me.

In a towering rage, I stormed onto the porch, and shouted, "What's the meaning of this?" or its closest equivalent in Cheyenne.

Unperturbedly, the young warrior (he was, for a change, a full-blooded Cheyenne) made the hand signal that meant his intentions were peaceful and launched into a formal and ceremonious speech. I noticed with a shock that he wore several scalps on his belt. "Oh learned one," he said, "we have always looked upon you as a brother, and we will never permit any harm to happen to you as long as there is strength in our arms." Then he began a long list of flowery and grotesquely exaggerated compliments. Impatiently I interrupted and demanded, "What do you mean coming here armed? Don't you know the government is angry and will make trouble for everyone unless you cooperate?"

My rudeness momentarily discomposed him, but he mastered himself, smiled broadly, and continued in a somewhat less formal vein. "The learned one need not fear the anger of the government any longer. We are not going to repeat the mistakes of our ancestors, and wait for the government to send its soldiers to attack us this time. There will be no treaty-making, no opportunity for betrayal. The white man will be wiped out without mercy before they have a chance to prepare."

Apparently misunderstanding my expression of horror and amazement, he hastened to reassure me. "Oh, not the learned one, he is our friend, our brother, and we have been sent by the big chiefs to protect you, in case warriors from some distant tribe make a mistake."

I had a vision of Indian warriors armed with bows and buffalo-hide shields being mowed down by the machine guns and flame-throwers of a tank division, and myself spending the rest of my life in prison if I escaped execution for high treason. Of course, as I should have realized at the time, I was vastly underestimating the military resourcefulness of the Indian.

While a completely accurate account of the campaign will probably never be written, I was able, in the months that followed, to assemble a mass of material, much of it obviously fanciful, relating to the events that took place among the Indians during the period my attention had been absorbed by the hearings, and imme-

diately thereafter. I am no authority on military matters, and have no desire to write an exhaustive treatise on the strategy employed. In its broad outlines, the strategy was both simple and traditional. In any case—surprise and subterfuge have always been the Indians' favorite weapons.

The tribal council of the Cheyennes never had the slightest doubt that the destruction of the bus meant the beginning of the end of the Watkins administration and probably of their freedom. For that matter, none of the Indian tribes had believed that the existing regime would last indefinitely. They had all had sufficient experience of the white man's treachery in the old days to have any faith in the benevolence of the government. While they trusted Watkins and his associates, they were well aware that our power was subordinate to that of Washington. Accordingly, the tribal councils of all the various tribes— including those who were nominally in a state of permanent war with one another—had met secretly and drawn up a rough plan of attack, for use if and when the government showed the least sign of changing its policy.

Before I had been notified to pick up the delinquent warriors, word of the incident and its probable consequences had been dispatched to every tribe, and preparations for action were begun. Since these would require some time, it was agreed that the young men, although perfectly guiltless in the eyes of their tribesmen, would have to be sacrificed; hence the inexplicable docility of their surrender.

The Indians knew perfectly well that they lacked the manpower and equipment to wage successful warfare on the whites in any orthodox manner. However, they possessed a secret weapon of enormous striking power—the semi-underground Indian societies of children that existed in virtually every town and village in the country. They had kept in irregular but close communication with their tribal brothers, and they had been thoroughly indoctrinated with hatred for the whites and belief in the sacred mission of the Indians to settle old scores definitively.

Once it was decided that the time had come to strike, emissaries from all the tribes were sent back to their old home territory, wearing conventional clothing, to contact the societies directly and rally them for combat. These young men travelled openly by bus, reaching the region from which they had originally come as quickly as possible. Once there, they travelled from town to town, spending a few hours with each of the local branches of the tribal society, explaining their mission and the plan of campaign; then proceeded to the next stop on their route. This phase of the action went off without a hitch, and was completed in less than a month. On the surface there was no indication that anything was happening. The emissaries came and went unnoticed by the adult population, and after they had gone the children continued to attend school as regularly as ever, and went about their usual occupations, giving no outward manifestation that anything out of the ordinary had

occurred.

Since absolute surprise was the major element of the plan, the timing had to be perfect, all the societies had to strike simultaneously. The general rising was set for March 19th, a Saturday, so the children would not be expected to be in school, and most of the adult population would be at home.

On the morning of the 19th, groups of four or five boys, between the ages of ten and sixteen, wearing their regular clothes (many of them had pleaded with the emissaries to be permitted to wear their Indian costumes, but this was strictly forbidden; while it might have been perfectly safe, the slightest risk of creating suspicion had to be avoided)—went from door to door in their own neighborhoods, ostensibly selling chances on a school lottery. At each house they found some pretext for getting inside; salesmanship was a required subject in all public schools, and every boy had to be adept at gaining entrance. Once inside, they stealthily drew knives and hatchets that were concealed beneath their clothes, and quickly and mercilessly massacred the adult residents of the house. Most of the time, this task was greatly facilitated by the fact that everyone was absorbed by the Watkins investigation on television—because of its enormous popularity with the public, the hearings did not recess for the weekend—and most people never knew what hit them. Children who were too young to have been included in the plan were of course spared. They generally joined the attack as soon as they realized what was happening, quickly forgetting their resentment at being left out of the secret in the excitement of battle.

Since each team had to visit only about a dozen houses, this whole part of the campaign was completed in a couple of hours, before the general alarm could be given. Cases of successful resistance and retaliation were few and of brief duration. Reinforcements were near at hand and those adults who managed to escape the surprise attack were hunted down and relentlessy dispatched by bands of yelling young savages with hastily painted faces. As soon as secrecy was no longer possible, the boys, with their bloody scalps hanging on their belts instead of hidden under their sweaters, banded together in units of twenty or more, attacked the people in stores, theatres and restaurants, ambushed those who had gone out driving, and mopped up the survivors among those who had remained at home.

The warriors from the Plains, riding as hard as they could, joined their younger brothers as soon as the open fighting began, but to their undying disappointment, seldom arrived soon enough to play an important part in the engagement.

By the time the military authorities were able to get the army on a war footing, the Indians were in control of the situation all over the country. Roads were blocked with wrecked cars, the railroads and airfield were put out of commission, power lines had been cut, and nearly all the material resources of the coun-

try had been either destroyed or captured. Several armies of fanatical warriors, totaling twenty million men, or boys, armed with rifles, shotguns, and revolvers as well as the knives and hatchets with which they had taken the field, were enthusiastically awaiting the opportunity to show their valor against serious opponents. For all its mechanized equipment, the regular army was at a hopeless disadvantage. Even atomic weapons were of extremely doubtful value against a widely dispersed and completely mobile enemy who had little, if any use for industrial products. Anything lethal enough to destroy such an enemy would render the entire country uninhabitable.

There can be no doubt, in view of the Indians' youth, inexperience and eagerness prove their courage, that a pitched battle against trained troops armed with modern weapons would have been extremely bloody. But such a battle never took place. The overwhelming majority of the conscript soldiers were young men who had themselves been active in the Indian societies until they had been drafted. They had not been included in the secret plan of the Indians because their loyalty was considered too problematical, but as soon as they found out whom they were supposed to be fighting, they deserted en masse, after massacring their officers, and sabotaging the heavy equipment, and made common cause with their fellow tribesmen.

It isn't bad here on the reservation. The food is reasonably plentiful, if monotonous—venison or buffalo steak day after day—and they leave us pretty much alone. The hardest thing is the scarcity of reading matter. The Indians, being illiterate—or rather post-literate—themselves, can see no virtue in books. If they would only let us go to the ruins of the larger cities to dig for books; it makes me sick when I think of all those deserted library stacks. But they say that cities are bad for white men; that we would only get into mischief if they let us go there.

I sometimes wonder if I should take advantage of the repeated offers to become a member of some tribe, as many of my former colleagues have done. But fundamentally I suppose I am really too civilized, or perhaps just too old for that kind of life. To be sure, Billy Watkins seems to be perfectly happy, ridiculous though he looks in a war-bonnet and buckskins, but of course, I could never expect to achieve the sort of semi-divine status he enjoys.

The life here is sort of aimless, and I sometimes get fed up with the anthropological shop-talk, but we do have some books. They don't withhold them out of malice, I believe. It's just that they can't understand what use we can possibly find for them.

# AVANT-GARDE ANARCHISM

PEACE FOR THE WORLD МИР ЗА МИРО

## BY RICHARD KOSTELANETZ

**S**ome artists may accept the limits of art as defined, as known, as given; others may attempt to alter, expand, or escape from the stylistic aesthetic rules passed onto them by the culture. This impulse to redefine, to contradict, to continue the sensed directionality of art as far as they are able, is independent of success. The fact that an artist does not actually succeed in adding anything of importance to the historical development of art does not, in this sense, make the term *avante-garde* inapplicable. It is his intent or desire that is enough to separate him from those who do not share his goals and beliefs.—Michael Kirby, "The Aesthetics of the Avant-Garde" (1969)

The term *avant-garde* refers to those out front, forging a path that others will take. Initially coined to characterize the shock troops of an army, the epithet passed over into art. Used precisely, *avant-garde* should refer, first, to rare work that satisfies three discriminatory criteria; it transcends current conventions in crucial respects, establishing discernible distance between itself and the mass of current practices; it will necessarily take considerable time to find its maximum audience; and it will probably inspire future, comparably advanced endeavors. Only a small minority can ever be avant-garde; for once the majority has caught up to something new, what is genuinely avant-garde will, by definition, be someplace else. Precisely because the term has the same meaning in English as in French, it need not be italicized. Problems notwithstanding, it remains a critically useful category, for politics as well as art.

But the new does exist, even apart from any consideration of progress. It is implied in *surprise*. So is the new spirit. Surprise is the most living, the newest element of the new spirit—its mainspring. It is by the element of surprise, by the important place it assigns to surprise, that the new spirit is distinguished from all earlier artistic and literary movements.—Guillaume Apollinaire, "The New Spirit and the Poets" (1917)

As a temporal term, avant-garde characterizes art that is "ahead of its time"—that is beginning something—while "decadent" art, by contrast, stands at the end of a prosperous development. "Academic" refers to art that is conceived according to rules that are learned in a classroom; it is temporally post-decadent. Whereas decadent art is created in expectation of an immediate sale, academic artists expect approval from their social superiors, whether they be teachers or higher-ranking colleagues. Both academic art and decadent art are essentially opportunistic, created to realize immediate success, even at the cost of surely disappearing from that corpus of art that survives, as the strongest art does, initially by being remembered. By contrast, one fact shared by both decadent art and academic art is that they realize their maximal audience upon initial publication.

The term avant-garde can be profitably used to distinguish writers

Facing page: John Furnival, "The Fall of the Tower of Babel," 1964

and artists who believe not only that the world they inhabit is essentially modern and that they need to find an aesthetic language to express this newness, but also that they are in some manner in advance of a future state and society which their innovative works will help bring into existence.—Charles Russell, *Poets, Prophets, and Revolutionaries* (1985)

Precisely because libertarian anarchism has never been empowered anywhere for long, because it has not yet happened, because advocating it has never gotten anyone a better job, because it favors opening the field of activity, its values remain avant-garde in ways that marxism, socialism, communism, conservatism, capitalism, and monarchism are not. Secondly, precisely because of proscribing coercion, no politics is more true to the avant-garde spirit than anarchism. Given that recognition, you can understand my gut suspicion of any artist who subscribes to politics other than anarchism, particularly if those politics portray the artist as a humble servant of ideology.

The avant-garde was something constituted from moment to moment by artists—a relative few in each moment—going toward what seemed the improbable. It was only after the avant-garde, as we now recognize it, had been under way for some fifty years that the notion of it seemed to begin to correspond to a fixed entity with stable attributes.—Clement Greenberg, "Counter-Avant-Garde" (1971)

Avant-garde art has been defined as "whatever artists can get away with." This is true, however, only in time and in context—only if the invention contributes to an ongoing perceptible tendency or challenges radically an acknowledged professional issue. As avant-garde art is not made in a vacuum, so it is not offered only to the wind. The exact same brand-new creation that might seem innovative at one time or one place can, even if redone precisely, seem irrelevant, if not decadent, at another. The vanguard, the leading edge of art, is the front of the train; the derriere-gard, the caboose. Most artists ride cars in the middle.

For a certain moment of history, a picture or a statue speaks a language it will never speak again: the language of its birth.—André Malraux, *The Imaginary Museum* (1953)

One secondary characteristic of avant-garde art is that, in the course of entering new terrain, it violates entrenched rules—it seems to descend from "false premises" or "heretical assumptions"; it makes current "esthetics" seem irrelevant. For instance, Suzanne Langer's theory of symbolism, so prominent in the forties and even the fifties, is hardly relevant to the new art of the past three decades. Theories of symbolism offer little intelligence toward understanding, say, the music of John Cage or Milton Babbitt, the choreography of Merce Cunningham, the poetry of John Ashbery, where what you see or hear is generally most, if not all, of what there is. This sense of irrelevance is less a criticism of Langer's theories, which four decades ago

seemed so persuasively encompassing, than a measure of drastic difference.

One reason why avant-garde works, not to mention anarchism, should be initially hard to comprehend is not that they are intrinsically inscrutable or hermetic but that they defy, or challenge as they defy, the perceptual procedures of artistically educated people. They forbid easy access or easy acceptance, as an audience perceives them as inexplicably different, if not forbiddingly revolutionary. In order to begin to comprehend them, people must work and think in unfamiliar ways. Nonetheless, if the audience learns to accept innovative work, it will stretch their perceptual capabilities, affording them kinds of perceptual experience previously unknown. Edgard Varése's revolutionary *Ionisation* (1931), for instance, taught a generation of listeners about the possible coherence and beauty in what they had previously perceived as noise.

It follows that avant-garde art usually offends people, especially serious artists, before it persuades; and it offends them not in terms of content, but in terms of Art. They assert that Varése's noise (or Cage's) is unacceptable as music. That explains why avant-garde art strikes most of us as esthetically "wrong" before we acknowledge it as possibly "right"; it "fails" before we recognize that it *works*. (Art that offends by its content offends only as journalism or gossip, rather than as Art, and is thus as likely to disappear as quickly as other journalism or gossip.)

Those most antagonized by the avant-garde are not the general populace, which does not care, but the guardians of culture, who do, whether they be cultural bureaucrats, established artists, or their epigones, because *they* feel, as they sometimes admit, "threatened." Those most antagonized by anarchism are those who see their fortunes as dependent, indirectly as well as directly, upon the beneficence of the state, whether now or in the future. The diametric opposite of avant-garde is not the conservative as such but academic, as the true opposite of anarchist is not the conservative but statist, each of our antagonists favoring subservience to hierarchical power.

proved of. — Edwin Denby, *Performing Arts Journal*, 11 (1979)

Disreputably unforgettable or commendably forgotten—given the chance, the avant-garde artist would prefer that his creation be the former. That is one explanation for why those new works that veterans dismiss while new artists debate are usually avant-garde.

The avant-garde consists of those who feel sufficiently at ease with the past not to have to compete with it or duplicate it. — Dick Higgins, "Does Avant-Garde Mean Anything?" (1970)

Though vanguard activity may dominate discussion among sophisticated professionals, it never dominates the general making of art. Most work created in any time, in every art, honors long-passed models. Even today, in the United States, most of the fiction written and published and reviewed has, in form, scarcely progressed beyond early twentieth century standards; most poetry today is similarly decadent.

Art may not change the world, but is made by those who would like to change it.—Saldon Godman, *Tongues of Falled Angels* (1974)

The "past" that the avant-garde aims to surpass is not the tradition of art but the currently decadent fashions; for in Harold Rosenberg's words, "Avant-garde art is haunted by fashion." Because avant-garde movements in art are customarily portrayed as succeeding each other, the art world is equated with the world of fashion, in which styles also succeed each other. However, in both

origins and function, the two are quite different. *Fashion* relates to the sociology of lucrative taste; *avant-garde*, to the history of art. In practice, avant-garde activity has a dialectical relationship with fashion, for the emerging remunerative fashions can usually be characterized as a synthesis of advanced art, whose purposes are antithetical to those of fashion, with most familiar stuff. When it does appear to echo advanced art, a closer look reveals the governing morsel as art actually of a period recently past.

It takes approximately twenty years to make an artistic curiosity out of a modernistic monstrosity; and another twenty to elevate it to a masterpiece. — Nicholas Slonimsky, *Lexicon of Musical Invective* (1953)

One difference between literature and visual art is that the merchandisers of the latter can successfully peddle the work of certain figures who were once genuinely avant-garde, although such produce is itself rarely avant-garde. For example, the purveyors of Salvador Dali can profit at levels unavailable to the purveyors of Gertrude Stein; the former artist can be commercially fashionable to a degree that the latter cannot.

Until quite recently, we could read a book or contemplate a painting without knowing the exact period during which it was brought into being. Many such works were held up as 'timeless' models beyond all chronological servitude. Today, however, all undated reality seems vague and invalid, and has the insubstantial forms of a ghost. — Julian Marias,

**Generation: A Historical Method (1970)**

Though fashion imitates the tone of innovation and exploits the myth of its value, the aim of fashion is standardization; the goal of fashion's creations is, simply, a formula that can be successfully mass-merchandised. That accounts for Jean Cocteau's formulation of fashion as what goes out of fashion. The avant-garde artist, by contrast, is interested in discovery and transcendence, not only of current fashion but also of himself (and, by extension, his or her own previous art).

> A revolution of the content—socialism—anarchism—is unthinkable without a revolution of form—Futurism.—Vladimir Mayakovsky, *Newspaper of Futurists* (1918)

When avant-garde inventions become fashionable—as, say, collage in visual art and associational syntax in poetry already have—then they begin to seem decadent, and everyone aspiring to create genuine vanguard art feels in his or her gut that this new fashion has a milestone that one is obliged to transcend. Whenever the current state of an art is generally perceived as decadent or expired, a new avant-garde is destined to arise.

> The situation of [Arnold] Schoenberg is typical—he was never in fashion and now he's become old-fashioned.—Milton Babbitt, *Words about Music* (1987)

The esthetic avant-garde ("left") rarely coincides with the political vanguard (also "left"), the former regarding the latter as culturally insensitive and humanly exploitative, and the latter regarding the former as individualistic and politically inept. Each thinks the other is naive about cultural change; and needless to say perhaps, each is essentially correct.

> For a very long time everybody refuses and then almost without a pause almost everybody accepts. In the history of the refused in the arts and literature and the rapidity of the change is always startling. When the acceptance comes, by that acceptance the thing created becomes a classic. It is a natural phenomena, a rather extraordinary natural phenomena that a thing accepted becomes a classic. And what is the characteristic quality of a classic. The characteristic quality of a classic it that it is beautiful....Of course it is beautiful but first all beauty in it is denied and then all the beauty of it is accepted. If every one were not so indolent they would realize that beauty is beauty even when it is irritating and stimulating not only when it is accepted and classic.—Gertrude Stein, "Composition as Explanation" (1926)

The term avant-garde can also refer to individuals creating such path-forging art; but even by this criterion, the work itself, rather than the artist's intentions, is the ultimate measure of the epithet's applicability to an individual. Thus, an artist or writer is avant-garde only at certain crucial points in his or her creative career, and only those few works that were innovative at their debut comprise the history of modern avant-garde art. The phrase may also refer to cultural groups, if and only if most

of its members are (or were) crucially contributing to authentically exploratory activity.

Art is not predictable. To put it the other way around, what can be predicted is not art. Art which does not surprise, does not enlarge, does not extend our knowledge, our consciousness, *something*, is not—by twentieth-century standards at least—worth the bother. So we can't talk about its future profitably. We can only talk round it and across it, or we can talk about it from the other side.—Reyner Banham, "The Future of Art from the Other Side" (1967)

The term is sometimes equated with cultural antagonism, for it is assumed that the "avant-garde" leads artists in their perennial war against the philistines. However, this retrograde antagonism is a secondary characteristic, as artists' social position and attitudes descend from the fate of their creative efforts, rather than the reverse. Any artist who sets out just to mock the Philistines is not likely to do anything more.

The stammering newborn work will always be regarded as a monster, even by those who find experiment fascinating. There will always be some curiosity, of course, some gestures of interest, and always some provision for the future. And some praise; though what is sincere will always be addressed to the vestiges of the familiar, to all those bonds from which the new work has not yet broken free and which desperately seek to imprison it in the past.... Hence it will be the specialists in the novel (novelists or critics, or overas-siduous readers) who have the hardest time dragging themselves out of its rut.—Alain Robbe-Grillet, "A Future for the Novel" (1956)

Certain conservative critics have recently asserted that "the avant-garde no longer exists," because, as they see it, the suburban public laps up all new art. However, it is critically both false and ignorant to use a secondary characteristic in lieu of a primary definition. *Avant-garde* is an art-historical term, not a sociological category. If an art critic in particular fails to use "avant-garde" as primarily an art-historical term, then he or she is exploiting the authority of his or her position to spread needless confusion. The fact that the avant-garde is widely discussed, as well as written about, scarcely makes it fashionable or lucrative—not at all.

The avant-garde, like any culture, can only flower in a climate where political liberty triumphs, even if it often assumes a hostile pose toward democratic and liberal society. Avante-garde art is by its nature incapable of surviving not only the persecution, but even the protection or the official patronage of a totalitarian state and a collective society.... The only omnipresent or recurring political ideology within the avant-garde is the least political or the most anti-political of all: libertarianism and anarchism.—Fenato Paggioli, *The Theory of the Avant-Garde* (1963)

The conservative charge is factually wrong as well, as nearly all avant-gardes in art are ignored by the middle-class public (and its agents in

the culture industries), precisely because innovative work is commonly perceived as "peculiar," if not "unacceptable," not only by the mass public but those middlemen who make a business of selling large quantities. Indeed, the pervasiveness of those perception is, of course, a patent measure of a work's being art-historically ahead of its time.

And the renewed primitivism of certain modern artists is similarly the expression of a deliberate anti-classical tendency. For, since it is instinctive, primitivism is the only alternative when one rejects classicism. Primitivism always reappears when one wearies of classicism and seeks something else.—Waldemar Deonna, "Primitivism and Classicism" (1946)

It is also erroneous to think of current avant-gardes as necessarily extending or elaborating previous avant-gardes. It was misleading, for instance, to classify the painter Jasper Johns as only a descendant of Dada, for implicit in Johns's best art is a conceptual leap that reflects Dada and yet moves well beyond it. Partial resemblances to Dada notwithstanding, Johns's work has been done for other esthetic purposes, out of other interests, from other assumptions. Indeed, the term avant-garde is most appropriate when it is applied to work that is so different in intention and experience that it renders the old classificaiton irrelevant.

Anarchism...is a natural creed for those who consider themselves aesthetically and socially in the avant-garde and therefore opposed to the existing order. Anarchists, moreover,

have been less tempted to set rules for artistic creation than other groups, and more inclined to accept art for what it is as it comes from the artist's workshop.—Francis M. Naumann & Paul Avrich, "Adolf Wolff," *Drunken Boat* 1 (1992)

Since the avant-garde claims to be prophetic, the ultimate judge of current claims can only be a future cultural public. For now, a future-sensitive critic should just try to posit tentative estimates.

For an educated person's ideas of Art are drawn naturally from what Art has been, whereas the new work of Art is beautiful by being what Art has never been; and to measure it by the standard of the past is to measure it by a standard on the rejection of which its real perfection depends. Oscar Wilde, *The Soul of Man Under Socialism* (1895)

One reason why the artistic innovations of the future cannot be described today is that whatever will later be judged avant-garde transcends, almost by definition, current imagination.

# John Cage: A Celebration

By Jackson Mac Low

Opposite Page: 1st Four-Language Word Event in Memoriam John Cage, 1992 by Anne Tardos & Jackson Mac Low; Acrilyic & collage on linen (48" x 36"); photograph of painting by Kevin Noble

**J**ohn Cage—whose presence, practice, and thought have brought about major changes not only in music but in all contemporary culture, not only in the United States but throughout the world—died of a massive stroke on 12 August 1992, less than a month before what would have been his eightieth birthday: 5 September.

I do not think he would have wanted us to go solemnly into mourning or indeed to make much of a to-do about his death beyond duly noting it and recalling his achievements and his actual presence and way of living. But despite the fact that he "didn't want to leave any traces," I think he would have been gratified by the sheer length of his *Times* obituary (beginning on page A1, its conclusion occupied most of page D21), while being alternately amused and exasperated by its inaccuracies.

For instance, at one point it has the performer of his *4'33"*(1952) "stand silently on the stage," whereas it was written for "any *instrument* or combination of *instruments*" and is explicitly "a piece in *three movements* during *all three* of which no sounds are intentionally produced" (my emphases; quotes from *John Cage* [New York: Henmar Press Inc.,/C.F. Peters Corp., 1962], a catalog of his music edited by Robert Dunn). The formality of the work is lost in the *Times*'s description: it is crucial that the instrumentalist silently delineate the beginnings and endings of the movements, as the pianist David Tudor did by soundlessly opening and closing the keyboard cover. (I forebear to comment on their characterizing this maximalist, even in the headlines, as "a *minimalist* composer!")

Mr. Cage, possibly more than any other modern artist, faithfully carried on what the poet and critic Harold Rosenberg called "the tradition of the new." In all the arts he practiced—music, poetry, theater, and visual arts—he continually devised new ways of working with the materials of the arts as well as "nonartistic" materials, and new relations between performers and composers. If something had been done before, he did it very differently or did altogether otherwise.

But when he was influenced by a fellow artist—often one substantially affected by his own work and artistic/philosophical principles—he readily and generously acknowledged the fact. Thus, of his silent *4'33"* he wrote, referring to the empty canvases Robert Rauschenberg had previously exhibited:

"To Whom It May Concern:
The white paintings came first,
my silent piece came later."
[*Silence* (Middletown, Conn.: Wesleyan Univ. Press, 1961), p. 98.]

And of his work in asyntactical poetry after 1967, he wrote: "My work in this field is tardy. It follows the poetry of Jackson Mac Low and Clark Coolidge..." [*M: Writings '67–'72* (Middletown, Conn.: Wesleyan Univ. Press, 1973) p. xxi]. And in his Introduction to "James Joyce, Marcel Duchamp, Erik Satie: an Alphabet" (1982) he wrote: "The

title of this lecture is a reference to the poetry of Jackson Mac Low which I have enjoyed for at least twenty-five years." This despite the fact that I'd never have written (beginning in 1954) the poetry to which he refers had he not provided compelling examples and inspiration in his music composed by nonintentional procedures from 1951 and in his conversation.

It is well known that Mr. Cage's work in the arts was strongly influenced by Asian philosophy and religion. The Hindu musical theory according to which one of the nine "permanent emotions" is expressed and resolved to tranquillity in each composition or performance significantly influenced his musical work in the 1940s, notably the *Sonatas and Interludes* for prepared piano (1946–48).

Then in about 1950 he discovered the *I Ching* ("Book of Changes," a basic Chinese classic), and Zen and Kegon Buddhism through Dr. Daisetz Teitaro Suzuki's books and later his classes at Columbia University, which we both attended in the midle and late '50s. The *I Ching* taught him the importance of asking questions rather than giving answers; and Buddhism, which radically de-emphasizes the ego, viewing it as an illusory formation, moved him to seek ways of making music that freed him from his intentions and tastes, allowing sounds to be percieved for their own sake—with "bare attention." The *I Ching*, Buddhism, and many personal experiences led to his composing by chance operations and other nonintentional procedures and to making compositions indeterminate of performance and sometimes even of score. As he wrote in "How the Piano Came to be Prepared" (originally a foreword for Richard Bunger's *The Well-Prepared Piano*, 1973; revised version by Mr. Cage, 1979:

"The prepared piano, impressions I had from the work of artist friends, study of Zen Buddhism, rambling in forests and fields looking for mushrooms, all led me to the enjoyment of things as they come, as they happen, rather than as they are possessed or kept or forced to be.

And so my work since the early 'fifties has been increasingly indeterminate..." [*Empty Words: Writings ''73–'78* (Middletown, Conn.: Wesleyan Univ. Press, 1979)].

Among North American and European thinkers, Henry David Thoreau, Arnold Schoenberg, Gertrude Stein, James Joyce, Marcel Duchamp, Erik Satie, Merce Cunningham, Henry Cowell, M.C. Richards, Morton Feldman, Buckminster Fuller, Norman O. Brown, Marshall McLuhan, George Herbert Mead, and Ludwig Wittgenstein were especially important to him. Note that several of these, though artists, are included as *thinkers*: all art that interested Mr. Cage had a powerful conceptual component as well as being both precise and playful.

Mr. Cage's deepest and longest-lasting relationship was with the dancer and choreographer Merce Cunningham, whom he met in 1938. During more than a half-century of

artistic collaboration, in which Mr. Cunningham revolutionized dance as Mr. Cage exploded the horizons of music, they completely changed the relation between sound and movement in dance productions. And through their personal relationship they sustained each other through afflictions and difficulties and shared the happiness of making and presenting their works. Their enduring partnership provided a continuing inspiration not only to their friends but to many who scarcely knew them.

But this isn't an obituary. It's a celebration. It's an act of thanksgiving to John Cage, to his inventor father and his mother, and to Arnold Schoenberg, Marcel Duchamp, Merce Cunningham, and the others who helped him become the person who did what he did and made what he made. More than any other artist of this century, his work has been *emancipatory*. It has helped countless other artists do and make things they'd never have dared to do or make—even if they'd thought of them—without the example of his own daring. And beyond the arts, it has helped sustain the vision of a free society, of peaceful anarchism, which we shared.

*Merce Cunningham (seated, center left), John Cage (to his left), and Marcel and Madame Duchamp (seated lower right) at the Film-Makers-Cinematheque around 1965. Photograph by Fred W. McDarrah.*

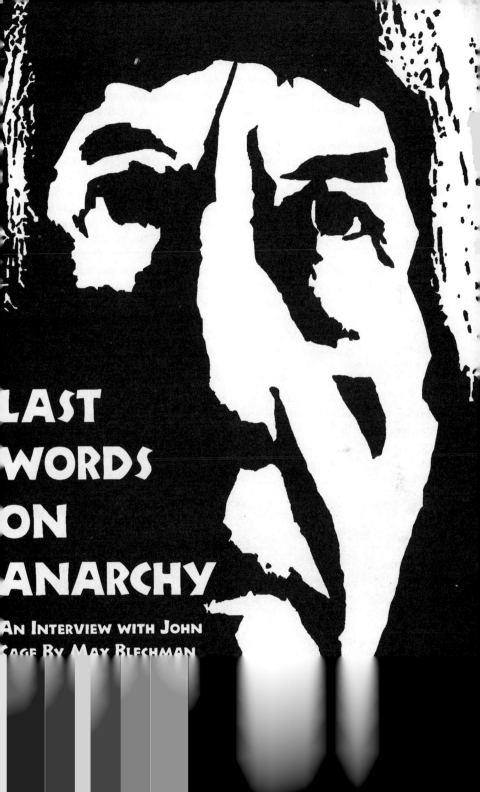

# LAST WORDS ON ANARCHY

## AN INTERVIEW WITH JOHN CAGE BY MAX BLECHMAN

[I interviewed John Cage in his apartment on July 24, 1992, just three weeks before his death. It is possible that this was his last interview; in all probability this was his last substantial conversation on the subject of anarchism. Authoritarianism never seemed to me more completely expelled from a person's being as it was from Cage's. His black cat, his warm unpretentious manner and his utopian personality created an atmosphere conducive to convivial dialogue and comraderie. There was no sign of death lurking around the corner. After the interview he enthusiastically told me of the many projects he was planning, one of which was to compose a piece for the bass entirely in D minor, consisting, if I remember correctly, of the 99 different tones intrinsic to that note. I will forever remember Cage grappling with ecsatic pauses, for the words with which this interview concludes. Cage's serene presence embodied the peaceful anarchy that we all, hopefully, will someday experience. — M.B.]

**H**ow would you describe your musical work in relation to anarchy? Richard Kostelanetz described your art as being anti-hierarchical in its structure (for example not using a conductor and not having a soloist with a back-up group), in its instruments (the piano having no more presence than the radio), and in its performance space (playing in gymnasiums as well as opera houses). Is that how you would characterize the anarchy of your compositions?

JC: I think that is well put. There are ten weekends of my music of the Museum of Modern Art in the summer garden, and ordinarily the music there would be difficult to hear because of the cars and the air conditioning and the birds, which haven't yet gone to sleep. The concert begins at 7:30 each Friday or Saturday, and the birds go to sleep at about 8:30. So the last part of the concert is free of the birds. But that only intensifies the presence of the air-conditioning system and the traffic. Then sometimes there is some saxophone playing that can be heard from Fifth Avenue. Ordinarily that would be very disturbing to any music. But there's no door closed to my music, it is full of silence. Not that it's all silence, but there can be seven minutes of silence during which you are perfectly free to hear what the ambiance is producing.

MB: So the composition is substantially different not only each time it's played but in the different places it's played.

JC: Of course. There's no attempt to make the art better than life. Hm? In the nineteenth century they used to say that art was good because it was more organized than life. It was a kind of model of order. I don't believe in that. I think that all of creation is at the center and that there are no better points than others. It's a Buddhist idea. Everything, whether it has senses or not, like a rock or a plant—well, some people say plants have senses and that you should talk to them. I don't do that but

222

[laughs]...they never say you should talk to stones. Anyway, each thing whether sentient or non-sentient is at the center of the universe. Everything is the world honored one, in other words everything is the Buddha. So that means that no one of the Buddhas should look down on another Buddha.

MB: You try to embody anarchy in your art rather than showing a conceptual anarchism that could be in the future...

JC: I give a model of how it works now.

MB: As opposed to dangling a heaven for people...

JC: For the orchestra I give up the conductor. I keep him, unfortunately, for the rehearsals. [laughter] I don't keep him as a conductor, I keep him as a guide.

MB: We can call him a facilitator.

JC: That is what I would call him.

MB: What is the difference between your attempt to break the wall between life and art and the Living Theatre's, with their emphasis on audience participation and so on?

JC: They do it with content, I do it without content. If you do it with content, you do it so to speak impurely, but if you do it without content it's pure information which then the listener, the user, can apply in any circumstance he wishes. We can't any longer assume that we speak the same language.

MB: You still do compositions with Merce Cunningham's choreography. Does your sharing of artistic creation also involve a sharing of social views?

JC: He is so busy. The amount of work it takes to keep a dance company going ... and he's doing yoga every morning, I don't think he has time to know whether he's an anarchist or not. Merce's life is devoted to dance, he still thinks of himself as a dancer even though he can hardly cross the room. But he can't conduct his work non-hierarchically. The administrator for Merce sent out some years ago a tree on a card and Merce was at the head of the thing and power went down through the senate and the judiciary ... [laughter] Of course it's not an anarchic model, it's the opposite, it's a foolish model. Merce's so devoted to his own work that he didn't let the Jettson group practice their own choreography, which they very much wanted to do. He wants so deeply to do his art that he can't admit that other people do too. But as he approaches my age, he's seven years younger than me, he won't be able to dance. The question is, how's his work going to continue? The board of directors of the Cunningham Dance Foundation suggested that for his work to continue, say, after his death, somebody in his company will have to take charge. Whether his work will continue after

his death or not I don't know. I think he would rather have his work continue than not. But then someone will have to act the way he did, or else you might have a Jettson group. But I don't know if dance can be organized anarchically. They might bump. [laughter]

MB: When did you get interested in anarchy?

JC: Let me see if I can remember. [Long pause] I think it was in the late '40s that I left the city and moved to a community that still exists in Rockland County called Gatehill Co-op. And it was formed in connection with Black Mountain College. Vera and Paul Wiliams had inherited a lot of money from the father of Paul who was an inventor and he didn't want to use the money for himself but for architecture. He wanted to build little houses that were not pretentious in size or anything and that idea attracted a lot of attention and we all had Black Mountain College in common. The Williamses would call themselves libertarian and there was a lot of that kind of thought that got around. I became aware of it and I concurred. Recently, I said something about anarchy to the widow of Max Ernst and she said that Max was an anarchist...

MB: Did you develop politically with any of the people at Black Mountain College who were anarchists, such as Paul Goodman?

JC: I didn't get along well with him. I liked his work, his ideas about anarchy, but I didn't like his reverence for the past, for the tradition. I spoke against Beethoven, for instance, in favor of Erik Satie. I gave a lecture which pointed out that Beethoven was wrong and Satie was right. I didn't say it in terms of anarchy but in terms of the structure of the work. The structure of Beethoven's work is such that it expresses himself, and Satie's work is such that it expresses nothing. Satie's work could be used to express something he wouldn't express but that somebody else would. In other words, Satie's work is like an empty glass into which you can pour anything, whereas Beethoven's structure is something into which you can only pour Beethoven. Or, if you pour something else, it's not as good as Beethoven. Emotions are mostly used by people to make them very happy or very sad. It's foolish. What is central to Indian thought is tranquility. For example, you can be in love or not be in love, but you should be tranquil about it or you might get jealous. [laughter] Or blind... blindly in love. You can use the emotions well but they're very very dangerous. They are used by politicians to murder large numbers of people.

MB: Getting back to an earlier question, was it the Wiliamses then, who introduced you to anarchism?

JC: Yes, but living in Rockland County also gave me the opportunity to live next to an important anarchist

who wrote *Men Against the State,* James Martin. When I met him he told me the story about going to Detroit and he decided to adopt two little boys. They started jumping on the beds and he said it made him so unhappy to make a rule: NO JUMPING ON THE BED. So I put that in one of my books because being an anarchist automatically makes you inconsistent with what you do. You can't be consistent with anarchy in what you say. You have to be inconsistent in order to live. Emerson felt inconsistency was very important. Yet I am consistent in what ways I can be. The other day it took me hours to find a document in my files that a publisher wanted. But I can't have a secretary. If I do, I'd have to tell the secretary what to do!

But I think there will be more and more people, and I hope to be one of them, who will respond affirmatively to the question of... [long pause] ... the practicality of anarchy. There was that dismal time when Emma Goldman went to be on the front in Spain and... [long pause]... I think it's coming back into practicality again. I have a friend who comes from Spain, and she knows a sculptor there who said in reference to the anarchist movement: "From failure to failure, right up to the final victory." She envisages, and so does he and so do I, and I think more and more people will, the political future of humanity as being victoriously anarchic. We cannot have anything but an anarchic, globalized humanity... [long pause]... we have to have a peaceful anarchy... if we don't... we'll have too much of what you might call grief.

# DRUNKEN BOAT

# BOOK REVIEWS

Blaise Cendrars

# CONRAD'S ANARCHIST PROFESSOR: AN UNDISCOVERED SOURCE

## BY PAUL AVRICH

**A**mong the most striking characters in Joseph Conrad's body of fiction is the anarchist Professor in *The Secret Agent.* When the novel was published in 1907, a reviewer in the *Times Literary Supplement,* a short but perceptive notice, found the Professor, Chief Inspector Heath, and Adolf Verloc to be its most interesting portraits, but "it is the Professor who principally increases Mr. Conrad's reputation, already of the highest."[1]

The Professor, whom Conrad calls "the perfect anarchist," is the only character in the book without a name. His motto is "No God! No Master!" He walks the streets of London with a bomb in his pocket to discourage the police from approaching. He need only press a rubber ball for an explosion to take place after an interval of twenty seconds. This, however, does not satisfy him, and he works fourteen hours a day in his laboratory to construct the "perfect detonator." "Madness and despair!" he exclaims in what are perhaps the most famous lines in the book. "Give me that for a lever, and I'll move the world." Lost in the crowd, "miserable and undersized," he meditates confidently on his power, keeping his hand in his trouser pocket around the rubber ball, "the supreme guarantee of his sinister freedom." At the end of the novel, he is the last one off the stage, prowling in the London streets while "averting his eyes from the odious multitude of mankind. He had no future. He disdained it. He was a force. His thoughts caressed the images of ruin and destruction. He

walked frail, insignificant, shabby, miserable—and terrible in the simplicity of his idea calling madness and despair to the regeneration of the world. Nobody looked at him. He passed on unsuspected and deadly, like a pest in the street full of men."

As literary character some have found the Professor grotesque and unconvincing. To Irving Howe, for example, he is so farfetched a monstrosity as to constitute a serious weakness of the novel. "Seldom did Conrad miscalculate so badly as in his view of the bomb-laden 'Professor,'" writes Howe, and "it is difficult to regard this grimy lunatic as anything but a cartoon."[2] Yet, as will be seen in a moment, the Professor was based on a real person. Moreover, Conrad himself meant him to be a serious portrayal of an actual revolutionary type from the late nineteenth century. "I did not intend to make him despicable," he wrote to R. B. Cunninghame Graham shortly after the novel was published. "He is incorruptible at any rate. In making him say 'madness and despair—give me that for a lever and I will move the world' I wanted to give him a note of perfect sincerity. At the worst he is a megalomaniac of an extreme type. And every extremist is respectable."[3]

Conrad, in fact, though he tried to conceal it, went to a great deal of trouble to fashion his characters and story after actual personalities and events. The subject of *The Secret Agent,* he remarks in the "Author's Note" to the novel, "came to me in the shape of a few words uttered by a

friend in casual conversation about anarchism or rather anarchist activities." The friend (whom Conrad does not identify) was Ford Madox Ford, who a decade before had belonged to the anarchist circle gathered in London around the precocious Rossetti sisters and had contributed to their paper, *The Torch.* Ford's conversations with Conrad, however, were much more than "casual." And not only did he supply Conrad with anarchist literature, but he also introduced him to Helen Rossetti, the driving force behind *The Torch.* Conrad became deeply interested in the subject and, despite his later disclaimers, read everything about it that he could lay his hands on. Besides *The Secret Agent,* moreover, he wrote two short stories dealing with anarchists, "An Anarchist" and "The Informer," the latter being a kind of work in progress in which we first encounter the Professor of the novel. In all three works, he betrays a knowledge of anarchism of the 1880s and 1890s based on a careful study of contemporary pamphlets and journals, of memoirs of anarchist and police officials, and of press reports of incidents involving anarchists.

Conrad always tried to conceal the extent of this research which was considerable. In his "Author's Note" to *A Set of Six,* [4] which contains both "The Informer" and "An Anarchist," he writes: "Of 'The Informer' and 'An Anarchist' I will say next to nothing. The pedigree of these tales is hopelessly complicated and not worth disentangling at this distance of time. I found them and here they are. The discriminating reader will guess that I have found them within my mind; but how they or their elements came in there I have forgotten for the most part; and for the rest I really don't see why I should give myself away more than I have done already."

Professor Norman Sherry of the University of Lancaster, in his meticulously detailed study of *Conrad's Western World,* has done an impressive job of tracing the sources of Conrad's characters and plots.[5] Thus "An Anarchist," as he shows, was based on an actual mutiny in the penal settlement on the Ile Saint-Joseph, French Guiana, on October 21, 1894, accounts of which appeared in the anarchist press.[6] By the same token, the source for *The Secret Agent* was an actual episode, the famous Greenwich Park explosion of February 15, 1894. Despite his pretense of ignorance, Conrad's data for this incident came from a whole array of London newspapers, police reports, and anarchist periodicals and pamphlets, from which, as Sherry writes, "specific details of revolutionary activity, attitude and character were derived.[7] " So deeply, indeed, did he immerse himself in this literature that, after the novel was published, "a visitor from America informed me that all sorts of revolutionary refugees in New York would have it that the book was written by somebody who knew a lot about them," Conrad tells us in his

"Author's Note" to the book.

But on whom did he model his character of the Professor? No such person figures in the actual incident, about which much has been written. The scholar must therefore look elsewhere. Professor Sherry suggests a number of possibilities, including the German-American anarchist Johann Most and a British anarchist doctor named John Creaghe, or a composite drawn from features of both men and possibly others. Yet neither Most nor Creaghe, for all their affection for dynamite, possessed what Sherry rightly considers the most startling characteristic of the Professor, namely his habit of always carrying an explosive in his pocket. This idea, says Sherry, Conrad may have derived from an Irish terrorist named Luke Dillon (known as "Dynamite" Dillon), or perhaps it was simply " an imaginative invention of Conrad's, since no such explosive-carrying person existed in anarchist circles in spite of the melodramatic and sensational image which anarchists had in the minds of the general public."[8]

Professor Sherry, however, is mistaken. For all his ingenuity in ferreting out sources, he has neglected to follow up a clue provided by Conrad himself. In the window of Adolf Verloc's shop, writes Conrad in *The Secret Agent,* were "a few apparently old copies of obscure newspapers, badly printed, with titles like *The Torch, The Gong*—rousing titles." *The Torch* is clearly the journal of the Rossetti sisters mentioned above, and *The Gong* Professor Sherry takes to be *The Alarm,* another anarchist paper published in London in 1896.[9] What Sherry has overlooked, however, is a similar reference in "The Informer" to *The Alarm* and *The Firebrand*, the latter being an anarchist weekly published in Portland, Oregon, between 1895 and 1897. *The Alarm*, accordingly, would seem to be not the British journal of 1896 but its American predecessor and namesake, edited in Chicago during the 1880s by the Haymarket martyr Albert R. Parsons. A search of its files confirms this supposition. On the last page of the January 13, 1885 issue, the bomb-carrying Professor springs into life. Here, by all appearances, is the original of Conrad's character:

DYNAMITE: Professor Mezzeroff Talks About It, And Other Explosives; A Good Word for Tri-Nitro-Glycerine, A New and Vigorous Child; He Carries a Bomb in His Pocket; How the Professor Carries Explosives Around with Him in Street Cars. Collated from the N.Y. "Voice!"

*There has been a great deal of discussion in the newspapers as to my nativity. I was born in New York. My mother was a Highlander, my father was a Russian, and I am an American citizen. I have diplomas from three colleges, and have devoted my life to the study of medicine. When I was a boy I fought in the Crimean War, and I bear the scars of five wounds. The wholesale massacre disgusted me with autocratic rule. I determined to devote my life to the*

welfare and elevation of humanity. I have kept my word, and no man or woman or child can today say that he or she has been wronged or injured by me. I am going to tell you some secret statistics which I have. I belong to two secret societies, and get State secrets from Europe forty-eight hours after they have transpired. Russia has 3,000,000 men under arms today, exclusive of the police, the paid spies and other civil supporters of the government. Germany has 2,500,000; France has 2,000,000; Austria 1,000,000; England 800,000, counting the militia; Turkey half a million; the rest of Europe 2,000,000. In all there are over 10,000,000 soldiers who are supported by the laboring men of the Old World. Yet, when I propose to use a bomb costing $25 in place of a Krupp gun costing $150,000, I am called a fiend. If we want to kill each other let us do it on business principles. Gunpowder kills at the rate of 1,200 miles a minute, dynamite at 200,000. If you use my explosive you can defend yourself against the armies of the world.

When I went to Boston the other day three detectives, one a woman, followed me and tried to find out where my college is where I teach how explosives are compounded, in order to put a stop to my career. Now, I have the same right to educate men in chemistry as Professor Chandler has, and I won't stop until every workingman in Europe and America knows how to use explosives against autocratic government and grasping monopolies. I have the receipt for forty-two explosives in a burglar proof safe, and should I die, they will be published to the world in order that all may know how to deliver themselves from tyrants and those who wrong them. I can take tea and similar articles of food from the family table and make explosives with them more powerful than Italian gunpowder, the strongest gunpowder there is. I will [the next few words are illegible] do with ten pounds of pure trinitro-glycerine, of whose composition England knows nothing, because the only men there who knew about it were blown up by it. I take it through the street in my pocket; carry it about in the horse cars.

Not long ago I was traveling with some friends in a car, and an old woman came and sat down on the

Illustration by Knickerbocker

*two bombs I had with me. A good lit-*
*tle nitric and sulphuric acid, with*
*pure glycerine, such as ladies use,*
*mixed in the proper proportions, and*
*five or six pounds of it, such as could*
*easily be carried in the pocket, would*
*destroy the big post office down town.*
*No confinement is necessary for tri-*
*nitro-glycerine. In the open air it will*
*expand 1,300 times its own size at the*
*rate of 200,000 feet a minute. You*
*can learn to make tri-nitro-glycerine,*
*and if you carry two or three pounds*
*with you people will respect you*
*much more than if you carried a pis-*
*tol. But don't use dynamite till the*
*government becomes autocratic, and*
*you cannot obtain your rights at the*
*polls.*

—PROF. MEZZEROFF.[10]

## Notes

1. *The Times Literary Supplement,* September 20, 1907, 285, reprinted in Norman Sherry, ed., *Conrad: The Critical Heritage* (London, 1973), 184-5.

2. Irving Howe, *Politics and the Novel* (Cleveland, 1957), 97.

3. *Joseph Conrad's Letters to R. B. Cunninghame Graham.* C.T. Watts, ed. (Cambridge, 1969), letter of October 7, 1907.

4. Volume XVIII of Conrad's *Complete Works,* Century edition (New York, 1924).

5. Norman Sherry, *Conrad's Western World* (Cambridge, 1971), 205-334. See also Eloise Knapp Hay; *The Political Novels of Joseph Conrad* (Chicago, 1963), 219-63; Ian P Watt, ed.; *Conrad, 'The Secret Agent"* (London, 1973); and Avrom Fleishamn, *Conrad's Politics: Community and Anarchy in the Fiction of Joseph Conrad* (Baltimore, 1967), 187-214.

6. See, for example, "The Massacre of the Anarchist Convicts in French Guiana," *Liberty* (London), April 1895.

7. Sherry, *Conrad's Western World,* 205.

8. *Ibid.,* 283.

9. Eloise Knapp Hay, in *The Political Novels of Joseph Conrad,* 237, wrongly surmises that *The Torch* refers to Lenin's *Iskra* (The Spark) and *The Gong* to Herzen's *Kolokol* (The Bell).

10. Compare C.W. Mowbray, a militant English anarchist and member of William Morris's Socialist League: "General Sheridan of the American army said 'arms are worthless' and that dynamite was a lately discovered article of tremendous power, and, such was its nature that people could carry it around in the pockets of their clothing with perfect safety to themselves, and by means of it they could destroy whole cities and whole armies." *The Commonweal* (London), November 29, 1890.

# KERR'S POETS OF REVOLT

Voltairine de Cleyre

Covington Hall

Carlos Cortez

## by Morgan Gibson

Covington Hall.
*Dreams & Dynamite: Selected Poems*
Edited & Introduced
by Dave Roediger.
Poets of Revolt Series # 1.
Chicago: Charles H. Kerr
Publishing Company, 1985.

Voltairine de Cleyre.
*Written in Red: Selected Poems.*
Poets of Revolt Series # 2.
Edited & Introduced
by Franklin Rosemont.
Chicago: Charles H. Kerr
Publishing Company, 1990.

Carlos Cortez.
*Crystal-Gazing the Amber Fluid.*
Poets of Revolt Series # 3.
Chicago: Charles H. Kerr
Publishing Company, 1990.

**N**o American publisher has been fanning the flames of revolt so long as Charles H. Kerr (1740 West Greenleaf Avenue, Chicago, Illinois 60626), established in 1886. Its current catalogue, a tabloid more informative and stimulating than most current political magazines, lists, for example, its standard edition of *The Communist Manifesto,* in print for nearly a century, as well as other classics by Marx, Bakunin, Godwin, Kropotkin, Malatesta, Thoreau, Oscar Wilde (*The Soul of Man Under Socialism*), and other radical authors. According to Studs Terkel, "Here is the publisher of Gene Debs, Clarence Darrow, Mother Jones, Mary Marcy, Jack London, Claude McKay, Carl Sandburg and hundreds of other outstanding figures—still at it, still fighting the good fight after a hundred glorious years."

Introducing the Sixties Series, Kerr has reissued *The Port Huron Statement,* Students for a Democratic Society's Manifesto for participatory democracy originally drafted by Tom Hayden and influenced by the ideas of Paul Goodman, Albert Camus, John Dewey, and others, along with Carl Davidson's *The New Radicals in the Multiversity and other SDS Writings on Student Syndicalism.* And difficult to obtain books from other publishers, such as the excellent series from Freedom Press in England, are also distributed by Kerr.

The Poets of Revolt Series is a new venture by Kerr that freshly links past and present, in a pocket-size format. Dave Roediger judiciously introduces the poetry of Covington Hall (1871–1951), a southern Wobbly devoted to interracial struggles of workers and farmers. Rising above most of the didactic rhymes in *Dreams and Dynamite,* reminiscent of the days when hobos and strikers sang around camp-fires, is the Blakean "Butterfly's Boast," ending "Lo, I struggled and I won! / I a caterpillar's son, / Born a worm in a cocoon, / In the Mountains of the Moon." "The Curious Christians" is as applicable as ever, beginning, "For Jesus' sake they shoot you dead, / Then pray to God to 'make you whole.'" And the Iron Johns, Snyders, and Antlers of today are foreshadowed in the poem beginning "I'd like to be a savage fer a little

while agen, / En go out int the forests where there ain't no business men; / Where I'd never hear the clatter uv their factories en things, / But jest the low, soft buzzin' uv the hummin's crimson wings..."

████████████████████████

Voltairine de Cleyre (1866–1912), named after Voltaire, was a much more famous, intellectual, and passionate poet than Hall. I first heard about her from Kenneth Rexroth, who fondly quoted her poems from memory. Emma Goldman praised her to the skies, and Alexander Berkman edited her *Selected Works*. Franklin Rosemont edited the Kerr selection called *Written in Red* and offers a brilliant introduction to her ecstatic personality and impact on the movement. Her hauntingly mad eyes stare at us from the flaming cover. A precocious socialist, she became an anarchist after the Haymarket riot, but eventually found even Red Emma too tame for her burning heart. Rosemont calls her a "*disturbing presence*," like Antonin Artaud. Influenced by Whitman and the English Romantics, her poetry is as deeply personal as it is didactic and prophetic. In "The Road Builders," recalling a black man who fell dead on the road he was building, she cries: "you drive upon his corpse." And in the Browning-esque "The Suicide's Defense," the "rescued" man condemns the judge who is about to sentence him for attempting to kill himself:

I hate you! Every drop
of blood that circles in your
plethoric veins
Was wrung from out the gaunt and sapless trunks
Of men like me, who in your cursed mills
Were crushed like grapes within the wine-press ground.
To us ye leave the empty skin of life;
The heart of it, the sweet of it, ye pour
To fete your dogs and mistresses withal!
Your mistresses! Our daughters! Bought, for bread,
To grace the flesh that once was father's arms!

████████████████████████

Like Covington Hall, Carlos Cortez (born 1923) has been an active Wobbly for most of his life, writing the popular "Left Side" column for *The Industrial Worker* for many years. His father was a Mexican Wobbly, his mother a German socialist and pacifist. Cortez was imprisoned during World War II for refusing to fight the "bosses' war" and has been active primarily in Milwaukee and Chicago, though he has also traveled internationally. His wife, Marianna, the radiant subject of several of his prints, is from Greece. Famous as a wood block artist who has exhibited abroad and at the Museum of Modern Art, Cortez has contributed a striking self-portrait for the cover of *Crystal-Gazing the Amber Fluid* and illustrations within it. Largely self-taught, he leads print workshops at colleges, universities, and museums. When I first met him

at an anti-nuke demonstration in Milwaukee thirty years ago, I thought, "He must be what the Wobblies were like"; but as we became close friends I realized that he was not an historical relic but a living embodiment of the IWW—authentic, free, caring for the world through mutual aid. If my characterization appears biased, the reader can find a more eloquent evaluation in Eugene Nelson's Introduction to the poems.

Unlike the Romantic styles of Covington Hall and Voltairine de Cleyre, Cortez's idiom is very much today's, projecting his presence so vividly that he might well be talking to us while contemplating the "amber fluid" between sips. There are echoes of the Beats, but Cortez was never beat, even when he envisions only bugs surviving the nuclear extinction of man. His Indian heritage provides him with an earthy cosmic optimism, shown, for instance, in "The Downfall of Disease-Giver," in which a crazy youth courageously vanquishes the only spirit that has terrorized the tribe, proving that "The mind can be a jail, but it can also be a mountain." Or in "Three Spirits," the

martyred Wobblies Frank Little, Wesley Everett, and Joe Hill look down upon freeway motorists speeding "toward some intangible oblivion," as if the libertarian spirit will survive — a theme that is amplified in other tender elegies to them and also Sacco and Vanzetti. Of course he mourns those who die under the curse of industrial "progress," including the extinct Tecopa pupfish; but he never gives up, even in jail, "face to face / With a window of iron / And a mattress of wood" ("Central City Blues"). His "Requiem for a Street" brings the vibrant multiculturalism of Chicago's old Halsted Street to life again. Perhaps Comrade Cortez's transcending anarchist faith is concentrated most memorably in the visionary lyric, "Speranz!"

A small green leaf
Breaks its way
thru a crack in the pavement,

Glories briefly
In its new-found freedom,
Then withers'

But the root beneath
grows
stronger and stronger.

# STORM DEMON

## WHO WAS B. TRAVEN?

## BY HAKIM BEY

[Introductory note: "B. Traven" was the pen-name of a man whose identity remains unknown. Most of his novels are set in Mexico. But he was probably born in Germany, around the turn of the century—perhaps 1891—or 1882. He claimed to be American. In 1919, using the name Ret Marut, which means "storm demon" in Sanskrit, (along with several other pseudonyms), he participated in the ephemeral post-War anarcho-communist Bavarian *Räterepublik* or "Munich Soviet" along with well-known anarchists such as Gustav Landauer, Ernst Toller, and Erich Mühsam. Around 1921 he surfaced in Mexico using a whole new set of pseudonyms. From there he sent manuscripts to the Büchergilde Gutenberg, a leftist book-club/publisher in Germany. As his fame grew he found it increasingly difficult to evade speculation about the "Mystery" of his identity. He is perhaps best remembered in America as the author of *Treasure of the Sierra Madre*, source of the John Huston film starring Humphrey Bogart. Traven died in Mexico in 1969, mourned as a great friend of his adopted land—his identity still unknown.]

Fine writing is no excuse.

You don't have to be a "good" writer to be a *great* writer.

**B**recht and Weill tried to make communism *popular* through "Epic Theater." They might have succeeded, if theater itself were still a *popular* artform. They triumphed in transforming the avant-garde, and their work is of inestimable value to aesthetic theory—but they scarcely reached "the masses" at all.

The adventure novel, however, really is a popular artform. As with film, "mechanical reproduction" deprives the popular novel of "aura" (in Walter Benjamin's phrase), but makes it accessible to the many. B. Traven's novels, and especially *The Deathship*, have been translated into every major language of the world and printed in multiple millions. He is ignored by the academic canoneers and aesthetic theoreticians for precisely this reason. He succeeded in making "political art" *popular*.

B. Traven had no doubt noticed that the adventure novel works extremely well as propaganda, but that most of its practitioners represent blatant reaction. From H. Rider Haggard to Sax Rohmer to Ian Fleming, the adventure novel has performed as the folk-epic of fascism. Traven's moment of genius was to see how the form could be turned upside-down and made to work *against* reaction—and *for* the free human spirit. Workers and "natives," who fill the reservoir of faceless villains in Rider Haggard, step forward in Traven to take on a new role, virtually never before contemplated in genre lit. Perhaps nameless but no longer faceless, they have become—both individually and collectively—the heros of the tale.

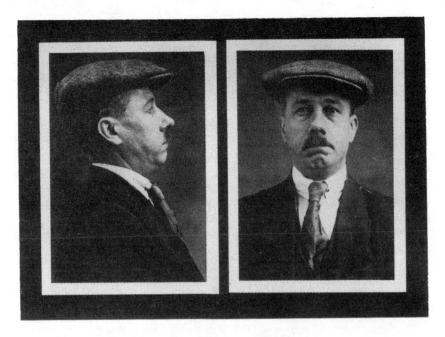

*London police photos of Ret Marut*

I believe Traven chose the adventure novel quite consciously and deliberately, not only because he had a taste for it, but because he believed it to be the only possible form for the modern epic. Like Brecht, he might have chosen film—if he were a millionaire. But film has never realized its potential in the field of agitprop-art precisely because it costs "millions" to make films, and thus (as might be expected) most films represent the values and ideas of those who can afford to make them.[1] Traven, working alone in his legendary Mexican jungle hut, needed only school exercise books and pencils (and of course a sincere leftist publisher, which amazingly enough he succeeded in finding) to create his epics.

Brecht and Traven can be compared in other ways. As I understand Brechtian "alienation," it has three purposes. First, by interrupting narrative flow with theory, the artist jolts the audience out of its passive trance of consuming art merely as entertainment, and invites it to participate intellectually in the meaning of the art. Second, "alienation" serves a function for the artist as well as the audience. It reminds the narrator that the point of the work is neither "fine art" nor the expression of the artist's ego, but rather (if possible) to *change the world*. Third, political art should be both entertaining and instructive. But the pleasure is not all contained in the narrative and the message all relegated to the device-of-alienation.[2] In a sense, alienation allows the nar-

rator to re-enter the action of the narrative from which the "artist's ego" has been so rigorously excluded. The author now has a chance to speak directly, to let off steam, indulge in rhetoric, polemic, autobiography, and to exercise wit and wisdom. Traven has been criticized by critics for precisely those passages of "alienation" where he breaks the narrative to rant, or make some sardonic comment. I however (and I suspect most *readers* as opposed to *critics*) thoroughly enjoy these moments when Traven speaks so directly to me. Traven is a great seducer;—if he hadn't been so shy he might have been a great revolutionary organizer (like his character "*der Wobbly*"). But he becomes his own best character in these passages, creating himself as an unforgettable voice, a kind of sarcastic Ishmael who alone has escaped to tell us the tale, to explain it, to show it forth.

When I began by stating that "fine writing is no excuse," I imagined Traven saying these words. There's no such thing as apolitical writing. Writing which justifies itself primarily by its "fine"ness implies the axiom of a *politique* based on aesthetic *rather than* human values. Most "great" writing is in fact reactionary in effect, even if not in conscious intention. Traven did not believe that art must concern itself with the "Social"—he was too anarchistic for such tripe. But he might well have said that the "greatness" of art can be assessed only by its libera-

tory effect on the reader. The "best" text in your life might be a crude revolutionary tract—or a love letter! A Joseph Conrad (whom Traven despised) or a T.S. Eliot enter the Canon as aesthetic fascists, both oppressive and repressed, and inject their poison into "Culture"—while Traven, who is neither a "good" writer nor an art-cop, remains outside in the vague and despised realm of "popular lit." Good! That a writer can infect the Bestseller List with an itch for freedom (*as anarchists understand freedom*)—that, surely, is worth a thousand Ph.D. theses and prestigious literary awards.

When I say that Traven was a great but not a good writer, I mean that he sometimes wrote clumsily—that he used fake americanisms when writing in German and clunky germanisms when writing in English—

*Traven in Chiapas*

that he avoided purple passages of pure description of the kind most appreciated by academic critics—that he allowed his own passions to warp the surface of his narrative—that he subordinated all impulses toward "fine" writing to the over-riding didactic *purpose* of his work—and that finally, despite (or because of) all this, his total achievement bears comparison not just with "great" writers (like, say, Balzac) but even with the bards and "epic rhapsodists"[3] of the past.

Like Homer, Traven created two major epics (in the Brechtian sense):—first, his "Odyssey," the series centered around the American wanderer/trickster/sailor/worker/Wobbly (sometimes called Gales, no doubt with a pun on *marut* as "storm-demon"), which really begins with *The Deathship* and continues with *Der Wobbly (The Cotton-Pickers)*, *Treasure of the Sierra Madre*, and a number of short stories. This is the epic of the individual hero, the free spirit, a working-class realization of Stirner's and Nietzsche's ideal. But Gales is not a "selfish" Individualist. Traven, like his old comrade Gustav Landauer, succeeded in synthesizing Stirner and Kropotkin.[4] The individual realizes the highest self precisely in love, and in struggle, where Self-interest and the interest of the Other coincide.

Traven's second epic, his "Iliad" so to speak, makes this even more clear. The "Mahogony Series" still has individual heros—even its Achilles, the "General from the Jungle" himself—but is focussed on the larger struggle of a group for the autonomy in which to exist (or even survive) as a collection of individuals or "union of self-owners" (in Stirner's phrase). As an artistic whole the Mahogony Series constitutes Traven's masterpiece, perhaps the most stirring work of revolutionary art I've ever read—the textual equivalent of Diego Rivera's murals.[5] Here again I seem to disagree with the critics, who pay much less attention to the Mahogony books that to *Deathship* or *Treasure of the Sierra Madre*. *Deathship* may be Traven's single most brilliant (and incidentally, most crudely written) book, but the Mahagony Series is a *genuine anarchist epic*. Dare I say it? ... *Homeric!*

Who was B. Traven? Should we care? Who was Homer for that matter? And does it matter?

In a sense, no. Traven wanted to disappear in the anonymity of his craft, as "Homer" has done. The "mystery" of B. Traven neither adds to nor detracts from the poignant magnificence (if you can imagine such a combination) of his *texts*. However, if we want to talk about Traven's *work* as opposed to his *texts*, then we must discuss his identity—because the construction of that identity was just as much an *oeuvre* or act-of-creation as any of his writing.

Traven was what I call an "ambulatory schitzophrenic," someone who needed to peel off personalities, *noms de plume*, aliases, a/k/a's,

secret code names, an endless series of snakeskins, merely in order to stay sane and whole. But he was also a "rational paranoid":—he *knew* that "they" *really* were out to get him. And they were.

In a collection of stories originally put together by Traven's widow, Rosa Elena Lujan, called *The Kidnapped Saint and Other Stories* (Lawrence Hill, 1975–1991), you may read the only translation (as far as I know) of a non-fiction text by Traven written as Ret Marut,[6] the personality he assumed in Germany as editor of the anarchist journal *Der Ziegelbrenner* (*The Brickburner*; it was shaped like a brick!) and as a collaborator with the Munich Soviet (or "Coffeehouse Republic") of 1919. This text, sarcastically titled "In the Freest State in the World," is a piece from Marut's journal describing how he literally escaped Landauer's fate (death at the hands of Thule Society proto-nazis) in the collapse of the *Räterepublik*. Marut, who already had such a mania for "disappearance" that he gave his public lectures in darkened chambers, was clearly freaked out by this incident. To come so close to death and yet "escape alone" to tell of it must feel like having a *second life*. It was thus that Ret Marut became B. Traven.

However, it seems clear that "Ret Marut" (the Storm Demon) had already buried at least one prior identity. Ret Marut came from nowhere, and began life as a young actor in second-rate German provincial theaters—appropriate work for someone destined to play so many roles.

Now who the hell was Ret Marut?

Early Traven biographies already take for granted that Traven was Marut;[7] he revealed it himself on his deathbed. But they fail to penetrate any farther back. Sometimes they even fall for one of Traven's most outrageous red herrings, the rumor that he was American, or that he was the illegitimate offspring of Kaiser Wilhelm! I like these biographies because they're written by Traven fans, buffs, amateurs. They *respect* Traven's desire for secrecy too much to succeed as scholars. Even Traven's wife didn't know who he "really" was.

The only half-way convincing solution to the mystery was propounded in 1980 by a BBC reporter, Will Wyatt, in *The Secret of the Sierra Madre* (Harcourt Brace Jovanovich, NY, based on an earlier TV special). This book is one of the most unpleasant biographies I've ever read. Wyatt pretends to admire Traven but one can sense that he really hates him and wants to *expose* him.

According to Wyatt, Traven was "really" the illegitimate son of a petit-bourgeois E. German brickmaker (aha!), a troubled adolescent who vanished shortly before "Marut" appeared. At the time I read this I was persuaded by Wyatt's painstaking and intrusive detective work. I felt he'd succeeded as a scholar precisely because he was *not* a Traven fan, but rather a rude son-of-a-bitch with *no respect* for his "subject."

However, I'm happy to report

that the most recent Traven biog, Karl S. Guthke's *B. Traven: The Life Behind the Legends* (Lawrence Hill, 1987–1991), translated from German by R.C. Sprung, has restored the mystery. Guthke is a careful German scholar but also a great admirer of Traven. He's especially good on the Ret Marut period and on Traven's anarchism. He also tears Wyatt's book to shreds. He can't *disprove* Wyatt's thesis, but he shows how flimsy the circumstantial evidence behind it really is. Best of all, where Wyatt gave us a neurotic con-man of doubtful sincerity, Guthke presents us with a flawed hero, a man who overcame defeat and terror and transmuted them into great art—a man who created himself anew, like a phoenix, out of the ashes of fear and failure. In Traven's utter success in hiding himself we can discover something of the impeccability of Casteneda's sorcerer.

In short, in order to understand Traven's *work*—in which he "disappears" as a mere limited identity and re-appears as the voice of the human spirit, anonymous but vividly individual, eternally *free* but perennially *sorrowful* over the world's enslavement (which limits his own freedom)—in order to grasp the essence of Traven's *art*, we must indeed ask "Who was B. Traven?" The mystery of this question restores to Traven's novels something of the "aura" which they lose in "mechanical reproduction." The "real" author has established a relation with us through the medium of the book. The "real" author of the book is an anarchist *angel*.

But—we are not interested in passports and identity cards, those symbols of ultimate evil in Traven's world-view. We are vitally interested in *identity*—but not in police procedure or the prying of spies and reporters. We *already know* that identity; but we do not speak of it. Because it is also *our secret*. Traven is for those who love him. And those who love Traven, love both the identity and the mystery.

[Endnote on editions of Traven: You may be able to find some of Allison & Busby's paperback editions, imported from England, although they are no longer being actively distributed in the U.S.A. Allison & Busby published the Mahogony Series under the general title of "the Jungle Novels" (they list *Trozas* but they never published it; it does not exist in English). Allison & Busby also did editions of *The Cotton-Pickers, The Kidnapped Saint & Other Stories, The White Rose,* and *The Night Visitor & Other Stories.*

*Treasure of the Sierra Madre* is in print from Farrar Straus Giroux. *The Deathship* has recently appeared in a good new edition from Lawrence Hill Books, now the only English-language publisher really committed to B. Traven. They also brought out the Guthke biog, *The Kidnapped Saint, The White Rose,* and *To The Honorable Miss S....*

Other than these, no Traven title is in print in this country. Lawrence

Hill Books would like to do American editions of the Mahogany Series, but have not yet secured rights from the more-or-less moribund Allison & Busby. Meanwhile... go on a treasure hunt!]

## Notes

1. I've never seen the Traven films made in Mexico, and don't know anyone who has. Do they still exist? As for "Treasure of the Sierra Madre," it was based on Traven's least political book (naturally), and Huston eliminated most of the agitprop value it had. He did however do justice to Traven's "allegory of Greed." But the movie did not make Traven popular (he was already popular), and it did not launch him in Capitalist America, which still continues to ignore him. Brecht never had much success in films either.

2. Of course in "Socialist Realism" this separation does take place and is carried to vulgar and excessive extremes. Brecht and Traven were great agitprop *artists* because they allowed for an infinite complexity of reflection between the poles of "entertainment" and "instruction."

3. A phrase of Nietzsche's.

4. Marut would have read Stirner in the edition published by John Henry Mackay, the Scots-German anarchist who edited a journal called *The Storm* (aha!) and had "rediscovered" Stirner. Marut may even have met Mackay (Landauer would have been the most probable link). Among Traven's books found in Mexico City after his death Guthke mentions (p. 374) a copy of Stirner's *The Ego and His Own* (along with Tristan Tzara's poems!). Marut is very "Stirnerite"; Traven reflects a certain "leftward" synthesis in which Stirner mixes with other influences.

5. The Series consists of *Government*, *March to the Monteria*, *Trozas*, *The Rebellion of the Hanged*, and *General from the Jungle*. I've read all these except *Trozas* (*Die Troza*), which has never been translated. The cycle of novels depicts horrific slave-labor conditions in the mahogany logging camps of S. Mexico, and recounts the fate of those condemned to suffer there. At last some brave workers, Indians and mestizos, overthrow the management and launch a full-scale military revolt, with glorious but ironic consequences:—they emerge from the jungle to discover that all of Mexico has also experienced a revolution!

6. A number of Marut's fictions are contained in *To The Honorable Miss S....*, and *Other Stories* by Ret Marut a/k/a B. Traven, intro. by Will Wyatt, trans. by P. Silcock (Lawrence Hill Books, Westport, CT/ Cienfuegos Press, Sanday, Orkney; 1981). Some of the tales are worthy of "Traven," especially the title novella, which foreshadows *The Death-ship* in some respects.

7. Such as *The Mystery of B. Traven* by Judy Stone (Wm Kaufman, Inc., Los Altos, CA, 1977), and *B. Traven—An Introduction*, by Michael L. Baumann (Univ. of New Mexico, 1976).

*B. Traven making expedition notes.*

# A REVIEW OF MAGPIE REVERIES

## By Freddie Baer

**D**amn it, Jim, I'm a doctor, not an engineer," Leonard "Bones" McCoy would say to Captain Kirk in what seemed to be every other episode of the first incarnation of *Star Trek*. When Max Blechman, editor of *Drunken Boat*, first approached me to review James Koehnline's book, *Magpie Reveries*, my reaction was, "Damn it, Max, I'm a collage artist, not a reviewer." I approached this assignment with a certain amount of trepidation; words are not my usual medium. I deal in sliced and diced pictorial representations, same as Koehnline.

But the idea is sound—have Koehnline and I review each other's book on facing pages. It gives us a chance to dissect the other's collage work and make cutting remarks about it.

I would prefer not to compare and contrast *Ecstatic Incisions to Magpie Reveries*, with one exception. Obviously, the preface written by Peter Lamborn Wilson in *Ecstatic Incisions* is far superior to the one written by Hakim Bey in *Magpie Reveries*. In a clear, concise manner, Wilson discusses the history of collage and its significance to today, as opposed to Bey who digresses on endlessly with arcane, obscure, and oblique references that to comprehend you need an advanced doctorate in the history of philosophy/philosophy of history.

The collages in *Magpie Reveries*, published by Autonomedia, are print-ed on one side of each page. The book has no page numbering and just one collage title ("Jes Grew") which made it hard for me to refer to specific collages. So I went through the book and hand numbered each collage; if so inclined, the reader may want to do the same to follow my remarks. All together, there are 50 collages in *Magpie Reveries*, 53 if you include the frontispiece and the two color cover collages.

It is hard to review *Magpie Reveries* without acknowledging James Koehnline's genius. His mandala-like collages are scrumptious visual feasts for the eye: a central focal point draws the viewer into the collage. Corners are filled either with an object that has been quartered or similar/dissimilar images that balance out each side, augmenting the symmetry of the piece. Backgrounds are manipulated: mirrored, flipped, reduced, and reduced again, creating kaleidoscopes and textures. More visual bric-a-brac is added, creating a mosaic whole.

Koehnline manipulates his images with xerox machines as much as he uses exacto blades. Collages 13 and 24 have the same background but a completely different feel due to the elements placed upon them. Again, the background and parts of collage 27 become collage 22. As layer upon layer of additional graphics are added, collage 27, "Jes Grew," mutates eleven different times, ending with collage 38; then, starting over with collage 39, the pattern is repeated through to collage 42. In each of these permutations, dissimilar

center images once again change the read of the original collage.

Koehnline's collages are a celebration of the primitive and natural world. Bits of organic matter, visions of non-existent worlds, swirls and flourishes, geometric patterns, unreadable manuscripts and ancient ephemera bubble up in his landscapes. He uses symbols, keys that unlock the unconsciousness and let one look inside oneself. It is healing to slowly examine *Magpie Reveries,* art therapy of a sort.

However, *all* graphic images serve as fodder for Koehnline's exacto knife. I find it disconcerting that the recognizable work of contemporary artists as well as anonymous nineteenth century engravers are pla-

garized. A still from George Melies' *A Voyage to the Moon,* is used as a centerpiece for the first collage. Illustrations by Virgil Finlay and Hannes Bok, science fiction artists from the 1950s, are incorporated into collages 36 and 40. (For those who like their Finlay straight, no chaser, Underwood/ Miller have just published two fabulous collections of his art, *Strange Science* and *Women of the Ages.*)

*Magpie Reveries* represents the early work of an incredibly brilliant artist. James Koehnline has a collage style unlike any other artist, contemporary or past; I look forward to see how his technique will develop. The future holds even more fantastic and imaginative artwork from Koehnline.

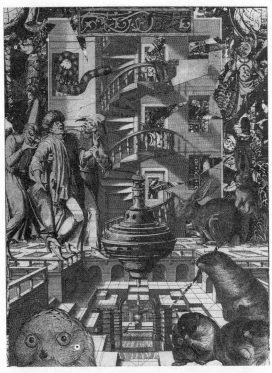

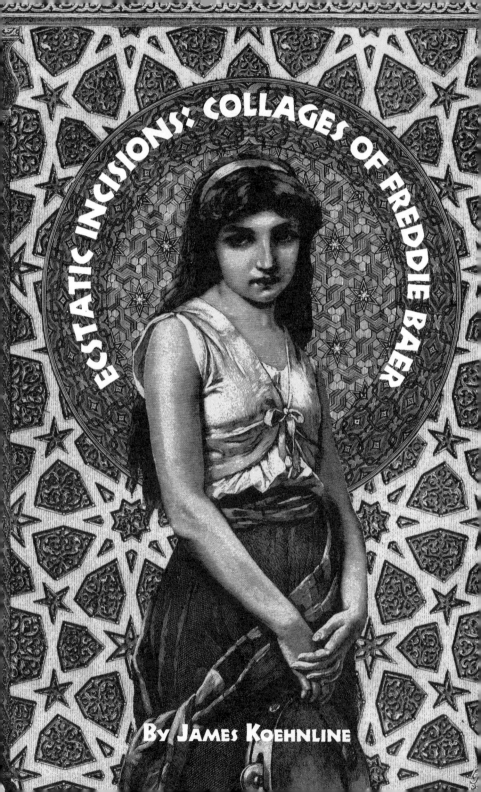

# ECSTATIC INCISIONS: COLLAGES OF FREDDIE BAER

## BY JAMES KOEHNLINE

**H**ere's to Freddie Baer, gifted collage artist, maker of the most beautiful silk-screened T-shirts, illuminator of dark polemics. Most of her work falls into the category that I think of as the "Dover School of Collage" (after the pictorial archives books from Dover Press). That is to say that she takes elements from 19 century engravings and recombines them to create marvelous new worlds. Freddie is not the first, the only *or* the last to work in this way. But she is one of the very best. There are those who would say that it's all been done before, by the likes of Max Ernst, Wilfried Satty, etc., but that doesn't mean the possibilities have been exhausted. Far from it. Freddie brings her own sensibilities to her work, and the beautiful results are uniquely her own. She says she started doing collage when she realized that "anyone could do it." Well, that is true, but not anymore so than to say that anyone can write poetry. The major part of collages being produced these days are so much dross. Luckily for us, Freddie isn't just anyone. I have no doubt that some readers will object to what they see as my "elitist" perspective on "art" and "beauty" when I should perhaps be expounding on the radically democratic virtues of this anti-artform. So be it. I may not know politically correct anarchist theory and criticism. But I know what I like, and I say again, Freddie Baer is one of the best.

I've been enjoying her work for about ten years, since I saw her piece entitled "Bosses, the Real Time Bandits" (apparently her first collage). I have accumulated quite a collection, mostly on yellowing newsprint and will-worn t-shirts. Her collages have appeared regularly on the covers of *Anarchy: A Journal of Desire Armed, Fifth Estate, Semiotext(e), Science Fiction Eye,* etc. Now at last, some of her best work has been collected in an oversized paperback book from A K Press entitled *Ecstatic Incisions: The Collages of Freddie Baer.* In addition to a good, representative selection of her work to date, there are a preface by Peter Lamborn Wilson, a lengthy, candid interview with Freddie conducted by Thomas Murray Sate, and texts from her collaborations with Hakim Bey, T. Fulano, Jim Gilman, Jason Keehn and David Watson. All in all, I'd say this book is a must for those who know and love her work, and a fine introduction for those unfamiliar with it.

Not being accustomed to writing reviews, I find it difficult to be critical of a fellow traveler for whom I have great respect, but I will make a couple of very subjective comments, just so this review won't read like uncritical advertising. Freddie is a dedicated anarchist and activist, very careful about who she works with, and yet, for me, her overtly political graphics are not nearly as strong as the sublimely surreal alternative worlds she creates, many of which have become meticulously silk-screened shirts for her T-Shirt of the month club. The best of these deserve a little more room to breathe and to work their magic on the viewer, without competing with an image on the facing page.

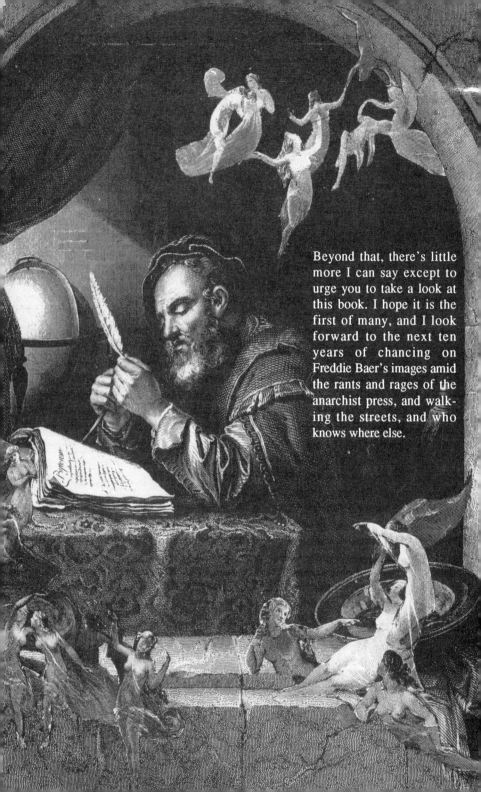

Beyond that, there's little more I can say except to urge you to take a look at this book. I hope it is the first of many, and I look forward to the next ten years of chancing on Freddie Baer's images amid the rants and rages of the anarchist press, and walking the streets, and who knows where else.

# HERBERT READ: CONTRADICTIONS AND CONSISTENCIES

## BY GEORGE WOODCOCK

I knew Herbert Read from 1940, when I met him in a Cambridge teashop, a neat, elfishly smiling man with a vestigial North Country accent who affected a kind of aesthetic dandyism by wearing a bow tie and a pork pie hat, up to his death in 1968. For almost a decade, until I left England for Canada in the spring of 1949, I saw him often. He was a regular contributor to my anarchist magazine *NOW* almost from the beginning, and as a publisher (with Routledge and Kegan Paul) he brought out my book on Proudhon and one of my books of verse, *The Center Cannot Hold*. He believed in anarchism, and was associating with anarchists before I was, and on that first Cambridge afternoon he gave me some idea of the movement as it existed and pointed out the people he thought I would find sympathetic, notably Marie Louise Berneri, who soon became my closest friend and remained so until her death in 1949.

As things developed, Read's involvement in organized anarchism and mine differed a great deal. Though he did have loose links with some avant-garde artistic groups, Read was too much of the cautious Yorkshireman to be a great joiner, and while with Welsh enthusiasm I plunged quickly into the work of the inner core of what we called "the movement," he remained aloof, and I think he welcomed the existence of *NOW* because it gave him — like his book *Poetry and Anarchism* — ways and means of speaking about anarchism without appearing to have converted himself into a propagandist.

I was ready, at least for the time being, to accept that propagandist commitment. I even joined the clandestine Anarchist Federation of Great Britain — a paper tiger if there ever was one — of whose existence I am sure Read was less aware during those tense war years than Scotland Yard. I became one of the active workers, an editor of *War Commentary* (which later became *Freedom*) and of Freedom Press, which published some of Read's pamphlets as it did my own. I took my share in managing the anarchist printing house, and treadled many a small leaflet on a platen press. I even made over *NOW* to Freedom Press, and then after one issue withdrew it it since the comrades clearly wished to make it into a pseudo-proletarian propaganda sheet.

Read — and Alex Comfort who also at this period drifted into the anarchist orbit — remained outside all this inner work, and often I acted as a kind of intermediary between them and the activists. But there were times of crisis when Read stood out very firmly for his convictions even if he did not directly support the kind of anarcho-syndicalism, outdated since the fall of Barcelona in 1938, that Freedom Press at least nominally sustained, and that resulted in organizational schisms from which he wisely distanced himself and which made me in the end draw away from what I had come to recognize as a kind of orthodoxy, fissionable because it had isolated itself from other life-directed movements, like

Previous page: Sir Herbert Read at Stonegrave, July 1966. Photo by Felicitas Vogler.

pacifism and feminism and environmentalism which in more recent years younger groups of anarchists have brought back into their view of social change.

Perhaps Read's most publicly active moment came when the offices of *Freedom* were raided and four of the editors were accused of sedition under some wartime regulation, though the war was clearly near its end. Read and I immediately organized writers, including Orwell and Forster and even conservative old Tom Eliot, in signing public protest letters. Then we organized the Freedom Press Defence committee to raise funds for the defence of the anarchists and to publicize our side of the case, and Read became its chairman. The trial was in fact a gift to anarchist propaganda, since items which Freedom Press had circulated to a few thousand people were presented to millions of readers through the press, even the "seditious" passages being highlighted as court reporting. And only three of Freedom's editors were imprisoned by a judge who acknowledged their idealism as he dealt with them according to the letter of the law. Marie-Louise was acquitted on a technicality, and this meant that the police plot to cripple Freedom Press by putting its operators out of the way was frustrated, for I came out of my reclusion and joined Marie-Louise in keeping the paper going, with the moral and intellectual support of our writers, including Read. Read was also willing, after the trial, to remain chairman of the Freedom

Defence Committee which we continued, with Orwell as Vice-Chairman and me as secretary, until 1949 to fight abuses under lingering wartime regulations. We gained no resounding victories, but we did get half a dozen people out of prison by putting pressure on the new Labour government and we did, with Orwell's help, force the police to ease their persecution of street sellers of radical literature.

Until I left England for Canada in 1949, I saw Read many times and in many settings; at his big self-designed house at Seer Green in Buckinghamshire, in the London flats of common friends like Léonie Cohen and Marie-Louise Berneri, at meetings of the Freedom Defence Committee, and often at lunch, sometimes in the Reform Club to which Read invited me, and sometimes at some cheap Soho or Fitzrovia restaurant to which I would invite him. Occasionally we would join George Orwell and Julian Symons at the Bodega in Fleet Street, and during the anarchist trial we and Julian lunched together almost every day near the Old Bailey.

This kind of frequent contact came to an end when I left for Canada. But we kept in touch by letter and in the early months of my absence had a great deal to discuss because Read had just laid on himself the burden of buying an old rectory in the Yorkshire dales near his birthplace, and he there and I in Canada were engaged in trying to create our own miniature economies. I quickly failed as a truck gardener, defeated

by worked-out soil, and I remember Read telling me that his experiments in pig breading were providing him with bacon at several times the price he would have paid to the local pork butcher. We began to feel that Tolstoyan self-sufficiency was not a practical goal for either of us.

We kept writing to each other, largely because we shared our differences with the anarchist orthodoxy. I was greatly disappointed when Read accepted a knighthood, for I knew that without Ludo's insistence on being Lady Read, he would probably have rejected it. Yet I did not join the anarchist chorus of self-righteous disapproval. With Augustus John, I perhaps stand alone among the anarchists in defending the right of any man to choose what does not harm others. And who, except Herbert himself, was harmed when the sycophants began calling him Sir Herbert, which for them was a convenient way of ignoring his anarchism?

I saw Read on the rare occasions when I visited England. The last time must have been in 1965 when I was on my way to India. Herbert had already been suffering from the dreadful oral cancer that killed him, and I think he was beginning to see a shadow of finality in his encounters. I remember how that normally undemonstrative man, when we parted at the bus stop, suddenly gripped my upper arm as we shook hands, and gave me an elfin smile of pure affection, the first time he had shown that our friendship meant a great deal to him.

Read died in 1968. At that time Faber & Faber were his main publishers and also mine, and the Fabers approached me to write the first book on Read after his death. We agreed the the time had not come for a full biography, so I wrote what one might call an intellectual biography, discussing Read's works and tracing their main sources. It appeared in 1970 as *Herbert Read: the Stream and the Source.*

And this brings me to the first full length biography, *The Last Modern*: *A Life of Herbert Read* by James King, which was published in 1990, twenty years after mine, an indication of the long decline in Read's general repute, which lasted for twenty years after his death, when he had seemed to stand at the summit of the English cultural world, a position as precarious and insecure as that of Oscar Wilde before him. Wilde fell noisily from scandal; Read collapsed quietly from neglect once he ceased to be in fashion.

I have delayed my comments on King's book because I wanted to place some stress on a current of Read's thought — his insistence on the links between education and art and the progress toward anarchism — that I feel will assume more importance as he is rehabilitated as a figure of our century. Read's tragedy was that he became celebrated for the wrong reasons, not as a good poet, nor as the writer of a novel — *The Green Child* — that deserved to have successors, not as a sensitive autobi-

Dear Mr Russell,

          Thank you very much for your
letter of the 15th. I enclose a copy of "War
Commentray",the anarchist periodical,which
gives a detailed account of the police court
proceedings of March 9th when the four anarch-
ists were charged,and details of the charges
brought against them. I also attach a copy of
the Circular Letter on which the prosecution
ᴄᴍᴇx is apparently to be maibly based.

          From these documents I hope you will con-
clude that this is an outrageous interference
by the political police with the ordinary
rights of freedom of expression,and that you
will have no hesitation in allowing your name
to appear as a sponsor to our appeal. Personall
ly I hope you may be prepared to go even
farther. I remember the sympathetic account
which you gave of anarchism in "Roads to Free-
dom",and if you still feel as you did then,
you might be inclined to appear as a witness
when the case is tried at the Old Bailey next
week,before Mr Justice Birkett. The Attorney
General is prosecuting:our Counsel is Mr Maude
K.C.

          If you have the inclination and the time to
do this for us,I will at once ask Counsel to
communicate with you. What we should ask you
to establish is the philosophical integrity of
the views we anarchists hold,and our right to
propagate them freely.

                    Yours sincerely,

ographer, not as a literary critic of depth and eloquence, all of which he was, but as the impresario of modern visual arts. As King says:

*He was famous, but fame had been dearly bought. His reputation as the defender of 'advanced' art was, as far as he was concerned, a dubious distinction. For him, such notoriety implied failure. Failure because... avant-garde was still, as far as most Englishmen were concerned, a strange uncomfortable notion, a concept which raised xenophobic shackles. Failure because Read's reputation rested on his writings on art — not on his poetry, his art or his literary criticism. For him, art criticism had been an accidental occupation, into which he had haplessly wandered and then been trapped. Failure because Read acquired the reputation of approving everything that was contemporary... Failure because modernism could be regarded as an eccentric blind alley, down which no sensible English person would want to stray.*

One might counter with the vision of Read as a kind of white knight defending the new and the young, for — apart from his unfortunate actual knighthood — he did have a considerable sense of chivalry and an interest in chivalric writings. But it is hard to find any consistent criterion except novelty in Read's judgements, except that he did perhaps tend to promote more than others those he regarded as friends, like Henry Moore, Barbara Hepworth and Ben Nicholson. At times he seems to have been swayed by fashion — in his passing support of surrealism for example — and he was certainly less than consistent in his support of the young artists he may have seen as his discoveries. It used to be said about him in London that "Herbert is always there for the Baptism, but never for the funeral."

King is quite right in remarking that for Read art criticism was an "accidental occupation." He fell into it when he asked for transfer from his boring civil service post to the staff of the Victoria & Albert Museum, which led to a Professorship of Fine Arts at the University of Edinburgh, and turned Read into a figure in the art world. But what was indeed an "accidental" occupation fitted in with some negative sides of Read's character, and especially his opportunism, whose causes were doubtless to be found in his childhood fall from the Idyllic existence of *The Innocent Eye* farmhouse childhood, to life in a dreary Calvinistic orphanage. One of Herbert's brothers once said to me, a bit ironically, that "the Reads were always regarded as snobs," and the search for self-elevation certainly ran in the family. Read's farmer father kept a hunter so that he could ride to hounds with the local gentry, posing as a gentlemen farmer, and the inherited ambitiousness played a part in Read's decision to accept a knighthood and in his buying the great white elephant of Stonegrave House back in his native country, a house so large that only a fraction could be kept warm in the winter. The need

imposed by such grandiose gestures came together with his opportunism to transform much of Read's life into a rather wretched series of pilgrimages trying to earn money by lecturing on art to fashionable audiences the world over.

Yet the other sides of Read's achievement were genuine and important, and in my view he holds a special position among anarchists nor only as an advocate but also as an original thinker. It has often been argued the Read merely restated in a new way the arguments of Kropotkin and Bakunin and Godwin. But in fact he did — in *Poetry and Anarchism* — declare more clearly than his predecessors the condition of freedom necessary for literary creation; creation and freedom, he suggested, were interdependent.

What most distinguishes Read's anarchism from the anarchism of past theoreticians, and brings it closer to the socialism of William Morris, is the stress he places on the role of the arts — on the artist as mediator, and on art itself as the vehicle of a revolutionary form of education.

The place of art in Read's ideal society becomes clear as soon as we move away from his plans for its organizational functioning, and sense the kind of life he would like to see lived in that future. It is, needless to say, the rural world of a self-proclaimed peasant, rather like that of *News from Nowhere* without its earnest laboriousness, for Read, while at times he denounces the factory system, realizes the "industrialism must be endured," and goes beyond that to search for means by which the machine can not merely perform the unpleasant tasks, which Morris eventually allowed, but can also produce beautiful objects, which Morris would never admit. At the same time, Read is aware that no civilization or people can lose touch with things, can abandon organic processes, can forget the feel of wood and clay and metal worked with the hands, and still remain healthy. Therefore he wishes to use machinery to simplify existence, to bring more leisure, to end pointless labours, so that when men leave the cities they will find "a world of electric power and mechanical plenty where man can once more return to the land, not as a peasant, but as a lord."

In such a world play will resume its true place in human life, since...

*it was* play *rather than work which enabled man to evolve his higher faculties — everything we mean by the word 'culture' ...Play is freedom, is disinterestedness, and it is only by virtue of disinterested free activity that man has created his cultural values. Perhaps it is this theory of all work and no play that has made the Marxist such a very dull boy.*

(*Anarchy and Order*)

Of play, of course, art is the highest form, and Read sees for the artist a high role in the free society, for he is...

*the man who mediates between our individual consciousness and the collective unconsciousness, and thus ensures social re-integration. It is only the the degree that this mediation*

*is successful that a true democracy is possible. (Poetry and Anarchism)*

Read wrote almost all his works on anarchism from the viewpoint of the artist or poet; in this he resembled and may have been influenced by Oscar Wilde, whose *Soul of Man Under Socialism* also envisaged a libertarian society as the best environment for the arts to flourish. But Read did not express an élitist point of view. He might intend artists to be, in Shelley's phrase which he quotes approvingly, "The unacknowledged legislators of the world," but he does not see them in this role as a minority, since what he hopes for, following on the development of a free society, in the universalization of art, in the sense that its standards will be applied to all human work (factory-made or hand-made) and that by this token all men will become artists. As the aim of work changes from profit to use, so will the life-view of the workers change.

*The worker has as much latent sensibility as any human being, but that sensibility can only be awakened when meaning is restored to his daily work and he is allowed to create his own culture.*

*(Politics of the Unpolitical)*

Then we shall realize that "every man is a special kind of artist," for "art is skill: a man does something so well that he is entitled to be called an artist." So art is brought down from the isolation to which bourgeois cultures have condemned it, and becomes a matter of everyday activity.

But perhaps Read's most important contribution to anarchist thought was in fact derived at least in part from the career of art criticism that in some ways had so negatively dominated his life by making him a public and fashionable — if not necessarily popular — figure. It was his concept of education through art. Read gave this a specifically anarchist direction in his Freedom Press pamphlet, *The Education of Free Men*, which developed the concepts of a liberated education proposed by earlier anarchists like William Godwin, but the most seminal statement of his views was *Education Through Art*, a proposal that for the early years of a child's life the development of the feelings rather than of the mind should have primacy, and that this could be done by nurturing the child's natural inclination to express himself in form and color. In this way a gentle kind of personality could be fostered, lacking the aggressiveness created by intellectual competition, and the ultimate result of this would be a more harmonious and therefore a more anarchistic society. In this way Read expanded the possibilities of anarchist action and also the possibility of a libertarian attitude emerging and social realities being transformed without the revolutionary violence that the old anarchists after Proudhon had deemed necessary. For though his attitude towards World War II, like Orwell's, was ambivalent, Read remained at heart a pacifist.

It was, ironically, not until long

*Read and Jung at Küssnacht, c. 1930*

after the period of his anarchist writings, not until the early 1960s (his own late sixties) that Read eventually moved into practical activism, and became involved in the passive resistance tactics of the of the Campaign for Nuclear Disarmament and the Committee of 100, sitting down in Whitehall not to usher in anarchy but to protest, with more conviction than hope, against the destructive aspect of existing unfree society.

Read's later years were marked by a steady loss of hope of seeing a better world in his time or foreseeing one for his children. He seized comfort where he could, and sometimes in unlikely places, for I find a letter written in November 1959, with a postscript on his recent trip to China: "China — very exciting! The communes as near to our kind of anarchism as anything that is likely to happen." But soon he realized that even here his optimism had been misplaced, and it was with a flickering confidence in the world that he performed in 1962 the symbolic act of putting his autobiographical writings together in the final form of *The Contrary Experience.*

*Nihilism — nothingness, despair, and the nervous hilarity that goes with them — remains the universal state of mind [he wrote then]. From such an abyss the soul of man does not rise in a decade or two. If a human world survives the atomic holocaust — and it is now difficult to see how such a holocaust is to be avoided — it will only be because man has overcome his*

*Nihilism. A few prophets have already pointed the way — Gandhi, Buber, Simone Weil, C.G. Jung — but the people are also few who pay heed to them. Spiritually the world is now one desert, and prophets are not honored in it. But physically it still has a beautiful face, and if we could once more learn to live with nature, if we could return like prodigal children to the contemplation of its beauty, there mights be an end to our alienation and fear, a return to those virtues of delight which Blake called Mercy, Pity, Peace and Love.*

Resignation, with a little hope: a melancholy but not an unusual end for an anarchist. One cannot help contrasting the mood of this passage with that in which *The Philosophy of Anarchism* was brought to an end twenty-two years before.

*Faith in the fundamental goodness of man; humility in the presence of natural law; reason and mutual aid —these are the qualities that can save us. But they must be unified and vitalized by an insurrectionary passion, a flame in which all virtues are tempered and clarified, and brought to their most effective strength.*

It is such words that evoke for me the Read I knew. Though in many ways his life was curiously bourgeois, his anarchism had fostered — or perhaps merely refined — a limpidity of nature and outlook such as I have always imagined Kropotkin possessed. His periodical relapses in the Tory conformity of his youth one had to balance against the occasions when he took public stands, particularly in the defence of other people, that cost him a great deal materially and in terms of his career. One blamed at time his inconsistency, but never doubted his sincerity.

On the whole, biography, when it is not an act of adulation, is a dismal art, and a life that is largely frustrated striving encourages the dismalness, as in this case. King has presented the facts well, and makes it clear why Read's hollow public reputation deflated in the years after his death. Yet he never seems to impress us sufficiently with Read's genuine achievements, and I think we can begin to understand the reason for this failure by considering the title of the book — *The Last Modern.*

The title suggests that Read's position in history is that of the final forlorn representative of a great movement. In fact, of course, modernism as vague a term as "post-modern" has been in its turn, referring to time rather than substance. How was Read really related to those we regard as the great moderns? His work had little in common with Joyce's colossal experiments with language. As a poet he was at heart a romantic, as opposed to the classicist Eliot, with whom King is constantly comparing him. He had an early enthusiasm for Vorticism, but otherwise little in common with that savage master of satiric comedy, Wyndham Lewis. And similarly, he was an imagist like the early Pound but had little resemblance to the Pound of the Cantos.

Certainly he did not share the anger that isolated both Pound and Lewis; a little of it might have been a good thing, for in King's account one has the impression of his life as an endless putting-up with something or other; an endless striving for the kinds of recognition that in the end mean nothing.

Yet Read's work in the final summing up means a great deal more than nothing. He wrote well about anarchism and launched at least one important new concept in the direction of education as a libertarian strategy. He was one of the first British intellectuals to edge out from under the oppressive shadow of Freud and recognize the value of Jung's insights, and was responsible as a publisher for the appearance of Jung's books in English. He was a good poet, responsive to the world of nature, and this responsiveness carried over into *The Green Child*, that extraordinary political-philosophical parable which stands alone in the English literature of his time (the closest relative is doubtless W.H. Hudson's *Green Mansions*, rather than anything the so-called moderns wrote). And finally, there is that extraordinary little autobiographical classic, *The Innocent Eye*, the tale of a Yorkshire childhood that is at once a socio-historic document, a model of quiet, evocative prose, and an exercise in the Proustian transforming power of memory, as became evident to me when I stood in the humdrum yard of Muscoates Farm, Reed's birthplace, and evoked the lyrical vision in which the book enwraps it.

Yet the ironically elegiac tone of King's biography is perhaps understandable. Here is a man who once seemed a great figure in the world of the arts, and whose name shrank dramatically with his death. How can one reawaken interest in him? The idea of linking him with those slightly older contemporaries who did succeed is an obvious one, but it had the disadvantage of leading one into incongruous comparisons and setting Read in contexts where he does not belong, at least in the long run. Any revival must depend on his true value as a writer and thinker, which I think was great, including as they did his recognition of the the interdependence of art and freedom. As an impresario of art he remained in the chains of fashion and publicity and hanged in them; as an artist himself and an anarchist, he was his own man, shy and taciturn in his writing, as in his normal speech, but admirably perceptive, understanding, creative.

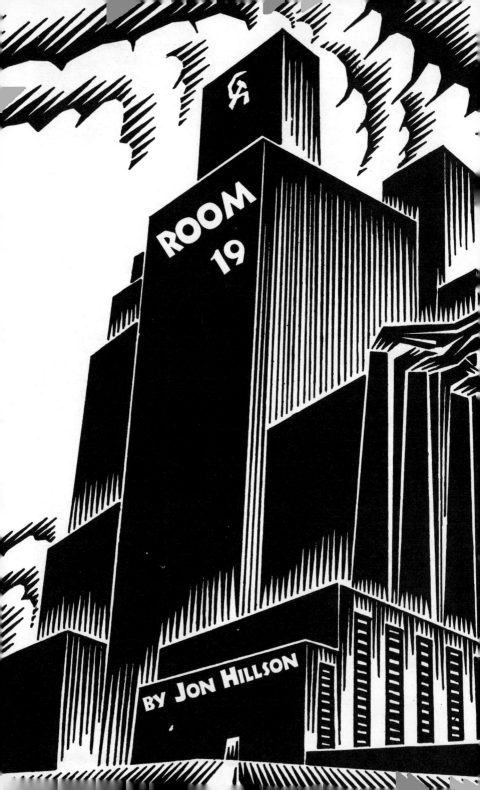

ROOM
19

BY JON HILLSON

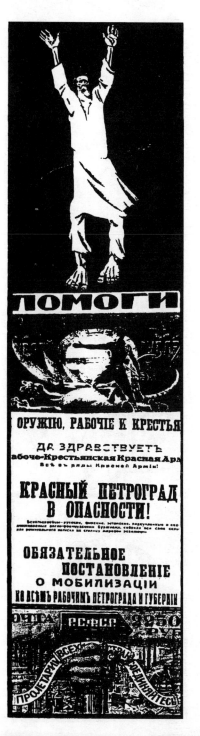

An innocuous building
for so monumental
a task!
behind iron gates
& anonymous
windows
technicians
in white smocks
toil like
busy
little
bees
investigating
in electromicroscopic
detail
the vinegrated cerebrums
of late soviet luminaries
to determine
what made
their heads
tick
this is
their mission
in its 67th
& final year
long rumored
now uncovered in
Room 19 at the
Brain Institute
of Moscow
former reputed
capital
of Marxism-Leninism
historical materialism
& militant atheism

Row upon row
of bowls of
pickled gray
matter
the cranial
entrails of
Lenin

Facing page: Illustration by Clifford Harper. This poem is illustrated with the collages of Freddie Baer.

Sergei Eisenstein
Maxim Gorky
Vladimir Mayakovsky
Kirov
Kalinin
the famous Pavlov
but not his celebrated
dog
various generals of
the Red Army &
forgotten members
of the Central
Committee
their noodles
excavated under the
orders of
the boss
of all bosses
Joseph Djugashvili
who tells em
in the cerebellums
the secret to
the data:
mind is matter
ideology is
phrenology
she is no witch
who
tied with rocks
sinks

Thats the
theoretical premise
of the Brain Institute
from the organ
itself
its flesh
its cells
can be deduced
the source of
political clarity
artistic creativity
military technique

will &
genius
which if found
could be reproduced
tested &
ingested
thus advancing the
formation of the
new soviet man
by leaps & bounds
especially at the
pinnacle of
collective social life
forgetting
however
Lenin declared
with that
not as yet fully
paralyzed brain
of his still
functioning:
"Stalin
having become
General Secretary
has concentrated
enormous power
in his hands
& I am not sure
that he always
knows how to
use that
power
with sufficient
caution
I propose to
the comrades
to find a way
to remove Stalin
from that position
& appoint
another man
more loyal
more courteous

& more considerate
to comrades
less capricious, etc"
Or that
the last act
of Mayakovskys
tortured noggin
was to
pull its plug
rather than submit to
the muse
of police art
unaware that it would
float in a jar of
the peoples formaldehyde
for six decades
scrutinized under
advanced
detection methods
sibling to
astrology
vitalism
numerology
aka existing socialism

Watch them
bustle & scurry
each night
scaling
the locked doors of
Room 19 & its
vaulted booty
with paraffin
carefully eyed
by dutiful
disciplined
Lydia Malofeyeva
comrade chief deputy
of brainkeeping
no peeking
no sneaking
watch them put chunks
of the tissue into a

Тов. Ленин ОЧИЩАЕТ
ЗЕМЛЮ ОТ НЕЧИСТИ.

ГРУДЬЮ НА ЗАЩИТУ
ПЕТРОГРАДА

РОССІЯ

35 КОП. 35

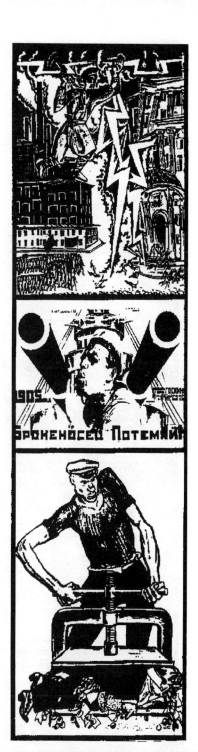

block of wax
then scaling off
a patina of brain
with a motorized
razorblade
a veg-o-matic
type device
to finely slice
the subject of slides
hundreds of thousands of
slides
of head cheese
for the big cheese
under the close &
quiet supervision of
the latest & last
incarnation of the
Central Committee
Gensec &
KGB
their ultimate act
of skulldiggery
still fresh in
brine
scooped
from Sakharovs
late pate
(the technicians
unsure which morsel
is his
engage in polemics
simultaneously
piling up shavings
since they are paid
piecework)
30,000 slides
alone of
Lenins brain
30,000!
how many cases
of carpal
tunnel
syndrome &

other
repetitive
motion
infirmities
befell
the unionized
workers
at the Brain Institutes
to get Lenins
key
organ
reduced to its
physiological essence?
each synapse
individually wrapped
here is what
is to be done
there is state &
revolution & the
right of oppressed
nations to
selfdetermination
all obviously assimilated
by comrades
as indicated by
recent events

In 67 years
of rigorous
scientific inquiry
the earnest cadres
discovered
they had absolutely
nothing to learn
at all
"They
thought maybe
the political figures
would have some type
of specific
brain structure"
Leonid Khaspekov
vicedirector of the

Brain Institute
says of his commissars
"that their brains
would differ greatly
from those of
other people
but of course
thats hardly
possible"

The narcotic
monotony of
the tasks
the automatic lullaby
of the machine
the routine
exponential
accumulation of cells on
glass
the fixed aroma of
the crypt
measured the
seemingly immutable
atmosphere
its fog
obscuring
the historical
u-turn
the reverse of
the pendulum
the dystrophic
conquests of the
apparently eternal
politbureau & its
perennial catechism:
they thought
that maybe
the political
figures
would have
some type
of specific
brain

structure
that their
brains
would differ
greatly from
other
people
but
of course
thats hardly
possible

But
of course
thats
always been
the
whole
point
comrades

[All quotes are verbatim]

# FROM POTEMKIN TO KRONSTADT

*We waited as long as possible for our blinded sailor-comrades*
*to see with their own eyes where the mutiny led. But we were*
*confronted with the danger that the ice would melt away and...*
*we were compelled to make the attack.*
*Leon Trotsky, Sochinenya, V.XVII:Bk 2, p 523*

*We did not want to shed the blood of our brothers and we did*
*not fire a single shot until compelled to do so. We had to defend*
*the just cause of the laboring people and to shoot—to shoot at*
*our own brothers...*
*Kronstadt Izvestia, March 8, 1921*

From *Potemkin* to Kronstadt
The wake of time has rolled
And grey has surfed to green and grey
Fell back again on gull black shoals.

The peasants of the Baltic Fleet
Take their slave life in their free hands
There is no bread in Petrograd
No golden sun in that lead land.

Across the ice the soldiers come
"Comrades, we are killing you!"
The ice is breaking! and each crack
Rifles us and shivers you.

Within the bay the heroes drown
Within the fort the heroes die
Blue beams of longing sweep the sea
Red screams of anguish slit the sky.

History will not speak
Heroes will not lie
Men who wanted love and life
Killed, were killed and died.

—Tuli Kupferberg

# HAVANA

mankind's hands against a wall in old havana
feel the rumble of souls washed in blood
of revolutionary change

hundreds of batista's boys cut down
in the name of justice a word like a
coin which anybody can toss around
& few know how to use

screams for mercy
echo off moro castle
ignored by those who
value human life no more
than a commodity

to be bought & sold by
one ideology to another

mankind's hands against a wall
in old havana leave blood stained
hands of revolutionary failure
32 years into the dream turned nightmare

packaged & sold to mouths
hungry for social justice

who never read the fine print
whe never heard the iron incarcerated
souls who ran from one boss only to
find & fear another.

—Jay Marvin

# SLOW JACK

In Times of Famine
You Learn to Fuck <u>FAST</u>. . . . Like a Cannibal.
Like Some Transient Killer
Come to Sacrifice the Faithfull
In Sympathetic Temples
In Degradation Rituals
Where they Pray in No Language
For Degrees of Death
As They Work Their Way Up . . To the <u>FRONT</u>
of the Torture Parade . .
Their Little Paper Faces
Seen in Close Detail
Smudged and Blurred
Like Obituary Photographs.
     All these Freight Train Buddahs
and Someday Heroes of Paradise
With Their Autistic Fear of Being Touched
Touched Before Dying
Touched Before Nightfall
Touched by the Full Moon Kidnap,Flight Deck Needle Freaks
Before Stumbling Out of the Bone-Crusher Crank-Bug
Pit of Death and Fever Dreams
To go Crawling to St. Cyanide
At the Televised Wailing Wall.
     But Our Lady of Chalma (The Patron Saint of Junkies)
Has Run out of Gas
and is Reduced, to Substituting Scumbag Forgeries
For Youthful Dreams of Ravishment
Which May be Cruel
But Not at all Unusual.
Cause' These Are the Days
When Good Samaritans are a Dime a Dozen . . . .
I Mean . . When Everyone Out on the Dogshit Sidewalks is Facing Destruction
<u>WHO</u> Thinks of the Future?
Or the Quality of Mercy?
When All Your Wounds are Open
     When You're Abandoned by god
and You Just can't Sleep in the Rain Anymore
and You Can't Find Your Eyes Anymore
As You Stand in Line For Sandwiches
In the Shadow of the Slaughterhouse.

       —Christian X Hunter

# TRIUMPH OF THE POSTMODERN

The violins tended to shriek
escaping their linear melodies
The symphony band in running shoes
tapped out tunes from MTV
and poets deconstructed themselves on NEA grants
and joined linguistics departments
as others (baffled into silence)
took to the hills chanting sawmill haikus
or opened up unisex hair parlors in Des Moines

You're so minimal!
cried studio-mates to each other
doing DeKooning in Day-glo
(perversive not subversive—
art an ice-cream cone about to melt-down)
Not to worry my dear
The maid can clean it up

And Mother 'married' the Count
of the Lower East Side
as it used to be called
as he used to be called
before he opened that Gallery
so Uptown my dear
a huge disaster darling
the kind that make millions
and he did he did
on the Tokyo Exchange
'My girl-friend painted them'
boasted the painter himself on-camera
raking in the shekels
with his diamond-paste tiara
(He'd been tri-panned in the Sixties)
Awesome! cried the cricket critics
and ever since it's been dolce vita except
the dolce's on the dry side
like certain lower Italian dessert wines
nobody drinks anymore

And 'The point of the painting
is the point'
another painter kept explaining
imperfectly aware that saying that
meant nothing at all
which was the point after all
before things got so metaphysical
like Dolores with his pants down
flying down to Rio for a Drag Queen Festa
(except it all happened
at The Dakota)
My dear he trilled
Park your surfboard by the door
There's no room up here
for such subjective realities
nor for the sirens wailing either
in Vaughan Williams' Antarctica
That is not what I meant at all at all
We're watching ocean waves during the eclipse
'live' on TV!
(Shadows of shadows on the walls of the Cave)

In the doom the women come and go
Heaps of this and that on gallery floors
(Mother snores)
Diamond-rubble, is it?
So when will it cohere?
But that's just the point my dear
Rome wasn't burnt in a day
We're falling through chaos to chaos
and we'll get there first this way
and laugh at you dancing your old dipsy-do
in your old Milky Way mummy mia
in your dear old figurative fantasia
of pointillist constellations
in picture-window landscapes
we all wished we lived in
as if we all hadn't all
read all the latest about
how we're all inside this

incoherent universe of broken symmetries
where all that falls
might fall apart in the end
into some kind of total darkness
although there once was a place pray tell
where all was light
which once was the place perhaps
some non-man-made god hung out

And so tra-la tra-la
It's fin de siècle again my dears
and the music of the spheres
some kind of mad mad laughter

—Lawrence Ferlinghetti

*This poem has been collected in* These Are My Rivers, *New Directions, 1993.*

# KALI–MA

## "VERSIONS" OF SOME DEVOTIONAL SONGS
## BY THE BENGALI YOGI RAMPRASAD

## BY DIANE DI PRIMA

Tara's name makes all prosperity vanish.
It leaves a torn knapsack
        & not always that.
As the goldsmith gathers gold & leaves the dross
        so her name steals good fortune.

O Mother, It is doubtful that your son can bide at home
when you & your lover sleep at the foot of a tree
        your bodies smeared with ash.

Tara encloses Ramprasad, you will not find him.
O friends & brothers! Forget me! I am gone.

I try to make an Image of illusion
Is She earthen?
I work clay in vain.

She bears a sword
       wears skulls
How can She soothe mind's pain?

I hear She is dark
       yet she illumines the world.
How paint that blackness?

Then too, She has three eyes:
       Sun, Moon & Fire
What artist could make an Image
       w/such eyes?

She strides on the battlefield w/ loosened hair
Fire burns on her forehead
Her eyes are the sun & moon
Her transparent face shines like an emerald mirror
She is the color of a new raincloud

       She routs rakshasas
       Swallows elephants
       Leaps over seas & mountains in a flash

Is it a goddess, demon,
       naga or woman?
Her repeated war-cries pierce the sky

# THOUGHTS ON THE EVICTION OF A SQUAT

A stunning show, a spectacle;
They need force of a thousand in full gear
To tear the building down.
We still will not back down.
Deeper in the park, I tell where they are,
The cowards,
For their helmets glitter.
A ridiculous scene too terrible,
I seek to get away:
My squatted room, just moved into.
I think of friends but recently made
Who don't know how much they mean to me;
I fear for them when sticks come down.

I seek to get away in dreams, still fully clothed.
I dreamt of cops with bayonets
Last summer,
But now of cops, unsure of their commands,
Who will break ranks and listen to an inner voice
Instead of that of their authority,
For all must live, at base,
And I have heard of such things happening
From poor B.B.
And if a few threw down the badge, but kept the gun,
Real change would start to happen, and
(Some will scorn me for this, but)
Such few could live with me.
A laughable thought, perhaps, because
The ones I see have no humanity.
They tore the building down.
The cowards, where do they live?

But the cat, he comforts me,
For his home is next to me.
I take off my clothes to go to sleep;
Belly bulging finally makes me know
I will shed blood tomorrow and
That there can be new life,
I take up the fight.

  —Mary Conte

## AFTER SUBLIME CHAOS

Clouds hand in the sunshine of victory.
Crowds multiply like bacteria in the mold of a New Culture.
Speeches harmonize cacophonies form the streets.
Bankers are in hiding, generals run naked
through the jungle, no one chasing them,
no one bothering to confiscate their papers.
Who could have prophesied such sublime chaos?
Anarchists and poets are nonplussed
surrealist anthropologists stare palsied
at intergenerational copulation.

I hardly know how to put it
before it passes
like all other victories
into oblivion.

       —Morgan Gibson

## SPRING IN MONTAUK, LONG ISLAND, AT 7A.M.
for Virginia Admiral

I am having a quarrel with a grey squirrel.
He is young and nimble, not without cunning; beautiful.
Although I nurture prejudice, a degree of caution
makes me uncertain if his lack of proportion

is related to membership in the rat race:
he is not far removed from man. With backward glance,
he scurries along the porch rail — is ours a war or a dance?
I pelt with fallen cones the pine tree he prepares to climb.

Whiskery, friskily again and again, he will return,
frenetic, and boldly. It is his design.
He has frightened away plump crested blue jay, dove,
red cardinal, even a tern, blue finch, robins, birds I love

who know the feeding station as their own. As usual
I am meddling in the world's ways; I cannot win. Proprietorial,
greedy in place of his sense of proportion,
he is unlike others who coexist in this small wood. Bird

song surrounds the porch above constant music of the Atlantic Ocean
(acknowledging its bravery by mellifluous imitation)
secure nourishment from land, sea and wind and beneficent man
(when he thinks on them) casual in sharing, gracious in

pecking order. Unscrupulous squirrel consumes their lot!
Here I am, meddling in the world's ways. Am I trying to win?
I roll two sheets of newsprint, surround birdhouse and lode.
It confuses him and, alas, the birds; but not for long.

Deftly, he removes obstruction to his gratification,
which a light wind blows aside. I am meddling in the world's way:
although I pursue him, he returns time and again,
engages two blackbirds to work for him. (One is lame

and fearless). They scatter seed, nibble a serf's quota
with fine lack of precision. Together, blackbird and his brother
are hurried from the scene by their wolf tailed boss.
Fierce toothed, he grins; bustling with presumption,

he assumes he will win. Absurdly, I meddle with him,
approach meekly now to remove paper and scattered cone,
that he may enjoy his feast and my hospitality, for look
how thin he is, how sparse his forage, how long his winter has been.

                                        —Dachine Rainer

# DRUNKEN BOAT

## BY GEORGE WOODCOCK

I received and read my copy of the first issue of *Drunken Boat* with a mixture of immediate elation and hangover sadness; elation that the links between anarchism and avant garde art were being seriously forged again, and sadness that over the past generation this vital conjunction in the history and practice of anarchism had been so neglected.

Indeed, it now seems to me that—looking back at the last 40 years or so, one can think of few periods in the history of anarchist thinking in which there has been so little of the fertile contact between the imaginative and the polemical that marked the early development of anarchist ideas and the looser movement (never a party) that represented anarchism in deed.

William Godwin, whom we generally regard as the father of anarchist thought, was himself a novelist of considerable Gothic power, whose *Caleb Williams* is generally regarded as the ancestor of the criminal suspense novel, and his close disciples included not only the poet Shelley and the novelist Mary Shelley, but also Edward Bulwer Lytton, the American Charles Brockden Brown, and Benjamin Constant (his translator), while Coleridge and Charles Lamb were among his friends.

This link between poets, novelists and political activists, arguing out and projecting each others' visions, was to be continued in the mid-nineteenth century by Proudhon and his intricate contacts with French literary and artistic circles from the 1848 rev-

olution to his death in 1864. The French critic, Sainte-Beuve, wrote Proudhon's first biography; Flaubert is on record praising his prose, and Baudelaire admired his ideas and supported him journalistically during the revolution; this initiated a connection that was to be continued between symbolists and anarchists later in the century. Proudhon and Courbet, both hailing from the Franche Comté, were close friends, and Proudhon wrote as a justification for Courbet's Realism his *Du Principe de l'Art et de sa Destination Sociale* (1865). Some of the great figures of Russian literature were connected with Proudhon, notably Alexander Herzen who financed some of his mutualist journals which Napoleon III's police constantly suppressed, and Leo Tolstoy, who visited him when he was in exile in Brussels and borrowed for his greatest novel the title of Proudhon's then current book, *War and Peace*. Courbet's deepest commitment to Prouhonian ideas was shown when in 1870 when, as a mutualist member of the International Workingmen's Association, he became actively involved in the Paris Commune and was prosecuted for his actions.

Godwin invented anarchism when he published *Political Justice* in 1783, Proudhon named it and proudly assumed the label when he published *Property* and called himself an anarchist in 1840; and an anarchist movement began to form in the 1860s when Bakunin organized the anti-state opposition to Karl Marx in the International Workingman's Association. Bakunin was the friend

of Turgenev and fought beside Wagner on the walls of Dresden defending the revolution during the great year of 1848. Turgenev made him the model for the hero of his early novel *Rudin* and Wagner is said to have incorporated him into Siegfried, while as the teacher of the regenerative power of destruction—"The urge to destroy is also a creative urge"—Bakunin influenced a whole generation of young European intellectuals.

Tolstoy, from his explicit criticism of the state and his implicit attack on the great man theory in *War and Peace*, perhaps remains the grand example of the links between imaginative literature and anarchist attitudes during the nineteenth century, despite his refusal to take on the label of "anarchist" for fear of being identified with the terrorists who flourished—and in movements other than anarchism as well—during the late nineteenth century.

But perhaps the most important period of the linking of anarchist action and thought and avant garde art was that which began in Paris at the end of the 1880s—the height of *La Belle Epoque*—and ended in London and other English-speaking centres like New York and San Francisco as late as the early 1950s.

The Symbolists, descendants of Baudelaire, in rejecting the supremacy of direct statement in favour of the authenticity of suggestion and correspondence, and the Impressionists and Neo-Impressionists, ultimate descendants of Courbet and emissaries of a prince of light some might call Lucifer, fitted well into an anarchist world which at that period spread widely enough to include the revolutionary anarchist communism of Peter Kropotkin, the revolutionary syndicalism of Georges Sorel, the defiant terrorism of Ravachol, the uncompromising individualism of Max Stirner and the peaceful educational experimentalism of Elisée Reclus and Sebastien Faure. Kropotkin had by now replaced Bakunin as the anti-authoritarian father figure, and he was not only the author of a brilliant autobiography, *Memoirs of a Revolutionist*, of a book on Russian writers, and of that marvellous speculative work, *Mutual Aid*. He was also the friend of the great late Impressionist painter Camille Pissaro who, with many other painters of the time (like Paul Signac, Van Dongen, Augustus John, Vlaminck and, for a time, Picasso), declared himself an anarchist. Kropotkin was even selected by Oscar Wilde in that strange spurious confession, *De Profundis*, as one of the two men whose lives he admired most of all—the other being the somewhat more disreputable Paul Verlaine.

Dedicated anarchist magazines of literature and the arts flourished at this time in France, Spain and elsewhere. Avant gardists like Rimbaud and Alfred Jarry combined experimental and social mockery in ways that anticipated Dada and Surrealism. Even the notable novelists of the time were fascinated by the anarchist personality as Henry James showed in *The Princess Casamassima* and Joseph Conrad in *The Secret Agent*

and *Under Western Eyes*. The later pre-Raphaelites were much involved in anarchism, as William Morris for a time shared with anarchists, the editing of *Commonweal*. William Michael Rossetti's teenage daughters edited the *Torch* from the family basement assisted by the young Ford Madox Ford who many years later wrote his recollections of the Sunday afternoon gatherings when London intellectuals would go out to eat Sophie Kropotkin's *borscht* in Boomley.

The links between anarchism and avant garde art continued even through the period when anarchism was at a low ebb during the 1920s and 1930s owing to the rival attraction of Communism, successful in Russia. This was particularly the case in literary circles, where Marxist fellow travelling was fashionable until the great disillusionment of the Spanish Civil War. Yet, a surprising number of modernist writers remained in touch with libertarian movements; Traven was a noted militant and Joyce, Kafka and Hasek were all connected at times with various anarchist literary groups, and though the surrealists at first affected an identification with Marxism, many of them eventually followed André Breton in veering towards anarchism. In the early 1940s French and Belgian members of the surrealist group in London exile would meet with Marie Louise Berneri, Vernon Richards, Simon Watson Taylor, me and other English anarchist intellectuals in a large tavern opposite the Tottenham Road Corner House, where we would often prolong the evening with food; several of them contributed to *NOW*, which was running at the time.

After *NOW* in England and the journals you mention in the States, there were a few lesser magazines in the late 1940s, Alex Comfort's *Poetry Folios* and Albert McCarthy's *Delphic Review*, and the various Walport journals, notably *Illiterati*, in Oregon. I think what marked all these journals and linked them to magazines of the same kind in the French 1890s was a resistance to social moral as well as political authority, an experimental attitude towards language and imagery, and a rejection of the kind of rarefied critical pedantry that produced such neo-Marxist enemies of the imagination as Derrida and his English-speaking jackals.

Since the very early 1950s there have been no journals of this type worth considering. There have been continuing journals of anarchist opinion like *Freedom* which have declined in quality over the years and nowadays seem to condescend to the workers who are supposed to be the majority of their readers. There have been scattered sheets put out by small groups in recent years usually with some interest in addition to anarchism, such as militant feminism or environmentalism. And there have been the serious theoretical journals, like Colin Ward's excellent *Anarchy,* and the current *Raven* in London, which started well but has now declined into its own kind of pedantry.

But nowhere for many years,

until the appearance of *Drunken Boat*, has there been a journal of any significance combining the values of avant garde art with those of militant anarchism, and for that reason one hopes its life will be as long and productive as beginnings suggest— though I suspect that five years is the natural life of any good literary review.

I think it might be of some use, at this point, to speculate why in recent years there have been so few anarchist-avant garde literary and artistic magazines. And here I should perhaps begin with the remark that in my personal experience as an anarchist militant as well as a poet, and in my study of the history of anarchism, I have not found "movement" anarchists much more friendly to adventure and experiment in the arts than "movement" Marxists. When I took *NOW* into the anarchist movement in 1943 and Freedom Press started to publish it, there were outcries after the first number from all the old-line comrades and the syndicalists. "What has this to do with a Tyneside shipyard worker?" was the kind of complaint expressed so strongly and often that very soon I took the journal under my personal printing again and Freedom Press merely distributed it, to keep the peace. Let no one persuade you that all anarchists are free of intolerance! Elsewhere experience has been very similar to mine, and even if one looks into the histories of journals of this type, it is usually from the artist's side, without much help from the militants (Emma Goldman and Alexander Berkman were notable exceptions) that the initiative has come. I remember particularly Félix Fénéon, that fine critic and supporter of Seurat, who was behind half the libertarian literary reviews of the French 1890s. And I remember how the subscription lists of such journals tended to be filled up with the names of painters and poets like Mallarmé who had never overtly committed themselves to anarchism. The real support came not from the anarchist militants, who were usually obstructive, but from the artists and their friends, who were also the real moving force behind the one group in recent years to be concerned with creativity—the Situationsists of 1968.

Why have writers not come forward lately as they did in the 1890s and the 1940s to found magazines that proclaimed the links between freedom and artistic creativity? I think the answer is that freedom has become a less urgent goal because literature, like the other arts, has allowed itself increasingly to be subjected to authoritarian academic structures. When Rimbaud was around in the 1890s, when I was around in the 1930s as a young poet, it never entered our minds to seek jobs in universities or to take "creative" writing courses, which did not yet exist. We became part of a flourishing autonomous world of literary creation, and worked our way somehow through its interstices, at times illuminating the cracks with brilliant blossoms, as Rimbaud did. Literary magazines then were not founded by universities for their added glory but by eccentric publishers like John

Lane setting up *The Yellow Book* or by writers with patrons like Ford Madox Ford establishing the *English Review*, or writers without patrons, like Julian Symons creating *Twentieth Century Verse* on a clerk's income or Félix Fénéon supporting his versatile ventures on an ascetic life style and—of all things—a salary as a minor bureaucrat on the French Ministry of War!

Except for a few Marxist editors, who were always talking about "Masses" but never found a single genuine proletarian writer, we established no codes or orthodoxies, no quasi-academic programmes. We were interested in the new, the exploratory, writing that was contemporary in the sense that it gave voice to the changing world known to us as individuals as well as collectively. We were—many of us—committed to anarchism, but not in the same doctrinaire ways as our more "militant" counterparts.

Now we have a situation where many poets (fortunately not all of them) enter their double careers as bards and academics in the graduate school and continue until death or Alzheimer's claims them. They establish their subsidized magazines supporting the anti-literary theories of megalomaniacs like McLuhan, the dry academic destructures of neo-Marxists like Derrida, and zealously publish the unadventurous works of their creative writing students. Of course, it has proved impossible to teach the latter to write if they were not natural writers to begin with. Just as in an art school one can teach a little art history and give some training in techniques, but not in how to create a work of the free imagination, so in a "creative" writing school one can do the same things as one might in a good English class, teaching the language and structure, recommending books to read, giving criticism when asked. As for inspiration, for originality, both of them are soon smothered in the steamy atmosphere of a forcing house enervating minds that should be out in the world, watching, experiencing, expressing, declaring, remembering.

It is because writers—and especially poets—have been so straitjacketed into the structure of academic literary bureaucracy that poets no longer equate freedom and creativity and no longer publish truly radical magazines of the arts, and why *Drunken Boat* should be welcomed and nurtured and perhaps be the forerunner of a new liberation of literature.